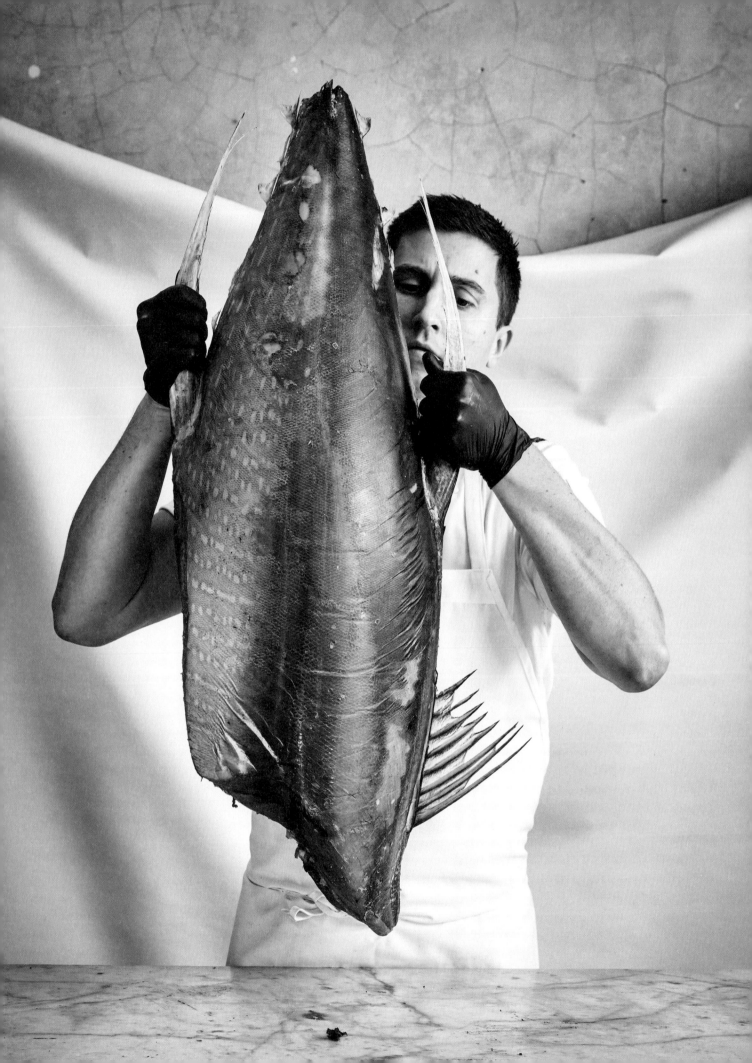

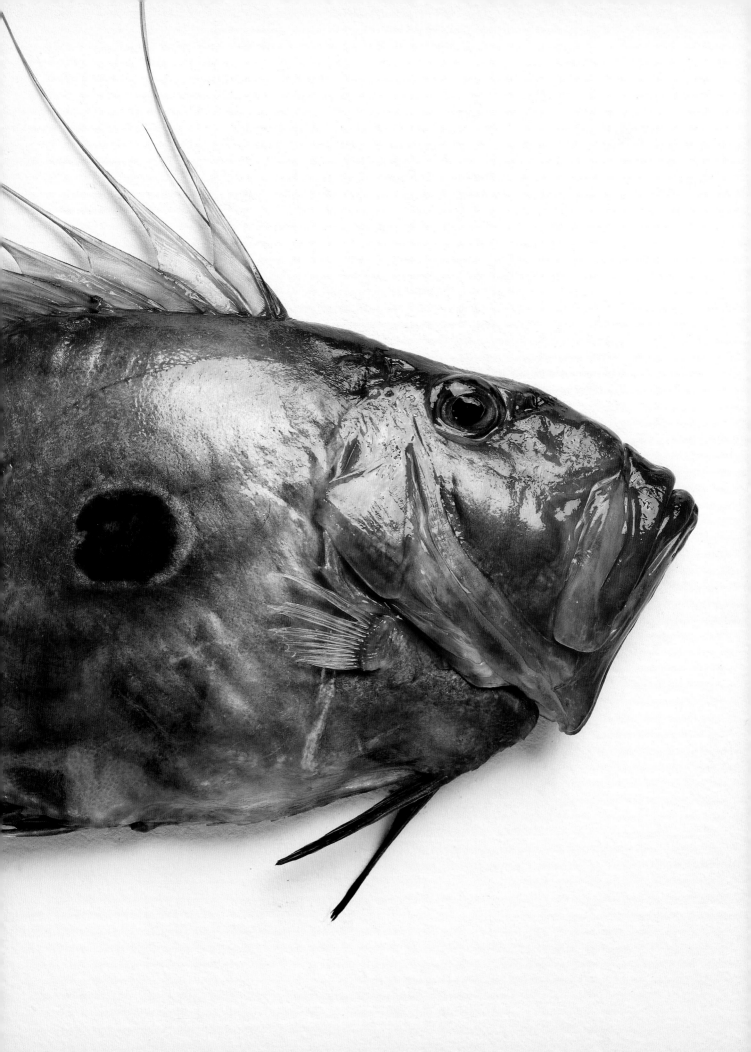

TAKE ONE FISH

The New School of Scale-to-Tail Cooking and Eating

Josh Niland

Photography by Rob Palmer

Hardie Grant

BOOKS

Contents

Introduction

'From my experience over the past 20 years as a chef and as a fishmonger, we were all so happy if we could achieve a yield of 55 per cent, but usually 50 per cent was the max. The other half simply ended up in the trash bin. Pure waste. Imagine, if we would let ourselves be inspired by Josh's philosophy and we would be able to reach let's say 70 per cent yield ... as a first, good step. A quick calculation would show us we would have around 57 million tonnes of extra potential seafood available for human consumption each year (we currently consume 143 million tonnes worldwide). The current global per head consumption is estimated at 22.3 kg. Josh's philosophy would make us eat so many more kilos from the same amount of fish caught (or simply lower the catch to preserve our oceans). Or with the same sustainable catch, we could serve so many more people on this planet a healthy, nutritious and delicious meal. I know it is not easy and we can certainly discuss this calculation, but I can tell you that I now see the world of seafood differently. Josh made me think.'

Author, Chef and Sustainability Warrior Bart van Olphen

Fish is the main source of protein for almost 1 billion people globally[1], yet more than 30 per cent of commercial fisheries are operating at unsustainable levels[2].

It is an increasingly pressing problem, without easy solutions. But what's key is challenging the system by shifting the focus towards valuing diverse species and all parts of their edible components.

My priority is to maximise the yield from one single fish, which I firmly believe should not be seen as something we only take the fillets from – this kind of thinking is lazy and neglectful and will only continue to result in the widespread depletion of our oceans. As documented in my first book, *The Whole Fish Cookbook*, there is a minimum of 90 per cent delicious potential in each and every fish in good condition, a number that represents nearly double the commonly accepted yield. What does this mean? Well, ultimately, for every fish caught we can generate the yield of two. So, one less fish is caught, effectively doubling the output of fish for the world.

I've written this book, then, not just for the recipes it contains to be cooked and enjoyed, but to continue these conversations about how we can think about fish in new ways. These ideas of handling fish differently and how we think about its offcuts, offal and storage potential could have wide-reaching impacts on the sustainability of one of the world's most important meats.

Yes, I know this is not new knowledge; there are chefs, families and communities all over the world that celebrate diversity in fish species along with consuming every part of a fish for necessary reasons. But there is still so much further to go down this particular road collectively.

1 According to the World Health Organization
2 According to the UN Food and Agriculture Organization

My desire here is to encourage you to see fish differently and to consider it as more than just the sum of its fillets.

Sustainable seafood options, for example, do now exist at some supermarkets, but fish offal is not readily available ... yet. (Though perhaps it is optimistic of me to think that people will readily buy fish liver or other offal at the supermarket?)

I'm no Captain Planet and I'm not suggesting you go and eat the eyeballs out of the single fish you buy at the shops, but this conversation is urgent: it's past time to question the normalisation of half a fish going in the bin. My desire here, as it has been throughout my career, is to encourage you to see fish differently and to consider it as more than just the sum of its fillets. And if this book can offer an immediate solution for how to take and use just one fish more efficiently, then to me it was well worth writing.

Over the pages that follow I have drilled down into this philosophy, selecting just fifteen fish species and showing their practical applications, analysing and articulating them in a way that should empower you to 'take one fish' and cook it with confidence, no matter the shape or size. Much consideration has been given to species selection, and my number-one priority has been availability, followed by the suitability of these fish to explore the widest spectrum of cookery methods. Alternatives are listed throughout, and I implore you to consider these recipes as a framework for the fish that you have access to locally and, of course, fish that are in their best condition.

More than anything, though, I hope that after reading this book you will feel motivated to set aside all those dated 'rules' of fish and let go of your fears (whether they are due to delicate flavours, texture or bone structure – or simply inexperience alone). Slowly, in time, as your confidence grows, your thinking about its possibilities will likely also evolve too. Mince it, marinate it, grill it over fire, smoke it, eat it cold for breakfast the next day, or gnaw on the bones ... yes, we are still talking about fish here!

Fish is so much more than two fillets held together by a head and a tail. It should be a real privilege to consume and something that, in both the cooking and eating, brings you and your family real joy.

Josh Niland

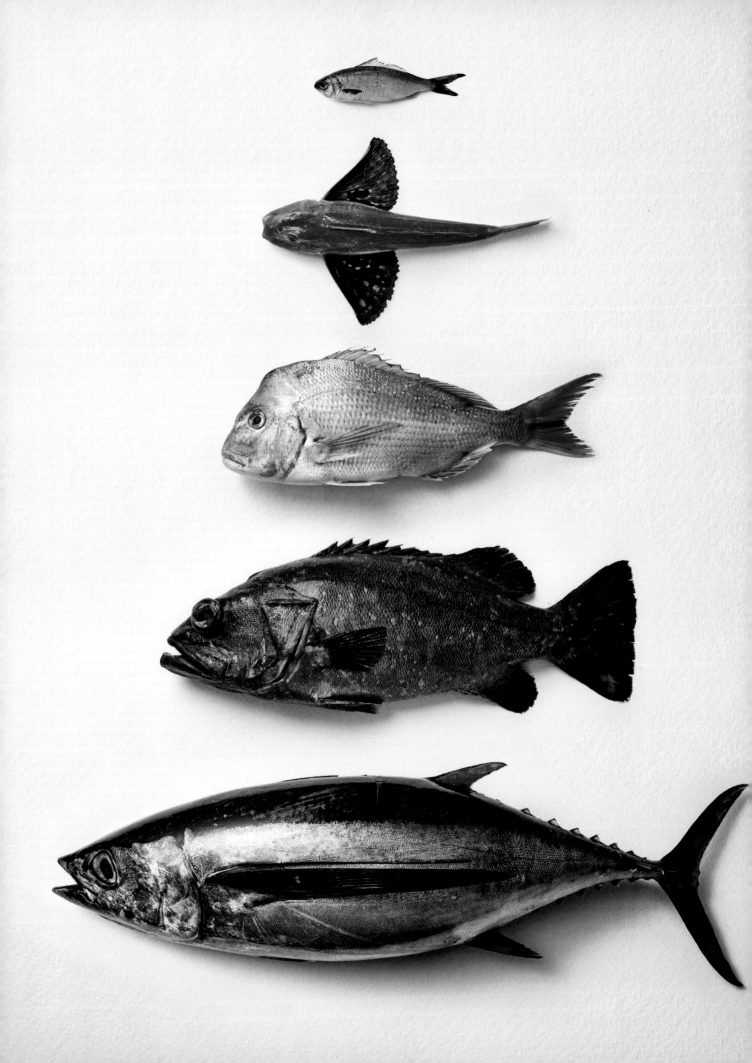

How to Use This Book

The aim of this book is to inspire and excite you by revealing the incredible culinary possibilities presented by fish, while also encouraging you to seek a better standard for quality and a greater understanding of what you can achieve in your own kitchen with one whole fish. I want to arm you with all the skills necessary, not only to cook fish better but to cook it in ways that are both more sustainable and more delicious. For sure, it may seem hard, but for the future of fish in our diets we must adapt and create desirability and deliciousness from the entirety of the fish we buy.

The biggest challenges of working with fish in the kitchen are, first, selecting the right fish and, then, cooking it right. Therefore these recipes are grouped by fish type and are categorised by size – starting with the smallest and working up to the largest. Some of the fish have been broken down into a number of cuts to showcase the potential that one fish represents, while others have been kept whole (and some have been shown both ways). Recipes can be scaled up or down depending on the number of people you are feeding, and those recipes featuring very small fish use a number of these fish per portion.

Working with fish can, at times, demand the same sort of precision and rigour as pastry making, and I will admit that there are complexities to some of the recipes that follow – mainly due to my commitment to giving you the most delicious recipe, without compromise. Yes, there may be ways to cook faster or with fewer ingredients (and that is fair enough when considering both time and budget!), but I wanted to showcase the full extent of a fish's potential here by not missing out on any of these forgotten parts and flavour pairings. I urge you to give them a go, too.

Attempting these will arm you with the confidence to venture beyond pan-frying a piece of pink or white-fleshed fish, or putting deep slashes in the side of a plate-sized fish and baking it to the point of doneness. It will also, hopefully, encourage you to challenge yourself further and cast your net a little wider as you gain confidence with a broader spectrum of species.

Look at the recipes that follow as a window into a world of opportunity rather than a list of specific demands and instructions – they are building blocks to arm you with a framework of understanding, as well as the specific methods needed to cook and present these fish at their very best. Don't be shy; please, tuck this book under your arm next time you set off to buy your fish.

Yes, fish in every sense can be challenging, expensive, laborious, fragile and bloody difficult to work with, but if you absorb the suggestions, thoughts and solutions I offer in this book I am confident you will develop an even deeper love and appreciation for this extraordinary superfood.

Need to Know: Buying and Storing

Picture this: a fish is caught, it is then killed or it dies. The fish then travels to a marketplace to be processed and sold. It is firstly vigorously scaled (2% of yield) and washed, then gutted (15%) and washed again before the head is removed (20%) and the fillets (48%) taken off the bone (15%). A further brief spritz of water follows (to give the fish its lustre and shine), then it is nestled among a generous shaving of ice together with many other fillets under, on top and alongside it. A customer sees and inspects the piece they like and asks for two portions, which are wrapped in plastic before being wrapped further in paper to ensure there are no drips. The fish then makes the journey in the car home, where it is put in the fridge ahead of dinner that same evening.

Come dinner time, the fish is unwrapped from its layers and a strong aroma of fish is detected. The fish is quickly rinsed under the tap, again, to remove this odour along with any imperfections on the exterior (be they scale or blood), patted dry with paper towel and cooked thoroughly before serving and eating. Rarely would there be fillets left uncooked or cooked fish as leftovers. It is all consumed, and the task of fish cookery and eating is over.

Now, imagine a carcass of beef arrives at a meat butchery, where it is taken apart into its many sections, one section being the sirloin on the bone. This sirloin is cut off the bone, washed and then steaks are cut from the sirloin and spritzed further for lustre and shine. These sirloin steaks are placed on a bed of freshly shaved ice and nestled in alongside, on top of and underneath other steaks. You see where I'm going with this ...

This may sound humorous to some and potentially ridiculous to others – one would assume the shelf life of the sirloin in question would drastically shorten and an odour would eventually develop, creating, perhaps, something referred to as 'beefy beef'. Again, humorous, yet how have we normalised 'fishy fish'? The idea that a fish has a period of excellence that would never exceed four or five days post-purchase in fact reflects ignorance and poor handling.

The use of water during processing and aggressive coarse scalers are designed for efficiency and speed. But what if we were to start celebrating quality over quantity? By not following this routine, we may extend a fish's shelf life by two or even three weeks, depending on the species in question.

Not all fish are suited to long-term storage, but there are a huge number of species that benefit from two to three days developing subtleties and flavours that weren't present on day one. And then there are those that taste unbelievably better come week four! This is knowledge I have acquired through observation and tasting fish at different stages throughout its storage time.

If the conversation about ageing and finding a moment where the right amount of moisture has been removed and all the natural fat within the fish is promoted doesn't interest you, then that's fine. BUT try making a fish with bruised flesh from harsh scaling, wet skin from washing and a fishy odour from mishandling taste delicious and you might feel differently.

This book is not here to say that ageing fish is the only way, but rather that a different standard does exist.

Tips When Buying Your Fish

1. **Have a game plan:** Know how many you are feeding and what methods of cookery you have available to you before you go to the fish shop.

2. **Know what to look for (whole fish):** Glistening eyes that are bulbous and clear, a firmness in appearance and to the touch, scales that are tightly composed and are unaffected by bruising, abrasions or deep cuts, and a light ocean or seaweed odour.

3. **Know what to look for (fillets):** Ensure that the fillets are dry and not sitting in a puddle of their juices, ice and water, that the skin is intact, free from bruising and marking, and that the flesh is translucent and glassy (it should not appear to be foggy, milky or have a brown lateral muscle, as these are all key indicators of a poorly handled fish).

4. **Know what to look for (frozen):** All of the above quality points are relevant, but also be certain to check packaging dates and inspect quality of freezing to make sure there is no freezer burn (telltale signs of which include ice crystals on the fish itself and discolouration in spots).

5. **Ask questions:** Speak to the attendant about what has just arrived, or what they would personally buy.

6. **Get the work done for you:** If you would like a fish to be filleted, de-boned, butterflied or have its skin removed, then ask for it! There is nothing wrong with getting a professional to do this for you, especially if it will improve your experience with the fish once you get home.

7. **Look past the top tier:** You don't always need to buy the centre cut of a fillet or pay top dollar for the most premium fish available. Instead, if a recipe calls for fish mince, or just the collars or even the tail of the fish (as many in this book do!), be specific and ask for these items. It would be ludicrously expensive to mince beef fillet or sirloin for a lasagne, not to mention it being the wrong cut to be cooking for hours. Fish have muscles and components to them that offer different flavours, textures and, importantly, come in at different price points. In short, start thinking about buying fish like you would meat.

8. **Demand diversity:** If you are looking for a fish that doesn't appear to be available, then ask for it! This will give the fish shop the confidence they might need to go out and buy more than the four species of heavily trafficked fish that they currently stock.

9. **Ask about cooking:** While you are shopping, ask about cookery methods that are applicable to the fish you have chosen. You might pick up some good advice that will lead not only to a delicious dinner but also a greater confidence moving forward.

10. **Be loyal but not submissive:** It is important to buy fish from responsible fish-shop owners whose products are ethically sourced; however, if you buy a fish and have a negative experience then be sure to give feedback. Don't settle for 'fishy fish' or a fish that is mushy or tough.

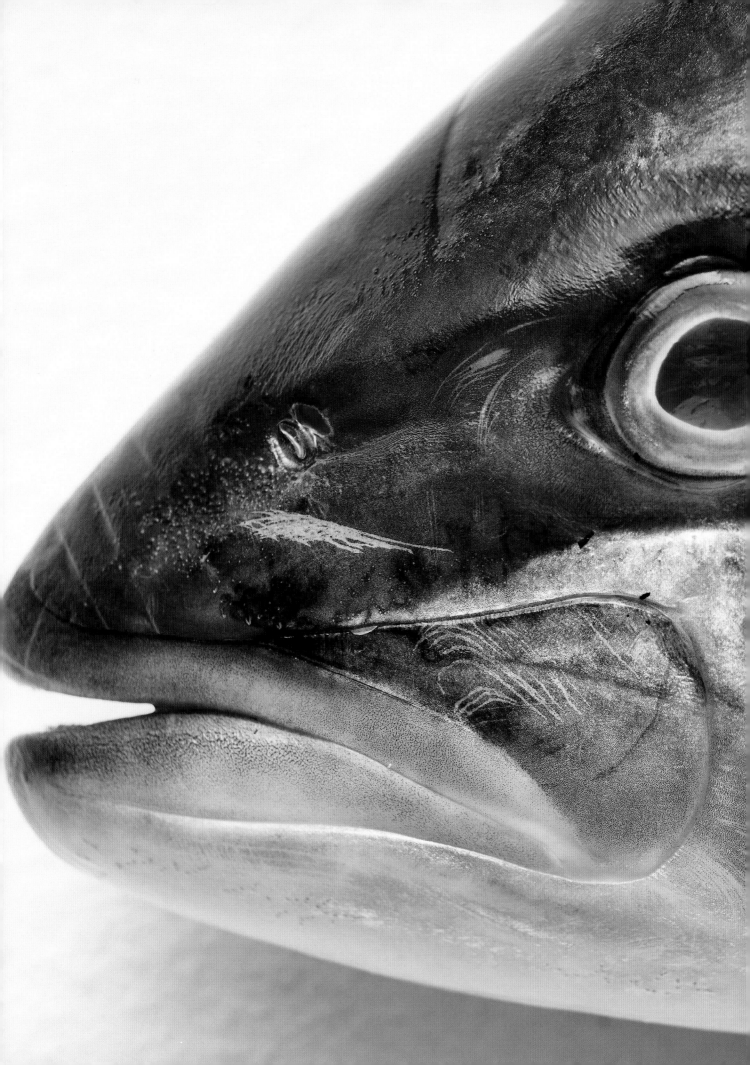

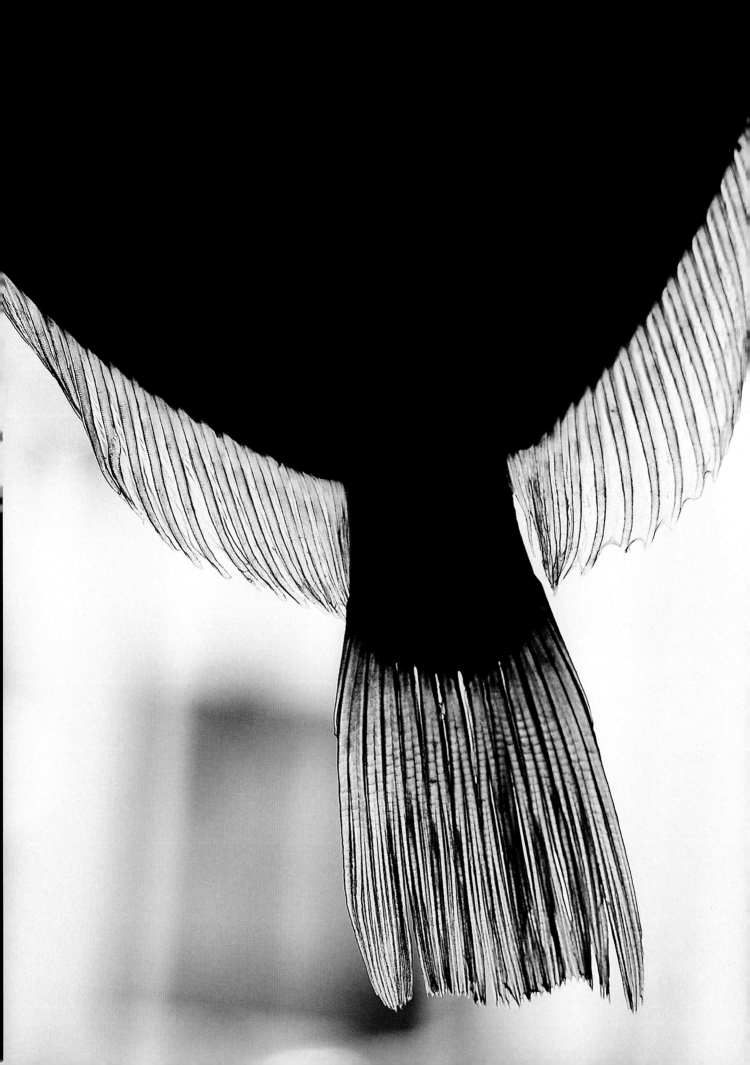

Storage Essentials

1. **Chuck the ice:** When you buy your fish, request that it is not directly surrounded by ice. Ask for the ice to be supplied separately or, alternatively, bring along an ice pack in a cooler bag for transportation.

2. **Wrap it in paper:** Request the fish be wrapped in paper, not plastic. Fish that is stored in plastic at variable temperatures will start perspiring, become damp and develop ammonia aromas (aka 'fishy fish').

3. **Take it out of the packaging:** Once home, remove the fish from its packaging. If your fish is already scaled and gutted and you are cooking it that day, then transfer it to a clean wire rack set over a small tray or dinner plate and place it in the main chamber of your fridge, uncovered, until ready to use. A minimum of 2 hours in the fridge like this will result in a skin that is dry enough to achieve crisp skin when pan-frying and give you confidence that it will not stick to your grill bars or pan (your fridge will only smell 'fishy' if you are buying poor-quality fish). If you are buying a fish for 2–3 days' time, still place it on the wire rack but instead of putting it in the central part of the fridge, clear out the crisper at the base and store it there with the humidity vents left open. This will allow the fish to sit at a slightly lower temperature and not dry out too far, as we want to maintain day-one excellence but remove some of the fish's unnecessary moisture. On the day you remove it from the crisper, ready to cook, put it in the main part of the fridge for 1 hour to dry the skin before cooking.

4. **Leave the skin on:** Regardless of whether you are pan-frying to make the skin crisp or poaching with the intent to discard the skin, it will benefit the fish's overall flavour profile and nutritional value if you leave the skin on. The seam of fat that sits beneath the skin provides much of a fish's wonderful flavour and is also a rich source of omega 3s.

5. **Do not wash a 'fishy fish':** Washing a fish will not remove the smell of ammonia – if anything, it will make the fish more challenging to cook and add to the issue. The only way to partially eliminate or dilute volatile aromas such as ammonia is through the use of acidity. Lemon juice or tomato-based cookery methods, along with garlic and other alliums all help mask odours (one reason that they are used so often in fish cookery), but the best approach is to shop wisely (see page 16) to avoid this situation in the first place.

6. **Keep it on the bone:** When working with a whole fish, keep it on the bone right up until you decide what to do with it. Leaving the fish on the bone reduces the potential for the flesh to be exposed to external moisture or bacteria growth.

7. **Hang for longer term storage:** If you want to store fish beyond its first few days, use a static fridge with no fan. Here fish can be stored on perforated trays but, ideally, they will be hung from the tail on hooks in a whole form post-scaling and -gutting. To maintain these fish over a period of time, wipe the skin and cavity of the fish with paper towel to remove the perspiration that naturally comes to the surface.

8. **Look after leftovers:** For leftover cooked fish, ensure it is completely cold and then store in a clean, dry, covered container (ideally with a ventilated lid) in the fridge for up to 2 days, making sure that the temperature is well maintained. If reheating to serve, do so thoroughly.

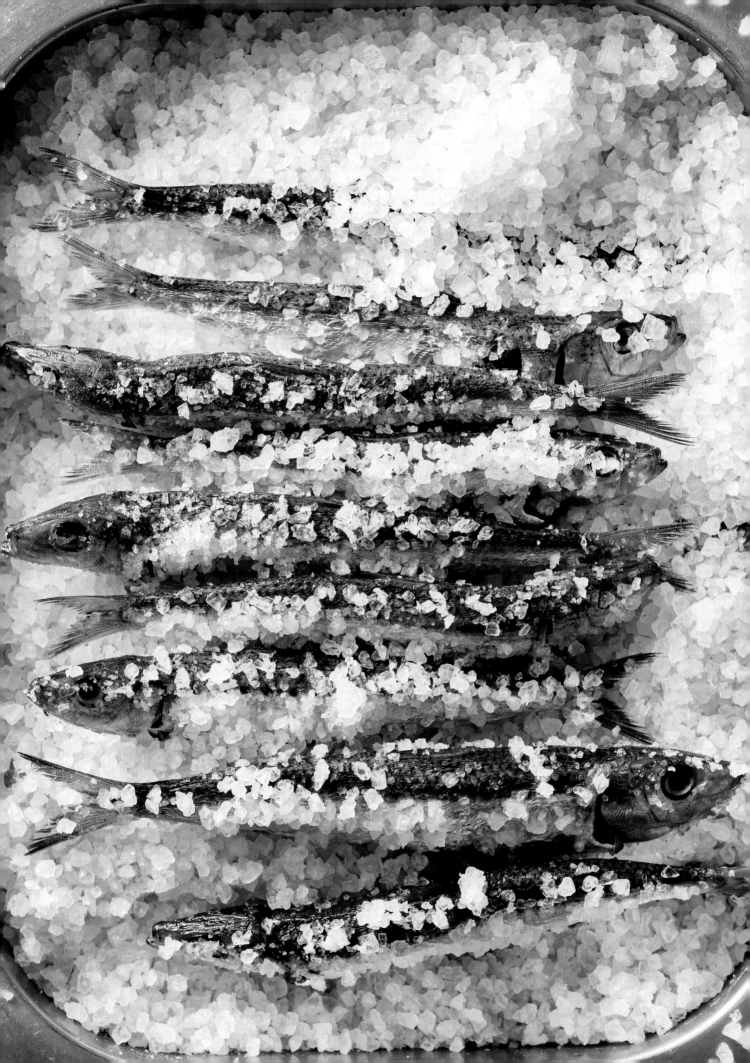

1

Sardines

Having grown up assuming a sardine's natural habitat was a can, I have since developed a particular fondness for this very special, oily little fish.

Capable of bringing incredible nuances of flavour to a dish, sardines should be celebrated in the same way as truffles or caviar – particularly as they offer this up at a fraction of the cost! However, many struggle to see past their strong flavour, tiny bones and rapid deterioration post-capture — all obstacles that can be overcome with a bit of thought and planning.

When sardines arrive in my kitchen, it is a priority to process them and see them on the menu hours later. The guts (and potentially the head, depending on how they are to be served) are removed, mixed with salt and fermented into a fish sauce (see Garum, page 257) that I believe everyone should have. Then the fillets are taken off the bone – cleanly and keeping the shape of the fillet as natural as possible – and are served unadulterated on a warm plate with extra-virgin olive oil and grilled bread. If you haven't tried a sardine like this, in its most natural form, then I urge you to do so, as it will give you an understanding and appreciation for this delicate and beautiful ingredient. My other preferred treatment is to grill them whole over charcoal, which delivers such incredible flavour that it makes the job of picking through the bones after cooking no burden at all.

Although sardines are readily available year-round, there are particular moments when they are at their best. When looking for quality sardines, be sure there is an even armour of scales, no abrasions or gaping holes around the stomach, clear eyes, fins and tail intact, and there's a touch of green, blue and silver in their colouring. The flesh of the sardine should be firm, rosy red and have a nice seam of fat that sits on top of the lateral line beneath the skin.

Alternatives
ANCHOVIES · BLUE MACKEREL · MULLET

Points to look for
CLEAR EYES · INTACT BELLY

Best cooking
RAW · GRILLED · CURED

Accompanying flavours
SAFFRON · LEMON THYME · OLIVES · CITRUS · CURRANTS

CHARCOAL SARDINES IN SAFFRON VINEGAR AND ALMOND OIL

This simple combination of saffron, almond and sardines is a wonderful way to kick off this book. The saffron vinegar brings an elegant floral sweetness that perfectly complements the savoury minerality of the grilled sardines and the subtle almond oil. These flavours also work with plenty of other small, richly flavoured fish, such as anchovies or mackerel. It is important that the whole sardines are rested for a couple of minutes after grilling to ensure the flesh comes away from the bone nicely.

Enjoy the sardines on their own like this to start a meal, or serve with glazed fennel and new potatoes for something more substantial.

SERVES 4 AS A STARTER OR 2 AS A MAIN

8 sardines, gutted, head and tail on
80 ml (2½ fl oz/1/3 cup) grapeseed oil
sea salt flakes and freshly cracked
 black pepper
1 tablespoon almond oil
Garum (page 257) or fish sauce,
 to taste
slivered almonds, to garnish (optional)

Saffron vinegar
small pinch of saffron threads
1 litre (34 fl oz/4 cups) chardonnay
 vinegar

To make the saffron vinegar, add the saffron to the vinegar in a sterile mason (kilner) jar or clean airtight container. Stir to combine and store at room temperature for a minimum of 24 hours. Obviously, the longer you can leave this vinegar to develop flavour the better – it can be made well in advance and will keep indefinitely in the pantry, gradually becoming more flavourful. Use it in salad dressings.

Either preheat a chargrill pan over a high heat or a charcoal grill with evenly burnt-down embers.

Thread the sardines onto metal or soaked bamboo skewers. Brush with the grapeseed oil and season with salt flakes.

Grill for approximately 1 minute on each side, or until evenly coloured and the flesh is warm to the touch. Carefully tip the grill rack to free the fish onto a clean surface. Alternatively, use an offset spatula to free the sardines from the grill. While you want the skin to be well coloured, it is critical that the sardines are still a little underdone. The saffron vinegar will finish off the 'cooking' process.

Leave the fish to rest for 2 minutes.

Brush the sardines with almond oil and season with a little more salt and a touch of pepper, then place them in the centre of a plate. Dress with a liberal spoonful of the saffron vinegar, garum or fish sauce to taste, and a few drops of almond oil, and top with a few slivered almonds, if you like.

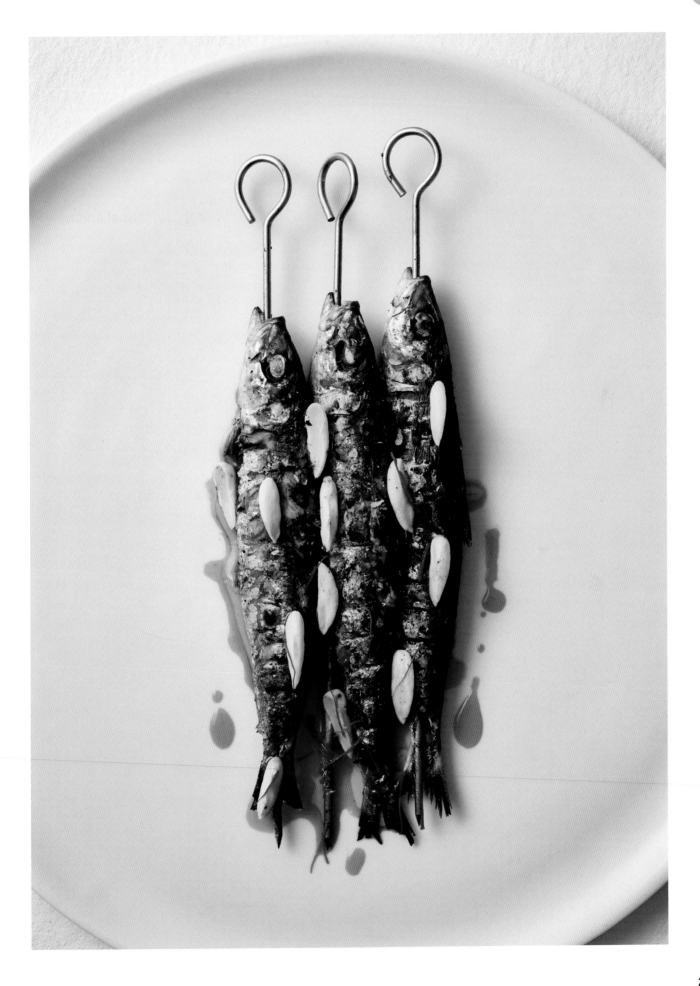

PISSALADIERE AND PICHADE

I fell in love with these two tarts while working in a Niçoise-style restaurant a number of years ago. It was far too difficult to decide which to include in this book, so I thought I'd do both. Traditionally from Genoa in Liguria, pissaladière is made with caramelised onion, olives, salted anchovies and a focaccia-style bread, while Pichade de Menton is similarly adorned but the caramelised onion is replaced with a base of slow-cooked tomatoes. Both are packed full of umami and are universally loved.

I decided to use fresh sardines here instead of salted anchovies. I know! Not exactly traditional, but I find the bright minerality and clean flavours of fresh sardines actually balance the dish better. I've also replaced the bread with a sour cream pastry, which gives a rich, slightly soft centre where the toppings sit but also has crisp, buttery edges. The pastry shell can be prepared ahead, as can all the toppings, so break down the recipe into individual tasks during the week and share these tarts with loved ones on the weekend. Serve with a simple salad of dandelion and pink lady apple, or make them into bite-sized portions for a glamorous canapé option.

SERVES 4

1 quantity Sour Cream Pastry
 (page 259)
12 whole fresh sardines, scaled,
 filleted and ribs removed
24 Ligurian olives, pitted and halved
60 ml (2 fl oz/¼ cup) extra-virgin
 olive oil
sea salt flakes, freshly cracked black
 pepper and Espelette pepper

Tomato jam

1 kg (2 lb 3 oz) ripe tomatoes, washed
 and cored
8 garlic cloves, coarsely chopped
½ teaspoon Espelette pepper,
 or to taste
60 ml (2 fl oz/¼ cup) Garum
 (page 257) or fish sauce
600 g (1 lb 5 oz) white sugar
200 ml (7 fl oz) red-wine vinegar

Caramelised onion

100 ml (3½ fl oz) extra-virgin olive oil
6 large brown onions, finely sliced
1 tablespoon sea salt flakes
1 bay leaf
1 star anise
2 thyme sprigs
1 rosemary sprig
freshly cracked black pepper

Make the pastry according to the instructions on page 259. Divide the dough in half then, using a rolling pin, roll out each piece between two sheets of baking paper to a circle about 5 mm (¼ in) thick. Place on baking trays lined with baking paper and chill the pastry in the fridge for at least 1 hour before baking.

Preheat the oven to 170°C (340°F).

Top each pastry sheet with a heavy baking tray to stop the pastry puffing up in places, resulting in an uneven finish. Bake for 15 minutes or until evenly coloured. Set aside to cool.

To make the tomato jam, finely dice half the tomatoes, leaving the skin on and seeds in, and set aside for later. Place the remaining tomatoes, garlic, Espelette pepper and garum or fish sauce in a blender and blend to a puree. Transfer to a deep saucepan, add the sugar and vinegar and whisk to combine. Slowly bring to the boil over a medium heat, stirring constantly, then reduce the heat to low and add the reserved diced tomato. Simmer gently for 30–40 minutes, skimming off any foam as it rises to the surface. Stir every 5 minutes to remove any solids from the bottom and scrape the side frequently so the jam cooks evenly. (It is critical to be patient here; if the jam catches over a high heat and caramelises, the finished colour will be dull and quite tan rather than reaching its bright red potential.) To check if the jam is ready, place a small spoonful on a cold plate – it's ready if it is softly set with no residual liquid running from it. If it has set too firm, add a splash of water and remove from the heat.

Pour the tomato jam into warmed, sterilised glass jars and allow to cool to room temperature. Store in the fridge for up to 4 weeks.

For the caramelised onion, heat the olive oil in a wide-based frying pan over a medium heat. Add the onion and salt and stir to combine and coat the onion. More than just a seasoning, the salt will draw moisture out of the onion, which is critical here.

Wrap the bay leaf, star anise, thyme and rosemary in a muslin pouch and add to the onion mixture. Reduce the heat to low, cover with a fitted lid and cook for 35–40 minutes, stirring every 5 minutes, until the onion starts to colour. Remove the lid and cook, stirring, for another 5–10 minutes. The onion is ready when it is jammy and a dark amber colour. Remove from the heat and cool, then store in a sterilised jar or airtight container in the fridge for up to 7 days.

Preheat the oven to 190°C (375°F).

To assemble the pissaladière, place your baked pastry on a baking tray lined with baking paper. Spoon the chilled caramelised onion evenly over the surface, leaving a 2 cm (3/4 in) border around the edge. Bake for 10 minutes or until the onion has toasty edges and has adhered nicely to the pastry.

Meanwhile, working with a very sharp knife, slice each sardine in half from head to tail, creating a long boneless strip. It's important to use a sharp knife to avoid damaging the fillets and ensuring the beautiful silver skin remains intact.

While the onion tart is still hot from the oven, arrange half the sardines in a neat lattice pattern, as shown in the photo overleaf. Dot olive halves in each lattice window.

Generously drizzle extra-virgin olive oil over the tart and season with black pepper and a little salt. Return to the oven for 2 minutes to warm the sardines and olives. Please don't overcook at this stage, otherwise the sardines will quickly go from being lovely and oily to chalky and dry. Remove from the oven and serve immediately.

To assemble the pichade, follow the same procedure as the pissaladière using the remaining sardines and olives, but replace the caramelised onion with the tomato jam and the black pepper with Espelette pepper.

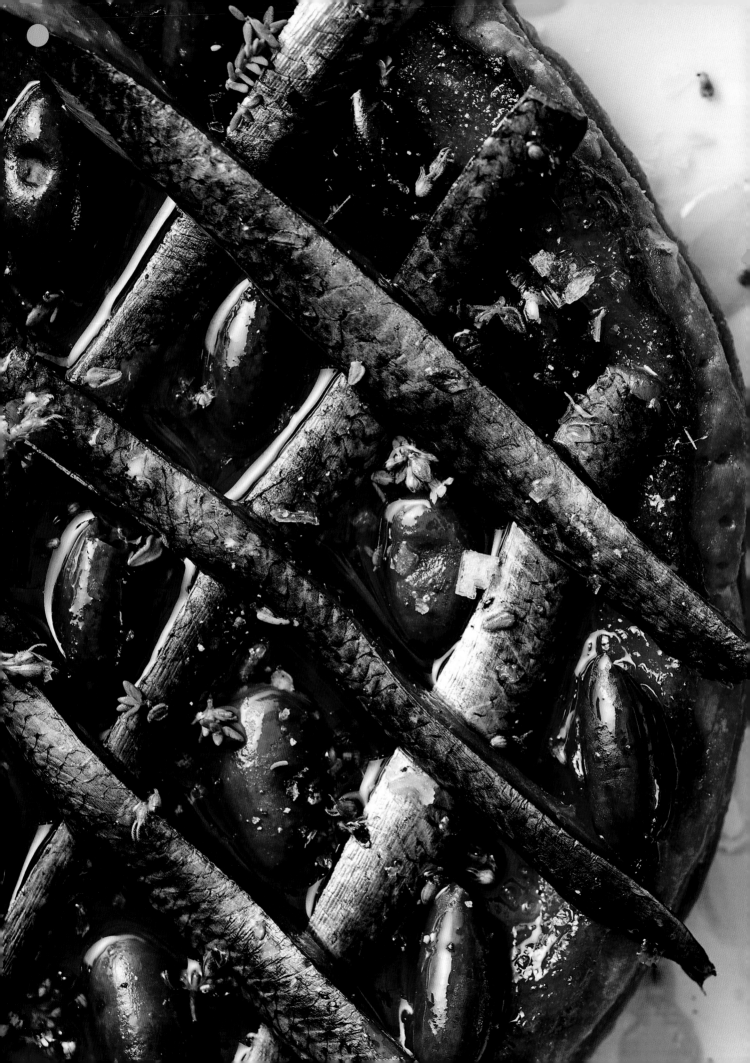

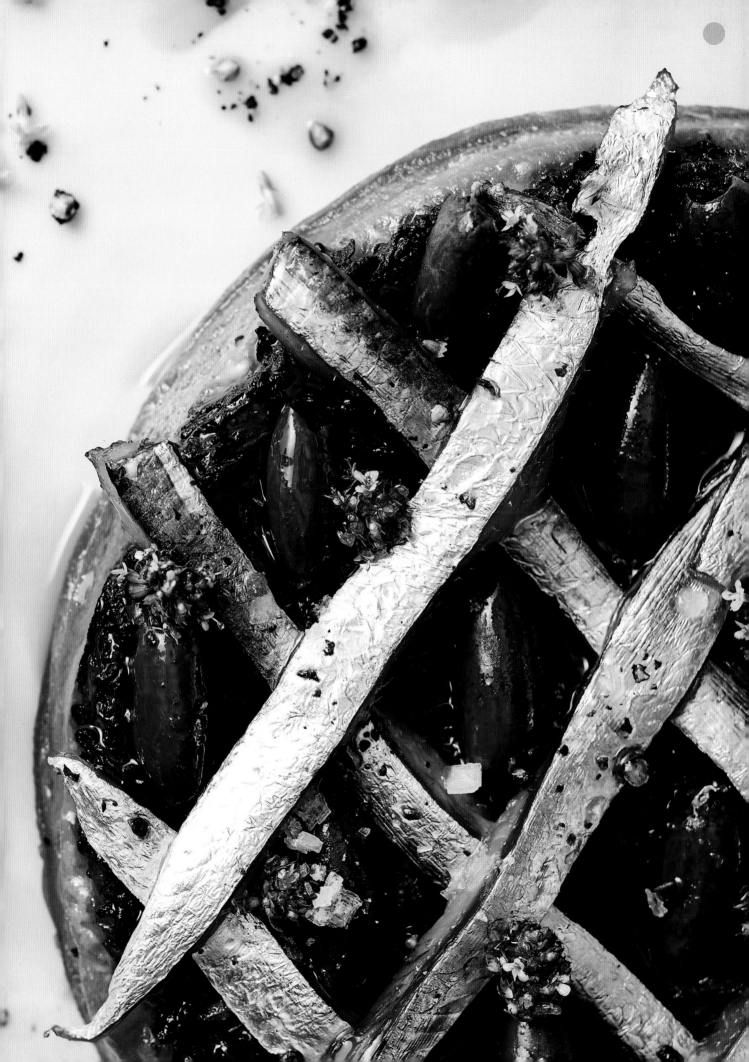

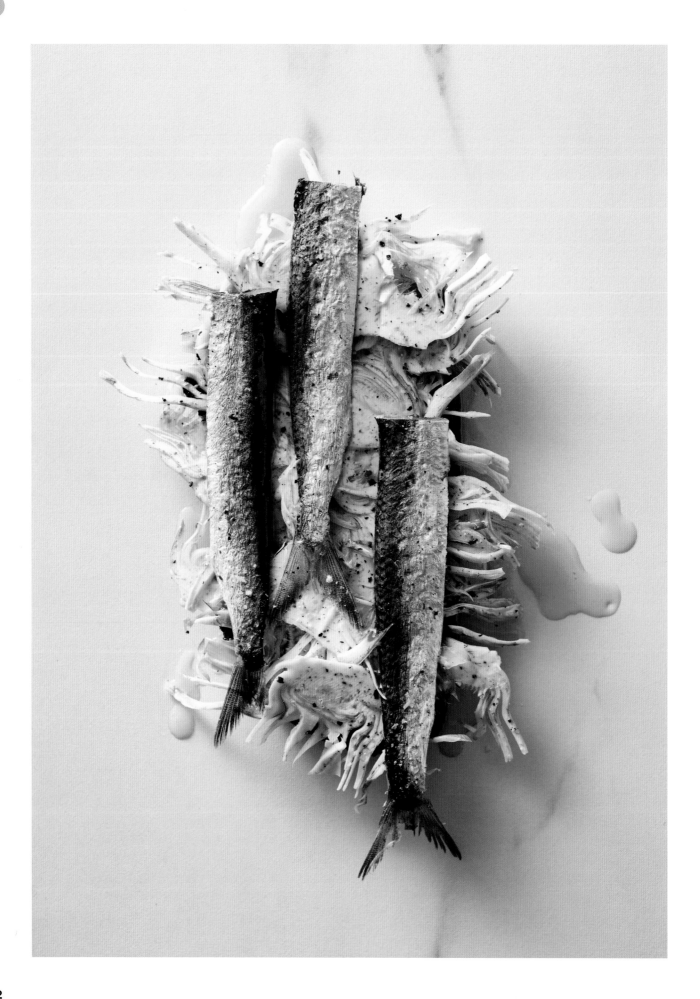

SALTED SARDINE FILLETS AND GLOBE ARTICHOKES ON GRILLED BREAD

The secret to this dish is to not compromise on the quality of produce – from the sardines to the bread and olive oil, right down to the salt you use to cure the sardines, everything needs to be as good as it can be. It's also a dish that requires patience. Yes, you could have something similar by pulling the ring back on a tin, but where is the fun in that?

Once you've gone to the trouble of making them, you'll be rewarded with your very own salted sardine fillets, which can essentially be used like salted anchovies in a huge range of dishes. Like pure umami, they'll add magic to pasta, compound butters, mayonnaise, salads and more, but be sure to save the brine from the salting process as well as this will serve as an excellent seasoning for other dishes. If artichokes aren't in season or unavailable, then grilled capsicums (bell peppers) and marjoram make a wonderful substitute, as do semi-dried tomatoes and lovage. This recipe is also excellent with store-bought salted sardines, anchovies and even tuna for those who want it right now!

SERVES 2, WITH LEFTOVER SARDINES FOR NEXT TIME

1 kg (2 lb 3 oz) fresh whole sardines
2 kg (4 lb 6 oz) best-quality rock salt
chilled water, for soaking
about 500 ml (17 fl oz/2 cups)
 extra-virgin olive oil

To assemble
2 slices of quality
 sourdough bread
70 ml (2¼ fl oz) extra-virgin olive oil
1 garlic clove, peeled and halved
6 baby globe artichokes, tough outer
 leaves and woody stems removed
zest and juice of 1 lemon
freshly cracked black pepper

To salt the sardines, first carefully scale the fish with a spoon. Using a sharp knife, make a cut behind the head on both sides running adjacent to the sardine's collars, then remove the head by twisting and gently pulling it off – the organs will follow in one piece. Instead of throwing away this part of the fish, remove the gills and gall bladder from the head and organs and make your own garum (fish sauce) (see page 257).

Place a layer of rock salt in the bottom of a non-reactive sterile storage container. Add a layer of sardines, then another layer of rock salt, followed by more sardines. Continue layering until you have used up all of the sardines, finishing with a layer of salt, making sure it completely covers all of the fish.

Close the lid of your container and place it in the coldest part of your fridge for about 2 weeks. After that time, the sardines will be cured and the flesh will have a darker complexion. Leaving the sardines for a longer period of time, up to a month, will impart a more rounded, savoury flavour profile.

To prepare the sardines for serving, if you are right-handed, start with the sardine's head end on your left, tail to the right and the backbone facing you. Make a clean cut down the frame of the fish, removing the fillet intact in one movement of the knife from head to tail. Repeat on the other side. Follow these instructions in reverse if you are left-handed. (The sardines do not require pin-boning, but it is important to cut the rib bones out using a small knife as they are fairly unpalatable.)

Taste the salted fillets – you will find they are unbelievably salty to the point of seeming inedible. Pour some chilled water into a small bowl and add the sardine fillets to remove some of the intensity from the cure. Taste every 15 minutes until you reach the level of seasoning you like. At this point, transfer the fillets to a piece of paper towel or a cloth, and carefully pat them dry.

Lay these beautiful fillets in a container and cover with extra-virgin olive oil. They are now ready to consume, or store in the fridge for up to 2 months.

When you are ready to prepare the toast, either preheat a grill pan over a medium-high heat or a charcoal grill with evenly burnt-down embers. Brush the bread with olive oil and grill for 1 minute each side or until charred. Rub a single garlic clove over the hot toast to expel its natural oils and aroma.

Using a sharp mandoline, thinly shave the globe artichokes into wafers over the hot toast. Working quickly so you can enjoy the toast nice and hot, position six salted sardine fillets on each slice of toast over the shaved artichoke. Add a few gratings of lemon zest, a squeeze of lemon juice, some extra-virgin olive oil and lots of pepper. Cut the toast to share immediately.

CUSTARD TART WITH SARDINE GARUM CARAMEL

This recipe is very close to my heart. Growing up, I would eat warm custard tarts with my mum on trips to do the groceries (while sitting in our local coffee shop, spooning all the chocolate powder off her cappuccino). With its wobbly custard filling and thin shortcrust pastry, this tart is my attempt to replicate those moments of childhood bliss. I have been reluctant to share this recipe before because of the constant development and improvements we have made to it over the years, but it's time something this good is enjoyed by all!

You might think it is ridiculous to put fish sauce anywhere near a custard tart (and you can certainly omit the garum caramel and finish the tart with freshly grated nutmeg instead if you prefer), but maybe try it once? The idea came from the flavours of Thai cuisine – sweetness from palm sugar, salt from fish sauce and sourness from lime juice. It may be a stretch for many, but, for those who dare try it, thank you for thinking outside the box.

SERVES 12

softly whipped cream, to serve
(optional)

Pastry
250 g (9 oz/12/3 cups) plain (all-
 purpose) flour, frozen
200 g (7 oz) unsalted butter, chilled
 and diced
½ teaspoon fine salt
55 ml (13/4 fl oz) chilled water
1 egg yolk, lightly beaten

Garum caramel
300 g (10½ oz) caster (superfine) sugar
150 ml (5 fl oz) water
Garum (page 257) or fish sauce,
 to taste
juice of 2 limes
pinch of sea salt flakes

Custard filling
360 g (12½ oz) caster (superfine) sugar
3 vanilla beans, split and seeds scraped
4 egg yolks
7 whole eggs
1.125 litres (38 fl oz/4½ cups)
 full-cream (whole) milk
375 ml (12½ fl oz/1½ cups) pouring
 (single/light) cream

To make the pastry, pulse the flour and butter in a food processor to create very fine crumbs. Dissolve the salt in the water and add to the crumb, pulsing briefly to combine, then turn out the dough onto a chilled surface and work it with the palm of your hands for 3–4 minutes to form a very firm dough. Wrap in plastic wrap and chill for a minimum of 3–4 hours or overnight.

For the caramel, combine the sugar and water in a very clean saucepan and cook over a medium heat until the sugar becomes a caramel colour. Do not stir the sugar while it boils as it will crystallise, but once it becomes golden in colour it's fine to stir to ensure it browns evenly. In this case we want it quite dark to balance out the sweetness of the tart. When the caramel is a dark golden but not smoking you need to stop the cooking by carefully adding the water – watch out as it will spit and create steam. Take the pan off the heat and whisk the water into the caramel to combine. Allow to cool, then stir in the garum or fish sauce, lime juice and salt. Adjust the seasoning to achieve a balance of sweet, sour, bitter and salt.

Preheat the oven to 190°C (375°F).

Roll out the pastry to a 2 mm (1/16 in) thickness, then line a 28 cm (11 in) tart tin. Line the pastry with baking paper and fill with baking beads or dried beans. Blind-bake for 30 minutes, then remove the paper and weights and cook for a further 10 minutes until cooked through, golden brown and dry.

Brush the tart shell with beaten egg yolk to seal the pastry while still warm, then return to the oven for 1 minute to cook the egg.

While the pastry is baking, make the custard filling. To do this, you can either use a Thermomix or food processor and bain marie. Blend the sugar and vanilla seeds in a Thermomix. Add the remaining ingredients, then reduce to speed 3 so that no air is incorporated into the filling. Set the timer to full and temperature to 60°C (140°F) and cook the custard until a probe thermometer reaches 63°C (145°F).

If you are using a food processor, blend the sugar and vanilla seeds together, then tip into a large heatproof bowl. Add the egg yolks and eggs to the bowl and whisk for 3 minutes or until pale. Combine the milk and cream in a saucepan over a medium heat and heat to just under boiling point. Slowly pour into the egg mixture and whisk until silky and well incorporated. Half-fill a large saucepan with water and bring to the boil over a medium heat (this will be your bain marie). Reduce to a very gentle simmer, then place the bowl over the pan and, using a rubber spatula, stir constantly until the custard reaches a temperature of 65°C (149°F). Remove from the heat and pass the custard through a fine sieve.

The idea is to have the custard ready at the same time as the egg-washed pastry shell. For the best results, they both need to be warm.

Reduce the oven temperature to 130°C (265°F).

Carefully pour the custard into the warm tart shell and bake for 45 minutes or until the centre just reaches 83°C (180°F) for a wobbly set. Allow the tart to stand at room temperature for at least an hour before serving (don't refrigerate it or you will lose the wobble).

To serve, pour a little garum caramel over the top and, using a very hot, very sharp knife, carefully portion the tart. Serve with a generous dollop of softly whipped cream, if you like.

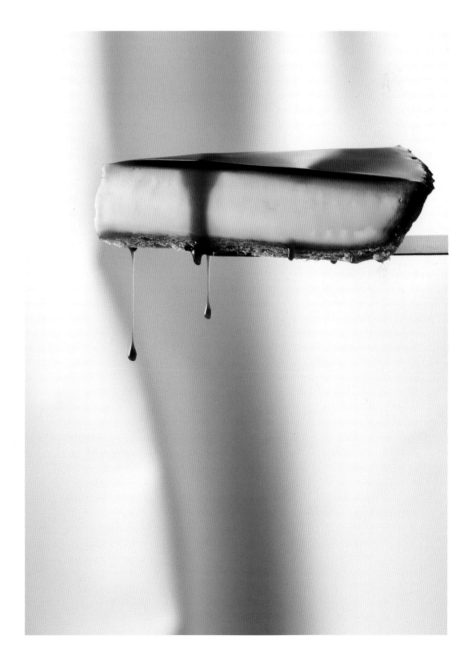

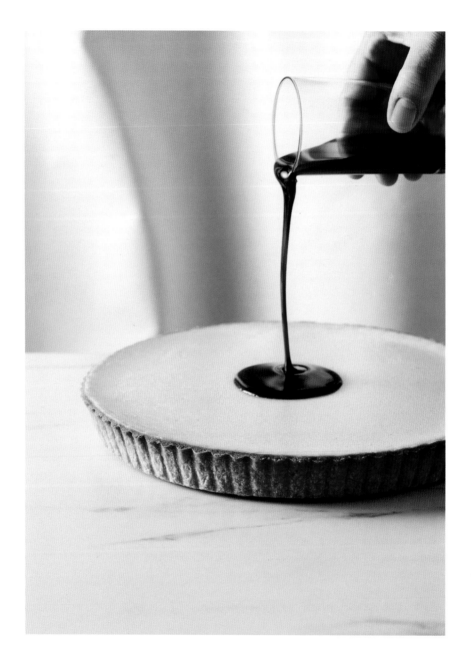

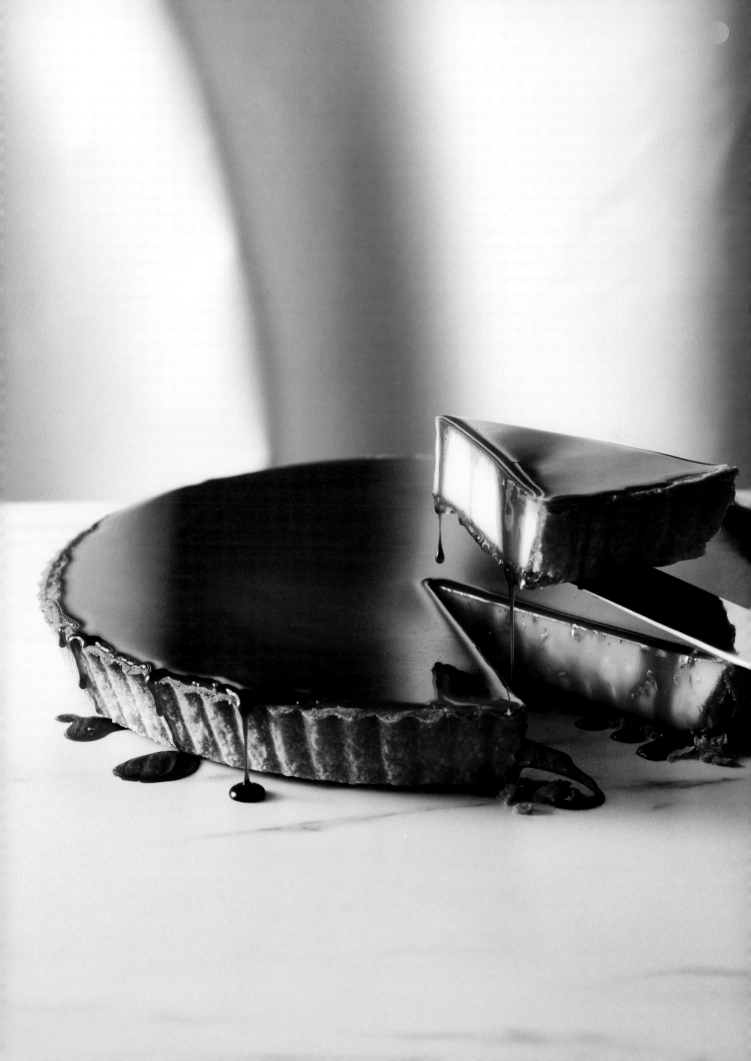

Herring

Versatile and flavourful, herring rightly deserve a place in this book. A crumbed herring eaten simply with remoulade and a few dressed green leaves is one of life's great pleasures, yet, like sardines, these fish are sometimes overlooked because they are perceived as labour intensive. Like a sardine, a herring's bones are fine and need attention either before or after cooking – it's tedious and somewhat time-consuming work, but it's worth every minute for total, unobstructed bliss. The solution is simple – put your fishmonger or local fish shop to work next time you are in store and get them to butterfly and pin-bone your herring for you, instantly getting one big hurdle out of the way!

It's also true that the dark flesh and natural oils can put some people off, but if the fish is well handled by all involved – from fisherman through market to table – then this shouldn't be a problem, and the flavour and aroma shouldn't be excessively 'fishy', but rather a fantastic vehicle for smoke, pickles and peppery ingredients such as mustard, horseradish and watercress. Finally, be sure to use a light hand when cooking, as herring carry little intramuscular fat and can dry out easily. Throwing a herring into a frying pan with a dusting of flour, a little butter and lemon juice couldn't be simpler, nor take much time, so see the commitment to sort the flesh from any bones as a small investment for such a great reward.

Alternatives
SARDINES · MACKEREL · TREVALLY

Points to look for
**FIRM FLESH · LIGHT AND BRINY AROMA · COMPLETE SCALE COVERAGE
BRIGHT AND VIBRANT GILLS**

Best cooking
SMOKED · PAN-FRIED · PICKLED

Accompanying flavours
MUSTARD · HORSERADISH · WATERCRESS · FIGS · APPLES

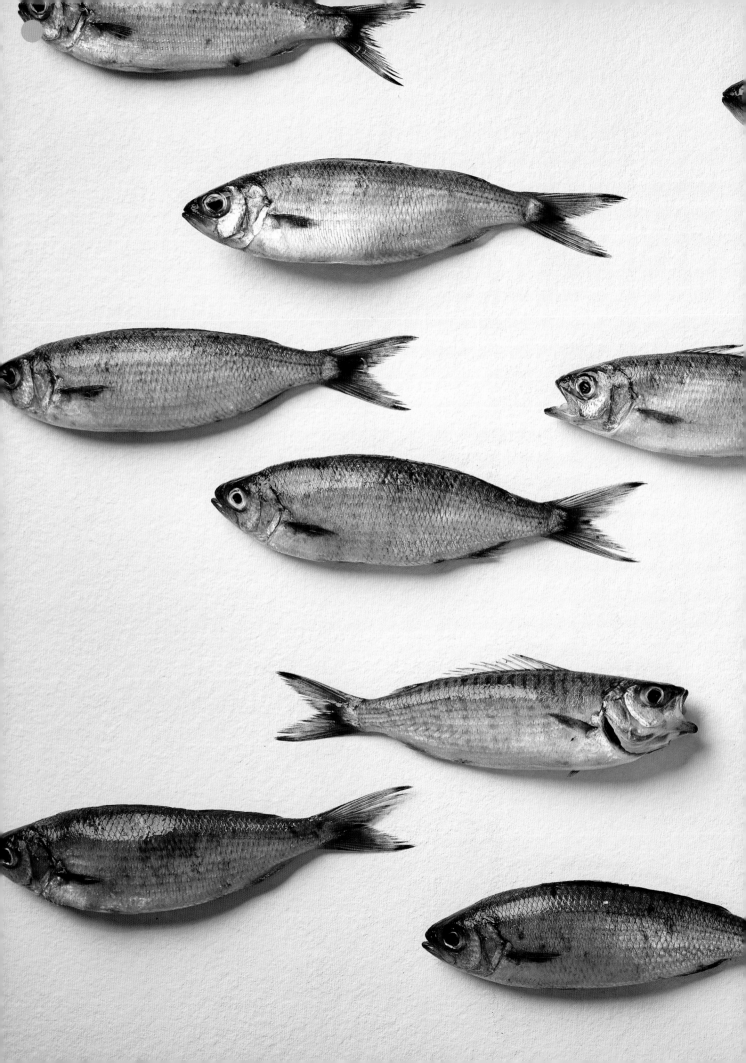

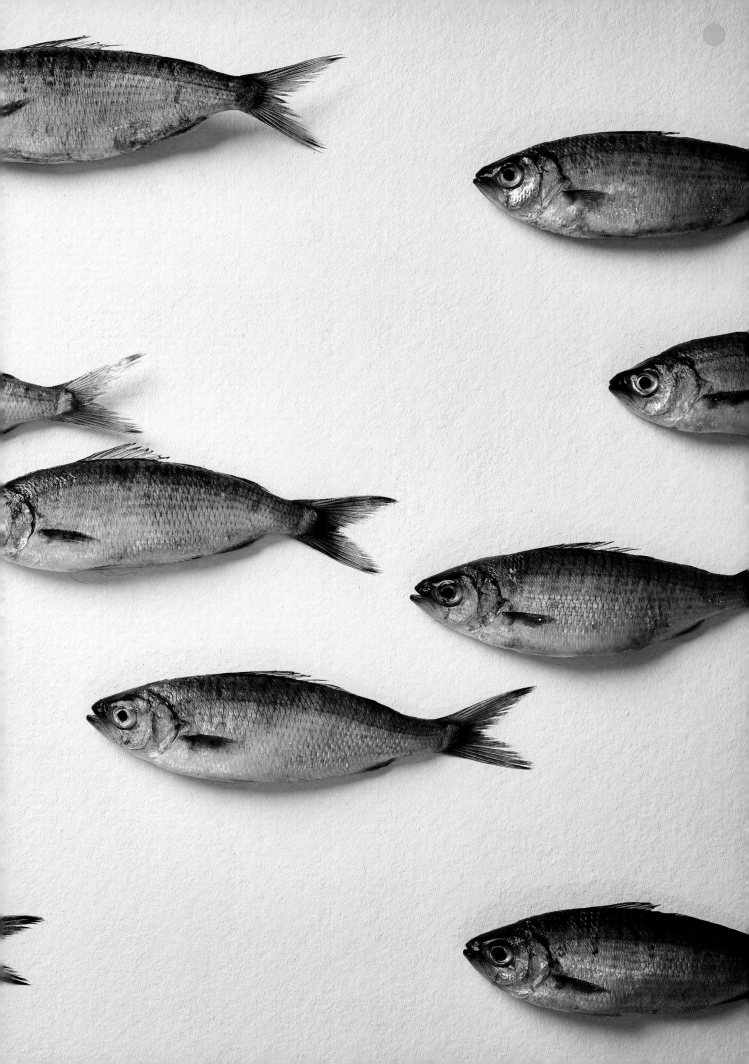

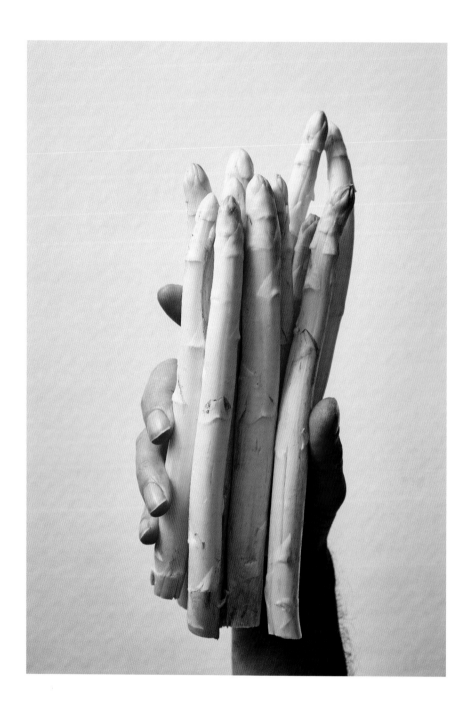

BBQ WHITE ASPARAGUS WITH HERRING GENTLEMAN'S RELISH

This makes an excellent start to a meal, and is a great way to showcase natural produce. The herring gentleman's relish is a wonderful condiment to dip asparagus into, but it can also sit happily in your fridge for up to six months, ready and waiting for anything from a slice of toast to a rib of beef.

When white asparagus season starts anywhere in the world, chefs fly into a frenzy to get it on their menus as quickly as possible. And when the spears are thick and juicy, I'm convinced a charcoal grill is the only way to cook them. When they are not in season, grilled salsify, fennel, globe artichoke or even kipfler potatoes are all good alternatives.

SERVES 6 AS A STARTER

24 new-season thick white asparagus spears, peeled and trimmed
1½ tablespoons extra-virgin olive oil, plus extra for dressing
sea salt flakes
lemon juice, to taste

Gentleman's relish
4 skinless herring fillets
150 g (5½ oz) fine salt
250 ml (8½ fl oz/1 cup) sherry vinegar
85 g (3 oz) pitted prunes, chopped
125 ml (4 fl oz/½ cup) tomato sauce (ketchup)
60 g (2 oz) light muscovado (soft brown) sugar
2½ tablespoons worcestershire sauce
4 French shallots, finely sliced
3 garlic cloves, finely grated
4 salted anchovy fillets
2 cloves
1 tablespoon mustard powder
1 teaspoon ground allspice
¼ teaspoon freshly cracked black pepper
pinch of cayenne pepper
2 tablespoons water

To start the gentleman's relish, season the herring fillets liberally on both sides with the salt and cure in the fridge for 24 hours. The next day, scrape away all the salt and pat dry with paper towel. (If you like, these salted fillets can be stored under extra-virgin olive oil and aromatics such as thyme, orange peel and garlic until required.)

Place the cured herring and remaining relish ingredients in a saucepan and simmer over a low heat for 30 minutes. Transfer to a blender and process until smooth. Pass through a fine sieve and store in a sterilised jar in the fridge until needed. Makes about 500 g (1 lb 2 oz).

Brush the asparagus with olive oil and season with salt flakes.

Either preheat a chargrill pan over a high heat or a use charcoal grill with evenly burnt-down embers. Grill the asparagus over the highest possible heat for about 6 minutes to impart a subtle smoky flavour and give the spears even, gentle colour. Don't let them colour too much or they will be bitter.

Dress with lemon juice and a little more olive oil and serve warm with the gentleman's relish.

SMOKED HERRING AND BUCKWHEAT BLINIS

This tastes as joyful as it looks, with the condiments lifting the smoked herring brandade into truly celebratory territory. Blinis are not hard to make but they often fall down for a few basic reasons: a stodgy mix that hasn't been lightened with egg white or leavened with yeast, too much ghee in the frying pan (creating a greasy crust around the edges) or sitting around for too long after being cooked. The other challenge is getting the size and colouring consistent, but here, practice makes perfect. As long as you keep all of the above in mind, you'll be fine.

SERVES 2 AS A LIGHT MEAL

4 French shallots, finely diced
90 g (3 oz/½ cup) cornichons, drained and finely diced
60 g (2 oz/½ cup) tiny salted capers, rinsed and drained
8 radishes, cut into thin wedges
30 g (1 oz/1 cup) picked watercress
extra-virgin olive oil, for dressing
sea salt flakes and freshly ground black pepper
seeded mustard, to serve (optional)

Smoked herring brandade
80 g (2¾ oz) Smoked Herring Fillet (either quality store-bought, or see page 258)
210 ml (7 fl oz) full-cream (whole) milk
1 bay leaf
70 g (2½ oz) skinless, boneless white-fleshed fish, such as ling or snapper
60 g (2 oz) butter, softened
juice of ½ lemon
2 tablespoons extra-virgin olive oil
60 g (2 oz) mashed potato
fine salt
1½ tablespoons sour cream or crème fraîche, plus extra to serve
2 bunches chives, very finely chopped

Buckwheat blinis
125 g (4½ oz) buckwheat flour
125 g (4½ oz) plain (all-purpose) flour
1 teaspoon fine salt
250 ml (8½ fl oz/1 cup) full-cream (whole) milk
10 g (¼ oz) dried yeast
3 eggs, separated
ghee, for pan-frying

To make the brandade, check the smoked herring meat and make sure it is boneless and skinless. Put the milk and bay leaf in a small saucepan and bring to the boil, then remove from the heat and add the smoked herring. Leave for 10 minutes, then strain the herring and discard the milk (or keep it to use in mashed potatoes or a root vegetable soup).

Steam the white fish in a bamboo steamer for 5 minutes or until the flesh is cooked and flakes apart easily.

Put the herring and fish in a small bowl, add half the butter and mash together with a fork. Drizzle over the lemon juice and 1 tablespoon olive oil, mixing with the fork as you go, then add the mashed potato and mix well. Add the remaining butter and olive oil and mix again, then season to taste with salt. Leave the mixture to cool, then fold in the sour cream or crème fraîche. Chill in the fridge for at least 1 hour.

For the blinis, sift both flours and the salt into a stand mixer fitted with the paddle attachment.

Pour the milk into a small saucepan and warm to blood temperature over a low heat. Remove from the heat, add the yeast and let it dissolve, then stand for 5 minutes until frothy.

Turn the mixer onto a low speed and combine the flours and the salt. Slowly pour in the milk and mix for 2 minutes to form a smooth batter. Cover the bowl with a tea towel (dish towel) and allow to prove in a warm place for 45 minutes or until doubled in size.

Add the egg yolks to the batter and mix with a whisk for 1 minute.

Add the egg whites to the very clean bowl of your stand mixer fitted with the whisk attachment, and whisk the whites to soft peaks. Add half to the batter and gently fold through to loosen it, then fold in the remaining egg white (this second batch aerates the batter to give the blini the desired lightness). Set aside to prove for another 15 minutes.

To cook the blinis, heat a wide-based cast-iron frying pan over a medium–low heat for a good 2 minutes before starting. It's important that the pan is hot. Add 1 tablespoon ghee and swirl it around to ensure the base is well greased, with a very light haze coming off the ghee.

Working in batches of six, add a tablespoon of batter for each blini to the pan, taking care to create neat circles. Cook for 30 seconds or until the edges are lightly golden and bubbles start to appear on the tops. Flip the blinis over and cook for another 30–60 seconds until they are firm but soft to the touch and the centres are set. Transfer to a wire rack to cool or place in a cloth napkin to keep warm. Repeat with the remaining batter. You should have enough to make 25–30 blinis.

To serve, assemble the shallot, cornichon, capers and radish separately alongside the herring brandade. Top the brandade with the finely chopped chives, dress the watercress with a little olive oil and season. Serve with the blinis and a little seeded mustard, if you like.

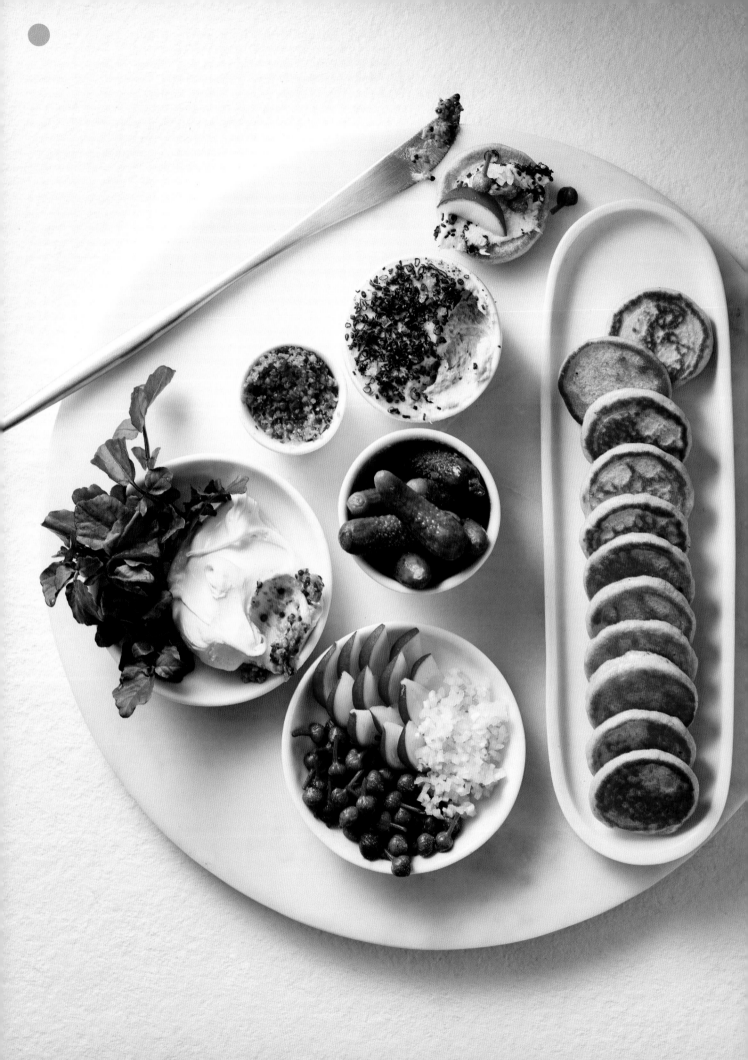

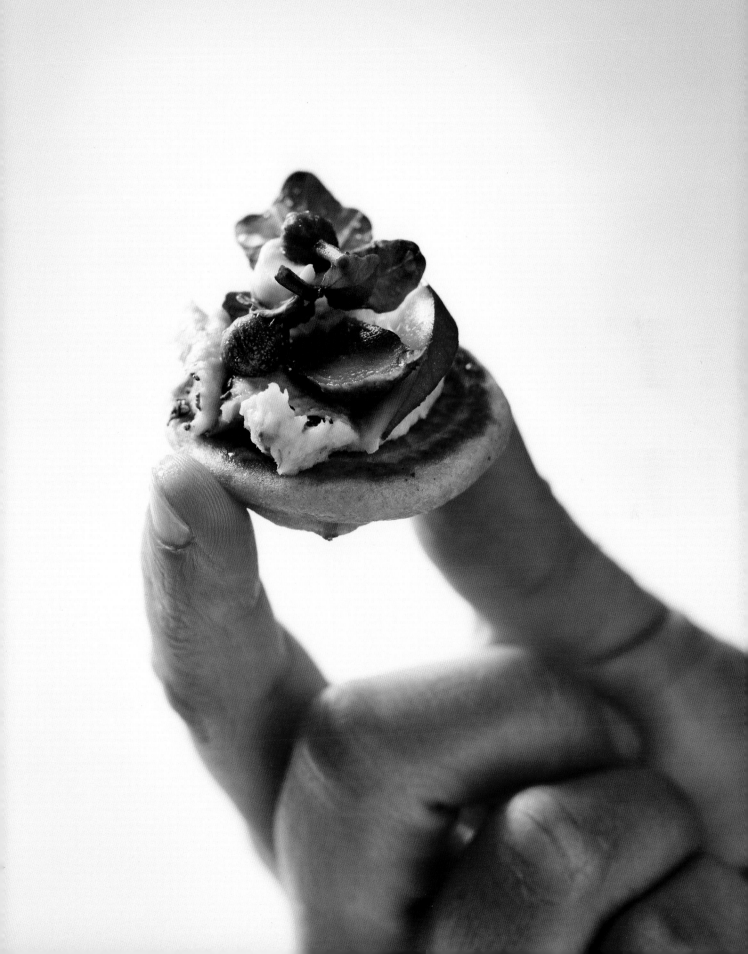

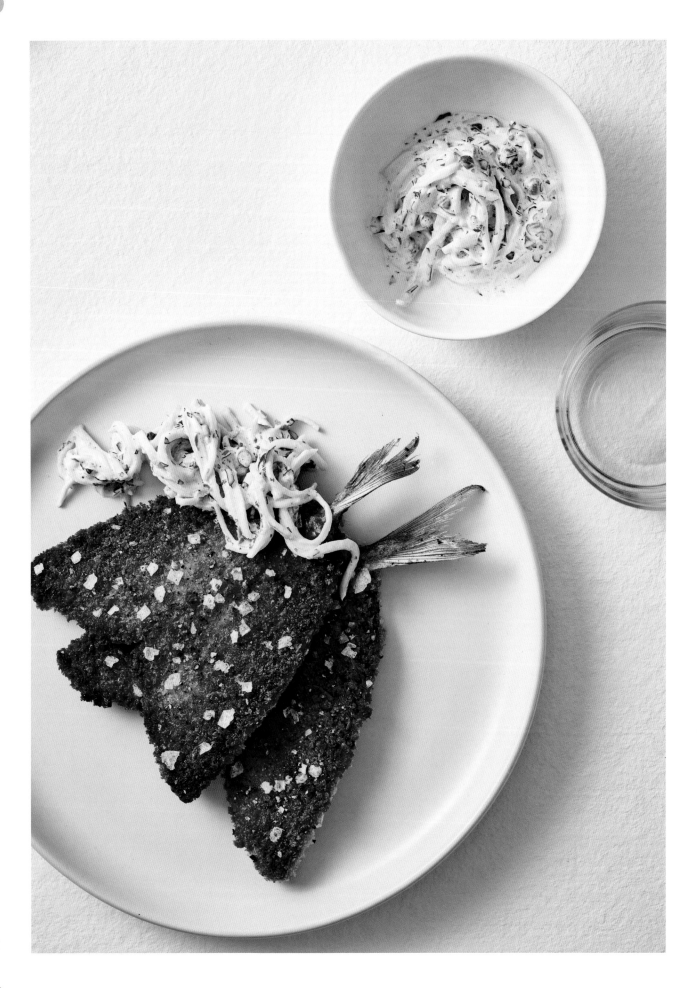

CRUMBED HERRING AND KOHLRABI REMOULADE

I can't think of any other dish that sums up my love for herring quite like this one. It's a real crowd pleaser with eaters of all ages and a wonderful way of visually showcasing this incredible fish. Kohlrabi is great for remoulade as it carries a lovely sweetness that goes so well with the herring, but if you can't get hold of it, cabbage, celeriac or potato are good alternatives. However, there really is no substitute for the freshness of the herring in this dish, nor the ghee that it is cooked in.

SERVES 4

4 × 100 g (3½ oz) herring,
 scaled only, heads off
150 g (5½ oz/1 cup) plain
 (all-purpose) flour
4 eggs
120 g (4½ oz/2 cups)
 panko breadcrumbs
200 g (7 oz) ghee
sea salt flakes and freshly cracked
 black pepper

Remoulade
juice of ½ lemon, plus extra if needed
200 g (7 oz) purple kohlrabi, peeled
 and finely sliced
sea salt flakes and freshly cracked
 black pepper
100 g (3½ oz) natural yoghurt
2 teaspoons dijon mustard
1 teaspoon freshly grated horseradish
1 large French shallot, diced
1 teaspoon tiny salted capers, rinsed,
 drained and finely chopped
30 g (1 oz) coarsely chopped cornichons
2 tablespoons finely chopped chives
1 tablespoon finely chopped tarragon

To prepare the remoulade, mix the lemon juice through the kohlrabi in a bowl and season with a pinch of salt flakes. Set aside for a few minutes. Combine all the remaining remoulade ingredients in a separate large bowl. Strain the kohlrabi and add to the bowl, then toss well to coat. Adjust the seasoning with extra lemon juice, salt and pepper if needed.

For the herring, I'm going to assume you're right-handed (if not, reverse these instructions). Place a fish on a chopping board with its head to your left and tail to your right. Draw your knife down the backbone from the head to the tail, cutting along one side of the bone.

Cut again to deepen the initial cut, carefully cutting all the way through to open up the fish, leaving the tail intact. Repeat on the other side of the backbone then, using kitchen scissors, snip out the backbone to give a kite-shaped fish with the tail intact. Use fish tweezers to remove the pin bones and rib bones. Repeat with the remaining herring.

Preheat the oven to 100°C (210°F).

Place the flour in one bowl, beat the eggs in another and tip the breadcrumbs into a third bowl.

Holding one of the prepared fish by the tail, dip it first in the flour, then the egg and, finally, the breadcrumbs, pressing gently to coat well. Place on a tray and repeat with the remaining fish.

Heat half the ghee in a large frying pan over a high heat to a light haze. Add two crumbed fish to the pan, skin side down, and fry for about 1 minute, carefully swirling them around to ensure even cooking and colouration. If you don't do this the crumb will scorch around the edges. Turn and briefly fry the other side, just to cook the rawness out of the breadcrumbs and add a little less colour than the top side. Place on a lined baking tray and keep warm in the oven.

Wipe out the residual fat and breadcrumbs from the pan, then repeat with the remaining ghee and fish.

Season the fish with a liberal sprinkling of salt and pepper. Serve the herring with a generous spoonful of remoulade.

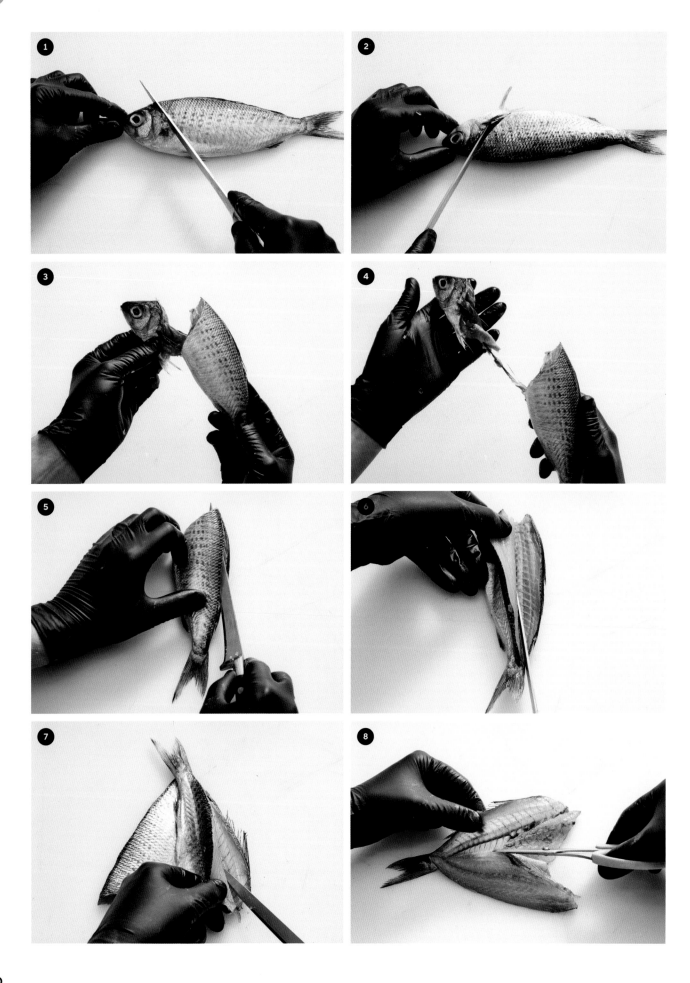

BUTTERFLY

Assuming you're right-handed (otherwise reverse these directions), place a fish on a chopping board with its head to your left and tail to your right.

1. Start by making a cut just behind the head on a diagonal that runs parallel to the fish's wing bones.

2. Flip the fish over and repeat the cut as before.

3. When these two cuts join up, pull the head of the fish off by gently breaking it off the spine.

4. As you pull the head, ensure that the fish's gut is pulled with it. If successfully done, this is a fast and clean way of gutting the fish. It's important that the gut is taken out like this, as we want to keep the belly intact.

5. Draw your knife down the backbone of the fish from the head end to the tail, cutting along one side of the bone.

6. Cut again to deepen the initial cut, carefully cutting all the way through (but not to puncture the belly) to open up the fish, leaving the tail intact.

7. Turn the fish around so the tail is facing away from you and repeat on the other side of the backbone.

8. Using kitchen scissors, snip out the backbone to give a kite-shaped fish with the tail intact. Use fish tweezers to remove pin bones and rib bones. (Alternatively, depending on species, it may be easier to remove the rib bones with a small, sharp knife.)

SM

3

Blue Mackerel

When it comes to blue mackerel, there's really only one thing you need to know – fresh is best. The fragility of this delicate fish is near unrivalled: its naturally soft flesh bruises very, very easily and it's therefore so important that mackerel are well handled post-catch, as they degrade rapidly.

Blue mackerel has always been seen as having a strong 'fishy' taste and this (together with poor past eating experiences, perhaps involving bones) can lead to some overlooking this beautiful fish altogether. Indeed, many historic recipes call for exorbitant amounts of vinegar to be added to stocks in which to cook the mackerel in order to eliminate or blanket the volatile aromas that a several-day-old fish can carry. To a certain extent, acidic ingredients are still seen as the only solution to the unforgettable aroma of ammonia that becomes present in fish just days after being caught, but by far the best way of mitigating this fishy odour (not only in mackerel but in all fish) is to keep the fish at a consistent cold temperature during transport, processing and storage, along with being sure not to wash it under tap water at any stage.

Blue mackerel's versatility across multiple methods and its mineral, saline-like flavour profile lends itself to a diverse list of dishes and accompaniments. For me, a fresh mackerel that has been gutted, pin-boned and spent a single night on a wire rack in front of a fridge fan to dry the skin slightly before being grilled over embers is as close to perfection as you can get. (Try it once this way and I assure you there will be no turning back.) Like most fish, blue mackerel is nearly always better when cooked on the bone, but in the recipes that follow I have removed as many of the smaller bones as I possibly can to encourage you to get cooking, and celebrating, this incredible fish.

Alternatives
SARDINES · BONITO · TUNA · HERRING

Points to look for
SEEK OUT LARGER FISH WITH VERY FIRM FLESH AND UNDAMAGED BELLIES (THE SKIN AROUND THE BELLY WILL DETERIORATE RAPIDLY WITH THE OFFAL INSIDE)

Best cooking
GRILLED · RAW · PICKLED

Accompanying flavours
CHERRIES · ONIONS · ROSEMARY · TOMATOES · CUCUMBER

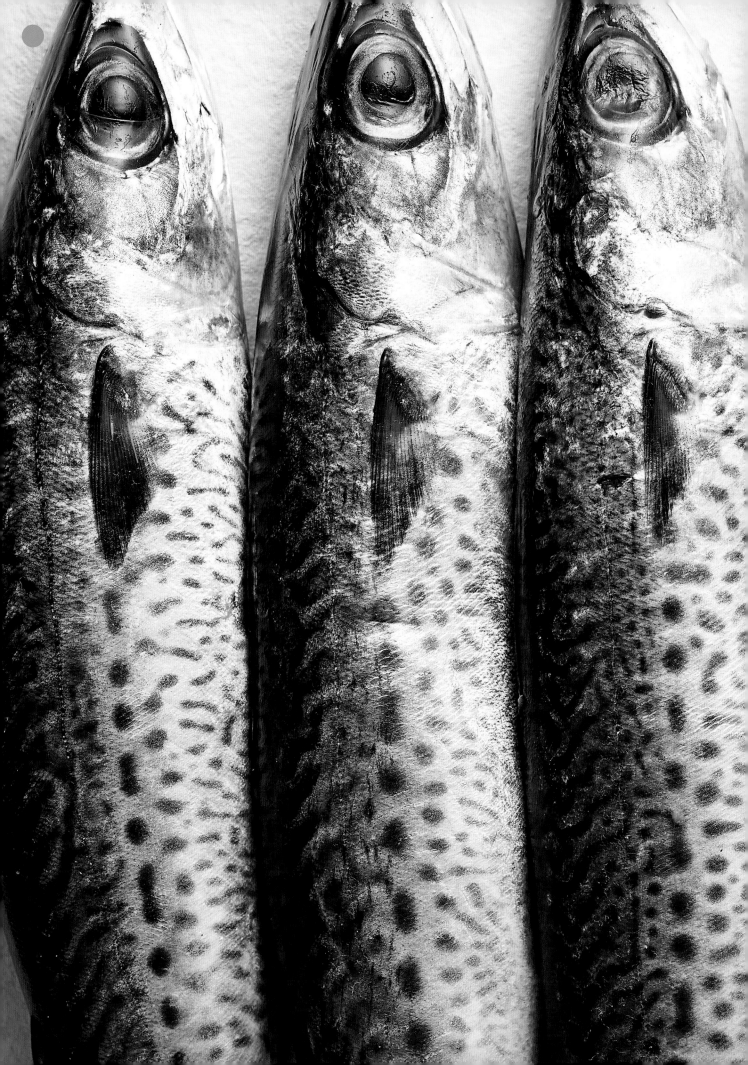

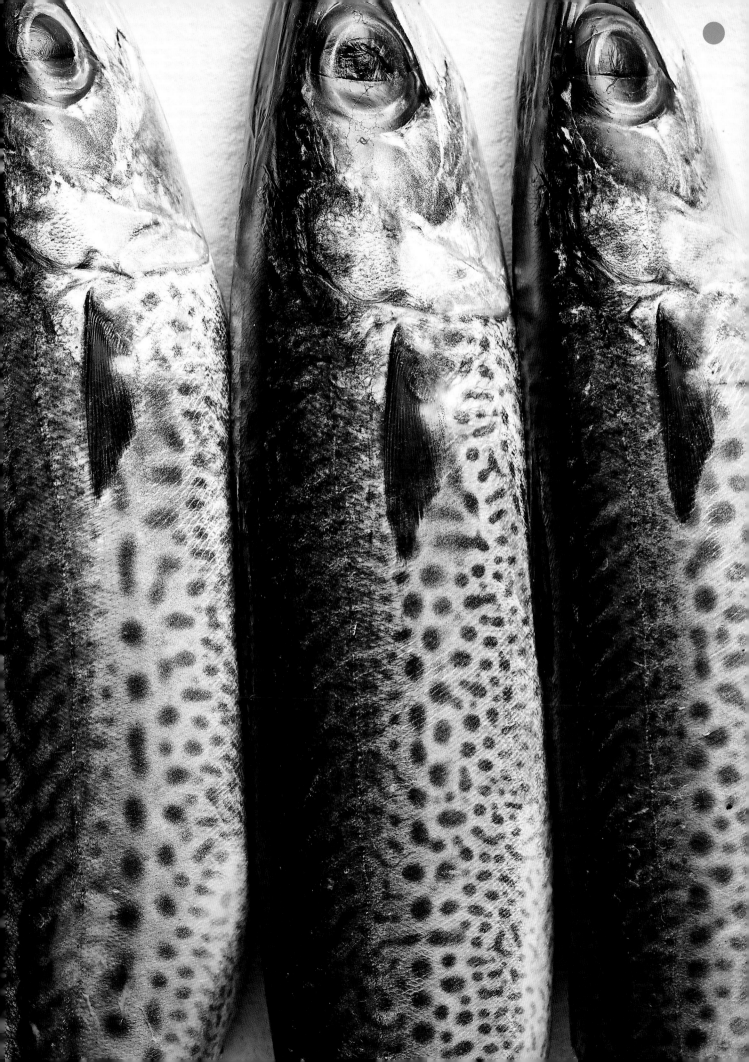

CHARCOAL BLUE MACKEREL WITH GREEN APPLE, SALTED CHILLI AND CHAMOMILE TEA VINEGAR SALAD

Blue mackerel carries a broad flavour profile, ranging from a natural sweetness on day one (best eaten raw and lightly seasoned at this point) through to an oyster-like brininess on the days that follow. The combinations here are inspired by the latter. The fresh cucumber, apple and light tannic tea are the perfect match for the fish and, once salted, the chilli brings welcome fruity – rather than hot and spicy – tones to the dish.

Because these chillies take a couple of months to prepare, it's well worth making the full quantity so you can reap the rewards of your labour many times over. They are phenomenal in pastas, compound butters or as a mild chilli addition to marinades for meat, fish and vegetables.

SERVES 4

4 boneless blue mackerel fillets,
 skin on
1 tablespoon melted ghee
1 tablespoon sea salt flakes

Salted chillies
2 kg (4 lb 6 oz) long red chillies
rock salt, to cover

Chamomile tea vinegar
1 tablespoon best-quality
 chamomile tea
250 ml (8½ fl oz/1 cup)
 chardonnay vinegar

Salad
3 granny smith apples, peeled and diced
2 telegraph (long) cucumbers, peeled
 and diced
4 celery stalks, peeled and diced
100 g (3½ oz) salted chillies, finely diced
6 small French shallots, finely diced
1 teaspoon toasted coriander seeds
Garum (page 257) or fish sauce,
 to taste

To make the salted chillies, split the chillies in half lengthways and spoon out all the seeds. Place in an airtight container and bury them in enough rock salt to completely cover. Leave for 6–8 weeks. This process helps remove the heat from the chilli and promote more of its floral characteristics.

Once these chillies have reached the desired level of tenderness and fragrance, store in the fridge for 8 weeks or so. Before using, scrape away any residual salt or seeds on the flesh. If you don't have the time for this, just deseed a single long red chilli, finely dice the flesh and add to the dressing.

For the chamomile vinegar, combine the tea and vinegar in an airtight container or sterilised mason (kilner) jar and leave to mature for at least 2 days. If you need a short-cut, warm the vinegar in a saucepan over a low heat to 50°C (122°F), then add the tea and allow to cool completely. It's now ready to use, but the flavour is far more floral and complex when it is left to infuse in the vinegar cold. When you have time, I recommend making a large batch to keep in the pantry.

To make the salad, combine the apple, cucumber, celery, chilli, shallot and coriander seeds in a bowl. Add 120 ml (4 fl oz) of the chamomile vinegar, along with garum or fish sauce to taste. The flavours should be a nice balance of salty and acidic. Dress the salad just before serving so the ingredients remain crunchy and retain their beautiful colours.

To grill the mackerel, either preheat a chargrill pan over a medium–high heat until a light haze appears, or use a charcoal grill with evenly burnt-down embers. Lightly brush the mackerel skin with ghee and season generously with salt flakes.

Carefully place the fillets, skin side down and well spaced out, on the hotter part of the grill, or in batches of two in the grill pan. Cook for 2–3 minutes until evenly coloured and the flesh is warm to the touch. The mackerel should be medium-rare. Carefully tip the grill rack to free the fish onto a clean surface. Alternatively, use an offset spatula to free the fillets from the grill. Rest, flesh side down, on a warm dinner plate or tray. It's important that the resting surface is warm as it is a gentle way of finishing the cooking process without drying out the flesh.

Brush the skin of the mackerel with ghee and season with a little more salt. Serve warm or at room temperature with a generous spoonful of the salad.

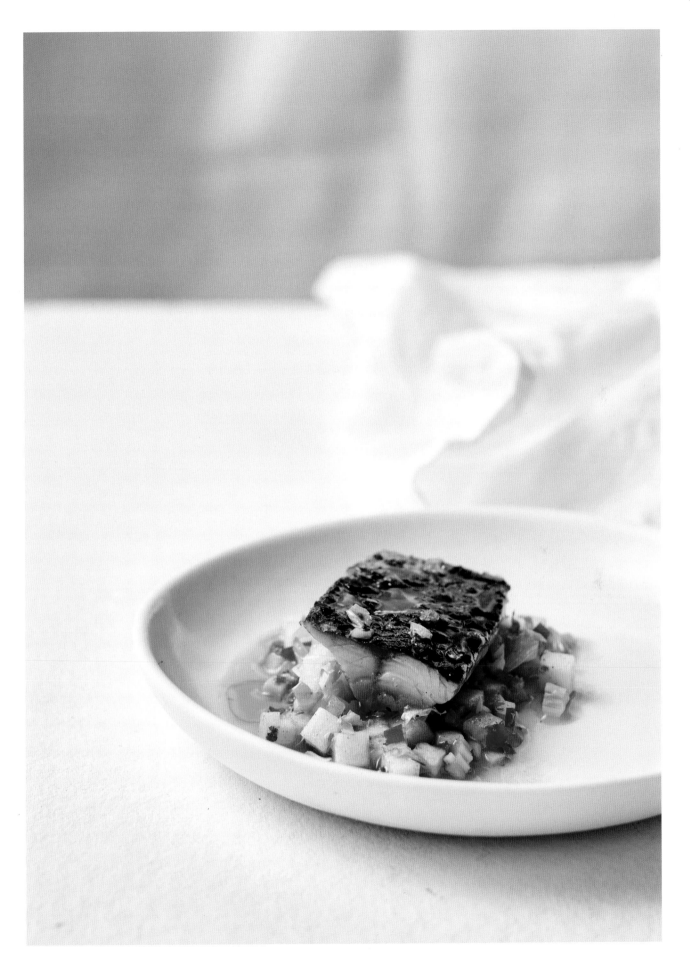

FRUIT AND NUT MACKEREL

Be sure to read through the instructions of how to prepare the fish here before you start this recipe. It definitely requires patience, but if you don't want to attempt it yourself, show your local fishmonger and they will be able to help. Also note that the stuffing should be made ahead of time so it is completely cool when you fill the mackerel. The result is a beautiful dish that brings glamour and luxury to a very underrated fish. Serve simply with a salad of leaves and a quality chutney, or a spoonful of parsnip puree and some roasted pears for something a little more substantial.

SERVES 2

2 × 250 g (9 oz) whole blue mackerel, head and offal included
60 g (2 oz) ghee

Stuffing

4 French shallots, finely diced
135 ml (4½ fl oz) extra-virgin olive oil
sea salt flakes and freshly cracked black pepper
½ teaspoon ground allspice
1/4 nutmeg, finely grated
zest of ½ lemon
75 g (23/4 oz) pine nuts, toasted
75 g (23/4 oz/½ cup) dried currants, soaked in warm water
4 thyme sprigs, leaves picked
1 bunch sage, leaves picked and finely sliced
200 g (7 oz/2½ cups) fresh breadcrumbs

Agro dolce

120 ml (4 fl oz) extra-virgin olive oil
6 French shallots, finely diced
150 ml (5 fl oz) white wine
375 ml (12½ fl oz/1½ cups) white-wine vinegar
150 ml (5 fl oz) water
75 g (23/4 oz) caster (superfine) sugar
125 g (4½ oz) dried currants
sea salt flakes and freshly cracked black pepper

To make the stuffing, put the shallot in a medium saucepan, cover with the olive oil and add a pinch of salt, then cook over a very gentle heat for 6–7 minutes until softened but not coloured. Add the allspice, nutmeg, lemon zest, pine nuts, soaked currants, thyme and sage and warm through for 1 minute. Transfer to a large bowl, add the fresh breadcrumbs and mix together well. If the stuffing is still a bit dry, add a little warm water or another splash of olive oil. Season with salt and pepper, then place in the fridge to cool completely.

For the agro dolce, heat the olive oil in a medium–large saucepan over a medium heat, add the shallot and cook until just golden. Add the wine, vinegar, water, sugar, currants and a little salt and pepper. Simmer briskly for 40 minutes, or until the shallot is very tender and the sauce is thick and syrupy. Measure out 225 ml (7½ fl oz) of sauce and chill in the fridge until needed. Any excess can be stored indefinitely and is a wonderful condiment for meats, fish or vegetables.

For the blue mackerel, place the fish on a board with the fish's tail in front of you and the head at the top of the board. The stomach should be down on the board and the dorsel fin at the top.

Using a very sharp knife, draw the blade from behind the head on one side of the spine to the tail. This first cut should only enter into the fish by about 3–4 mm (about 1/8 in). Repeat this cut on the other side of the spine, then draw down further on both of these initial cuts. The cuts at the tail end need to stop 10 per cent short of the base of the fish to ensure the belly and tail don't split and open. The objective here is to remove the spine from the fish without puncturing the belly, so the fish can be stuffed.

As the fish is still whole it must be gutted. When both cuts reach the top of the fish's rib cage, switch to scissors and carefully cut the rib bones away from the centre spine.

Now the rib is separate from the spine, snip the spine behind the head and in front of the tail, then carefully peel the spine away from the flesh. Be careful not to tear the flesh or skin at this stage.

Once the spine is removed, use a paper towel to wipe out the gut of the fish. Remove the gall bladder and set aside for making Garum (page 257). The gills sit behind the head of the fish. Working with scissors, snip the gills on both sides, then, using your hands, grab the gills and discard. The final step is to pin-bone the mackerel. Repeat with the second fish.

You can now fill the cavities with the cold stuffing. Place a square of baking paper that fits the stuffed area on top and refrigerate the stuffed fish for at least 30 minutes before cooking.

Preheat the oven to 180°C (350°F).

To cook the mackerel, heat an ovenproof frying pan large enough to fit both mackerel over a medium–high heat. (If your pan isn't large enough, just cook them in two batches.) Add the ghee and heat to a light haze.

Leave the baking paper on top of the stuffing and carefully place the fish, paper side down, into the hot fat. The paper will protect the stuffing from taking too much colour and help it set in place. It also allows you to place your offset palette knife or fish flip under the paper without disturbing the crust. Cook on the stuffing side for about 3 minutes until evenly coloured from edge to edge.

Drain off the fat, then place the pan in the oven and bake, still stuffing side down, for 6 minutes, or until the internal temperature of the thickest part of the mackerel reaches 42–44°C (107–111°F).

Remove from the oven and, using a fish flip, carefully turn the fish out of the pan onto a serving plate. Peel off the paper and rest the fish for 2 minutes to allow the residual heat of the stuffing to gently cook the fish through.

Season the crust generously, then liberally spoon on the agro dolce. Serve immediately.

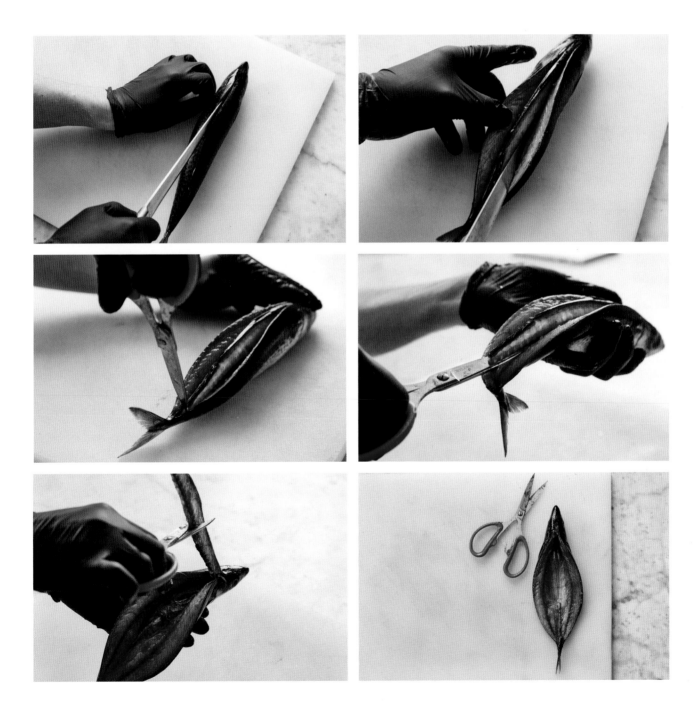

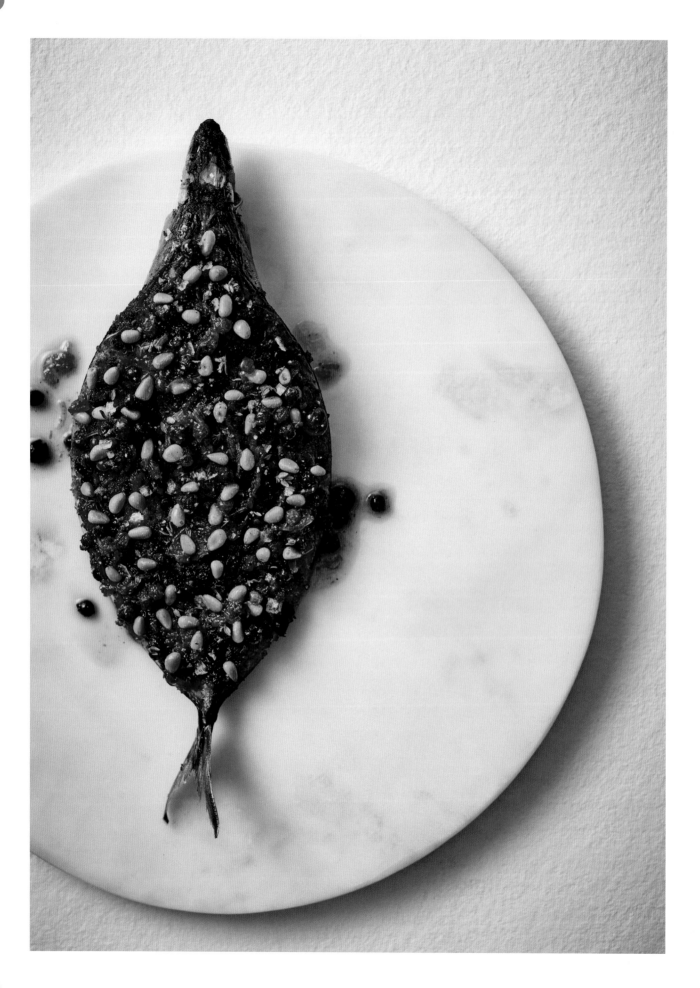

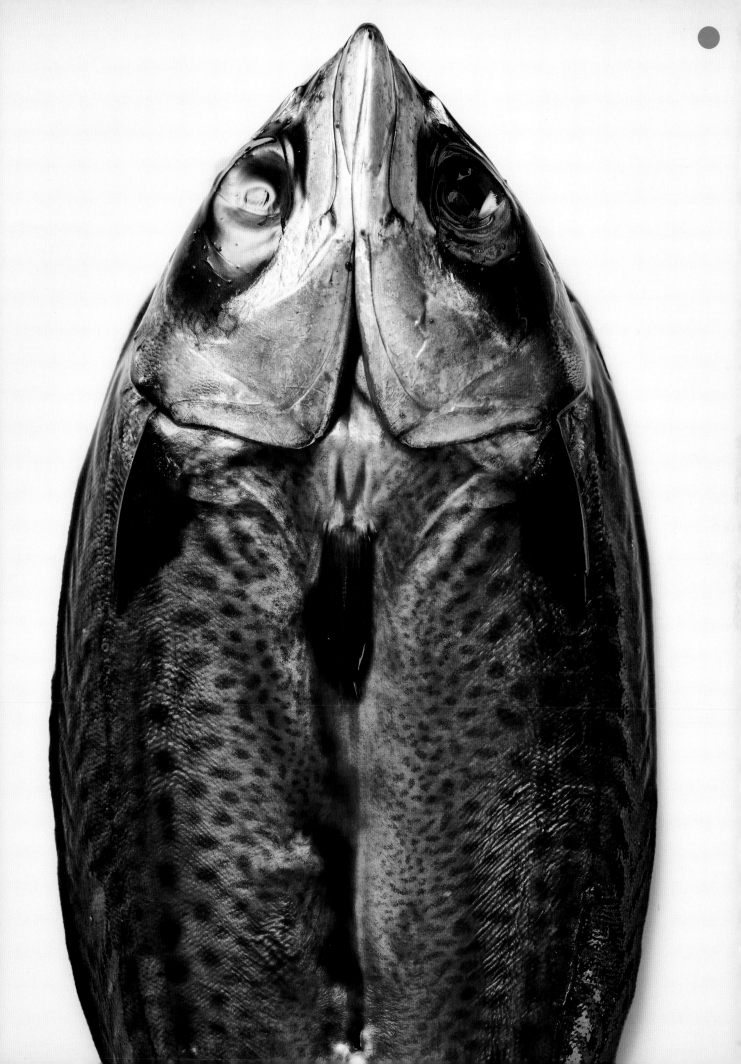

HOT-SMOKED BLUE MACKEREL AND CONDIMENTS

Smoke + mackerel = pure delight! This sticky, smoky mackerel comes without any of its tiny bones; served with these beautiful condiments, it makes a glorious weekend lunch for one, though it can also be easily scaled up for a dinner party with friends. The curing and smoking process described here also works well with other fish, such as herring, sardines and bonito, so feel free to experiment with whatever you have to hand.

SERVES 2–4

300 g (10½ oz) boneless butterflied blue mackerel, skin on (see page 51 for details)
80 g (2¾ oz) molasses
1½ teaspoons fine salt
80 ml (2½ fl oz/1/3 cup) water
1 × 14 g (½ oz) brick of apple wood chips, soaked in water for at least 1 hour
extra-virgin olive oil, for brushing
sea salt flakes and freshly cracked black pepper

Condiments

2 soft-boiled eggs (6 minutes from the boil)
2 tablespoons tiny salted capers, rinsed and drained
5 French shallots, finely diced
4 celery heart stalks, leaves intact
8 salted anchovy fillets
80 g (2¾ oz) hot English mustard
120 g (4½ oz) crème fraîche or sour cream
4 slices of seeded rye bread, buttered

To cure the mackerel, place the fish in a sterilised container or tray. Whisk together the molasses, salt and water in a separate bowl, then pour over the fish and cover. Cure in the fridge for a minimum of 12 hours but no more than 24 hours. Remove the mackerel from the brine and place on a trivet, skin side up, ready to smoke.

You need a smoker that is capable of hot-smoking, or the most suitable alternative – a cheap double steamer lined with foil and soaked wood chips in the base is always good. Add the wood chips to the steamer base and ignite. Place over a low heat to maintain a steady temperature. Once the chips are smouldering, place the fish in the steamer basket, set it on the base and cover with the lid. Make sure the temperature you are working with does not exceed 120°C (248°F), as this will alter the texture of the fish too much – ideally it should be around 90°C (195°F). Smoke for 30–35 minutes.

If you are using a commercial smoker, place the cured mackerel on a wire rack suited to your smoker and smoke for 30–35 minutes, depending on your desired degree of smokiness and doneness.

Remove from the smoker and rest until it reaches room temperature, then store uncovered in the fridge, skin side up, to dry any surface moisture until you are ready to serve.

Remove the mackerel from the fridge and place, skin side up, on a serving plate. Brush with a little olive oil and season very lightly with salt flakes and pepper. Next to the mackerel place half a soft-boiled egg, a pile of capers, diced shallot, celery heart, anchovy fillets, mustard, a spoonful of crème fraîche or sour cream and buttered seeded bread. Serve at room temperature as a share dish for four or a special Sunday lunch for two.

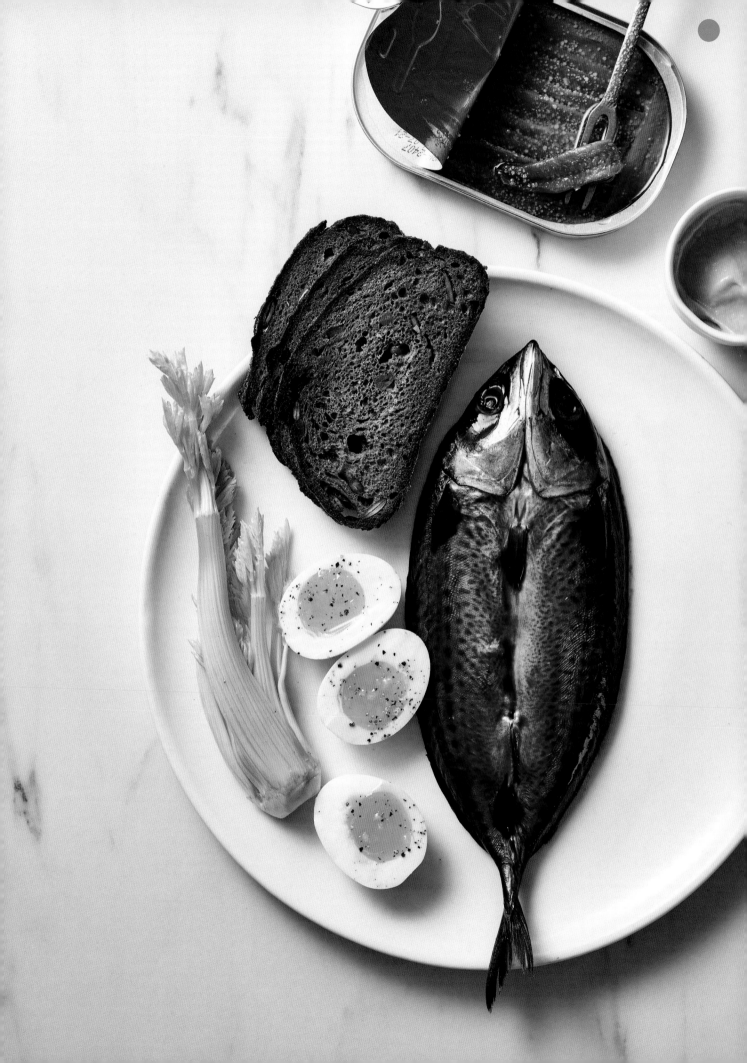

4

Gurnard

Gurnard live on the seabed and use their peacock-like fins to find crabs, fish and shrimp that live among the sediment. This diet and lifestyle produces a delicious, firm flesh that holds together well across a wide number of cookery methods; however, as gurnard's fat is predominantly limited to a very thin layer immediately under the skin, the flesh has low oil content and can readily dry out if not handled with close attention.

Before I first tasted gurnard I had been told that it would be similar to flathead – both texturally and from a flavour point of view – but I actually found it to be firmer and with a longer, sweeter finish. Saffron, fennel, mushrooms, almonds, olives, tomatoes, artichokes, chickpeas and seaweed are all excellent flavours to pair with a red gurnard.

Whether fried in batter, crumbed into fingers, roasted on the bone, steamed, poached, marinated and grilled or baked in a pie, this fish is the all-rounder we should all be putting on our tables.

Alternatives
RED MULLET · SNAPPER · MONKFISH

Points to look for
**BRIGHT COLOURING · FIRM FLESH · BRIGHT EYES AND GILLS
MEMBRANE WITHIN FINS UNDAMAGED**

Best cooking
ROASTED · FRIED · STEAMED · POACHED · GRILLED

Accompanying flavours
**FENNEL · MUSHROOMS · ALMONDS · OLIVES · TOMATOES
ARTICHOKES · CHICKPEAS · SEAWEED**

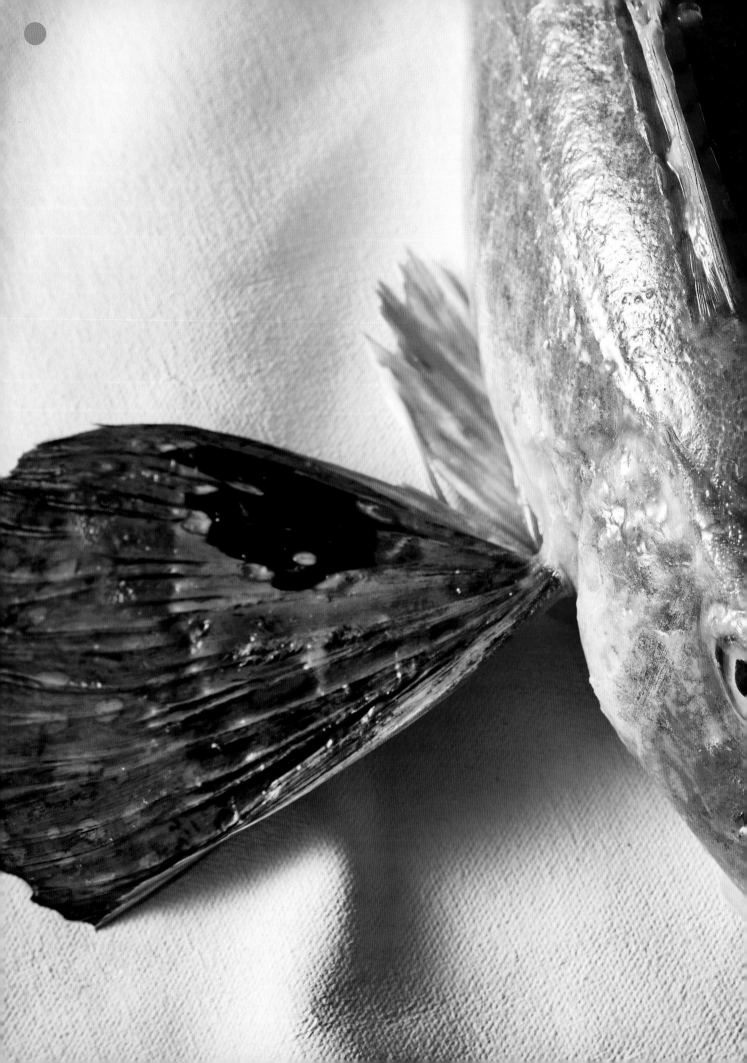

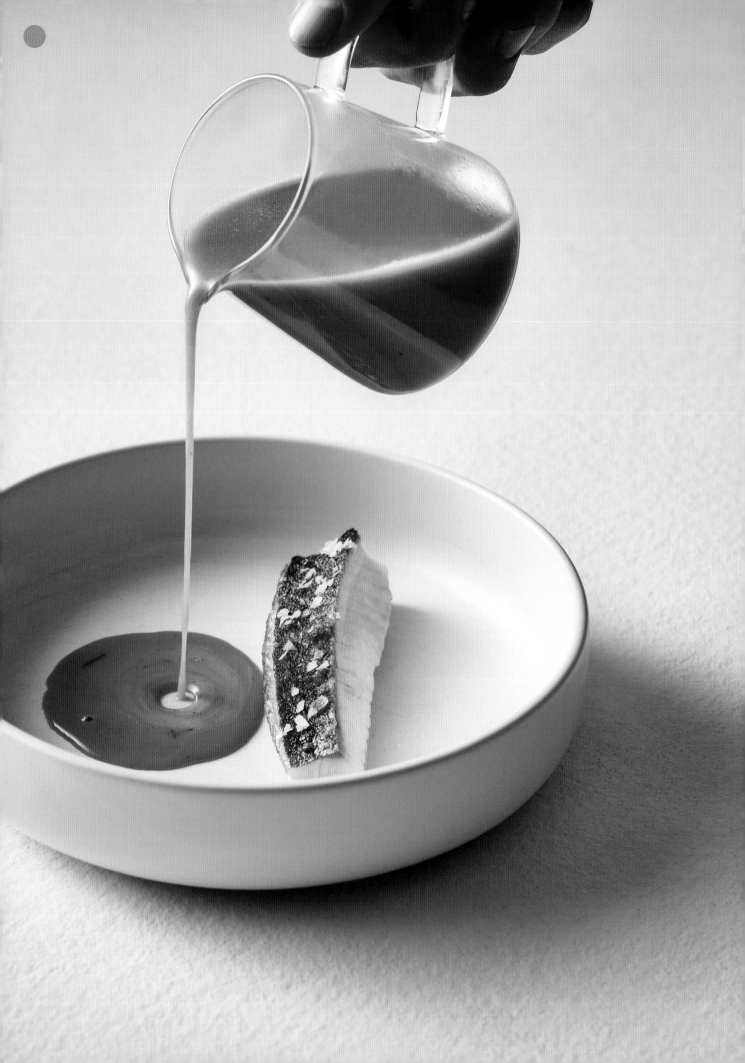

GURNARD SOUP

Soups go in and out of fashion but, for me, aside from a full-blown bouillabaisse, this is the one you need to have in your repertoire. Although I've used gurnard, other fish such as leatherjacket, red mullet and flathead, or even shellfish such as crabs or prawns (shrimp), can easily be used in its place. It's preferable to use a mouli to grind the soup base and extract as much of the flavour as possible, but if you don't have one you can pulse it briefly in a food processor. And don't be shy with the salt here – it really helps to bring out all the wonderful flavours in the soup.

SERVES 4–6

100 g (3½ oz) ghee
4 × 80 g (23/4 oz) boneless red gurnard
 fillets, skin on
sea salt flakes

Soup base
4 × 300 g (10½ oz) whole red gurnard,
 gills, guts and gall bladders removed
120 g (4½ oz) ghee
large pinch of sea salt flakes
2 onions, finely sliced
8 garlic cloves, crushed
3 small fennel bulbs, finely sliced
2 tablespoons tomato paste
 (concentrated puree)
3 tomatoes, coarsely chopped
¼ bunch thyme sprigs
5 lemon thyme sprigs (optional)
2 teaspoons fennel seeds,
 lightly toasted
2 star anise
generous pinch of saffron threads
200 ml (7 fl oz) white wine
1 tablespoon Pernod
freshly cracked black pepper
lemon juice, to taste

To make the soup base, use a sharp cleaver to chop each gurnard into approximately eight small pieces, including the liver and roe.

Heat 100 g (3½ oz) of the ghee to a light haze in a large, wide, heavy-based saucepan over a high heat, add the chopped fish and salt flakes and cook for 10 minutes or until coloured all over. Transfer to a bowl. Using a wide barbecue scraper, scrape off any caramelised fish from the base of the pan and add to the bowl.

Heat the remaining ghee in the pan over a medium heat. Add the onion and cook for 10 minutes until softened, then increase the heat to high and cook the garlic and fennel for a further 5 minutes. Stir in the tomato paste and cook for 5 minutes, then return the cooked fish to the pan, along with all the remaining ingredients except the salt, pepper and lemon juice. Pour in enough water to cover, then put the lid on and bring to the boil. As soon as it's boiling, remove the lid and simmer over a medium heat for 20 minutes, or until thickened slightly and the taste is well rounded. Pass the stock through a mouli (or pulse in a food processor), then strain through a fine-mesh sieve, discarding the pulp. Return to the pan, season well with salt, pepper and lemon juice and keep warm.

To cook the gurnard fillets, heat 75 g (23/4 oz) of the ghee in a large cast-iron frying pan over a medium–high heat to a light haze. Place the fillets in the centre of the pan, skin side down and making sure they are not touching each other, and put a fish weight or small saucepan on their thickest sides. Keeping the pan temperatures quite high, cook for about 1 minute, or until you start to see colour around the edges of the fillets. Use an offset palette knife to lift the fillets, then reposition them to take on new colour. Now place the fish weights in the centre of the pan, covering the majority of the fillets. This will aid in setting the fillets gently from the rising heat. Cook for another 2 minutes, then remove the weights. Discard the ghee in the pan and replenish with 45 g (1½ oz) fresh ghee. (This is just to help temper the pan as at this stage it is important to keep the pan heat high but not so high that the skin burns, leaving the flesh on top raw.) If the flesh still seems cool to the touch at this point, position the weight on top for another 1–2 minutes, depending on the thickness of the fillets.

If you find the fillets exceed your pan size, either use two frying pans or cook them in batches, and double the quantity of ghee.

Once the fish is 75 per cent of the way set, the top of each fillet is warm and the skin is crisp from edge to edge, transfer them directly into warm soup bowls, skin side up, and season the skin with salt flakes. Pour a generous amount of soup around the gurnard until the sides of the fish are completely submerged but the skin remains dry (and therefore crisp). Serve immediately.

RED GURNARD, SEAWEED AND DAUPHINE POTATO PIE

Everything old is new again. I first made this dauphine potato recipe as an apprentice chef; the mashed potato was mixed with choux pastry then spooned into the deep-fryer and cooked until crisp and fluffy. All these years later, I decided it would make the perfect topping for my gurnard and seaweed pie. Red gurnard is the ideal fish for a béchamel-based pie like this; its firm texture, sweetness and rich shellfish characteristics shine through, even beneath the golden potato topping. The seaweed brings a level of complexity and savouriness to the pie that spinach or other green vegetables just can't, so take the time to source the best quality you can find.

SERVES 4–6

500 ml (17 fl oz/2 cups) full-cream (whole) milk
2 tablespoons white miso paste
10 cm (4 in) piece of kombu
10 g (¼ oz) bonito flakes
50 g (1¾ oz) butter
50 g (1¾ oz/⅓ cup) plain (all-purpose) flour
20 g (¾ oz) dried wakame seaweed, softened in cold water
sea salt flakes and freshly cracked black pepper
800 g (1 lb 12 oz) boneless red gurnard fillet, skin on, cut into 3 cm (1¼ in) chunks

Dauphine potato
1 kg (2 lb 3 oz) whole royal blue or Dutch cream potatoes
rock salt, for cooking
50 g (1¾ oz) butter
100 ml (3½ fl oz) water
pinch of sea salt flakes
100 g (3½ oz/⅔ cup) plain (all-purpose) flour
3 eggs, lightly beaten
½ teaspoon baking powder
freshly grated nutmeg, to taste
freshly cracked black pepper
1 egg, extra, plus 1 egg yolk, lightly beaten to make an egg wash

Whisk the milk, miso, kombu and bonito flakes in a saucepan over a medium heat. Bring the mix up to approximately 85°C (185°F) and hold over a low heat to keep warm for about 20 minutes.

In a separate saucepan, melt the butter over a medium heat. Add the flour and cook for 2 minutes or so, stirring with a wooden spoon to form a roux. Remove the strip of kombu from the hot milk and strain off the bonito flakes, then gradually add the strained milk to the roux, one-third at a time, whisking after each addition to create a smooth sauce. When you have incorporated all the milk, bring the sauce to the boil and add the softened wakame. Season to taste, then remove from the heat and closely cover the sauce with plastic wrap or baking paper to stop a skin forming. Refrigerate until completely cold.

Add the gurnard chunks to the chilled béchamel and combine well, then spoon the filling into a 2.5 litre (85 fl oz/10 cup) baking dish or two smaller baking dishes suitable for a pie.

Preheat the oven to 190°C (375°F).

For the dauphine potato, place the washed potatoes on a baking tray covered with a generous layer of rock salt and bake for 1 hour, or until tender when pierced with a skewer or sharp knife. Remove the potatoes from the tray one at a time, then, while hot, scoop out the flesh into a wide-based saucepan. Mash and then stir over a low heat for 1–2 minutes to steam off any excess moisture.

Increase the oven temperature to 200°C (400°F).

Place the butter, water and salt in a large saucepan over a low heat until the butter has melted. Increase the heat to medium–high and bring to the boil, then remove from the heat and beat in the flour until well combined. Set the pan back over a medium heat and beat for a further 2–3 minutes until the mixture comes together and starts to leave the side of the pan. Transfer to a stand mixer fitted with the paddle attachment and beat for 1–2 minutes until the dough is no longer hot but still warm. Add the egg a little at a time, checking the texture of the mixture as you go until it reaches dropping consistency (that is, it should fall very slowly from a spoon when held over the bowl). You may not need all the egg to reach this point.

Combine the dauphine base with 500 g (1 lb 2 oz) of the warm mashed potato, stir in the baking powder and nutmeg and season liberally with salt flakes and pepper. Scoop the mash into a piping bag and pipe evenly over the filling. Brush the surface lightly with the egg wash, then drag a fork from one end of the pie to the other to create indentations in the potato.

Bake for 35 minutes, or until the dauphine potato is crisp and golden. Finish with a sprinkling of salt flakes, then rest the pie for 5 minutes before serving.

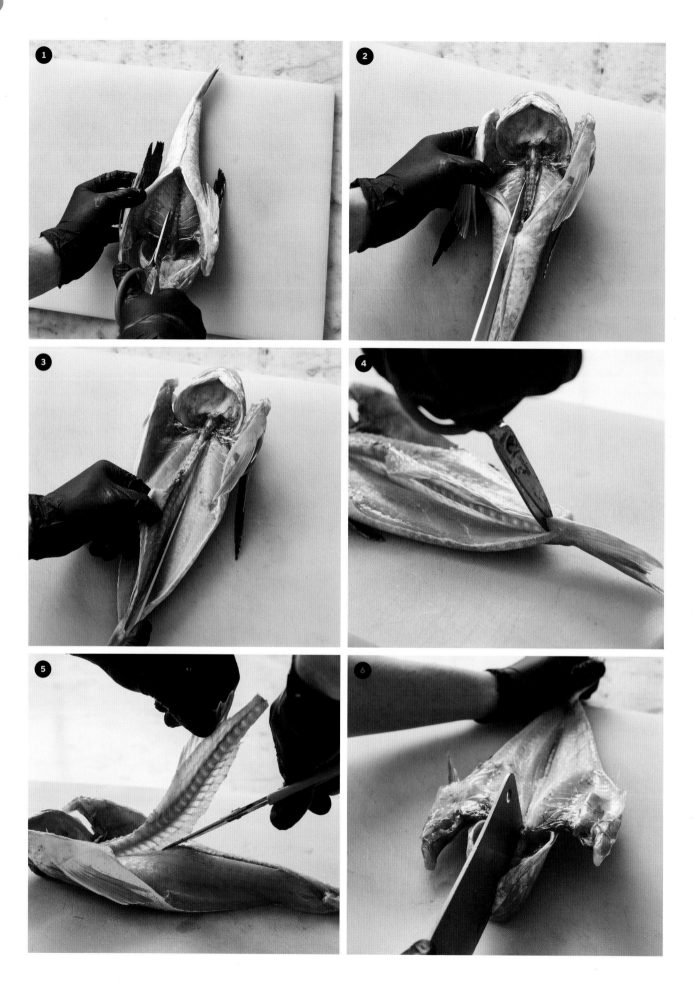

REVERSE BUTTERFLY

Make sure the fish is scaled and gutted before attempting this method. Position the fish in front of you with the head nearest to you and the tail furthest away.

1. Using sharp kitchen scissors, begin cutting down the left-hand side of the spine to disconnect the ribs from the spine, but stop at the fish's anus. Repeat this step down the right-hand side of the spine. This now gives you a clear track to use your knife in the next step.

2. Position the fish now with the head facing away from you. Using a small, sharp knife, draw the blade down the scissored opening that you have made next to the spine.

3. Repeat on the opposite side.

4. When these two cuts meet up at the tail, use kitchen scissors to snip the tail, then just behind the head where it meets the spine.

5. Pull the spine carefully off the skin of the fish, making sure to support the surrounding flesh so it doesn't rip or do damage.

6. With the head of the fish pointing towards you, use a cleaver or heavy chef's knife to break the bones and flatten the head and collars without cutting through the flesh; this results in a uniform thickness for even cooking. Use fish tweezers to remove pin bones and rib bones. (Alternatively, depending on the species, it may be easier to remove the rib bones with a small, sharp knife.)

RED GURNARD TIKKA WITH SPICED CHICKPEA YOGHURT

Chicken tikka is a dish that I have always loved eating but rarely cooked. That is, until we tested this recipe a couple of years ago and noticed just how well the gurnard flesh took to the marinade and how beautiful and caramelised it was once it came off the charcoal grill. This recipe calls for a reverse butterflied red gurnard with the pin bones removed, but if you aren't one to shy away from the odd bone, it's also spectacular when cooked on the bone. While there are a number of other species you could try in this dish, none quite have the succulence or sweetness of red gurnard, which is an excellent vehicle for carrying robust flavours.

Additional vegetables, rice and condiments can be added to make this a more substantial meal, but simply rolling up the fish and yoghurt in a naan bread makes a fun grab-and-go weeknight dinner or weekend lunch on the barbecue. On that note, this recipe really is worth firing up your grill for – the flavour is off the charts once the marinade gets all charred and smoky.

This style of spiced chickpea yoghurt is traditionally made with small pearls of fried chickpea-flour batter, but I love the texture the fried chickpeas provide against the chewy naan, crunchy pickles and smoked, buttery fish.

SERVES 4

2 × 350 g (12½ oz) boneless reverse butterflied (see page 75) whole red gurnard, skin on

Spiced chickpea yoghurt
1 litre (34 fl oz/4 cups) canola oil
125 g (4½ oz) drained tinned chickpeas
sea salt flakes
125 ml (4 fl oz/½ cup) full-cream (whole) milk
250 g (9 oz/1 cup) natural yoghurt
1 teaspoon finely diced green chilli
¼ teaspoon red chilli powder
¼ teaspoon toasted cumin seeds
¼ teaspoon toasted fennel seeds
¼ teaspoon kombu powder

Tikka marinade
6 garlic cloves, finely grated
1 tablespoon finely grated fresh ginger
1 tablespoon finely grated fresh turmeric
¼ teaspoon smoked paprika
2 teaspoons achar masala (Indian pickle masala spice blend) (optional)
1 teaspoon bishop's weed (ground elder) (optional)
350 g (12½ oz) natural yoghurt
1 teaspoon fenugreek seeds
½ teaspoon cumin seeds
2 teaspoons coriander seeds
sea salt flakes

To serve (optional)
Naan Bread (page 261)
Grilled Pickles (page 260)
coriander (cilantro), round-leaf mint and fresh fenugreek leaves
lime wedges

To make the spiced chickpea yoghurt, heat the canola oil in a small saucepan over a medium heat to 180°C (350°F). Carefully add one-third of the chickpeas and fry for 3–4 minutes until very crisp and golden. Remove with a slotted spoon, drain well on paper towel and season with salt flakes. Repeat with the remaining chickpeas.

In a large mixing bowl, whisk together the milk and yoghurt until smooth. Add the fried chickpeas and remaining ingredients and stir to combine. Season with salt if needed and store in the fridge until required.

For the tikka marinade, combine the garlic, ginger, turmeric, smoked paprika, achar masala, bishop's weed (if using) and yoghurt in a bowl. Working with one at a time, toast the whole spices in a dry frying pan over a medium heat for 1–2 minutes or until fragrant. Transfer the lot to a spice grinder or mortar and pestle and grind to a powder, then stir into the yoghurt, along with salt to taste.

Place the fish, skin side down, on a large baking tray or wide plate, spoon over the marinade and rub it into the flesh. Turn the fish over and repeat on the other side, ensuring both are generously coated all over. Transfer the fish, uncovered, to the fridge and leave for a minimum of 2 hours, or up to 12 hours, to impart as much flavour as possible.

About 30 minutes before you are ready to cook, remove the fish from the fridge to allow their temperature to rise slightly for even cooking.

Either preheat a chargrill pan over a medium–high heat or a charcoal grill with evenly burnt-down embers.

Brush away some of the marinade from the fish, leaving just a thin layer of yoghurt (too much and it will catch on your grill and burn; too little and you won't have that beautiful fragrant crust). Place the fish, skin side down, on the grill and top with a square of baking paper, then a fish weight (or another heavy object weighing about 1.7 kg/3 lb 12 oz to generate the heat transfer from skin to flesh). Cook for about 2 minutes, managing the heat so you don't scorch the skin to bitterness. Turn the fish over and cook very briefly, for 20 seconds or so, just to allow the yoghurt to set slightly and the surface of the fish to warm. Immediately transfer to a serving plate, skin side up, and allow the residual heat to finish cooking the fish.

Serve simply with the spiced chickpea yoghurt, along with naan bread, pickles and fresh herbs for rolling if you like. Finish with a squeeze of lime.

5

Red Mullet

Red mullet is, quite simply, one of my favourite fish. With a diet heavy in crustaceans, its flavour profile has strong shellfish characteristics and its flesh, with its fine-textured flake, is naturally sweet (though it can be a little soft at times, which is why it is critical that you select firm, well coloured and unblemished fish). When it comes to cooking, mullet is best treated simply; pan-frying and grilling are two of the best methods of cookery, as they accentuate the irresistible shellfish characteristic of the skin, while baking in the oven with nothing more than a little quality olive oil and salt flakes can also yield pretty spectacular results.

To unlock the full range of culinary opportunities in a mullet, I like to think outside the usual 'fish' box and categorise it by the way that it tastes (indeed, this is a guiding principle for me across the board). So, as mullet tastes like prawns, crab or lobster, I like to treat it this way, removing all the usual preconceived ideas around what 'should' be served with it. Creativity to me is rooted in this way of thinking – the fruits of an underlying skill set combined with a desire to improve upon what we know.

Alternatives
PRAWNS · SNAPPER · SEA BASS · GURNARD · LEATHERJACKET

Points to look for
FIRM FLESH · INTACT SCALES · NO HARSH AMMONIA AROMA

Best cooking
PAN-FRIED · BAKED · GRILLED · CRUMBED

Accompanying flavours
CARROTS · SAFFRON · CORN · SEAWEED

RED MULLET AND SAUCE OF ITS OFFAL

I love this recipe as it really puts the mullet front and centre in all its glory. The sauce takes time and effort but the end result is rich and full of flavour; and the fish itself is prepared in quite a unique way, as the pin bones and rib bones are removed but the spine is left intact. I have done this to preserve the shape of the fish as it cooks and also to give the flesh maximum flavour from the bones. There is something very satisfying about being presented with a whole fish on a plate like this, all the while knowing there's no risk of running into any little bones.

SERVES 4

4 × 250 g (9 oz) whole red mullet, scaled
60 ml (2 fl oz/¼ cup) extra-virgin
 olive oil
sea salt flakes

Sauce
1 × 500 g (1 lb 2 oz) whole red mullet,
 gills and gall bladder removed
110 g (4 oz) ghee
2 tablespoons white wine
½ brown onion, finely sliced
1 garlic clove, crushed
½ small fennel bulb, tops on, finely
 sliced
½ tomato, coarsely chopped
1 tablespoon tomato paste
 (concentrated puree)
1.25 litres (42 fl oz/5 cups) water
½ teaspoon whole black peppercorns
2 thyme sprigs
small pinch of saffron threads
sea salt flakes and freshly cracked
 black pepper
lemon juice, to taste
25 g (1 oz) butter, chilled and diced

To prepare the mullet, start by wiping the skin to ensure there is no surface moisture, then use scissors to cut off all the fins (as these will be the first things to burn off on the grill). Insert a short, sharp knife into the anal passage of each fish and draw the blade towards the head in a nice even cut. Remove the gills and gall bladder and discard, setting aside the other offal for use in the sauce.

Using scissors, separate the rib bones from the spine as if you were preparing to butterfly the fish (see page 51), then, once the two lines are cleared on both sides of the spine within the cavity, use a pair of fish pliers to carefully remove all the pin bones and rib bones. (This will ensure the only bone left within each fish is the central spine.) Wipe the fish thoroughly once more, then brush the whole fish, including inside the cavity, with a little olive oil. Season well with salt and set aside.

For the sauce, use a sharp cleaver to chop the fish into small pieces. Place 80 g (2¾ oz) of the ghee in a large, wide, heavy-based saucepan over a medium heat and heat to a light haze. Add the chopped fish and reserved offal from the prepared whole mullet and fry for 10–12 minutes, or until coloured all over. (It's important that the frames and offal take on a good amount of colour without burning as this will be the foundation of the sauce.) Remove from the pan and set aside in a bowl. Deglaze the pan with the wine, use a wooden spoon to scrape the caramelised fish off the base, then pour this liquor into the bowl with the fish.

Heat the remaining ghee in the pan to a light haze, add the onion and sweat for 10 minutes until softened. Increase the heat to high, add the garlic and fennel and cook for 5 minutes or until tender. Stir in the tomato and tomato paste and fry for another 5 minutes until fragrant. Return the fish pieces and liquor to the pan, along with the water, peppercorns, thyme and saffron, then cover with a lid. Bring to the boil, then remove the lid and simmer for 30 minutes. Pass the hot liquid through a mouli, or pulse it in a food processor, then strain the mix through a fine-mesh sieve, pushing lightly on the solids with a ladle to extract as much flavour and liquid as possible. Discard the pulp. Return the sauce to the pan, bring to a simmer and reduce slightly until it is almost thick enough to coat the back of a spoon. Season generously with salt flakes, pepper and lemon juice, and set aside.

Either preheat a chargrill pan over a medium heat or a charcoal grill with evenly burnt-down embers.

Place the prepared mullet on the grill and cook over a medium, steady heat, brushing with a little more olive oil as you go, for about 3 minutes each side or until lightly coloured. Remove from the grill and leave to rest for 3 minutes. (At this point the fish should have an internal temperature of 50°C (122°F) to ensure the flesh comes away from the bone but isn't dry.) Season the fish once more with a little salt to finish.

While the fish is resting, warm the sauce over a medium heat and whisk in the cold butter to thicken it further and give it a silky, smooth finish.

Spoon a generous amount of sauce onto the centre of individual plates, place the mullet on top and serve immediately.

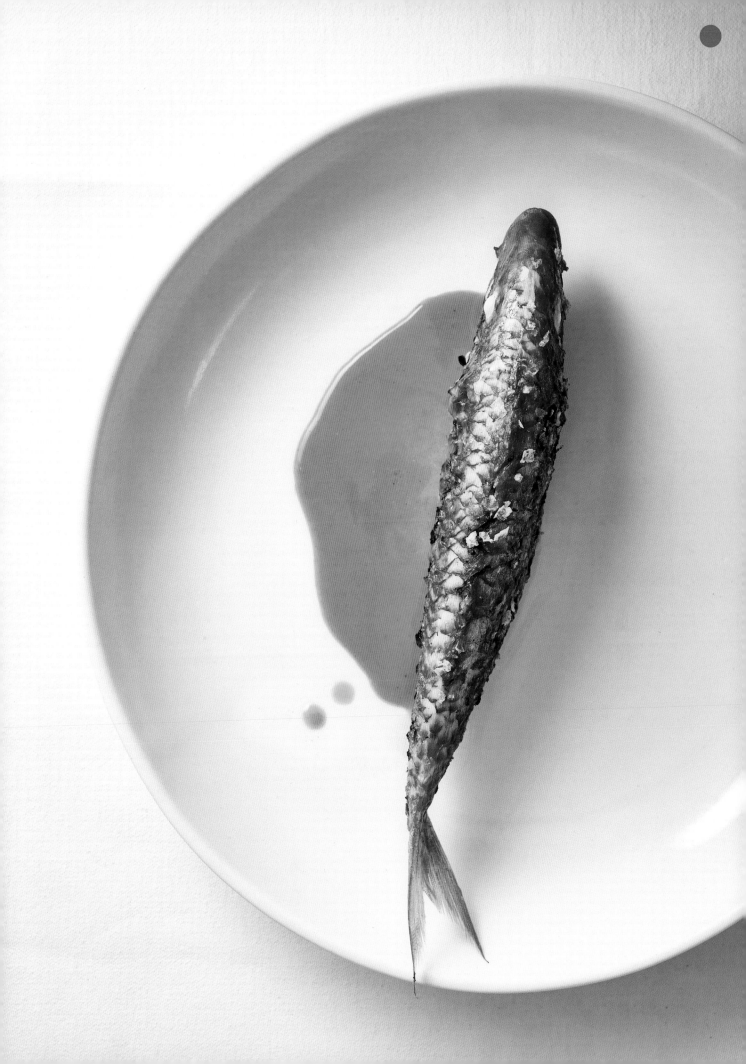

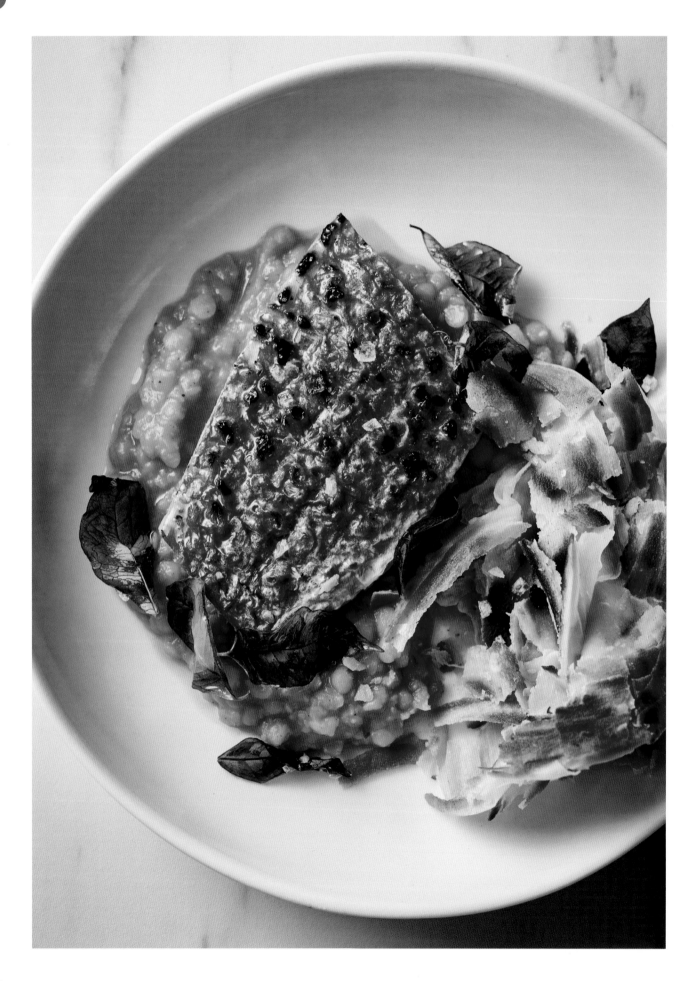

RED MULLET AND WHITE POPPY CHANA DAL

While this is by no means a traditional recipe for chana dal, I love the warming flavours these spices bring to the dish, sitting underneath the sweet caramelised red mullet fillet. The dal recipe is a versatile one that can be enjoyed on its own for a mid-week dinner or served on the weekend with all the trimmings. Do try the paratha when you have time. Ideally they should be made on the day, though they do freeze well, layered between sheets of baking paper.

SERVES 4

80 g (2¾ oz) ghee
¼ scud chilli, finely sliced
1 garlic clove, finely sliced
zest of ½ lemon
1 coriander (cilantro) root, washed,
 scraped and finely chopped
4 × 80 g (2¾ oz) boneless red mullet
 fillets, skin on
60 ml (2 fl oz/¼ cup) grapeseed oil
sea salt flakes

Dal

250 g (9 oz) split chickpeas (chana dal)
1 litre (34 fl oz/4 cups) cold water
2 teaspoons grated garlic
1 tablespoon grated fresh turmeric
1 tablespoon grated fresh ginger
½ teaspoon ground cardamom
sea salt flakes
40 g (1½ oz/¼ cup) white poppy seeds
2 tablespoons finely chopped
 coriander (cilantro)

Tadka

100 g (3½ oz) ghee
2 cloves
2 garlic cloves, finely sliced
2 French shallots, finely sliced
1 ripe roma (plum) tomato, diced
½ teaspoon cumin seeds
½ teaspoon ground coriander
½ teaspoon dried mango powder
½ teaspoon chilli powder
1 teaspoon garam masala
1 teaspoon dried fenugreek leaves

To serve (optional)

20 fried curry leaves
1 quantity Paratha (page 259)

To make the dal, wash the chickpeas under cold running water until the water runs clear, then add to a large saucepan and pour over the water. Add the garlic, turmeric, ginger and cardamom and bring to a simmer over a high heat. Cover and cook for 25 minutes, or until the chickpeas are tender. Remove from the heat.

To make the tadka, heat the ghee in a wide frying pan over a medium–high heat until it is at a light haze, then add the cloves and let them toast and sizzle for about 30 seconds until fragrant. Add the garlic and shallot and cook, stirring constantly, until medium brown, then add the tomato and cook for a further 2 minutes. Add the spices and toast for another 2 minutes or so until fragrant, then reduce the heat to medium and cook for 10 minutes, or until fragrant and the tomato, garlic and onion are completely coated in the spices. Remove the pan from the heat and fish out the cloves. Transfer the mixture to a blender and blend until very smooth.

Gently stir the tadka through the dal until incorporated. The consistency of the dal should be velvety, not watery. If it needs it, reduce the dal further over a medium heat to remove any excess moisture. Season to taste with salt flakes and keep warm.

Before cooking the mullet, place the ghee in a small saucepan with the chilli, garlic, lemon zest and coriander root. Warm over a low heat for 4–5 minutes, until the ghee is fragrant and carries the flavour of all the ingredients, then spoon the mix into a small bowl.

Either preheat a chargrill pan over a medium–high heat or a charcoal grill with evenly burnt-down embers.

Brush the mullet fillets with the grapeseed oil and season the skin liberally with salt flakes. Place, skin side down, on the grill and put a fish weight or empty saucepan on the flesh to assist with even cooking and heat transfer. Cook for 2 minutes to develop good colour across the skin and warmth over the flesh. When the fish is about 60 per cent cooked, remove from the grill. The remaining cooking will take place when sitting on top of the warm dal, so be sure to leave the fillet underdone otherwise the flesh will dry out. Liberally brush the skin with the flavoured ghee and season with salt.

Just before serving, stir the white poppy seeds and coriander through the dal, then spoon into individual bowls. Place a crisp-skin mullet fillet on top of each and serve immediately. If you like, garnish with crispy fried curry leaves and serve with warm, flaky parathas.

RED MULLET IN ROAST FENNEL GRAVY

To me, red mullet is very much a luxury ingredient and, with a flavour profile reminiscent of shellfish, one that needs little to reach its full potential. With a fish like this it's important to really pay attention to the cooking – too much heat and this elegant protein can quickly enter the realm of dry chicken breast. Good-quality mullet can (and almost should) be served half-cooked; in this dish, the warm fennel gravy will gently cook the flesh the rest of the way. As much as I love this vegetarian gravy with the red mullet, it also pairs perfectly with roast chicken, lamb, pork and crispy potatoes.

If you don't want to try your hand at reverse butterflying the mullet yourself, be sure to ask your fishmonger to do it for you. And take out all the pin bones while they're at it!

SERVES 4 AS A STARTER OR 2 AS A MAIN

2 × 200 g (7 oz) boneless reverse
 butterflied red mullet, head and tail
 on (see page 75 for details)
60 ml (2 fl oz/¼ cup) grapeseed oil
sea salt flakes

Roast fennel gravy
4 fennel bulbs
125 g (4½ oz) butter
300 ml (10 fl oz) white wine
125 ml (4 fl oz/½ cup) olive oil
pinch of sea salt flakes
190 ml (6½ fl oz) verjuice
60 ml (2 fl oz/¼ cup) chardonnay
 vinegar

For the roast fennel gravy, cut each of the fennel bulbs vertically into three pieces so that the roots hold the slices together. Add the butter, wine and olive oil to a large shallow pan and place over a medium–high heat to melt the butter. Add the salt and then lay the fennel pieces, cut side down, over the base of the pan. Cook, turning once, for about 20 minutes until the fennel is very well caramelised but not black (as the wine fully evaporates the idea is that the fennel will caramelise but not burn). Add the verjuice and vinegar, scraping the base to deglaze the pan, and continue to reduce down until slightly thickened and concentrated. Smash the fennel up a bit with the back of a wooden spoon to give all its flavour to the sauce, then season to taste with a little extra salt if needed. Pass through a strainer, pressing down hard on the solids, which you can then discard or use for another meal. Return the gravy to the pan and keep warm until needed (or put it in the fridge if you are making it ahead of time).

Either preheat a chargrill pan over a medium heat or a charcoal grill with evenly burnt-down embers.

Brush the butterflied mullet with grapeseed oil and season the skin liberally with salt. Place the mullet, skin side down, on the grill and put a fish weight or small saucepan on top of the flesh closest to the head, as this is the thickest. This weight will help the heat transfer from skin to flesh without the need to turn the fish over. Cook for 2 minutes to develop good colour across the skin and warmth over the flesh, then move the weight to the centre of the fish and cook for another minute, or until the fish is about 60 per cent cooked through. The warm fennel sauce and the warmth of your serving plate will finish cooking the fish.

Remove the mullet from the grill and place on warm serving plates, skin side up. Spoon the warm fennel gravy around the edges and serve immediately.

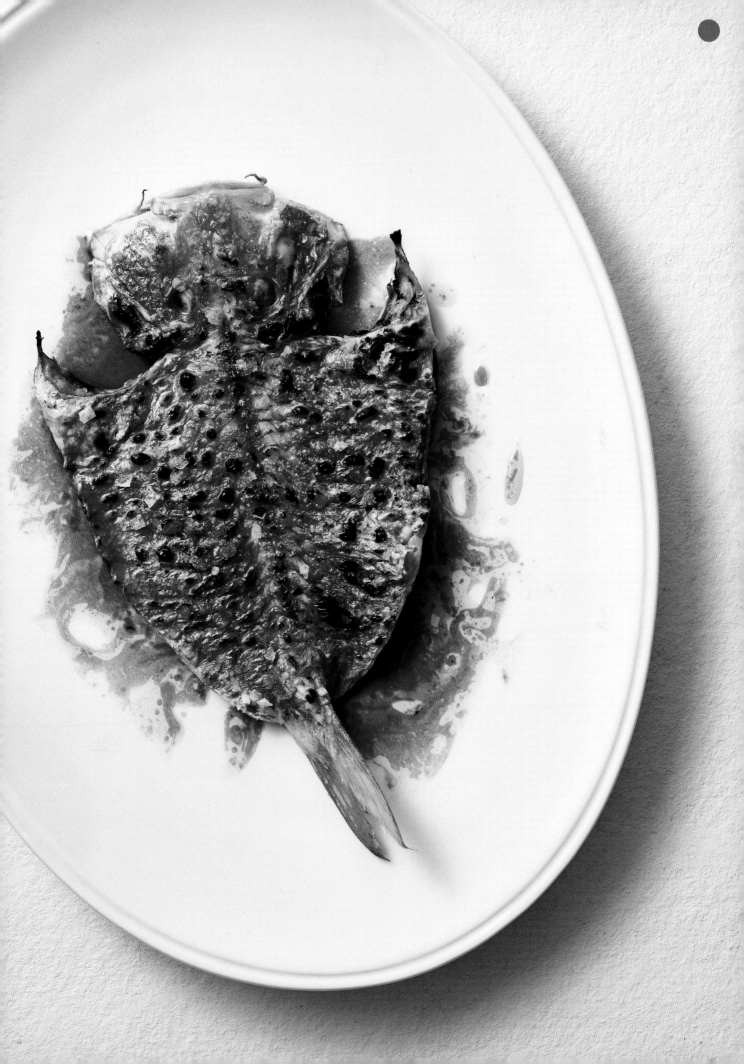

John Dory

John dory, Saint Pierre or the Peter's fish embodies my restaurant Saint Peter. It's a fish that carries so much meaning – from the biblical black spot on both sides (said in legend to be the thumbprints of Saint Peter himself), to the incredible opportunities it offers for cooking each individual muscle and organ. This has led to us now achieving a yield of more than 90 per cent from the weight of the whole fish, a real achievement for the teams at my fish butchery and restaurant.

The best approach to cooking a john dory is to cook it on the bone. (Yes, I know this is certainly a theme throughout this book, but if there was a fish to embrace this thinking it would definitely be john dory!) Harnessing the gelatine, fat and deep, savoury flavours that doing so affords is an experience every bit as glorious as that offered up by other proteins. Dare I say, perhaps even more glorious?

When john dory enters the kitchen my mind goes straight to flavours such as juicy green almonds, parsley to bring minerality to the rich offal, mushrooms to promote the fish's natural savoury characteristics and, of course, globe and Jerusalem artichokes for their ability to bring sweetness, nuttiness and complementary textures to the dory's buttery fillets.

Alternatives
CORAL TROUT · SNAPPER · GURNARD · TURBOT · FLOUNDER

Points to look for
**WHOLE UNGUTTED FISH WITH UNDAMAGED SKIN
(LOOK FOR THE LIVER AND ROE WITHIN THE CAVITY)
COOK ON THE BONE WHERE POSSIBLE**

Best cooking
**POT ROASTED · GRILLED · CRUMBED · RAW
POACHED · STEAMED · BAKED · PAN-FRIED**

Accompanying flavours
**ALMONDS · PARSLEY · MUSHROOMS · ARTICHOKES · PEAS
TOMATOES · PARSNIPS · PEARS**

SALT AND PEPPER JOHN DORY TRIPE

For me, a fish stomach was really the final frontier in working out how we could remove the textural, visual and overall discomfort that an average consumer feels towards an organ. By salting the fresh stomach, you purge it of all of its impurities and improve its colouring. It's really important that the stomach is very fresh and unaffected by any damage, and just as important that the stomach is washed free of the significant amount of salt that needs to be used. Ask your fishmonger to set aside the best available stomachs (this recipe works well with any fish) or, better still, harvest them yourself from the whole fish. Patience is definitely required during cooking to give it time to soften adequately, otherwise it will be as tough as old boots.

There is a great affection for all things salty, crispy, crunchy and fried, so I do hope you take the huge leap and give this recipe a try.

SERVES 4

250 g (9 oz) fresh john dory stomach
400 g (14 oz) fine salt
2 litres (68 fl oz/8 cups) vegetable or
 Brown Fish Stock (page 256)
150 g (5½ oz/1 cup) plain
 (all-purpose) flour
4 eggs
150 g (5½ oz/2½ cups) white panko
 breadcrumbs
cottonseed oil, for deep-frying
1 tablespoon freshly cracked
 black pepper
1 tablespoon ground sichuan pepper
1 teaspoon ground white pepper
sea salt flakes

Start by washing the fish stomach under cold running water to remove any impurities, then turn the stomach inside out and repeat to ensure it is completely clean.

Place the stomach in a clean container with a fitted lid and bury it in the fine salt to cover it completely. Cover and place in the fridge for a minimum of 6 days. During this time the salt will liquify and form a type of brine. It takes time, but the result will be a stomach with no bitterness or harsh flavours.

Shortly before you are ready to cook, remove the stomach from the salt and soak it in cold water for 30 minutes, changing the water every 10 minutes to remove any trace of saltiness.

Bring the stock to the boil in a saucepan, then reduce the heat to a simmer. Add the stomach and cook gently for 1 hour or until tender. Remove from the heat and leave to cool in the stock, then transfer to the fridge until completely cold.

Place the flour in one bowl, beat the eggs in another and tip the breadcrumbs into a third bowl.

Cut the chilled stomach into 2–3 mm (1/8 in) thick rings. Dip the rings into the flour, then the egg and, lastly, in the breadcrumbs to coat completely, then refrigerate for 10 minutes to set the crumb.

Heat the oil for deep-frying in a deep-fryer or large saucepan over a medium–high heat until it reaches 180°C (350°F).

Combine the three peppers in a small bowl.

Deep-fry the stomach rings for 2–3 minutes or until golden brown. Remove with a slotted spoon and drain on a wire rack. Season with salt flakes and the mixed pepper, taking care not to over-season as the rings have already been seasoned during the brining process. Serve immediately with your favourite condiments (I like tartare, aïoli and green chilli sauce).

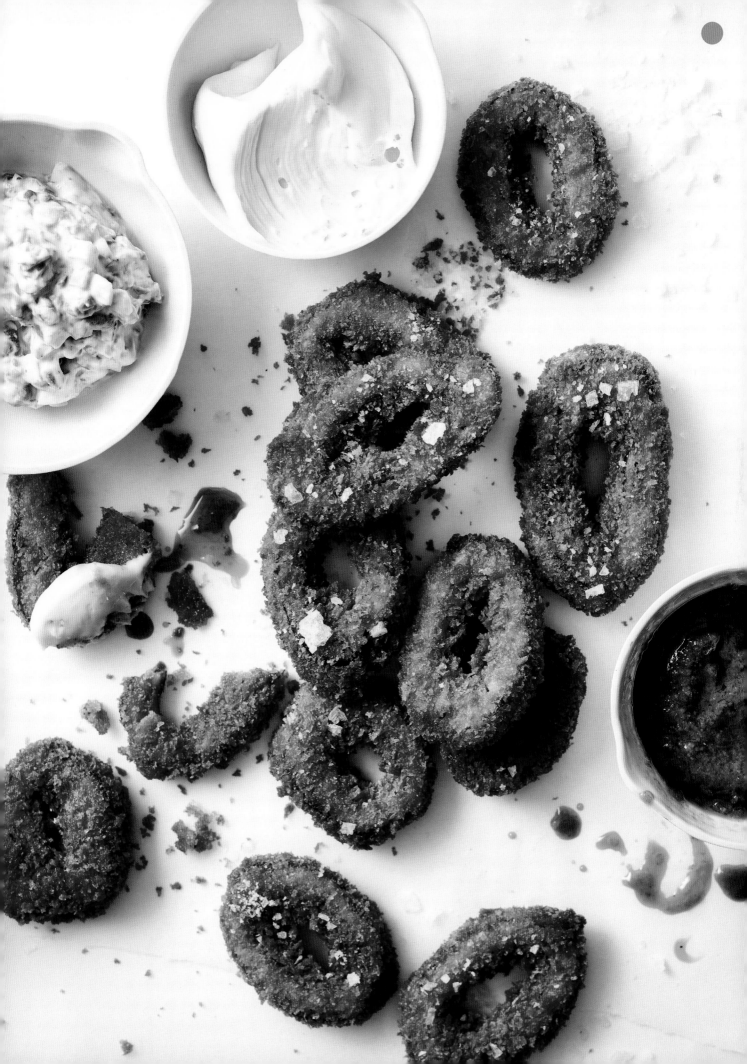

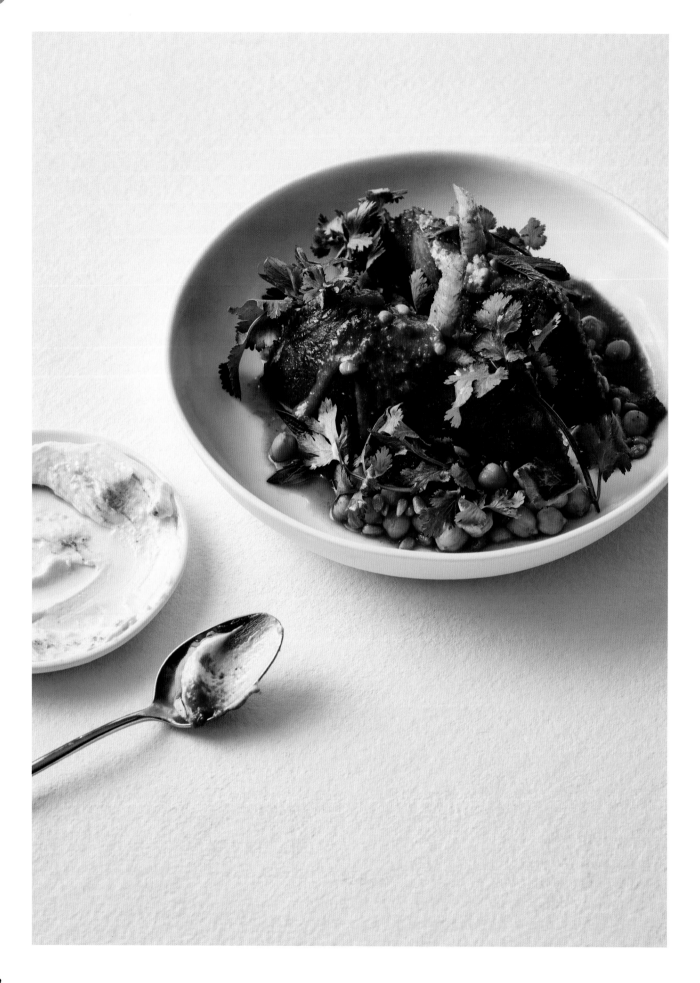

JOHN DORY TAGINE

6 × 150 g (5½ oz) john dory tail
 shank chops or darnes
60 ml (2 fl oz/¼ cup) extra-virgin
 olive oil
sea salt flakes
30 g (1 oz/¼ cup) sultanas
 (golden raisins) or currants
7 g (¼ oz/¼ cup) coriander
 (cilantro) leaves
5 g (¼ oz/¼ cup) mint leaves
couscous, to serve (optional)

Tagine paste
12 g (½ oz/¼ cup) chilli flakes
25 g (1 oz/¼ cup) ras el hanout
2 tablespoons ground cumin
2 tablespoons ground coriander
2 tablespoons ground turmeric
3 teaspoons sweet paprika
3 large onions, finely diced
6 large garlic cloves, finely grated
100 g (3½ oz) peeled ginger,
 coarsely chopped
2 long red chillies, seeds removed
12 thyme sprigs, leaves picked
1 bunch coriander (cilantro), washed
1 bunch flat-leaf (Italian) parsley,
 washed
12 salted anchovy fillets
250 ml (8½ fl oz/1 cup) extra-virgin
 olive oil

Tagine base
100 ml (3½ fl oz) extra-virgin olive oil
2 × 400 g (14 oz) tins crushed
 tomatoes
½ star anise
500 ml (17 fl oz/2 cups) Brown Fish
 Stock (page 256)
pinch of sea salt flakes
1 × 400 g (14 oz) tin chickpeas,
 drained and rinsed
1 large fennel bulb, coarsely diced
generous pinch of saffron threads,
 soaked in 60 ml (2 fl oz/¼ cup)
 boiling water
90 g (3 oz/¼ cup) honey
zest of 1 orange
lemon juice, to taste
Garum (page 257) or fish sauce,
 to taste

Salt and vinegar pine nuts
80 g (2¾ oz/½ cup) pine nuts
1 teaspoon fine salt
3 teaspoons sherry vinegar

Preserved lemon yoghurt
90 g (3 oz) preserved lemon,
 pith removed
350 g (12½ oz) natural yoghurt

Tagine is a dish that carries a certain weight of expectation and, while it may not be an overly modern way of cooking, it's certainly a winner. I use john dory shanks here as they are visually striking and not too complicated to prepare, though any bone-in cut such as a darne will also work well. The shanks are gently cooked in a flavourful paste, lending liquid gelatine from the skin and bone to the beautifully balanced sauce. Do take care though, as overcooking is still a possibility, instantly turning a refined dish into a very dry one.

The pine nuts and preserved lemon yoghurt can be prepared in advance and stored in airtight containers in the fridge until needed. If the pine nuts lose their crunch, just refresh them in a hot oven for a few minutes.

To make the tagine paste, blitz all the ingredients in a blender until completely smooth.

For the tagine base, warm the olive oil in a large, wide-based saucepan over a medium heat. Add the tagine paste and cook, stirring, for 10 minutes, until thoroughly cooked out and aromatic. Add the crushed tomatoes, star anise, stock and salt. Bring to a simmer and cook for 25–30 minutes until thick and fragrant, then add the remaining ingredients and mix well.

Rub each of the john dory shanks with a little olive oil and season lightly with salt flakes.

Using a tagine pot or flameproof casserole dish with a fitted lid, pour in enough of the sauce to completely cover the base to a depth of roughly 2.5 cm (1 in), then nestle the shanks into the sauce. Bring to the boil over a medium heat, then cover with the lid, reduce the heat to low and leave to simmer very gently for 6 minutes, or until the fish registers 46–48°C (115–118°F) when a probe thermometer is inserted into the thickest part, close to the bone. Remove from the heat and leave the residual heat of the tagine to finish cooking the fish.

To make the salt and vinegar pine nuts, add the pine nuts and salt to a dry frying pan set over a high heat and toast for 3–4 minutes, tossing the nuts as you go, until evenly coloured all over.

Add the sherry vinegar, and continue to cook, tossing, for 2 minutes, until the nuts are thoroughly dried out. Remove from the heat.

For the preserved lemon yoghurt, place the preserved lemon in a blender and blitz to a fine paste, adding a splash of warm water if necessary to deliver a silky smooth finish. Stir into the yoghurt and set aside until needed.

To serve, bring the tagine to the table and serve with the pine nuts, preserved lemon yoghurt, sultanas or currants, coriander and mint leaves, and couscous, if you like.

JOHN DORY CHOPS WITH ANCHOVY AND REAPER BUTTER AND JERK CAULIFLOWER

This dish is inspired by my friends Jeremy Chan and Paul Carmichael, of Ikoyi and Momofuku Seiobo, respectively. I fell in love with the intense, fruity complexity of chillies via Paul's menu, then, years later, I was blown away by Jeremy's ability to walk the line between pain and pleasure using some of the world's hottest chillies. Until then I'd always been reluctant to pair a delicate protein such as john dory with such fiery ingredients, but adding a support cast of anchovy, ginger and garlic leads to pretty unforgettable results.

The cauliflower can be enjoyed as a meal in its own right and shouldn't be seen only as a side. It's great for a midweek dinner or as an accompaniment to grilled meats and poultry. The Carolina reaper chilli is VERY HOT and needs to be prepared a couple of weeks ahead. It can be replaced in the butter with sambal oelek, or blended grilled green or red chillies. The chilli butter itself will keep for ages in the freezer and is a very useful thing to have to hand.

SERVES 3

1 small cauliflower (about 600 g/1 lb 5 oz)
100 ml (3½ fl oz) melted ghee
sea salt flakes
zest and juice of 1 lime
2 × 300 g (10½ oz) bone-in centre cut
 john dory chops or darnes
2 tablespoons grapeseed oil

Fermented Carolina reaper chilli
300 g (10½ oz) Carolina reaper chillies
1 litre (34 fl oz/4 cups) water
30 g (1 oz) fine salt

Jerk marinade
60 ml (2 fl oz/¼ cup) light soy sauce
2 tablespoons worcestershire sauce
2 tablespoons chopped spring onion
 (scallion)
2 tablespoons thyme leaves
1 tablespoon very finely chopped garlic
1 tablespoon very finely chopped ginger
1 tablespoon tamarind paste
1 teaspoon ground allspice
1 teaspoon dark brown sugar
1 teaspoon ground cinnamon
small pinch of ground cloves
1 bay leaf
½ scotch bonnet chilli or bird's-eye
 chilli, very finely chopped
sea salt flakes

Anchovy and reaper butter
500 g (1 lb 2 oz) unsalted butter,
 softened
4 French shallots, finely diced
4 garlic cloves, very finely chopped
90 g (3 oz) finely grated young ginger
12 anchovy fillets, finely chopped
1 teaspoon fermented Carolina reaper
 chilli, blended to a fine puree
zest and juice of ½ lemon
1 teaspoon sea salt flakes

To make the fermented chilli, place the chillies in a clean mason (kilner) jar. Stir the water and salt in a large mixing bowl or jug until the salt has dissolved, then pour the brine over the chillies until they are completely submerged. Close the lid and leave to ferment in the pantry away from direct sunlight for a minimum of 2 weeks. The chillies are ready when they have developed a mild acidity and the flesh has softened slightly. Store in the fridge for up to 6 months.

For the jerk marinade, combine all the ingredients in a large mixing bowl.

Add the cauliflower to the bowl and liberally coat with the marinade. Transfer to the fridge and leave to marinate overnight.

Preheat the oven to 200°C (400°F) and line a baking tray with baking paper.

To make the anchovy and reaper butter, place the butter in a large bowl and beat with an electric beater on low speed until pale and creamy. Mix together the remaining ingredients in a small bowl, then add to the butter and mix on low speed until well combined. Place a double layer of foil 20 cm (8 in) in length on a work surface and place one-third of the butter along the closest edge, leaving about 5 cm (2 in) free at either end. Roll into a 5 cm (2 in) thick log and twist the ends to seal. Repeat twice more, then refrigerate the three logs for 1 hour or until set. The logs will keep in the freezer for at least a month.

Brush the marinated cauliflower with half the ghee, then place on the prepared baking tray. Roast the cauliflower for 1½ hours, checking every 15 minutes to brush with the remaining ghee, until soft in the middle when spiked with a metal skewer and nicely caramelised on the outside. If after this time the cauliflower has taken enough colour but is still underdone inside, cover with foil and add a splash of water to the tray to aid in steaming. Remove from the oven and season with salt flakes, lime zest and juice.

Meanwhile, cook the john dory chops. Either preheat a chargrill pan over a medium heat or a charcoal grill with evenly burnt-down embers.

Brush the skin of the chops with the grapeseed oil and season well with salt flakes. Place them directly onto the grill bars and cook for 1 minute on each side to brown the skin, then continue to cook, turning as you go, until the internal temperature of the thickest part reaches 44°C (111°F) on a probe thermometer. Transfer to a wire rack and leave to rest for 2 minutes.

While the fish is resting, heat 2 tablespoons of water over a medium heat in a saucepan until simmering. Dice 100 g (3 1/2 oz) of the chilled anchovy and reaper butter and add to the pan, whisking, to form a sauce.

Serve the chops on warm plates alongside a puddle of the sauce and with the whole cauliflower in the centre of the table for dividing up among guests. Use any leftover jerk cauliflower to make a frittata for breakfast the next morning!

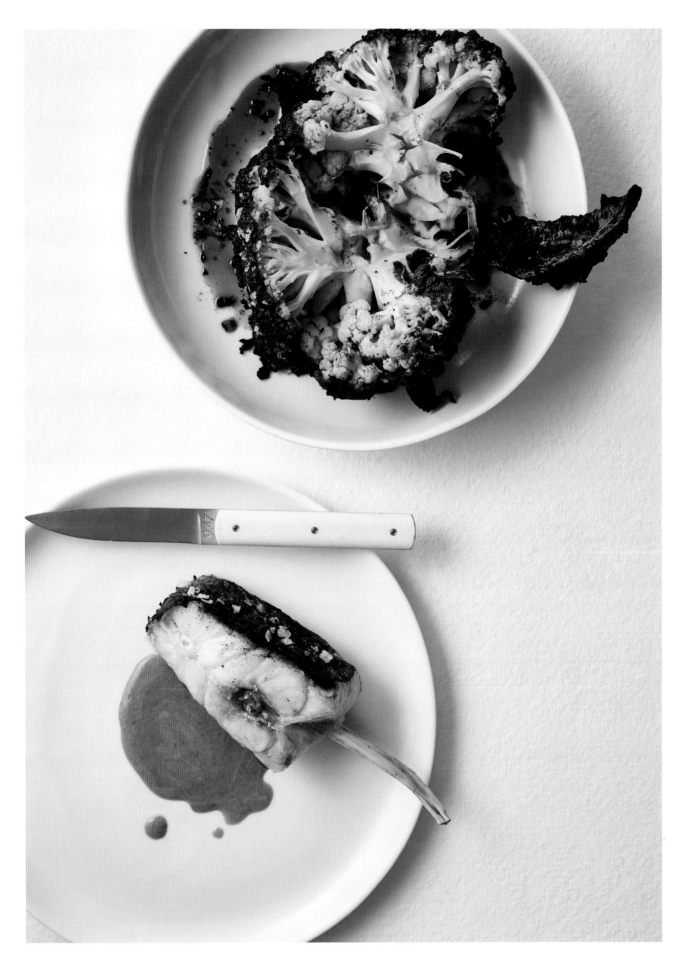

JOHN DORY LIVER TERRINE WITH CHOPPED SAUTERNES JELLY

John dory liver is a beautiful thing that has many practical uses – it can be turned into pâté, pan-fried and enjoyed on toast, or transformed into a liver sauce, just to name a few. But when the livers are at their finest this wonderful firm-textured terrine is my favourite way to use them. And although it carries far less intensity than traditional foie gras, it will fool many into thinking it is the real thing. When buying fish livers, make sure they are firm, pale and unblemished, carry no odour and are not at all slimy or contaminated with any other matter from the fish.

This terrine needs to be prepared a day in advance. I've given you the option of making a brioche with the rendered fat from the fish, but a quality bought brioche also makes a great alternative. If sauternes is unavailable, try using a good sparkling wine or riesling instead.

SERVES 6–8

650 g (1 lb 7 oz) raw john dory livers, cleaned and deveined
2 tablespoons sea salt flakes
1 teaspoon caster (superfine) sugar
½ teaspoon freshly cracked black pepper
60 ml (2 fl oz/¼ cup) sauternes
Fish Fat Brioche (page 264) or other quality brioche, toasted, to serve

Sauternes jelly
10 g (¼ oz) titanium-grade gelatine leaves
ice-cold water, for soaking
50 g (13/4 oz) caster (superfine) sugar
375 ml (12½ fl oz/1½ cups) sauternes

Grease and line a 20 x 7.5 cm (8 x 3 in) terrine mould with plastic wrap, leaving enough of an overhang to cover the top of the terrine.

Preheat the oven to 90°C (195°F) and line a roasting tin with a folded tea towel (this provides insulation so the bottom of the terrine doesn't cook too quickly).

Season the livers on all sides with the salt, sugar and pepper. Drizzle 1 tablespoon of the sauternes into the terrine and firmly press any large lobes of liver, smooth side down, into the bottom. (Wedge in any loose pieces of liver to make the lobe fit snugly.) Drizzle over another tablespoon of sauternes, then add the smaller pieces of liver, smooth side up, and firmly press down to create a flat surface and snug fit. Drizzle over the remaining sauternes. Cover the surface of the terrine with the overhanging plastic wrap, then cover the mould with a lid or foil. Place in the prepared roasting tin and pour enough hot water into the tin to reach halfway up the sides of the terrine.

Bake in the middle of the oven until a probe thermometer inserted diagonally into the centre of the terrine registers 46°C (115°F). This should take approximately 1½ hours, but it really depends on the size of your mould.

While the terrine is baking, make the sauternes jelly. Soak the gelatine in chilled water. Combine the sugar and 110 ml (4 fl oz) of the sauternes in a small saucepan and bring to the boil. Squeeze the water from the gelatine leaves, then whisk into the pan to dissolve. Stir in the remaining sauternes, then pour the mixture into an airtight container and place in the fridge for 5–6 hours until firm to the touch.

When the terrine is ready, take it out of the tin, discard the water and remove the towel. Return the terrine to the tin and remove the lid or foil. Put a fitted piece of cardboard directly on the plastic wrap and place a weight (about 750 g/1 lb 11 oz) on top. Place in the fridge and leave to set for at least 24 hours.

When it's ready, unmould the terrine by running a hot knife around the edge. Invert it onto a plate, then invert again, fat side up, onto a serving dish. Cut into thick slices with a heated sharp knife.

Cut the sauternes jelly into small cubes, similar in size to green peas.

Top each slice of terrine with a spoonful of the jelly and serve with toasted brioche, salt flakes and a final grind of pepper.

JOHN DORY, SMOKED EEL GREMOLATA

This method for cooking a whole fish on the grill is simple but does require patience and attention. By separating the fish head from the body and cooking them separately you can monitor the degree of cooking from head to tail. It's essential that your fish has dry skin to begin with so it won't stick to the grill, and just as important is to rest the fish after cooking as the residual heat will gently set the flesh through to the bone, leaving you with something perfectly cooked rather than dried out to the point of no return.

SERVES 4

1 × 3 kg (6 lb 10 oz) whole john dory, gutted
100 ml (3½ fl oz) grapeseed oil
sea salt flakes and freshly cracked black pepper
dressed watercress leaves, to serve

Gremolata
300 g (10½ oz) hot-smoked eel, skin and bones removed, finely chopped (optional)
zest and juice of 4 lemons
3 garlic cloves, finely grated
100 g (3½ oz) fresh horseradish, finely grated
300 ml (10 fl oz) extra-virgin olive oil
sea salt flakes and freshly cracked black pepper
20 g (3/4 oz/1 cup) flat-leaf (Italian) parsley leaves

Burnt apple puree
6 granny smith apples, peeled, cored and cut into 5 mm (¼ in) thick slices
2½ tablespoons grapeseed oil
2 French shallots, finely sliced
1 garlic clove, finely sliced
200 ml (7 fl oz) verjuice
100 g (3½ oz) butter
sea salt flakes and freshly cracked black pepper

Place the john dory in the centre of a cutting board and begin to scissor the fins from the top of the fish and from the collars on both sides. Using a large chef's knife, cut the head and collars off the fish in one piece, then draw the blade down from behind the head to the belly flap which sits alongside the collar. Do this on the other side as well so the cuts meet up at the top of the fish. Using your hands, break the spine so the head and collars separate cleanly away from the rest of the fish.

To make the gremolata, combine the eel, if using, lemon zest, garlic, horseradish and olive oil in a bowl. Season to taste with salt, pepper and lemon juice, and set aside.

For the charcoal grill, make sure the grill is hot and the charcoal has cooked down to hot embers.

For the burnt apple puree, toss the apple slices with 1 tablespoon of the grapeseed oil to coat well, then lay them on the grill and cook, turning occasionally, for 10 minutes, or until completely charred on both sides. Remove from the grill and cut into small pieces.

Heat the remaining oil in a frying pan over a low heat. Add the shallot and garlic and cook for 3 minutes, or until translucent, then add the burnt apple and verjuice and simmer for 6–8 minutes until the verjuice has nearly evaporated. Add just enough water to cover and half the butter, then cover with a fitted lid and simmer gently for 10 minutes or until the apple is completely soft. Strain off the cooking liquid, then blend the apple pulp to a very fine puree, slowly adding the remaining butter as you go. Season to taste and set aside.

Divide the coals across the floor of the charcoal grill to create a cooler side and a more intense side.

When you are ready to cook the fish, brush the skin of the body, and the collar and head section with a little oil and season liberally with salt flakes.

Place the head and body, skin side down, directly on the grill bars over a high heat. Cook both pieces for 1 minute on each side or until nicely coloured, then move them both to the cooler side of the grill. Cook the head and collars for another 8–10 minutes, turning every 2–3 minutes until the meat surrounding the head and collars has just set. Cook the body, turning as per the collars, for another 15–17 minutes, or until a probe thermometer inserted into the thickest part of the fish reaches 42°C (107°F). Remove from the heat and transfer to a wire rack set over a tray to rest.

While the fish is resting, stir the parsley through the gremolata and warm the apple puree over a low heat.

To assemble the dish, position the head and collars on a small serving dish alongside a dressed watercress salad. Spoon the gremolata onto a second larger plate and sit the john dory body on top. Season with extra salt flakes and a few twists of black pepper and serve with the burnt apple puree to add both sweet and savoury notes. Store any leftover puree and gremolata in an airtight container in the fridge for up to 4 days; they are both excellent with grilled meats and vegetables.

MEDIUM

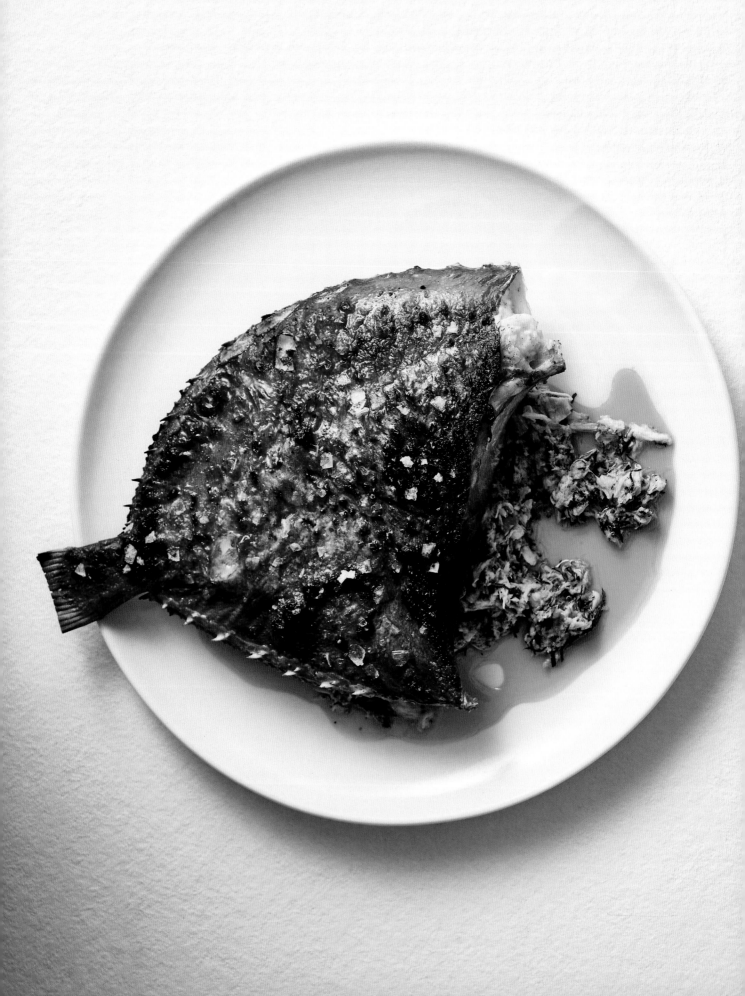

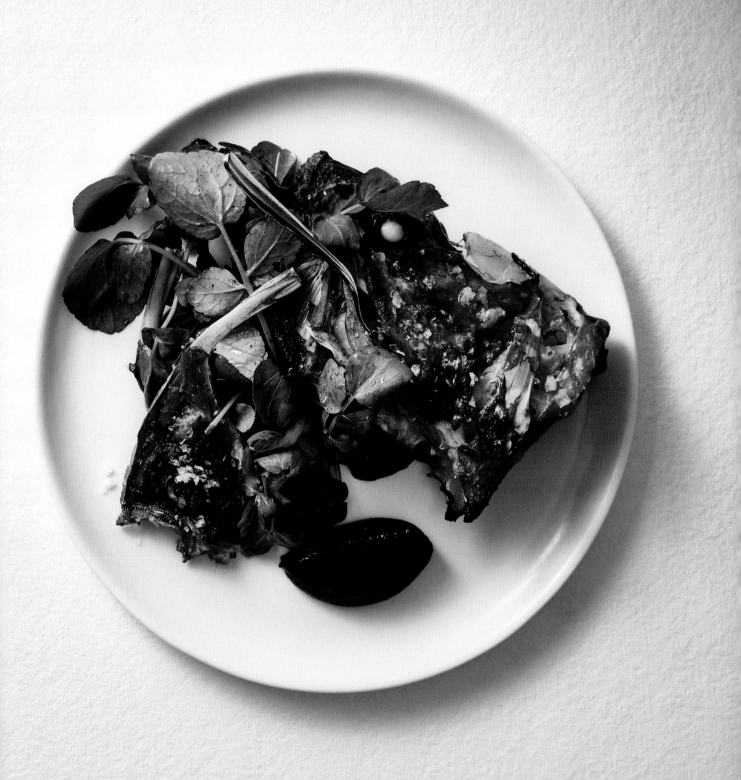

7

Coral Trout

Coral Trout – aka the Ferrari of the Ocean – is a fish I absolutely adore, as it offers up limitless culinary possibilities. An investment and a fish that won't be landing on the table every night of the week (nor month, for that matter), when you do get your hands on one I suggest serving it whole with all the trimmings. We are extremely lucky to have access to this incredible fish in Australia, but for those of you further afield, turbot and larger sea bass make fine alternatives, too.

When a coral trout arrives through the doors of Fish Butchery, we scale it, remove the offal and hang the fish up for dry ageing (see page 19), which helps to dry the skin and achieve a result that is far crisper and will not have you digging it off grill bars or the bottom of your frying pan. This skin, along with the fine slick of fat that resides beneath it, carries all of the coral trout's wonderful nuances and complexities of flavour and is best enjoyed completely unadorned, while its firm, dense flesh lends itself to subtle flavours such as cucumber and borage when raw.

If you do make the commitment to buying a whole coral trout, then be sure to map out a game plan to ensure you realise the fish's full potential. If it's the finely sliced belly eaten raw the day you buy it followed by the roasted saddle and tail on the bone for dinner the following day, then don't forget to scrape any leftovers off the bones and mix them with a quality mayonnaise and a little fresh tarragon for a life-changing fish sandwich.

Whether whole or butchered, raw or cooked, if you look past the fillet here and embrace every opportunity that exists within this remarkable fish, I promise you won't be disappointed.

Alternatives
TURBOT · JOHN DORY · SEA BASS

Points to look for
**SEEK OUT IKI JIME SPIKED FISH
BE SURE TO TEST A SMALL PORTION OF FISH BEFORE
COMMITTING TO COOKING THE WHOLE PIECE**

Best cooking
**PAN-FRIED · STEAMED · GRILLED · RAW · POACHED · CRUMBED
BATTER FRIED · CURED**

Accompanying flavours
**RAW – CITRUS · CUCUMBER · GREEN ALMONDS · PURSLANE
COOKED – PEAS · BROAD BEANS · POTATOES · CHIVES · CAULIFLOWER**

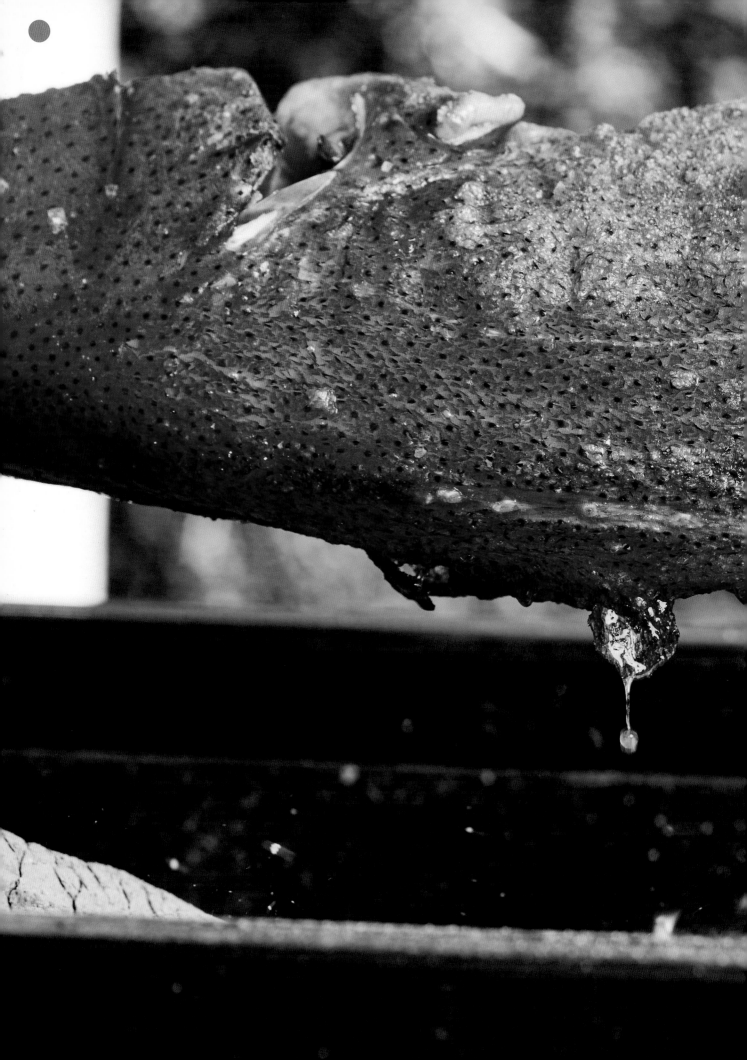

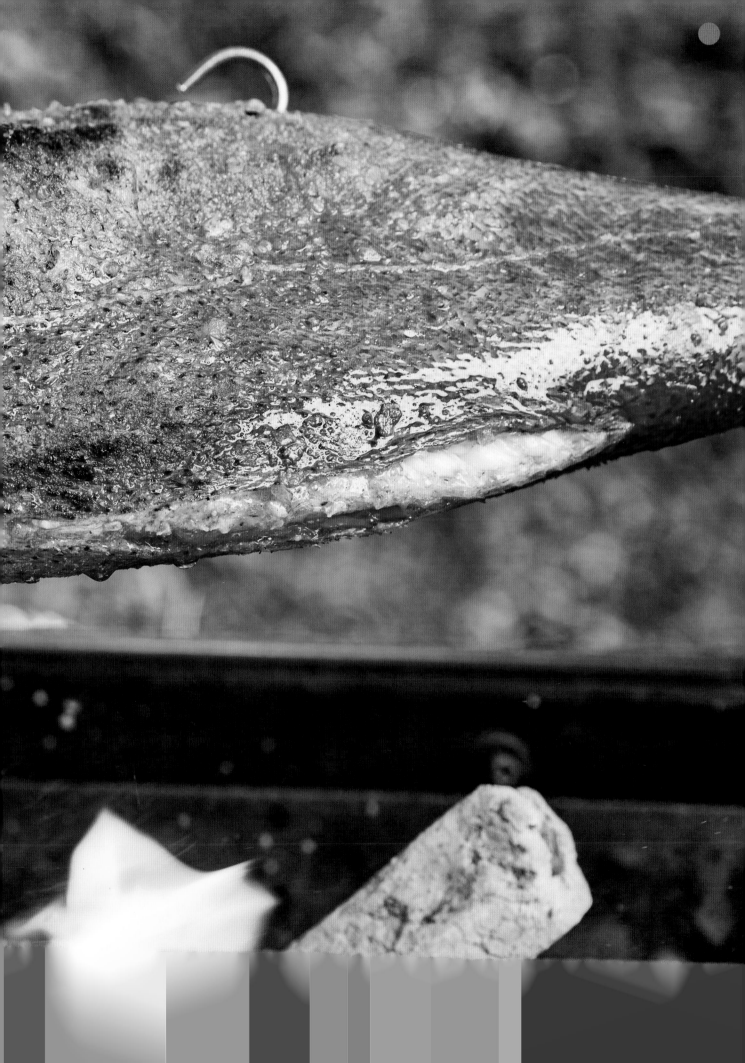

HALF SPLIT CORAL TROUT COCKTAIL WITH SYRACUSE POTATOES

There is so much to love about the timeless prawn cocktail but who's to say this beautiful marie rose sauce can't bring the same magic to a fish? Coral trout flesh is so sweet it shines when lightly grilled, seasoned and served simply. But, like a cut of meat, the various muscles and parts cook at different times and temperatures, often using different methods. Crumbed fish collars and cheeks are delicious, and essentially what I wish the fish fingers of my childhood had actually tasted like. Pairing crumbed parts of the coral trout with grilled is a wonderful gesture, and your guests will appreciate the care you've taken to achieve the best flavour. Syracuse potatoes are a specialty of upstate New York, and I promise these salty, soft, yet waxy little spuds will win you over.

If preparing the coral trout in this way is too challenging, that's fine. Just remove the fillets as you would normally, or ask your fishmonger to do it for you.

SERVES 6

1 × 2 kg (4 lb 6 oz) coral trout
150 g (5½ oz/1 cup) plain (all-purpose) flour
4 eggs, lightly beaten
150 g (5½ oz/2½ cups) white panko breadcrumbs
grapeseed oil, for brushing
sea salt flakes
70 g (2½ oz) ghee

Marie rose sauce
130 g (4½ oz) quality thick mayonnaise
1 tablespoon tomato sauce (ketchup)
1 teaspoon worcestershire sauce
2 teaspoons finely grated fresh horseradish
a few drops of Tabasco sauce

Syracuse potatoes
1 kg (2 lb 3 oz) new potatoes, scrubbed clean
10 thyme sprigs
1 bay leaf
120 g (4½ oz) fine salt
1 teaspoon ground toasted fennel seeds (optional)

To prepare the coral trout, first cut the collars off the fish and carve out the jowl. Debone the collars. Place the rest of the fish in the middle of a cutting board with the tail facing you and the belly cavity exposed and open. Using a sharp knife, cut down one side of the central spine as though you were going through the top side of the fish to remove the fillet, but once you reach the point where the fillet is about to be cut off but is still attached to the head, turn the fish so the head is now facing you. Using the top third of the knife, split the head in half. This will result in a fillet that still has the tail and the head intact. Remove the pin bones using fish pliers or tweezers, then repeat on the other side, laying the fish flat to the bench and again ensuring the head and tail remain intact on the fillet.

Place the flour in one bowl, beat the eggs in another and tip the breadcrumbs into a third bowl.

Dip the jowls and collars into the flour, then the egg wash and, lastly, into the breadcrumbs to coat completely, then place on a tray and refrigerate until you're ready to cook.

Prepare a charcoal grill, making sure the grill is hot and the charcoal has cooked down to hot embers. To create the gentle heat required for this particular method, take care not to overload your grill with too much charcoal and make sure the coals are spread evenly across the floor of the grill.

Meanwhile, to make the marie rose sauce, mix together all the ingredients in a bowl. Set aside in the fridge until needed.

For the Syracuse potatoes, place the potatoes and fresh herbs in a large saucepan and pour over enough water to just cover. Stir in the salt until completely dissolved. Bring to the boil over a high heat, then reduce to a simmer and cook until the potatoes are tender and the water has evaporated, about 40 minutes.

Meanwhile, brush the skin of the coral trout halves with a little oil and season with salt flakes. Place on the grill, skin side down, and top with a fish weight or a saucepan for even heat transfer and colouration on the skin. Cook over a gentle heat for 10–12 minutes until the skin is evenly coloured and the flesh is translucent and registers 44–45°C (111–113°F) on a probe thermometer. (It is important to move the weight around every few minutes to conduct enough indirect heat to ensure the flesh is cooked gently.)

Use an offset spatula to carefully transfer the coral trout halves to a large serving platter, then turn them over. Brush the skin with a little more grapeseed oil, season with another sprinkling of salt and leave to rest.

While the fish is resting, heat the ghee in a frying pan over a medium–high heat to a light haze. Add the crumbed collars and cook for 2 minutes each side, then remove and drain on paper towel. Cook the jowls for 1½ minutes each side and set aside with the collars.

To finish the potatoes, remove the pan from the heat and rest for 5–10 minutes to allow the salt crust to develop. Briefly return to the heat for another minute to toast the exterior of the potatoes and reinforce the salt crust. Pile the potatoes into a large bowl and dust with the ground fennel, if using.

Position the grilled coral trout in the centre of a large serving plate and spoon a generous amount of marie rose sauce into the spaces where the collars and jowls used to be. Return the crumbed parts of the fish to their original places, season with salt flakes and serve immediately with the potatoes and remaining marie rose sauce.

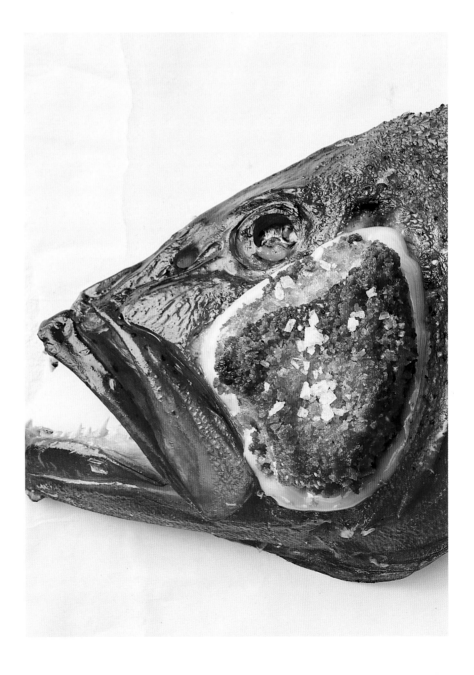

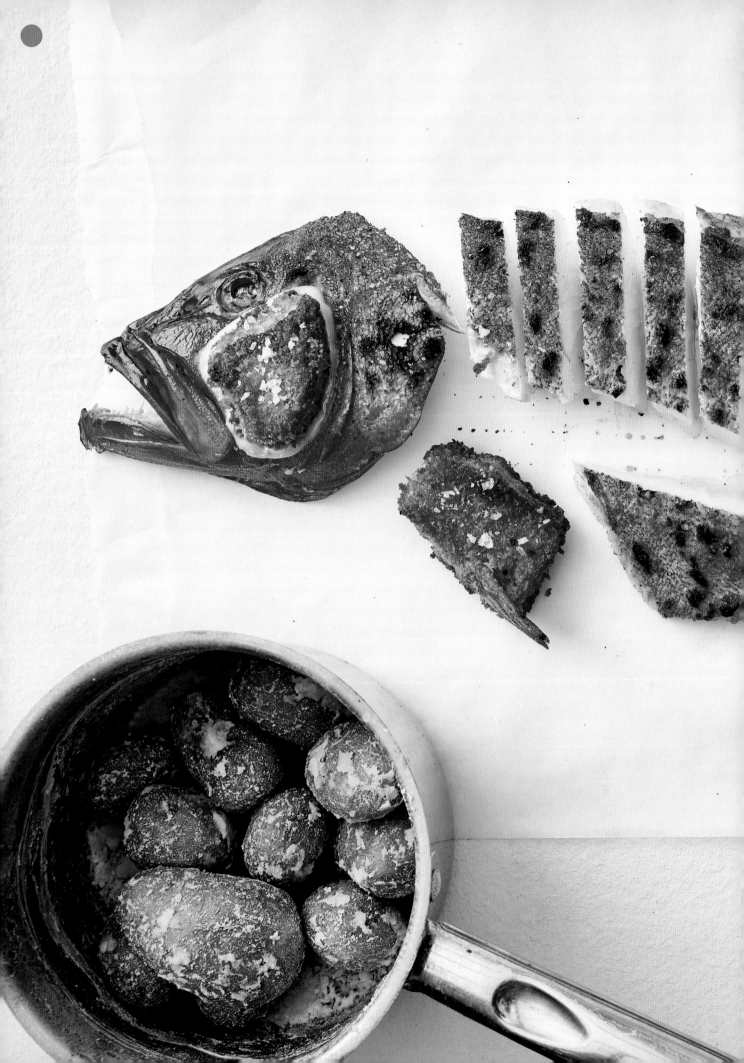

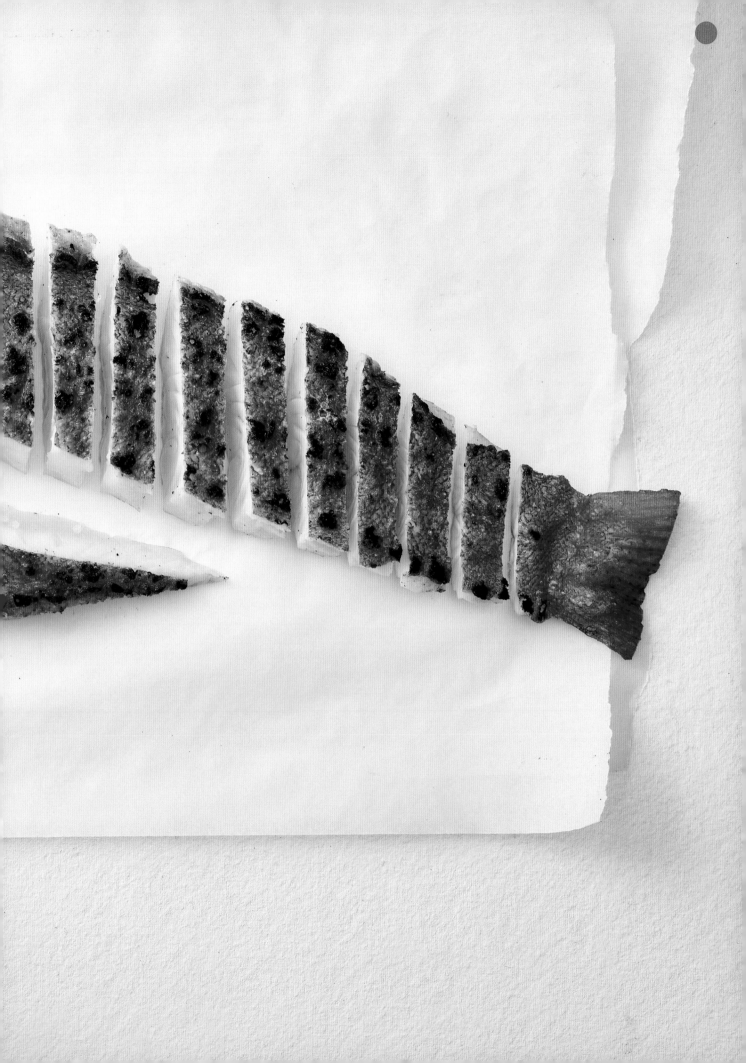

SALT AND VINEGAR WHOLE CORAL TROUT

The inspiration for this dish came from seeing how the chefs at Spanish restaurant Elkano cook their turbot – a fish with incredible flavour and texture when cooked on the bone, and one which is sadly unavailable in Australia. Fortunately, coral trout can deliver something similar, especially when the gelatine is activated over charcoal to carry this mouthwatering salt and vinegar seasoning.

This recipe is more a method of cookery, really. I give details for cooking it with a grill rack or grilling basket, but it also works brilliantly with a rotisserie grill. The most important thing here is to start with a high-quality fish that has been dry handled, as achieving a good result with a wet fish borders on the impossible.

SERVES 6

1 × 1 kg (2 lb 3 oz) whole coral trout, gutted and pin-boned
60 ml (2 fl oz/¼ cup) best-quality seaweed vinegar or white wine vinegar (not too sweet)
125 ml (4 fl oz/½ cup) extra-virgin olive oil
sea salt flakes

About 45 minutes before grilling, remove the coral trout from the fridge and let it come to room temperature.

In a spray bottle fitted with a misting nozzle, shake together the vinegar, olive oil and 1 teaspoon salt. Set aside.

For the charcoal grill, make sure the grill is hot and the charcoal has cooked down to hot embers. Divide the coals across the floor to create a cooler side and a more intense side of the grill.

Season the coral trout liberally with salt flakes, then place it in a grilling basket and set it over the hot side of grill. (Alternatively, separate the grill bars on a conventional wire rack so you have the flexibility of removing and turning the fish easily.) Cook until the skin begins to blister slightly, about 4 minutes, then carefully turn the fish over and cook for another 4 minutes, generously misting the first blistered side with about one-third of the vinaigrette as you go. Flip the trout back over, and cook the first side again for another 3–4 minutes until the skin is well blistered and the flesh is opaque, misting the second side with half the remaining vinaigrette. The fish is ready when the skin is evenly coloured and the internal temperature registers 44°C (111°F) on a probe thermometer.

Remove the coral trout from the grill and rest on a large serving platter for 8–10 minutes, then spoon over the remaining vinaigrette.

Carve the trout, discarding the spine and reserving the collar and head, and transfer the fillets to serving plates. Pour the resting juices from the serving platter into a small saucepan and bring to a simmer, whisking to form a glaze. Spoon the glaze over the fillets and serve right away.

MEDIUM

116

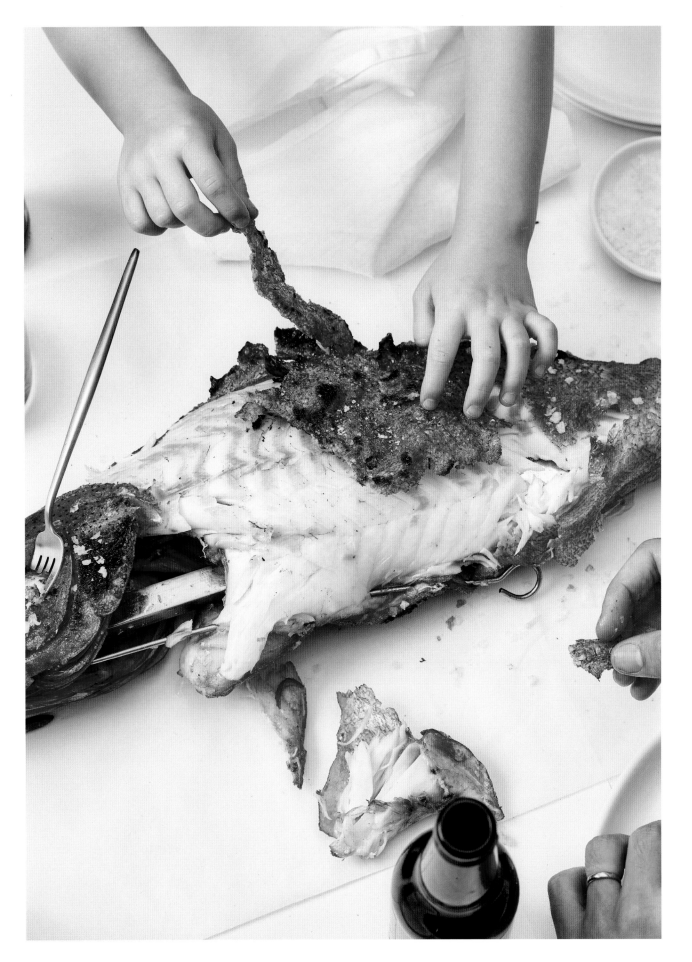

CORAL TROUT, CRISP SKIN AND TARRAGON MAYONNAISE SANDWICHES

Firstly, I agree, this is an extensive recipe for a sandwich but if something's worth doing ... Certainly, you can make a quick version by simply poaching the coral trout, shredding the flesh and adding the seasonings below, but if you do commit to this recipe as it is written the result will be texturally far superior, as the crisp skin between the soft bread slices is pure heaven. This is a phenomenal sandwich for a weekend lunch with friends – great with crisps and a pickle! Or make them smaller and serve as canapés at your next gathering.

 The reason for using two cooking methods here is to create a very crisp skin by pan-frying and then a silky, moist flesh by poaching in ghee. Placing a small wrapped plate in the base of your poaching pan will help you achieve an even result on both the top and bottom of the fillet.

SERVES 4

500 g (1 lb 2 oz) ghee
2 teaspoons toasted fennel seeds
1 star anise
1 × 320 g (11½ oz) boneless coral trout fillet, skin on
sea salt flakes and freshly cracked black pepper
8 slices of fresh white bread

Tarragon mayonnaise

2 egg yolks
2 teaspoons dijon mustard
2 teaspoons apple-cider vinegar
150 ml (5 fl oz) olive oil
100 ml (3½ fl oz) grapeseed oil
1 tablespoon lemon juice
sea salt flakes and freshly cracked black pepper
1 bunch tarragon, leaves picked and finely chopped, stems reserved

To make the mayonnaise, whisk together the egg yolks, mustard and vinegar in a bowl. While continuing to whisk, slowly add the two oils to emulsify. Add the lemon juice and season to taste, then stir in the tarragon leaves to finish. Set aside.

Take a small flat saucer or plate and wrap it in plastic wrap so that it is taut from edge to edge. Place the wrapped plate in the bottom of a large saucepan – it should fit comfortably with plenty of room for easy removal later. Add the ghee, fennel seeds, star anise and reserved tarragon stems and place over a low heat. Bring to a steady temperature of 48°C (118°F).

Heat 60 ml (2 fl oz/¼ cup) of the infused ghee in a cast-iron skillet or frying pan over a high heat to a light haze. Put the fillet in the pan, place a fish weight or small saucepan on top and cook for 2 minutes, or until you see colour around the edges. Use an offset palette knife to lift up the fillet and move it to a clean surface in the pan. Cook the weighted fillet for another minute, or until the skin is golden brown and crisp but the flesh is still very raw and cool. Remove from the pan and, using a sharp knife, carefully cut the skin from the flesh. Set the skin aside on a wire rack to cool.

Lower the partially cooked fillet into the warm infused ghee so that it is completely submerged and leave it to poach for 10 minutes, then remove the pan from the heat and leave the fish to stand in the ghee for a further 4 minutes. Remove from the ghee and rest on the wire rack for 5 minutes.

While the coral trout is resting, place 2½ tablespoons of the infused ghee in the skillet or frying pan and heat over a medium heat to a light haze. Add the skin, underside down, and cook carefully, without letting it burn, for another 30–60 seconds to add more colour and crispness. Season with salt and set aside. Cut into four even pieces.

Carefully pull the rested fillet into large pieces and place in a bowl. Add a few tablespoons of the mayonnaise and salt and pepper to taste, and gently stir together. Spoon the mixture onto four slices of bread and position the crisp skin on top. Sandwich with the remaining bread slices and serve as a whole square so you don't have to share!

Any leftover mayonnaise will keep in an airtight container in the fridge for up to 4 days.

GLAZED CORAL TROUT HEAD PASTRAMI WITH MOLASSES AND ANCHOVY GLAZE

When I say pastrami, I'm really referring to the delicious smokiness achieved from the grill and the light crusting of freshly toasted coriander seeds, black peppercorns and yellow mustard. The use of rich molasses, subtly acidic verjuice and toasted spices brings both visual comfort and robust flavour and texture. Eating a fish head might be one person's dream and another's worst nightmare. It is important to start with a very fresh head and ensure it is thoroughly grilled so that all the meat falls off the bone and the glaze becomes sticky and moreish. To me, the best way to eat this is by pulling the flesh off and rolling it up in lettuce leaves with fresh herbs. Serve by itself or as an accompaniment to the rest of the coral trout as a share dish with friends.

SERVES 2

1 × 550 g (1 lb 3 oz) coral trout head,
 split in half
1 tablespoon ghee
sea salt flakes
lettuce leaves and fresh herbs, to serve

Molasses and anchovy glaze
160 g (5½ oz) molasses
90 g (3 oz) anchovy fillets,
 finely chopped
100 ml (3½ fl oz) Brown Fish Stock
 (page 256)
2½ tablespoons verjuice

Pastrami seed mix
1 tablespoon coriander seeds, toasted
1 tablespoon yellow mustard seeds,
 toasted
1 tablespoon black peppercorns,
 toasted

To make the glaze, place all the ingredients in a wide-based saucepan over a medium heat, bring to a simmer and cook for 30 minutes, or until the liquid is the consistency of runny honey. Remove from the heat and set aside to cool to room temperature.

Preheat the oven to 200°C (400°F).

For the pastrami seed mix, individually break down the seeds and peppercorns using a mortar and pestle, then combine in a small bowl.

Place the coral trout halves on a wire rack, cut side down, and set the wire rack inside a baking tray. Brush the head with the ghee and season well with salt flakes. Bake for 20 minutes, or until the head is crisp and has taken on some colour, and all the wonderful gelatine it contains has broken down. (Alternatively, the head can be grilled on a charcoal grill/barbecue.) Remove from the oven and leave to rest for 5 minutes.

Reduce the oven temperature to 180°C (350°F) and turn the grill setting on.

Brush the molasses glaze over the rested coral trout head, then place under the oven grill and cook for 5 minutes, or until the fish head is very dark and sticky but not burnt (be careful as it can burn quickly). Remove from the grill and liberally sprinkle the pastrami seed mix over the surface. Serve immediately with lettuce leaves and herbs for rolling.

PEKING CORAL TROUT TWO WAYS

There is a lot of pressure when you start throwing words around like Peking and 'san choy bow' as these dishes conjure up significant feelings. Your mind immediately goes to crisp, fatty duck skin beautifully enrobed with a fine glaze and the cold crunch of iceberg lettuce and minced duck meat. I have done my absolute best to honour these textures and flavours in a new form with coral trout. I'm hoping the density of the flesh and the crispness of the skin will convince you to cook this dish again and again.

SERVES 2 AS A MAIN OR 4 AS A STARTER

Pancakes
500 g (1 lb 2 oz/3 1/3 cups) plain
 (all-purpose) flour
250 ml (7 fl oz/1 cup) boiling water,
 plus 1 tablespoon extra if needed
60 ml (2 fl oz/1/4 cup) sesame oil

Skin glaze
90 g (3 oz/1/4 cup) honey
180 ml (6 fl oz) Chinese black vinegar

San choy bow
100 g (3 1/2 oz) ghee
400 g (14 oz) boneless coral trout
 fillet, skin on
sea salt flakes
125 g (4 1/2 oz) bean sprouts
120 g (4 1/2 oz) jicama, peeled and
 finely diced
2 green apples, cored and finely diced
6 large French shallots, finely diced
4 spring onions (scallions), finely sliced
80 g (2 3/4 oz) ginger, peeled and
 finely diced
50 g (1 3/4 oz/1/3 cup) peanuts, toasted
 and coarsely ground
1 teaspoon sesame oil
1–2 teaspoons light soy sauce
1 large iceberg lettuce

Garnishes
1 telegraph (long) cucumber,
 cut into 5 cm (2 in) batons
3 spring onions (scallions), halved
 lengthways, then cut into
 5 cm (2 in) batons
80 ml (2 1/2 fl oz/1/3 cup) hoisin or
 oyster sauce, or to taste

To make the pancakes, place the flour in a large bowl and stir in the boiling water. Set aside to cool, then knead to a smooth dough. Cover and leave to rest for 20 minutes, then divide the dough into 18 even portions.

Take one portion and flatten it to a 6 cm (2 1/2 in) circle, about 4 mm (3/16 in) thick. Brush the surface with sesame oil, then overlay with another second flattened portion. Roll the two pieces together to form a 12 cm (4 1/2 in) circle, about 2 mm (1/16 in) thick. Repeat with the remaining portions. Very lightly brush the base of a large frying pan with a thin layer of oil, add two pancakes and fry over a medium heat until the underside is toasted and dotted with colour. Turn over and fry the other side for 20 seconds. Take the pancakes out of the pan and forcefully throw them onto a clean surface. This will make it easier to separate the two pancakes. Carefully tear the pancakes apart and store under a tea towel (dish towel) to stop them drying out. Repeat with the remaining pancakes. The pancakes can be made a day ahead and stored in an airtight container in the fridge.

To make the glaze, bring the honey to the boil in a saucepan over a high heat. Reduce the heat to medium and simmer for 5 minutes, or until the honey has darkened and caramelised slightly without burning. Carefully whisk in the black vinegar and cook for another 15 minutes, or until reduced and thickened. The glaze is ready when you can spoon the syrup onto a cold plate and it runs briefly, then begins to grip onto the plate as it cools. Remove from the heat and keep warm.

For the san choy bow, start by cooking the fillet. Heat 60 g (2 oz) of the ghee in a cast-iron skillet or frying pan over a medium heat to a light haze. Put the fillet in the centre of the pan, place a fish weight or small saucepan on top and cook for 2 minutes, or until you see colour around the edges. Lift up the fillet using an offset palette knife and move it to a clean surface in the pan. Cook for 1 more minute, then remove the weight and discard the ghee from the pan. Replenish with the remaining fresh ghee and continue to cook for another 3–4 minutes, or until the flesh is 75 per cent of the way towards being set, the top of the fillet is warm and the skin is crisp from edge to edge. Transfer the fillet, skin side down, to a wire rack and leave to rest for 1 minute, then cut off the skin and place it next to the fillet on the rack. (This should be quite simple to do if the skin is nice and crisp.)

Using two forks, shred the fillet flesh to a mince-like texture, then place in a bowl. Add the bean sprouts, jicama, apple, shallot, spring onion, ginger, peanuts, sesame oil and light soy sauce to taste and gently toss to combine.

Remove the core from the iceberg lettuce and carefully separate the leaf 'cups'. Transfer to a serving platter, alongside the coral trout filling.

To finish the skin, return it to the hot pan, underside down, and cook carefully, without letting it burn, for another 30–60 seconds to add more colour and crispness. Remove from the heat and brush liberally with the glaze, then cut it into quarters.

Warm the pancakes slightly in a steamer basket, then transfer to the table. Serve with the cucumber, spring onion, hoisin or oyster sauce and crisp fish skin for rolling with the coral trout san choy bow.

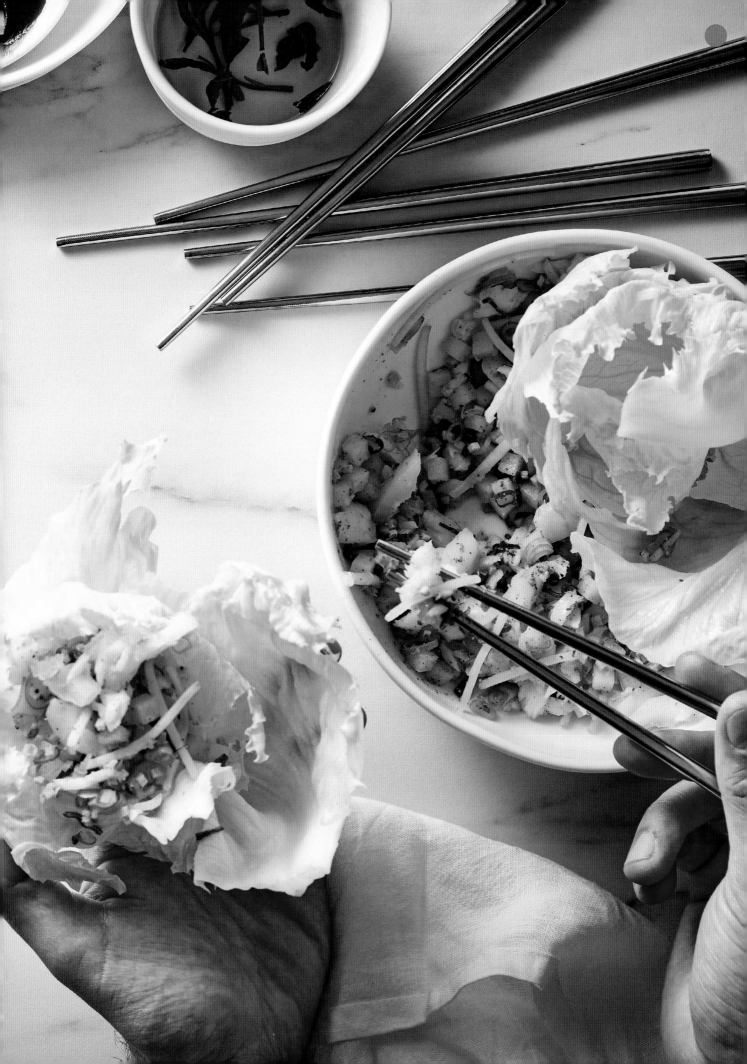

Snapper

I have worked in very few restaurants that didn't have snapper on their menu – its texture and simple, sweet flesh suit a wide variety of accompanying flavours. It would often appear as a whole fish deeply slashed across the fillets and filled with slices of lemon and fennel, or pan-fried as fillets and positioned above just about anything that comes into season (and used as a vehicle more so than as the driver).

While there are in excess of 110 species of snapper in oceans globally, most of us probably only get to interact with one or two, and the manner in which these fish have been captured, killed and stored can greatly affect their flavour. There have been many times where I have been floored by the quality and handling of line-caught and iki jime spiked snapper, which carry a wonderful minerality and light shellfish quality quite able to stand alone as a beautiful product.

In the following recipes my aim is to show some diversity in cookery methods so you see these extremely versatile and much-loved fish in a new light, creating a canvas for you to begin experimenting with some recipe ideas of your own.

Alternatives
SEA BREAM · FLOUNDER · JOHN DORY

Points to look for
BE OPEN TO SPECIES OTHER THAN PINK SNAPPER
SEEK OUT LINE-CAUGHT, IKI JIME SPIKED FISH FOR ASSURED QUALITY

Best cooking
PAN-FRIED · POACHED · STEAMED · RAW · CURED

Accompanying flavours
FENNEL · MACADAMIAS · CARROTS · FIG LEAVES · SESAME
YOGHURT · TARRAGON · CURRY LEAVES

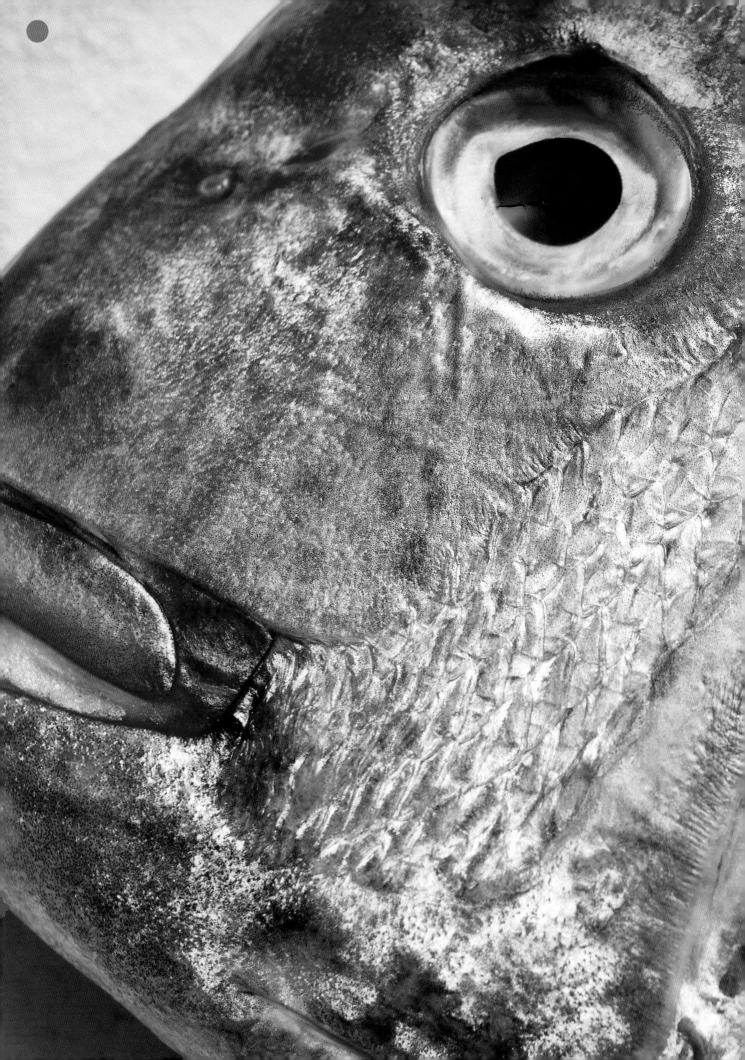

RAW GOLDBAND SNAPPER, SCALLOPS, SHALLOTS AND ITS PUFFED SWIM BLADDER

This dish really showcases the potential of a fish beyond its fillet. Using the swim bladder is not necessary by any means and shouldn't be seen as a reason not to try this recipe, but I promise it will add intriguing texture and flavour to the result. Ask your fish shop or market for the freshest swim bladders if you want to give this component a go. The success of the dish hinges on the quality of the fish, oil and capers you use. There is no soy or citrus acidity, so these ingredients are very much in the spotlight, ready to be eaten simply, as anything of great quality should be.

SERVES 4–6

90 g (3 oz) snapper swim bladder
grapeseed, canola or cottonseed oil, for deep-frying
sea salt flakes
300 g (10½ oz) boneless goldband snapper fillet, skin on (or best available)
250 g (9 oz) best fresh scallop meat, roe on
2 large banana shallots, finely diced
75 g (23/4 oz) best salted capers, rinsed and drained
160 ml (5½ fl oz) extra-virgin olive oil

Cut the bladders down one side, then lay them out flat. Using a pastry card or knife, carefully scrape away any imperfections, then transfer the bladders to a medium saucepan and cover with cold water. Bring to the boil, then reduce the heat to a very gentle simmer and cook for 30 minutes, or until the bladders are soft, translucent and almost jelly-like in consistency.

Meanwhile, if you don't have a dehydrator, preheat the oven to its lowest setting, about 60–70°C (140–158°F). Line a baking tray with baking paper.

Remove the bladders from the liquid with a slotted spoon and spread out on the prepared tray. Transfer the tray to a dehydrator or preheated oven and leave until the bladders are completely dry – this can take up to 5 hours in the oven. (At this point they can be stored indefinitely in an airtight container for later use.)

Half-fill a large saucepan with oil for deep-frying and heat over a medium-high heat to 185–190°C (365–375°F). Using a small pair of tongs, very carefully place the dried swim bladder in the oil for just a few seconds until the skin has puffed up and tripled in volume but not coloured. Quickly remove it from the oil and drain on a wire rack. Season liberally with salt then, using a serrated knife, cut it into manageable pieces that can be broken up easily when eating the dish. Set aside.

To prepare the snapper fillet, turn it onto the flesh side so the skin is facing up. Using your knife, place the blade between skin and flesh at a 45 degree angle on the corner of the skin closest to where the head would have been, then draw the blade away from you towards the tail of the fillet so the skin comes off, leaving behind the 'silver skin' and all those lovely natural oils. Separate the loin from the belly, so the slices are even and simpler to cut. Starting at the head end of the loin with the skin side facing up, cut the fillets into thin slices. For the belly, working on a slight angle, take thin slices from the head end, skin side up.

Slice each scallop in half horizontally so you get two medallions. Season lightly with salt flakes.

Assemble the loin and belly slices and scallop medallions on individual serving plates. Scatter over the shallot and capers and drizzle over the olive oil. Finish with the fried swim bladder pieces and serve.

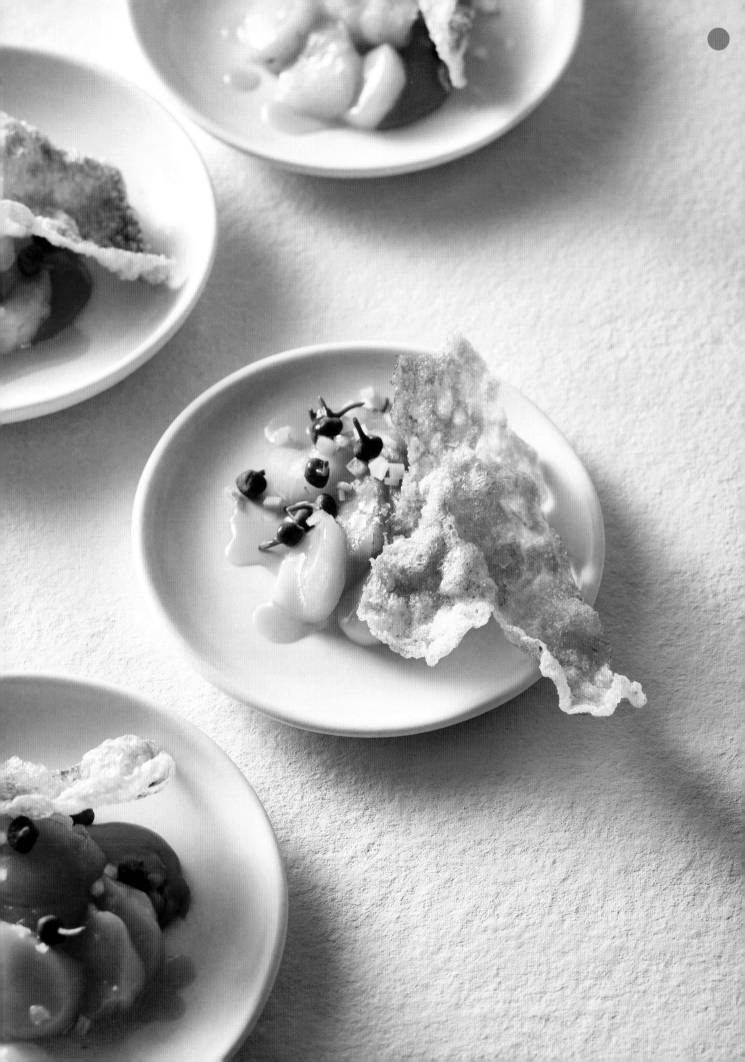

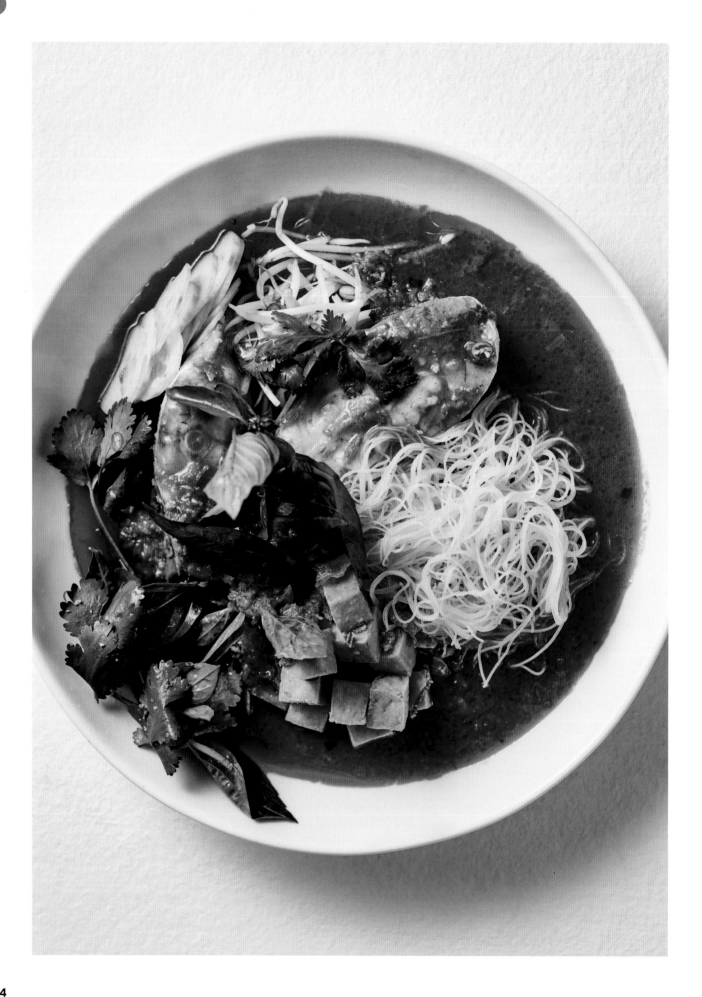

FLAMETAIL SNAPPER LAKSA

Although I can offer alternatives to the type of snapper in this recipe (such as goldband snapper, pink snapper, jobfish or red emperor), I must stress the importance of using one with a similar flavour profile to the flametail. It carries a generous shellfish quality that aligns itself beautifully with the prawn and shrimp flavours in the laksa base. I've never loved excessive chilli in my food so the following recipe walks the line between knocking you over with heat and wondering if there was actually any chilli there in the first place.

The laksa paste makes more than you need here. Store the rest in an airtight container in the fridge for five or six days, or up to two weeks in the freezer - it makes a wonderful rub for grilled fish, chicken, vegetables, lamb or pork.

SERVES 4-6

vegetable oil, for deep-frying
160 g (5½ oz) firm tofu, cut into
 small cubes
1 × 400 ml (13½ fl oz) tin coconut milk
750 ml (25½ fl oz/3 cups) Brown Fish
 Stock (page 256)
2 tablespoons Garum (page 257)
 or fish sauce, plus extra to taste
600 g (1 lb 5 oz) boneless snapper
 darnes, spine in (see note)
2 tablespoons lime juice
400 g (14 oz) fresh thin rice noodles
 (or best available dried)

Laksa paste
1 teaspoon dried prawns (shrimp)
150 ml (5 fl oz) vegetable oil
8 French shallots, coarsely chopped
6 garlic cloves, finely grated
2 red bird's eye chillies, finely chopped
2 coriander (cilantro) roots, washed,
 scraped and finely chopped
2 dried long red chillies, finely chopped
1 lemongrass stem, white part only,
 finely chopped
1 tablespoon finely chopped
 coriander (cilantro)
2 teaspoons roasted shrimp paste
zest of 1 lime
1 teaspoon finely grated fresh galangal
1 teaspoon finely grated fresh ginger
1 teaspoon finely chopped fresh
 turmeric
1 teaspoon coriander seeds,
 toasted and ground
1 teaspoon ground turmeric

To serve
bean sprouts
fried shallots
finely sliced green chilli
slices of cucumber
coriander (cilantro) and mint leaves
quality chilli oil

Heat the oil in a deep-fryer or large saucepan over a medium–high heat until it reaches a temperature of 180°C (350°F). Being extremely careful, lower the tofu into the hot oil in batches and deep-fry until puffed and golden brown, approximately 4–5 minutes. Drain well on paper towel and set aside.

To prepare the laksa paste, toast the dried prawns in a dry frying pan over a medium heat for 3 minutes until fragrant, then roughly grind using a mortar and pestle. Transfer to a high-powered blender, along with all the remaining ingredients, and blitz to form a fine paste (depending on the size of your blender you may need to do this in batches).

Place 130 g (4½ oz/½ cup) of the paste in a large heavy-based saucepan and pour in the coconut milk. Bring to the boil over a high heat, stirring to combine, then reduce the heat to medium and simmer for 15 minutes. Add the fish stock and simmer for a further 15 minutes. Stir in the garum or fish sauce.

Remove the pan from the heat and pass the soup through a fine sieve, discarding the solids. Return the soup to the pan and bring back to the boil. Reduce the heat to low, add the snapper darnes and simmer gently for 1 minute only. Remove the pan from the heat, cover with a fitted lid and leave for 3-4 minutes until the fish is translucent and just cooked. (The best way to check if a fish on the bone is cooked is to remove a portion from the hot stock, insert a probe thermometer into the side and push it into the centre close to the bone - if the temperature reads between 40°C (104°F) and 50°C (122°F) the fish is done.)

Once the fish is cooked, remove it from the laksa and leave it to rest on a plate for 2 minutes.

Meanwhile, return the laksa stock to a simmer. Add the lime juice and extra garum or fish sauce, if needed, then cook the noodles in the broth according to the packet instructions.

Divide the noodles, snapper darnes and tofu pieces evenly among large bowls and ladle over the hot broth. Serve garnished with bean sprouts, fried shallots, sliced chilli, cucumber, fresh herbs and a drizzle of chilli oil.

Note: A darne, also known as a cutlet, is a bone-in steak cut from the lower half of the fish. Being from the lower half means that there is just one central bone, which is easy to eat around. It will also help the fish retain its shape while cooking, as well as give you a more flavourful fish and stock.

SMOKED SNAPPER QUICHE

There is something so satisfying about a well-executed quiche, and this recipe ticks all the boxes. Smoking the snapper helps impart extra flavour into the skin, which is used to enrich the custard base, while the feta helps give the filling a lovely bone-white finish. You'll notice the pastry calls for flour that has been kept in the freezer – this ensures it stays very cold, resulting in a crisp, short pastry.

The snapper needs to be cured overnight before smoking, and requires only a light seasoning so you don't have to rinse it in water for hours once it comes out of the salt. If you don't have a smoker, you can always use an aluminium foil-lined double steamer with soaked wood chips in the base instead. Alternatively, the smoked snapper can be replaced with another variety of quality smoked fish to save you the extra steps.

SERVES 6–8

600 g (1 lb 5 oz) boneless snapper fillet, skin on
35 g (1¼ oz/¼ cup) sea salt flakes
1 × 14 g (½ oz) brick of apple wood chips
100 g (3½ oz) Greek feta, crumbled

Pastry
250 g (9 oz/12/3 cups) plain (all-purpose) flour, frozen
200 g (7 oz) unsalted butter, chilled and diced
½ teaspoon fine salt
55 ml (13/4 fl oz) chilled water
1 egg yolk, lightly beaten

Custard
250 ml (8½ fl oz/1 cup) full-cream (whole) milk
250 ml (8½ fl oz/1 cup) pouring (single/light) cream
½ bunch lemon thyme, leaves picked and stems reserved
3 eggs
sea salt flakes
¼ teaspoon freshly cracked black pepper
pinch of freshly grated nutmeg

To cure the snapper, place the fillet in a sterile container or tray and cover it with the salt flakes evenly on all sides. Cure uncovered in the fridge for 12 hours. Remove the snapper from the container. (Please do not wash the fish at this point.) There should be no residual salt on the surface – if there is, just scrape it off with a knife.

Add the wood chips to a smoker capable of hot-smoking and bring the temperature to 90°C (195°F). Place the cured snapper on a wire rack suited to the smoker and smoke for 30–35 minutes, depending on your desired degree of smokiness and doneness. Remove from the smoker and rest until it reaches room temperature, then store uncovered in the fridge, skin side up, until needed. Remove the skin and set aside in the fridge until you are ready to make the custard.

To make the pastry, pulse the flour and butter in a food processor to create very fine crumbs. Dissolve the salt in the water and add to the crumb, pulsing briefly to combine, then turn out the dough onto a chilled surface and work it with the palm of your hands for 3–4 minutes to form a very firm dough. Wrap in plastic wrap and chill for a minimum of 3–4 hours.

Preheat the oven to 190°C (375°F).

Roll out the chilled pastry on a lightly floured surface to a 4 mm (3/16 in) thickness and use it to line a 28 cm (11 in) tart tin. Line the pastry shell with a square of baking paper, fill it with uncooked rice or dried beans and blind-bake for 10 minutes, then remove the paper and weights and bake for a further 10 minutes. Brush the tart shell with the beaten egg yolk to seal the pastry. Set aside.

To make the custard, combine the milk, cream, lemon thyme stems and the skin from the smoked snapper in a large saucepan. Bring to a simmer over a medium heat, then remove from the heat and leave to cool for 10 minutes. Strain, discarding the solids, and pour into a blender, along with the eggs, salt, pepper and nutmeg. Blend on low speed for about 10 seconds to combine, then increase the speed to high and blend until the custard is aerated and foamy.

Break the smoked snapper fillet into large flakes and arrange over the base of the tart shell, along with the crumbled feta and lemon thyme leaves. Pour over enough of the custard to cover the ingredients and half-fill the pastry shell. Transfer the quiche to the oven and pour in the remaining custard to fill the shell all the way to the top. Bake for 25 minutes, until the top of the quiche is browned and the custard is softly set when the tray is wobbled. Remove from the oven and leave to cool to room temperature before serving. For best results, place in the fridge overnight and serve chilled or gently warmed in the oven the next day. By this time, the quiche will have a slightly firmer composition and the smokiness of the snapper will become rounder and more subtle.

MEDIUM

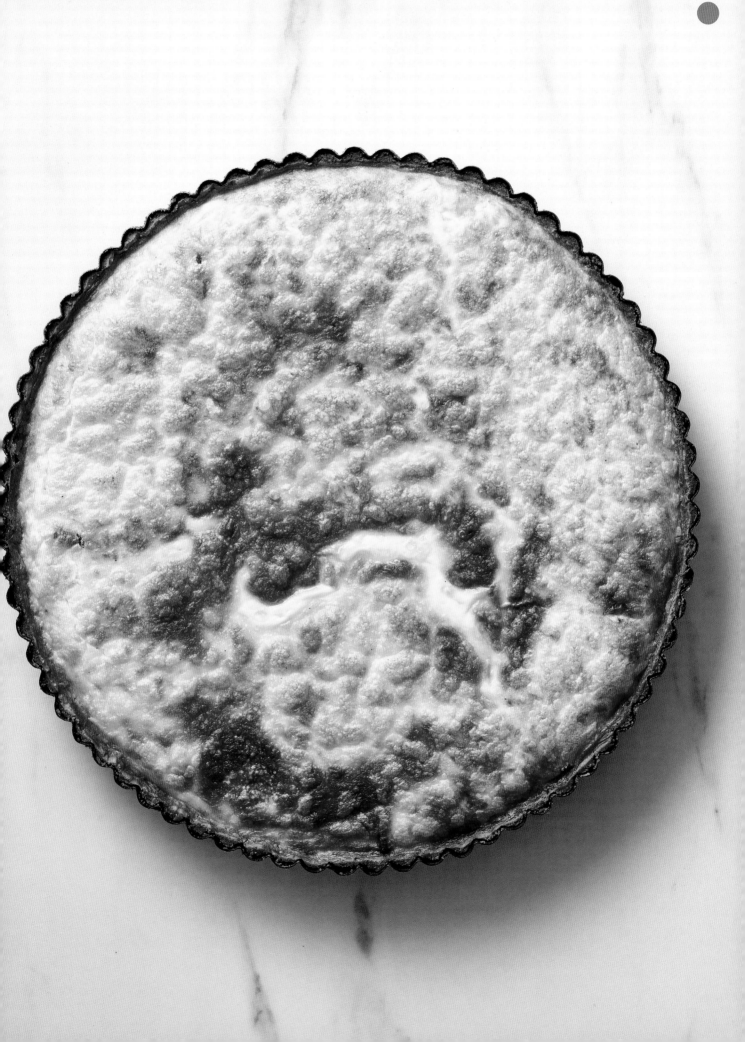

SNAPPER BAKED IN SALT PASTRY

This is the simplest way to bake a whole snapper with show-stopping results. Once mastered, you can vary the technique with myriad flavours and species, or even the pastry (which is not edible here), but the most critical thing is the resting time after baking. As you can imagine, there is a lot of heat trapped within, and allowing this residual heat to work its magic results in perfectly cooked fish that comes easily off the bone.

There is a big difference between a fish being cooked and being overcooked. When cooking on the bone, there is a sweet spot where the flesh decides to give way off the bone and the natural gelatine and fat are still present. After this moment a fish will start to lose moisture, which ultimately gives it its texture, flavour and appearance. You can always cook a fish a little more if necessary, so always err on the side of underdone for a fish like snapper.

SERVES 4

1 × 1 kg (2 lb 3 oz) whole snapper, scaled, gutted and pin-boned, spine left intact

Salt pastry
600 g (1 lb 5 oz/4 cups) plain (all-purpose) flour
150 g (5½ oz) egg whites
420 g (15 oz) fine salt
300 ml (10 fl oz) water

To make the salt pastry, place all the ingredients in the bowl of a stand mixer fitted with the dough hook attachment. Mix together on a low speed for 5 minutes or until a firm smooth dough forms, then turn out onto a lightly floured surface and knead for 1 minute into a ball. Wrap in plastic wrap and leave to rest for 1 hour.

Preheat the oven to 220°C (430°F) and line a large baking tray with baking paper.

Unwrap the dough, cut it in half and roll out each piece to a square about 3 mm (1/8 in) thick. The squares should exceed the width and height of the whole snapper. Carefully place one pastry square on the prepared baking tray and position the fish in the centre. Brush the edges of the pastry with a little water, then carefully cover the fish with the second pastry sheet, crimping the two sheets together with a fork to seal the edges.

Trim away any excess pastry and reroll the trimmings, shaping them as you please for presentation purposes. Place in the oven and bake for 25 minutes. To check if it's ready, insert a probe thermometer through the pastry into the thickest part of the fish. For best results, the temperature should be sitting around 40–42°C (104–107°F) when it is removed from the oven.

Rest the fish in its pastry for about 10 minutes to reach a serving temperature of 48–50°C (118–122°F), then transfer to the centre of the table, ready for the theatrical removal of the pastry before serving.

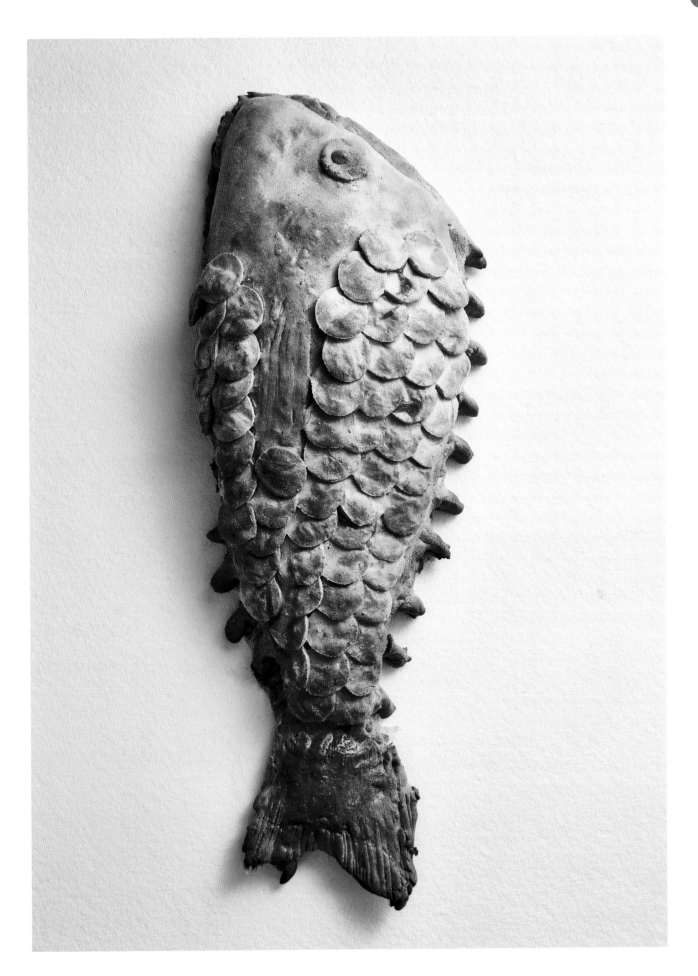

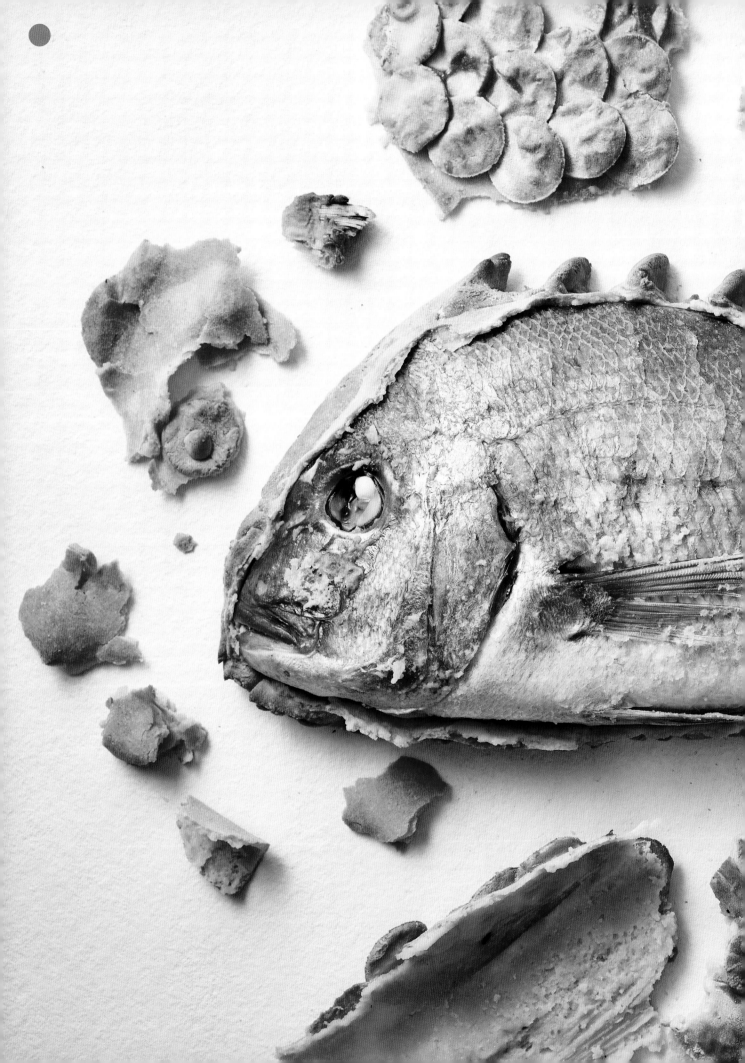

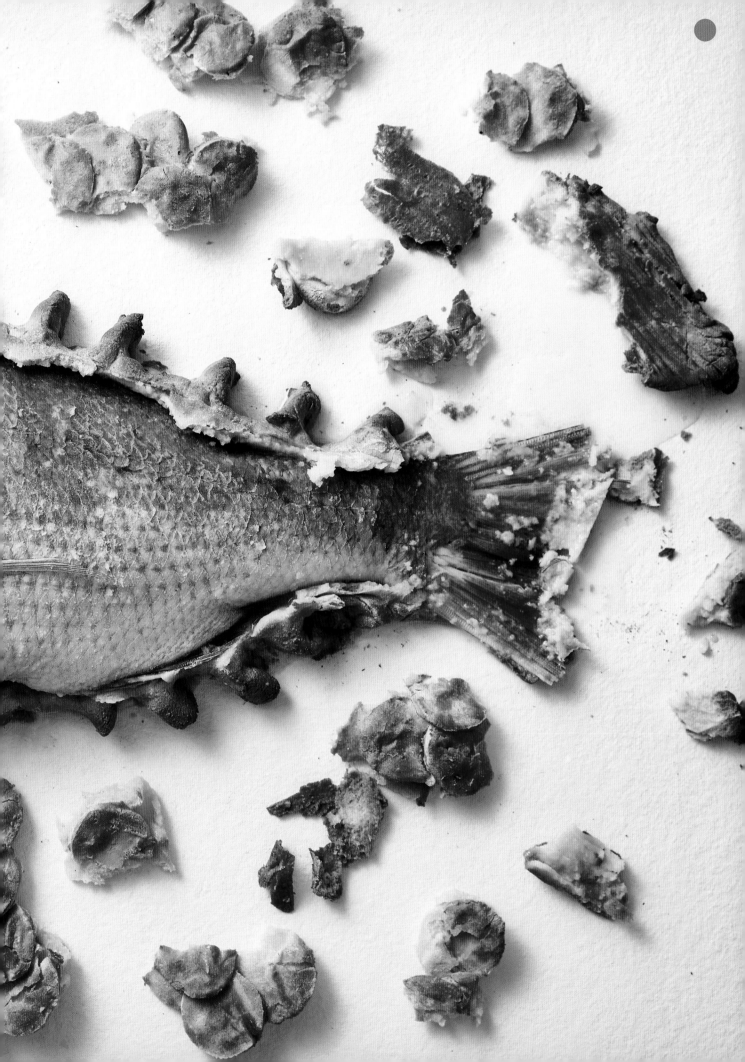

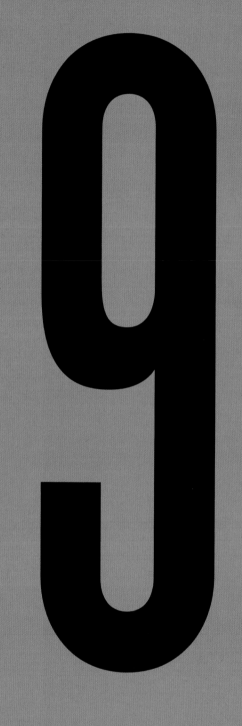

Flounder

Flounder and other flat fish are strange things. When a flounder is born it is bilaterally symmetrical, with an eye on each side, and swims near the surface of the sea, but after a few days it begins to lean over to one side, and the eye on the other begins to migrate to what eventually becomes the top side of the fish. With this development a number of other changes in bones, nerves and muscles occur, and the underside of the flounder loses its colour. As a table fish, flounder are revered for this unique skeletal makeup, which carries no pin bones, together with four fillets that can be simply removed from the one central frame.

When I see a flounder, I like to think about how best I can both harness the gelatine it contains and showcase its firm fillets. Often the answer is by applying direct heat from a wood burning or charcoal burning grill, enriching the flesh and skin with a deep savouriness achieved by smoke and seasoning.

Flavours such as chilli, butter, capers, mushrooms, vinegar, seaweed, mussels and anchovy all get me really excited to cook with flounder, but the key is getting that method of cookery correct and pairing the fish with the right amount of seasoning to knock it out of the park.

Alternatives
TURBOT · SOLE · JOHN DORY

Points to look for
GENEROUS FIRM COVERAGE OF FLESH FROM EDGE TO EDGE

Best cooking
GRILLED · STEAMED · FRIED · RAW

Accompanying flavours
**CHILLI · BUTTER · CAPERS · MUSHROOMS · VINEGAR
SEAWEED · MUSSELS · ANCHOVIES**

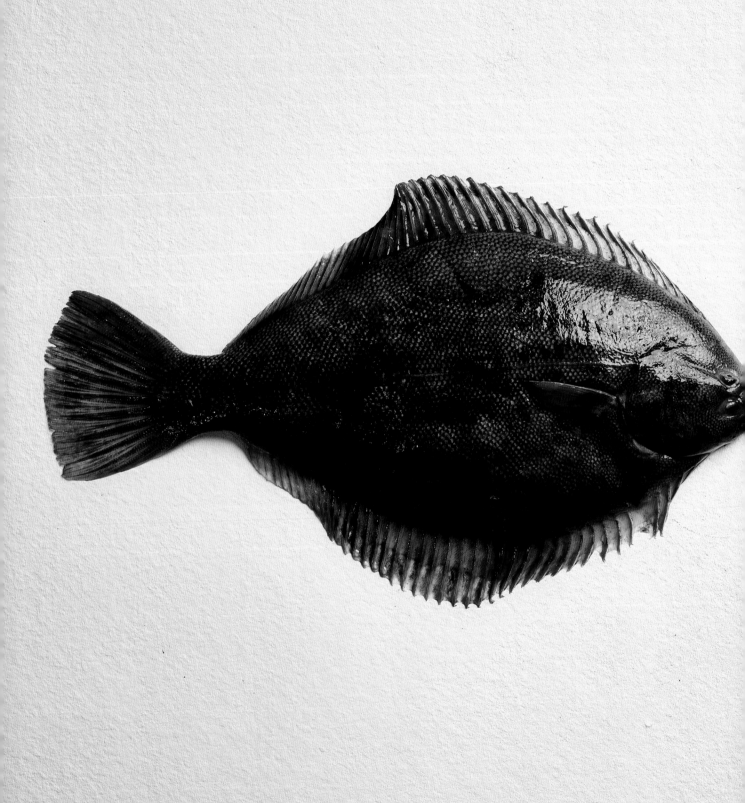

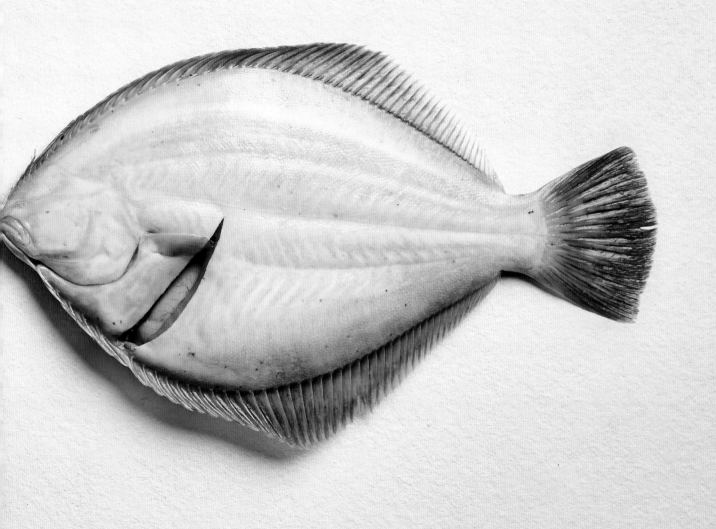

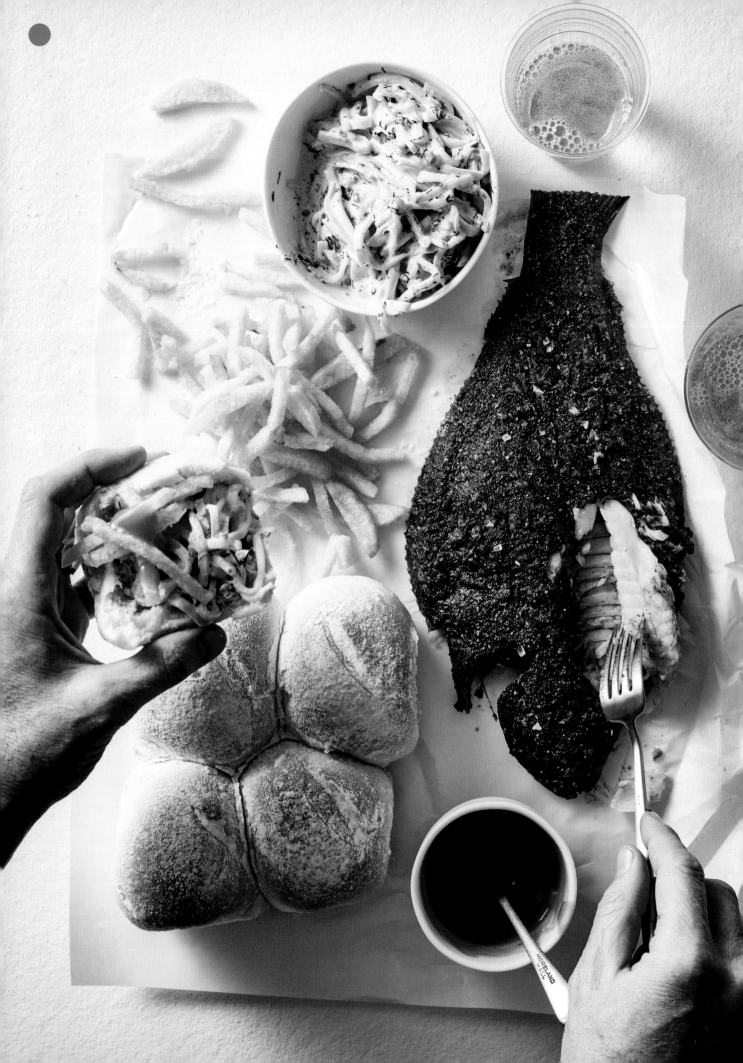

CHARCOAL FLOUNDER WITH CELERIAC COLESLAW AND FLOUNDER GRAVY

This is my interpretation of the classic chicken–shop dinner. From the seasoning added to the flounder to the soft white bread rolls, coleslaw and amazing gravy, this is a dish I hope you will want to cook again and again. Flathead, turbot and halibut all make excellent alternatives here, too. If you have one, use a grill basket specific to cooking flat fish, as it will enable you to flip the fish easily for controlled cooking.

SERVES 4

2 × 500 g (1 lb 2 oz) whole greenback
 flounder, gutted and scaled
60 ml (2 fl oz/¼ cup) grapeseed oil
sea salt flakes
4 soft white floury bread rolls, warmed
cold butter, for spreading
Flounder Gravy (page 263), to serve
 (optional)
Fries (page 263), to serve (optional)

Flounder seasoning
2 tablespoons freshly ground
 fennel seeds
2 tablespoons freshly ground
 black peppercorns
2 teaspoons freshly ground
 cumin seeds
2 teaspoons freshly ground
 coriander seeds
1 teaspoon onion powder
1 teaspoon garlic powder
1 teaspoon ground turmeric
1 teaspoon cayenne pepper

Celeriac coleslaw
¼ red cabbage, finely shredded
1 large celeriac, finely sliced
2 carrots, finely sliced
300 g (10½ oz) quality mayonnaise
60 ml (2 fl oz/¼ cup) chardonnay
 vinegar
sea salt flakes and freshly cracked
 black pepper
1 teaspoon toasted celery seeds

For the flounder seasoning, combine all the spices in an airtight container and set aside until needed. It will keep in the pantry for up to 1 month.

To make the celeriac coleslaw, place the cabbage, celeriac and carrot in a large bowl. Whisk together the mayonnaise, vinegar, salt, pepper and celery seeds in a small bowl. Pour about half of the dressing over the salad and toss to combine. Slowly add more dressing until you've reached your desired ratio of coleslaw to dressing. Set aside.

Prepare a charcoal grill, making sure the grill is hot and the charcoal has cooked down to hot embers. Level out the embers so the heat is even.

Using scissors, snip off any fins around the skirt of the flounder, as these will be the first things to scorch and become tatty during cooking. Brush the fish on both sides with a little grapeseed oil and season well with salt flakes and the flounder seasoning (about 2 teaspoons for each fish).

Place the flounder directly on the grill racks, dark (top) side down, and grill for 4 minutes each side, or until the internal temperature on the bone of the flounder reaches 48°C (118°F) on a probe thermometer.

Transfer the fish to a large serving platter and leave to rest for 5 minutes. Serve with the coleslaw, warm bread rolls, cold butter, gravy and a generous mound of fries, if you like.

RAW FLOUNDER, FRAGRANT LEAVES, HERBS AND CITRUS DRESSING

While raw flounder might not have the sexy allure of raw tuna or snapper, I actually think the flavour and texture of a very fresh flounder can surpass both. The acidity in the citrus dressing really brightens and elevates its natural savoury qualities, while the bone soy sauce adds a depth of flavour that rounds out the dish beautifully. (That said, if making the sauce feels like too much trouble, you can always just use white soy mixed with a little quality fish sauce instead.) The fragrant leaves, herbs and vegetables that accompany the fish make this dish a lot of fun to eat and share with friends.

SERVES 6

2 × 400 g (14 oz) whole flounder
200 ml (7 fl oz) white soy sauce

Citrus dressing
2 limes, 1 zested and juiced,
 1 segmented and diced
2 lemons, 1 zested and juiced,
 1 segmented and diced
1/2 blood orange, zested, segmented
 and diced
2 tablespoons white soy sauce,
 or to taste
1 teaspoon caster (superfine) sugar,
 or to taste
1/2 pomelo (Chinese grapefruit)
1/2 telegraph (long) cucumber, peeled
 and finely diced
pearls from 1 finger lime
125 ml (4 fl oz/1/2 cup) extra-virgin
 olive oil
75 ml (21/2 fl oz) grapeseed oil

Garnishes
1 butter lettuce
generous handful large shiso leaves
generous handful mint leaves
generous handful large nasturtium
 leaves
200 g (7 oz) large daikon (white radish)
 or kohlrabi, peeled and cut into thin
 discs with a mandoline

Preheat the oven to 200°C (400°F) and line a baking tray with baking paper.

To prepare the flounder, start by removing the fillets from the top and bottom of the fish. Draw the blade down the centre of the fish from head to tail, following the line of the spine, then sweep the blade across both the left and right fillets, being sure to stay as close to the bone as you can as the fillets aren't very thick. Repeat this step on the underside as well, giving you four fillets from each fish. Refrigerate until needed.

Remove the gills and gut from the head of the fish frames, then place the frames on the prepared tray and roast for 20 minutes or until golden and crisp. Transfer the hot bones and cooking juices to a container, add the white soy and cover with a lid. Leave to cool completely, then strain and set aside.

While the bone sauce is cooling, prepare the dressing. Add the juice and zest from the limes and lemons, and the blood orange zest, to a bowl and mix with the white soy and sugar to dissolve.

To remove the cells from the pomelo, make a small incision in the very top of the fruit, then remove the skin with your hands, leaving the segments intact underneath. Gently pull the segments apart, then carefully peel away the white membrane to expose the pomelo within. Using your thumb and index finger, gently encourage each of the cells apart by opening the segment and removing the fruit from within.

Add the pomelo cells to the dressing bowl, along with the diced lime, lemon and blood orange segments, cucumber and finger lime pearls. Leave for 1 hour for the flavours to mingle, then taste and add a little more sugar or white soy if needed to balance the flavours. Set aside.

To prepare the flounder for serving, remove the skin from each fillet by angling the blade of a sharp knife down towards the skin and sliding it between skin and flesh in one motion. Cut the fillets from head to tail into thickish slices. (I prefer to cut slices a little thicker than usually feature in raw dishes, just so that I can appreciate the texture of the flounder against the vibrancy of the leaves and crunch of the cucumber in the dressing.)

Place the flounder slices on a serving plate and brush with a little of the bone sauce. Arrange the garnish leaves and daikon or kohlrabi alongside. Whisk the oils into the citrus dressing to combine, then spoon it over the dish and serve.

GAI YANG STYLE BONE-IN FLOUNDER CHOPS WITH STICKY RICE, HERBS AND LETTUCE

Every time I go to Sydney institution Chat Thai I find myself ordering the same dish – gai yang and sticky rice, a traditional Thai dish of charcoal-grilled marinated chicken served with sticky rice and a chilli-spiked dipping sauce. It is exceptionally moreish and easily one of my favourites. Here, I've recreated it with flounder, as its complex, savoury quality (especially when cooked on the bone) works perfectly with the flavours and cooking style. The fresh ingredients in the marinade may require a little time and effort to round up, but they make all the difference to the finished dish.

SERVES 6

3 × 500 g (1 lb 2 oz) whole flounder, gutted and scaled
350 g (12½ oz/13/4 cups) glutinous white rice, soaked overnight in cold water
70 ml (2¼ fl oz) grapeseed oil

Marinade
6 garlic cloves, finely diced
6 coriander (cilantro) roots, washed, scraped and chopped
1 lemongrass stem, white part only, finely diced
20 kaffir lime leaves, stems removed, finely sliced
2 teaspoons finely grated fresh turmeric
½ teaspoon ground white pepper
30 g (1 oz) tamarind pulp, dissolved in 2½ tablespoons boiling water, strained, seeds discarded
20 g (3/4 oz) dark palm sugar (jaggery), crushed
60 ml (2 fl oz/¼ cup) Garum (page 257) or fish sauce, plus extra to season

Dipping sauce
4 garlic cloves, peeled
1 coriander (cilantro) root, washed, scraped and finely chopped
1 long red chilli, finely diced
350 ml (12½ fl oz) rice vinegar
100 g (3½ oz) caster (superfine) sugar
200 ml (7 fl oz) water
3 kaffir lime leaves, stem removed, finely sliced
50 g (13/4 oz/¼ cup) glutinous white rice
1 teaspoon Garum (page 257) or fish sauce, or to taste

To serve
3 butter lettuces, washed and leaves separated
generous handful shiso leaves
handful sawtooth or regular coriander (cilantro) leaves
handful mint leaves

To prepare the flounder, place one fish in the middle of a clean chopping board with its head at the top and its tail at the bottom. Take a pair of scissors and trim the fins from the body. Switch to a cleaver or large sharp knife and chop off the head and tail, then cut the body in half down the length. Chop each half into three square chops, trimming the ends of the exposed bones with a small sharp knife, if you like. Repeat with the remaining flounder.

To make the marinade, combine all the ingredients in a large bowl. Add the flounder pieces and turn to coat well, then transfer to the fridge and leave to marinate overnight.

For the dipping sauce, pound the garlic, coriander root and chilli to a paste using a mortar and pestle. Transfer to a saucepan and add the vinegar, sugar and water. Bring to a simmer and cook over a high heat for 15–20 minutes until the sugar has dissolved and the sauce is syrupy. Remove from the heat, add the lime leaf and refrigerate until required.

Drain the soaked glutinous rice and cook in a large steamer lined with muslin (cheesecloth) over a saucepan of boiling water until fluffy and sticky, approximately 20 minutes.

Meanwhile, prepare a charcoal grill, making sure the grill is hot and the charcoal has cooked down to hot embers. Level out the embers so the heat is even.

Brush the marinated flounder chops with grapeseed oil, then place directly on the grill racks and cook for 2 minutes each side, or until the skin is toasted and caramelised and the thickest piece of fish registers 45°C (113°F) on a probe thermometer. Remove from the heat and leave to rest for 5 minutes.

While the flounder is resting, finish the dipping sauce. Toast the glutinous rice in a dry frying pan over a high heat for 4–5 minutes until tan in colour, then grind to a coarse powder using a mortar and pestle. Stir into the chilled dressing and season to taste with garum or fish sauce.

To serve, pile the flounder chops onto a large serving platter. Pour the dipping sauce into a small ramekin or jug, place on the platter and serve immediately with the sticky rice, lettuce and fresh herbs.

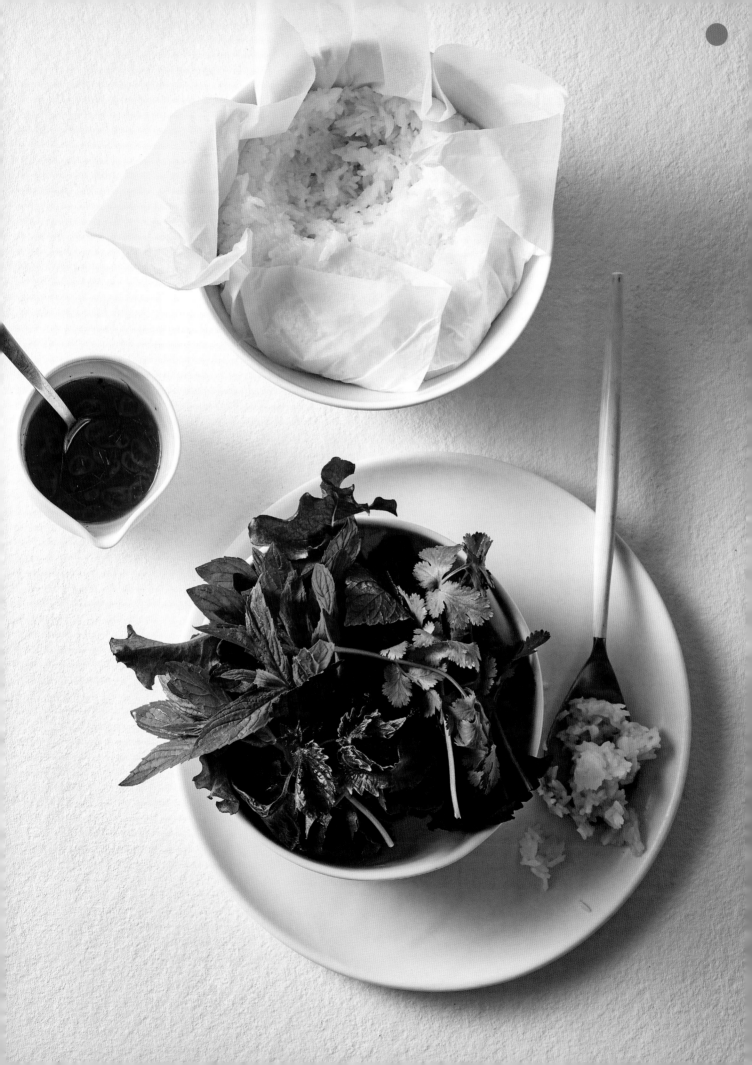

10

Groper

While by no means an everyday purchase, groper is a beautiful, high-yielding fish that deserves to be treated with a great deal of reverence. Everything from the fillets to the head, eyes, bones, liver, spleen, heart, roe, stomach and intestines has delicious potential here, and, if buying a whole fish, you will want a plan of attack that makes use of each and every one of these parts, where possible. Groper's exceptionally juicy flesh, which can be cooked in a wide variety of ways, suits a varied range of flavour pairings too – from peas to anchovy, mushrooms to ginger and sorrel to seaweed – while the skin (and the slick of natural fats that reside just below it) holds exceptional flavour and tastes amazing when pan-fried or roasted.

Bass groper and similar species are best eaten between days four to nine post-capture, as there is a certain succulence that you want to maintain in the flesh. By dry ageing (see page 19) it further past this timeline, you run the risk of losing what it is that makes this fish incredibly special, while methods that enhance this desirable characteristic, such as steaming and poaching, will achieve outstanding results. As the fish's moisture-filled muscles do not carry the kind of dense fattiness that is so desired in raw fish dishes, I haven't listed this as a suitable option here. However, if you have the ability to cut the top loin from a bass groper fillet, then this particular firm muscle can indeed be eaten like this or, better still, kissed with hot charcoal or a hot cast-iron pan to create a tataki-like finish.

Alternatives
BAR COD · HAPUKA · SNAPPER

Points to look for
FIRM BELLY CAVITY · INTACT SCALES · BULBOUS GLISTENING EYES
FIRM GLASSY (NOT MILKY OR FOGGY) FLESH · VIBRANT RED MUSCLE

Best cooking
POACHED · STEAMED · PAN-FRIED · BAKED · CRUMBED · DEEP-FRIED · CURED

Accompanying flavours
PEAS · FENNEL · BORLOTTI BEANS · ANCHOVIES · MUSHROOMS
POTATOES · GINGER · CHIVES · SORREL · SEAWEED

PUFTALOONS WITH GROPER TARAMASALATA

First up, how good is the name puftaloon?! Essentially scones that are fried and then baked, making them crisp and golden on the outside and soft and fluffy on the inside, these are a nod to the excellent scones my mother and grandmother used to make when I was growing up. The taramasalata has a texture very similar to whipped cream and, while I did consider adding a 'jam' element (beetroot or red capsicum?), I love their comforting simplicity just as they are, especially when served fresh from the oven.

The secret to a good puftaloon is not to develop too much gluten, so make sure you only mix the ingredients very briefly when working up the dough. The taramasalata is relatively easy to prepare but does need a little planning – allow one day for salting and another for smoking and overnight drying.

MAKES ABOUT 10

Taramasalata
400 g (14 oz) firm quality bass
 groper roe
about 1 kg (2 lb 3 oz) table salt
100 g (3½ oz) apple wood chips, soaked
200 ml (7 fl oz) olive oil
250 g (9 oz/1 cup) sour cream
100 ml (3½ fl oz) Garum (page 257)
 or fish sauce
2½ tablespoons sherry vinegar

Puftaloons
300 g (10½ oz/2 cups) self-raising flour
35 g (1¼ oz/1/3 cup) milk powder
1 tablespoon baking powder
pinch of fine salt
250 ml (8½ fl oz/1 cup) buttermilk
60 g (2 oz) ghee

To make the taramasalata, completely cover the fish roe with the salt, then refrigerate, covered, for 24 hours. The following day, brush any excess salt from the exterior of the membrane.

To smoke the roe, preheat your oven to the lowest possible temperature (about 90°C/195°F) and place a roasting tin full of soaked smoking chips in the bottom. Light the chips and allow the smoke to flood the oven. Put the cured roe on a wire rack inside a baking tray, then place in the oven and smoke for about 40 minutes, until the roe is firm and stained from the smoke. Remove from the oven and leave to rest, then refrigerate overnight, allowing the membrane to dry lightly.

The next day, cut the roe into small pieces, then place in a blender with the olive oil and blitz for about 10 minutes until smooth. Some blenders may take longer then others – take as long as you need, as it is critical that the base is incredibly smooth and well emulsified.

Meanwhile, whisk the sour cream to soft peaks.

Season the blended roe with garum or fish sauce and vinegar, then remove from the blender and whisk into the whipped sour cream. Cover and store in the fridge until needed. The taramasalata will keep for up to 3–4 days.

Preheat the oven to 185°C (365°F).

To prepare the puftaloons, combine the flour, milk powder, baking powder and salt in a bowl. Pour in the buttermilk and stir briefly just until the ingredients come together in a very rough-looking dough. Tip the dough onto a sheet of baking paper and roll it out evenly to a 2 cm (3/4 in) thickness. Using a 6 cm (2½ in) ring cutter, carefully cut out approximately 10 discs. (Try to space them close together as the trimmings can't be rerolled here – the result will be noticeably inferior.) Leave to rest for 20 minutes before using.

Working in batches, add just enough ghee to coat the base of a large ovenproof frying pan and heat over a medium heat to a light haze. Working in batches of four, add the puftaloons and cook for 1 minute on each side until golden, swirling the pan carefully or moving the puftaloons so they don't build up too much heat in one part of the pan. Place the pan in the oven and bake for a further 5 minutes, turning halfway through. Serve immediately with the taramasalata.

FRIED BASS GROPER BURGER WITH TAMARIND HOT SAUCE

Fried fish burgers are served the world over, but my marinated fish collars offer something a little different and add a huge burst of flavour. You could add a multitude of other garnishes but I find too many ingredients make for a chaotic burger, and take away from the quality of the fish. The hot sauce takes two weeks to ferment but it is definitely worth the wait, resulting in a fiery, fragrant concoction that you will be slinging across all manner of other dishes. Do try to get collars for this recipe as the darker muscle really does improve the texture and flavour here. Ask your fishmonger to cut the bones out of the wing to save you one extra task.

SERVES 4

400 g (14 oz) boneless bass groper collars, skin on
100 g (3½ oz/2/3 cup) plain (all-purpose) flour
100 g (3½ oz) potato starch
canola oil, for deep-frying
sea salt flakes
2 tablespoons quality mayonnaise
juice of ½ lime

Tamarind hot sauce
250 g (9 oz) peeled papaya
250 g (9 oz) scotch bonnet chillies
8 garlic cloves, peeled
1 French shallot, peeled
6 coriander (cilantro) roots, washed and scraped clean
1½ tablespoons fine salt
1 tablespoon light palm sugar (jaggery)
60 ml (2 fl oz/¼ cup) tamarind puree (or tamarind water), or to taste

Marinade
1 tablespoon finely grated fresh ginger
1 tablespoon finely grated garlic
2 tablespoons light soy sauce
1 small egg, lightly beaten
1 tablespoon vodka

To serve
4 potato rolls or soft burger buns, halved and lightly toasted
iceberg lettuce leaves
sliced pickles

To make the tamarind hot sauce, place all the ingredients in a blender and blitz to a fine puree. Pour the mixture into a sterile mason (kilner) jar, cover the opening with a square of muslin (cheesecloth) and secure with a rubber band or kitchen twine. Store out of direct sunlight and leave the ingredients to ferment with the lid off for a minimum of 2 weeks. If needed, add extra tamarind for acidity and to round out the flavour profile.

For the marinade, combine all the ingredients in a bowl.

Using a sharp knife, score the skinless side of the bass groper collars in a crosshatch pattern, taking care not to cut too deeply into the flesh (this will speed up the cooking process and encourage even transfer of heat). Add to the marinade and toss to coat, then cover and marinate in the fridge for at least 4 hours but preferably closer to 24 hours for best results.

Drain off any excess liquid from the collars and set aside on a plate, reserving the marinade.

Mix together the flour and potato starch in a shallow bowl.

Dredge the marinated collars in the flour mix and leave to stand on a wire rack for at least 1 hour, then dip them into the reserved marinade and then back into the flour mix once again. Leave to stand for a further 1 hour. A more significant crust can be developed here if you can leave the collars to stand overnight after the first coating, but both outcomes are excellent.

When you are ready to cook, pour canola oil into a heavy-based saucepan to a depth of 4 cm (1½ in) and heat to 180 °C (350°F). Deep-fry the collars for 5–6 minutes until cooked through and golden brown, stirring occasionally with a slotted spoon to stop them sticking together or catching on the base of the pan.

Remove the collars and drain on a wire rack. Season with salt flakes and dress the outside crust with a little tamarind hot sauce.

Add a few splashes of the hot sauce to the mayonnaise. Stir in the lime juice and season to taste with salt.

To serve, spoon the mayo onto the base of four lightly toasted rolls or buns. Place the crispy fried collars on top and finish with iceberg lettuce, your favourite pickles and the top half of the buns.

PRESSED BASS GROPER THROAT TERRINE

While this might not exactly be your average Tuesday night dinner, please don't dismiss it out of hand. It's such a versatile recipe – once set and made it can be sliced as a terrine and served with toast and pickles like this, offered up as a cold cut with boiled egg, celery, anchovies and bitter greens, or portioned into nuggets, crumbed and deep-fried. This particular part of the fish, which is loved and celebrated in the Basque country and other parts of Europe, brings a lot of gelatine, flavour and natural sweetness. As you'll be needing quite a few throats here it is best to request them in advance from your fishmonger.

SERVES 2

10 bass groper throats
200 ml (7 fl oz) verjuice
2¼ tablespoons extra-virgin olive oil
sea salt flakes and freshly cracked
 black pepper
½ bunch tarragon, leaves picked
 and finely chopped

To serve
quality sourdough
semi-dried tomatoes, halved
pickled onion, sliced into rings
extra tarragon leaves
extra-virgin olive oil
sea salt flakes and freshly cracked
 black pepper

Line a small stainless steel tray, approximately 18 cm (7 in) x 8 cm (3¼ in) x 6 cm (2½ in) deep, with plastic wrap. (If you don't have one, lightly grease a mixing bowl with a similar capacity and line with plastic wrap.)

Place the bass groper throats in a large, wide saucepan. Add the verjuice, olive oil and a pinch of salt and bring to a simmer over a medium heat. Cover with a square of baking paper to keep them submerged and cook gently for 12 minutes, or until the throats are very tender. Increase the heat and boil until the cooking liquid has reduced and thickened to a sticky glaze around the cooked throats.

Add the chopped tarragon and season well with salt and pepper, then decant the throats and glaze into the prepared mould. Cover closely with a sheet of baking paper to ensure the top doesn't dry out and chill in the fridge for a minimum of 12 hours until set firm.

The next day, turn out the terrine and, using a hot sharp knife, cut into thickish slices. Top grilled sourdough with beautiful semi-dried tomatoes, pickled onion rings and extra tarragon leaves, finishing with slices of the terrine. Brush with a little extra-virgin olive oil, season liberally with salt and pepper, and eat.

DRUNKEN BASS GROPER, MUSHROOMS AND CONDIMENTS

This dish is inspired by two incredible Australian chefs, Kylie Kwong and Neil Perry. I have had many memorable experiences with a dish of this nature at both of their restaurants. The big, fleshy, succulent bass groper really comes into its own here as it soaks up the flavours from the stock. And while this dish is designed to be eaten hot on the day you cook it, another option is to make it a day ahead and store the fish in the stock overnight, then serve it cold the next day.

Depending on the particular fish, the gelatine from the skin and bones can set the stock into a jelly, which is so delicious. The stock itself may be used in other ways; it's brilliant for cooking mushrooms, chicken, pork and vegetables of all kinds. Similarly, the ginger spring onion sauce also translates very well to a number of other recipes.

SERVES 4

4 × 150 g (5½ oz) bass groper darnes, skin on
12 fresh shiitake mushrooms
100 g (3½ oz) oyster mushrooms
100 g (3½ oz) enoki mushrooms
1 teaspoon sesame oil
XO sauce (shop-bought or homemade, see page 257), to serve

Ginger spring onion sauce
50 g (1¾ oz) finely grated fresh ginger (older ginger will be spicier)
6 spring onions (scallions), finely sliced
350 ml (12 fl oz) peanut oil (or canola oil)
60–70 ml (2–2½ fl oz) light soy sauce, to taste

White pepper, sesame and sichuan seasoning
1 tablespoon ground white pepper
1 tablespoon white sesame seeds
1 tablespoon sichuan peppercorns

Stock
2.5 litres (85 fl oz/10 cups) shaoxing rice wine
175 ml (6 fl oz) light soy sauce
75 g (2¾ oz) dried shiitake mushrooms
225 g (8 oz) peeled fresh ginger, cut into 2–3 mm (1/8 in) thick slices
7 spring onions (scallions), cut into 5 cm (2 in) batons
2 tablespoons ground white pepper
4 star anise
2 garlic bulbs, halved
8.5 litres (287 fl oz/34 cups) water

To make the ginger spring onion sauce, combine the ginger and spring onion in a small heatproof bowl. Heat the oil in a small saucepan until almost smoking, then immediately pour it over the ginger and spring onion mixture. You should see and hear it sizzling. (If this isn't happening the oil isn't hot enough, so return it to the heat and try again.) Season with the soy and mix together well. Set aside to cool to room temperature. The sauce will keep in the fridge for up to a week, but the flavour will start to lose its punch over time.

For the white pepper, sesame and sichuan seasoning, toast the ingredients individually in a dry frying pan until aromatic, then use a mortar and pestle to grind them together into a powder. Spoon into a small bowl and set aside.

Add all the stock ingredients to a large saucepan and bring to the boil over a high heat, then reduce the heat and simmer for 1 hour. Remove from the heat. Add the groper chops, cover with a lid and set aside for 10–12 minutes, until the flesh is just opaque and the internal temperature of the fish at its thickest part measures 44°C (111°F) on a probe thermometer.

Using a slotted spoon, carefully transfer the fish pieces to a clean plate and gently peel away the skin (it should peel off easily if the flesh is cooked). Leave to rest for 3–4 minutes.

While the fish is resting, add the mushrooms to the hot stock (still off the heat) and leave for 2 minutes to gently warm through.

Divide the fish pieces among serving bowls, top with the tender mushrooms, drizzle over a little sesame oil and ladle over a little of the stock to finish. Serve immediately with the ginger spring onion sauce, sichuan seasoning and a small bowl of XO sauce.

Note: This stock can be used over and over again, and will become increasingly flavourful and viscous every time you use it. To store it safely, bring the stock to the boil after every use, then strain off any impurities and keep in an airtight container in the fridge. If you find the flavour becomes unbalanced from reduction, just add some water; similarly, if it needs a boost, add soy sauce, shaoxing or fresh aromats to restore the flavour profile.

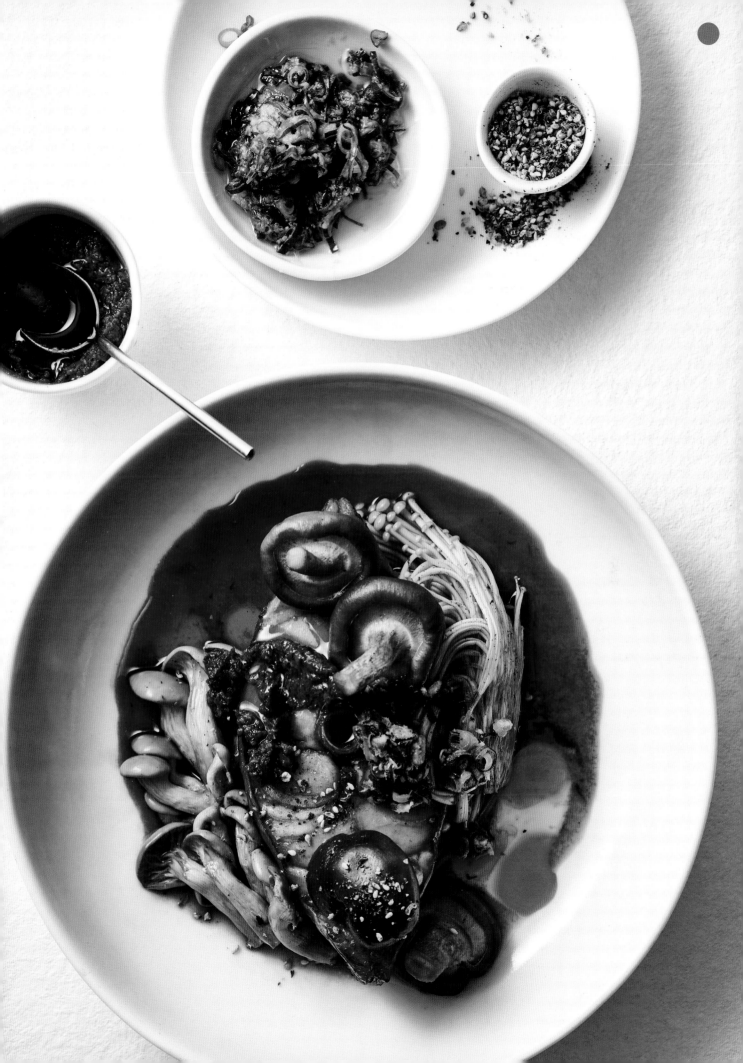

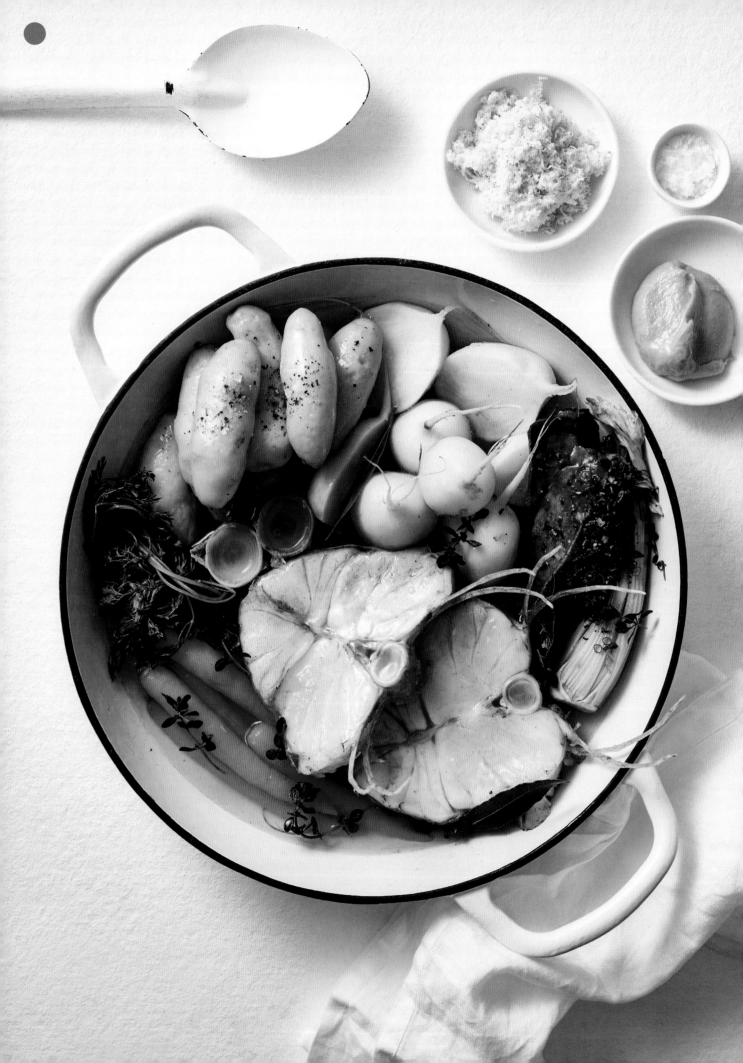

GROPER POT AU FEU

When I was in Paris a few years ago, I had the great honour of dining with my friend Canadian chef Matty Matheson at Daniel Rose's inspirational La Bourse et La Vie. Among the plates of jaw-droppingly good foie gras, sweetbreads and leek vinaigrette came a humble pot au feu. Now, while I'd certainly eaten pot au feu before, I'd never seen such reverence placed on each and every component of the dish – from the finesse with which the meat was cooked to the way the crystal-clear broth was dotted with perfectly picked chervil leaves. No doubt the setting and company contributed to such a glowing memory (I was eating lunch in a bistro in Paris), but the dish certainly made a big impression and inspired me to create this version with groper.

When seeking out the array of cuts for this recipe, either commit to a small groper that is manageable for you or ask your fishmonger to set these ingredients aside for you. It won't be any trouble – all of these cuts are seen by fish shops around the world every day.

SERVES 6

400 g (14 oz) unpeeled small
 kipfler potatoes
1 large onion, finely sliced
3 large leeks, white and pale green
 parts only, finely sliced
3 carrots, peeled and finely sliced
6 celery stalks, finely sliced
6 flat-leaf (Italian) parsley sprigs
6 thyme sprigs
2 fresh bay leaves
1 teaspoon whole black peppercorns
sea salt flakes and freshly cracked
 black pepper
6 litres (202 fl oz/24 cups) cold water
1 × 1.5 kg (3 lb 5 oz) bass groper head,
 eyes and gills removed
6 small turnips, washed
3 swedes (rutabaga), peeled and
 cut into 6 pieces each
12 baby carrots, washed
12 baby leeks (optional)
2 × 250 g (9 oz) bone-in
 bass groper chops or darnes
1 × 8 vertebrae of bass groper bone
 marrow (optional)
1 × 200 g (7 oz) fresh bass groper liver
1 bunch chives, finely sliced
freshly grated horseradish and dijon
 mustard, to serve

Cook the potatoes in a saucepan of salted boiling water until tender. Drain and leave to cool, then peel and set aside until needed.

Place the onion, leek, carrot and celery in a large saucepan.

Tie the parsley, thyme and bay leaves in a piece of muslin (cheesecloth) to make a bouquet garni and add to the pan, along with the peppercorns and 1 tablespoon salt. Pour in the cold water and bring to the boil over a high heat, then reduce the heat to low. Add the fish head and simmer, partially covered with a lid and frequently skimming any foam off the surface, until the head is completely cooked, about 20 minutes. Remove the groper head from the pan and set aside to cool.

Strain the broth, discarding the solids or using them in another meal, then return it to the pan and bring to the boil over a high heat. Cook for 45 minutes, or until reduced down to 1.5 litres (51 fl oz/6 cups). Add the turnips, swede and baby carrots, cover and simmer over a low heat for 25–30 minutes, until the vegetables are just tender. Add the cooked potatoes and baby leeks, if using, then cover and simmer for a further 5 minutes until the leeks are tender and the potatoes have taken on the flavour of the broth. Remove the vegetables with a slotted spoon and assemble them on a generous serving platter.

Bring the broth back to the boil. Add the bass groper chop and bone marrow, if using, then remove from the heat, cover with the lid and set aside for 9 minutes. Add the liver to the pan and set aside, covered, for another 3 minutes, or until the fish reaches an internal temperature against the bone of 46°C (115°F) and the liver pieces have been warmed through to medium-rare but are still nice and pink. Remove the fish and liver pieces from the hot broth and leave to rest on separate plates. Cover the cooked liver with cut chives and season liberally with salt flakes and cracked pepper.

Strip away the jowls, cheeks and meat from around the jaw and at the top of the cooled fish head. Separate out the bone marrow, using a knife to cut between each vertebrae.

Position the bass groper chop just off centre on the serving platter. Spoon the marrow from the vertebrae alongside the tender vegetables and top with a few pieces of cooked meat from the head and the sliced liver. Ladle over the broth, season liberally and serve with grated horseradish and mustard.

11

Ocean Trout

Ocean trout is part of the Salmonidae family of ray finned fish that includes salmon, chars, graylings and freshwater whitefish. With their nutrient-dense flesh, bright orange 'brand' and fail-safe list of tried and tested methods of culinary application they are a favoured species of many, and it seemed important that one of these fish be included here, even though I rather dislike what they have become – a bit of a no-thought 'go-to' fish cookery option. In fact, they offer up a broad spectrum of opportunity that goes well beyond a pan-fried medallion.

Ocean trout is a very fatty fish, one reason why they are so prized for curing and smoking – their luxurious texture and rich flavour a timeless staple when executed well. Beyond this, trout is commonly found in the form of a boneless, skin-on fillet. Many people will have cooked with the fillets before but maybe not considered fine tuning. For example, first dry the skin on a wire rack set over a tray in your fridge for a minimum of 12 hours. This also slightly reduces the flesh, making the fats within the trout more prominent. Removing surface moisture from the skin like this also greatly reduces the risk of the fish sticking while cooking.

There are myriad methods of cookery that can be explored when working with ocean trout and many flavours that showcase the trout's natural flavour. Complementary flavours include quality citrus, asparagus, figs, green beans, hazelnuts, celeriac, aromatic Thai herbs and fragrant chillies, along with beetroot, grilled corn and shellfish such as mussels or vongole, which really emphasise the sweetness of the trout. Ocean trout can be transformed into wonderful fish sausages, silky smooth mousses, baked inside pastry as a wellington, eaten raw or lightly cured and smoked to showcase its richness and delicate texture. When you think about it, after all that, buying skinless, boneless fillets sounds kind of boring.

Alternatives
SALMON · FRESHWATER TROUT

Points to look for
FIRM FLESH · VIBRANT NATURAL COLOURING OF SKIN AND FLESH

Best cooking
PAN-FRIED · POACHED · STEAMED · RAW · SMOKED · CURED · BAKED

Accompanying flavours
**FIGS · BUTTER BEANS · BACON · ASPARAGUS · NUTS · FENNEL
CITRUS · BEETROOTS · SAFFRON · CHILLI**

SCOTCH EGGS

As with so many traditional dishes there are disputes over the origin of the Scotch egg, with claims ranging from India to Yorkshire, even the grand department store Fortnum & Mason in London. In 2019 I was lucky enough to cook at a Fortnum & Mason event, and naturally one of the canapés was a Scotch egg. Although I didn't use ocean trout or salmon on that occasion, the versatility of this recipe allowed me to use red gurnard and a little sea bass fat to increase the fattiness of the sausage. This recipe can be adapted to suit all size eggs; from a very large duck egg down to a bite-sized quail egg, and can also be seasoned with different herbs and spices than the ones listed below. However, in my opinion they must be served with mustard or, at the very least, a quality mayonnaise.

MAKES 8

10 free-range eggs
150 g (5½ oz/1 cup) plain
 (all-purpose) flour
sea salt flakes and freshly cracked
 black pepper
2½ tablespoons full-cream (whole) milk
120 g (4½ oz/2 cups) white panko
 breadcrumbs
canola oil, for deep-frying

Filling
2 tablespoons ghee
10 French shallots, finely diced
250 g (9 oz) ocean trout belly,
 cut into large chunks
chilled water, if needed
250 g (9 oz) skinless, boneless white fish
 fillet (ling, cod, groper or snapper),
 cut into 1 cm (½ in) dice
1½ teaspoons fine salt
½ teaspoon freshly ground cumin seeds
½ teaspoon freshly ground coriander
 seeds
½ teaspoon freshly ground fennel seeds
2 tablespoons finely chopped coriander
 (cilantro)
2 garlic cloves, finely chopped
1 teaspoon smoked paprika
½ teaspoon cayenne pepper
1 teaspoon lemon thyme leaves
2½ tablespoons dijon mustard
pinch of freshly grated nutmeg
15 g (½ oz/¼ cup) finely chopped chives

To make the filling, heat the ghee in a small saucepan over a medium heat to a light haze. Add the shallot and sweat for 6–7 minutes, until softened. Remove from the heat and chill in the fridge.

Working in small batches, blend the ocean trout belly in a food processor to a smooth mousse, adding a splash of chilled water to help everything emulsify if the mixture seems too oily. Add the remaining filling ingredients, including the chilled shallot, and blend until well combined. Set aside.

Fill a bowl with iced water. Bring a large saucepan of water to the boil. Carefully lower eight of the eggs into the boiling water and cook for exactly 6 minutes, then transfer immediately to the bowl of iced water and leave to cool for 10–15 minutes.

With clean hands, divide the filling mixture into eight even portions and roll into balls.

Once the eggs are cool enough to handle, carefully peel off the shells. Place each portion of filling between two sheets of plastic wrap and flatten into a circle large enough to enclose the egg, then remove the plastic wrap. Place an egg in the centre of each filling circle, then wrap the filling around the egg, gently pressing together to seal but being careful not to press too hard. Place in the fridge for at least 20 minutes.

Preheat the oven to 180°C (350°F).

Place the flour in one bowl and season with salt and pepper, then beat the remaining eggs in another and stir in the milk. Tip the breadcrumbs into a third bowl.

Roll each egg in the seasoned flour, gently tapping off any excess, then dip it in the beaten egg mixture. Finally, roll it in the breadcrumbs, making sure it is evenly coated.

Heat the oil for deep-frying in a deep-fryer or large saucepan over a medium–high heat until it reaches a temperature of 190°C (375°F).

Working in batches of two, add the Scotch eggs to the oil and fry for 2 minutes until golden brown. Remove with a slotted spoon and drain on a wire rack over a baking tray. When all the eggs have been fried, place the tray in the oven for 3–4 minutes, then serve immediately while the yolks are still runny.

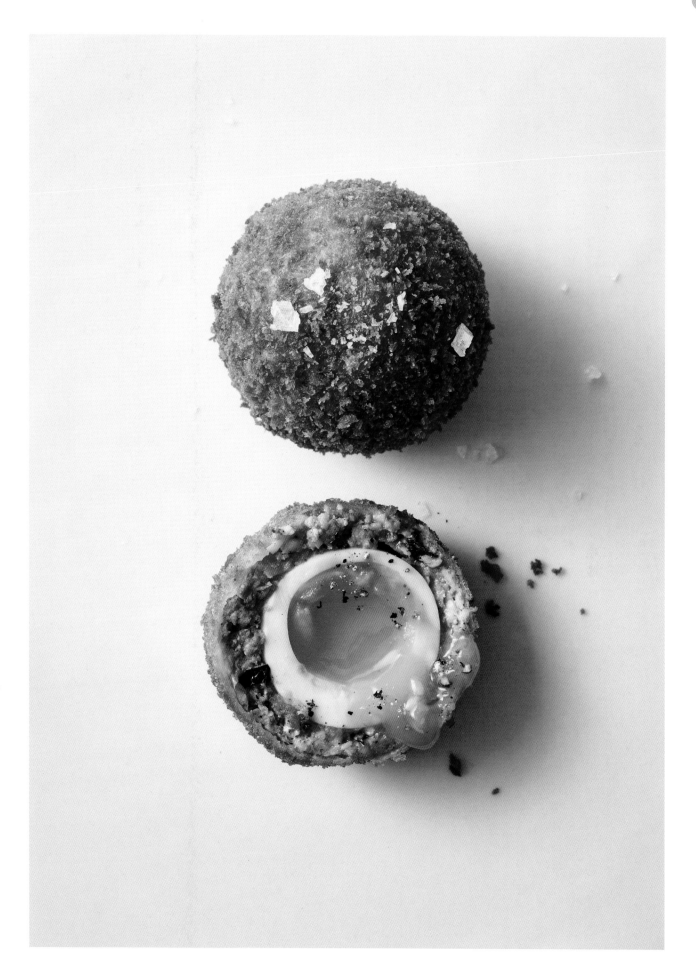

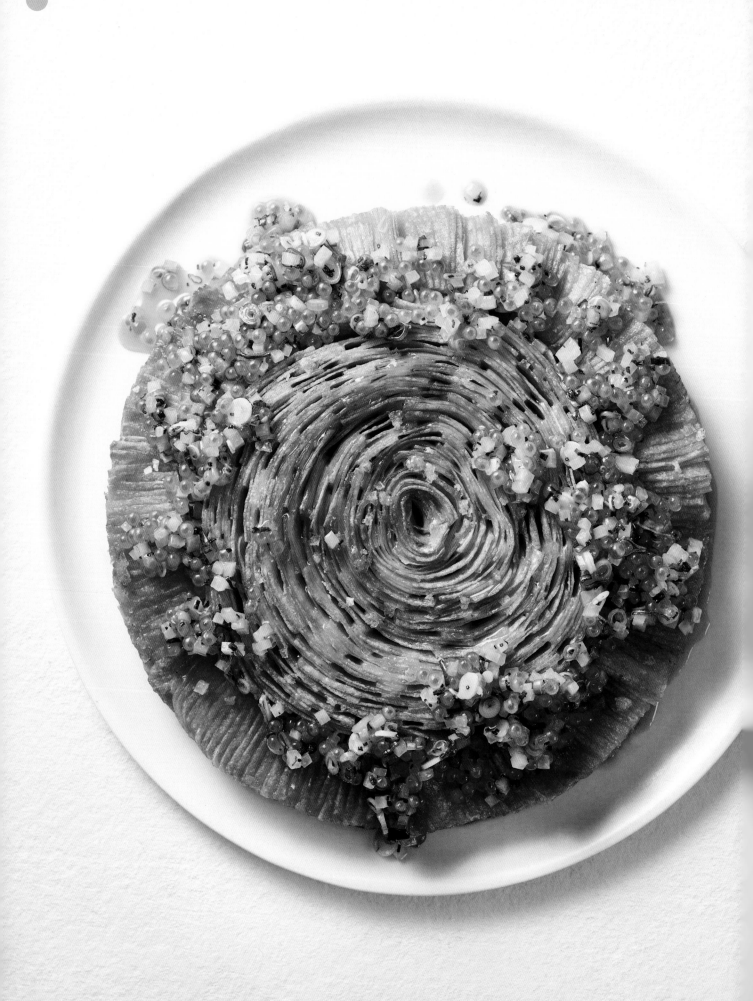

POTATO TART WITH TROUT ROE DRESSING

There are plenty of ways to slice and bake a potato. One fascinating preparation that I recently discovered is Argentine chef Francis Mallmann's 'domino potatoes'. Inspired, I thought how beautiful it would be to apply this somewhat laborious technique to a tart shell. It took some time but we finally settled on the right shape that could be neatly sliced into portions. This recipe can definitely be layered and baked in a standard baking dish, but if you follow the method below this spectacular arrangement of caramelised potatoes with saline pops of trout roe and onion deserves to take pride of place in the centre of the table.

SERVES 8 AS A MAIN OR 12 AS A STARTER

300 g (10½ oz) ghee, melted
sea salt flakes and freshly cracked
 black pepper
24 extra-large desiree potatoes

Trout roe dressing
3 French shallots, finely diced
3 spring onions (scallions),
 finely sliced
2 bunches chives, finely chopped
100 g (3½ oz) ocean trout or salmon roe
1 tablespoon Garum (page 257)
 or fish sauce, plus extra to taste
120 ml (4 fl oz) extra-virgin olive oil
zest of 1 lime
zest and pearls of 3 finger limes

Preheat the oven to 200°C (400°F).

Grease and line a 28 cm (11 in) tart shell with baking paper, then brush the lined shell with ghee and season with salt flakes.

Peel the potatoes with a vegetable peeler. Using a sharp knife, trim the four sides of each potato to form an even brick. Take half the potatoes and, using a mandoline, slice lengthways into rectangular slices about 3 mm (1/8 in) thick, keeping them in order as you go, just like a line of shingled dominoes. Repeat with the remaining potatoes, this time cutting them crossways into square slices, keeping them together. (Use the potato offcuts to make mashed potato or soup.)

Arrange the square slices, quite tightly packed, like dominoes around the outer edge of the tart shell to create a full ring. With the palm of your hand, angle the slices slightly to resemble a line of dominoes that has tilted over.

For the rectangular slices, stand them up on their wide edge and layer them, again tightly packed, concentrically like a snail shell towards the centre of the tart. It's best to add one potato at a time, using the frame of the potatoes already in the shell as a foundation.

Brush the finished tart with ghee and season with salt and pepper. Bake for 50 minutes, or until the potato is browned on the edges and tender in the middle when tested with a skewer. Remove from the oven and allow to rest for a few minutes.

While the tart is resting, make the dressing. Combine all the ingredients in a bowl, then taste and adjust the garum or fish sauce if needed.

To serve, place the tart in the centre of the table, drizzle over the dressing and enjoy immediately.

OYSTER CHARENTAISE AND TROUT MERGUEZ SAUSAGE

The first time I ate this French classic was at Bannister's, Rick Stein's restaurant on the New South Wales south coast. I was floored by the combined textures of the sausage and oyster, along with the heat from the merguez (and probably the cold chablis I was drinking with it). As tempting as it was to precisely replicate this amazing plate of food, I wanted to see if I could make a merguez sausage from fish. It took a few attempts, but we finally landed on the right level of seasoning and heat to complement the oysters and allow the two to sing in harmony. Excellent bread, butter and wine are all critical components here as well.

SERVES 8

90 cm (35½ in) length natural lamb
 sausage casings
48 oysters, freshly shucked
bread, butter and wine, to serve

Trout merguez mix
2 tablespoons ghee
10 French shallots, finely diced
250 g (9 oz) ocean trout belly, cut into
 large chunks
250 g (9 oz) skinless, boneless white fish
 fillet (ling, cod, groper or snapper),
 cut into 1 cm (½ in) dice
1½ teaspoons fine salt
½ teaspoon freshly ground cumin seeds
½ teaspoon freshly ground
 coriander seeds
½ teaspoon freshly ground fennel seeds
2 tablespoons finely chopped
 coriander (cilantro)
2 garlic cloves, finely chopped
1 teaspoon smoked paprika
½ teaspoon cayenne pepper
60 ml (2 fl oz/¼ cup) extra-virgin
 olive oil

Soak the sausage casings in water for 45 minutes.

Meanwhile, for the merguez mix, heat the ghee in a small saucepan over a medium heat to a light haze. Add the shallot and sweat for 6–7 minutes, until softened. Remove from the heat and chill in the fridge.

Working in small batches, blend the ocean trout belly in a food processor to a smooth mousse, adding a splash of chilled water to help everything emulsify if the mixture seems too oily. Add the remaining filling ingredients, including the chilled shallot, and blend until well combined. Set aside.

Using a sausage filler fitted with an attachment wide enough to fit the diced fish through, add the merguez mix to the barrel. Force the mix carefully through the filler into the prepared casings. Create 15 cm (6 in) lengths and coil each one into a round, then tie them off. (Of course you can make straight sausages if preferred, but for presentation a coil looks stunning.) Continue until you have used all the sausage mix – you should have enough to make eight coils.

Place the sausages on a wire rack to dry out the casings before using – ideally overnight, but even a few hours would still help the drying process.

The following day, prepare a charcoal grill, making sure the grill is hot and the charcoal has cooked down to hot embers. Level out the embers so the heat is even.

If you are using bamboo skewers, soak them in water first so they don't scorch during cooking.

Insert a metal or bamboo skewer into each sausage to hold the coil shape in place while grilling.

Place the sausages over the grill rack and cook for 5–6 minutes, making sure the heat is kept moderate until the skins have set. Once this has happened and the sausages are firm without much colour, bring the coals together to create an intense heat and allow the sausages to colour up on all sides for 1 minute or so. Remove from the grill and set aside to rest.

Serve alongside your favourite oysters, preferably something lean and salty that can balance out the fattiness and spice of the sausage. Offer fresh bread, butter and wine to complete the feast.

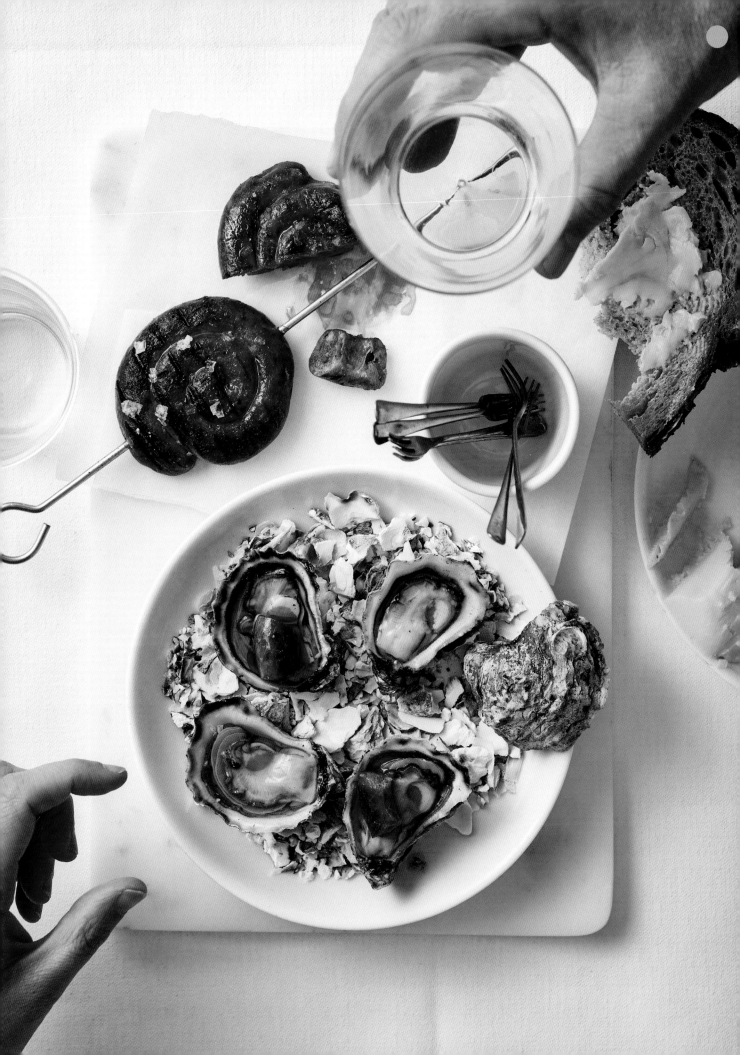

DRY-AGED OCEAN TROUT, MEYER LEMON, SAGO AND CHIVE SAUCE

This is a great dish to present to your guests with a flourish and carve at the table. Cooking one large piece of fish, rather than individual fillets, is definitely the way to go if you're feeding more than two people; you only need to manage one cut in the pan. Just make sure you cook it over an even moderate heat – if it's too hot at the beginning you'll scorch the skin, forcing you to flip the fish to the flesh side, which will then firm up and become dry. (This is why I always try to avoid cooking a fish on its flesh.)

For best results, remove the fillet from the packaging ahead of time. If there is any surface moisture, place it on a wire rack, skin side up, in the fridge for at least two hours to let it dry slightly before pan-frying. If you are working with a very fresh, dry-handled fillet you can leave it for a further three or four days to mature the flavour. This will give you a more savoury result and skin that resembles the glass-like finish of roast duck.

Treat this sauce as a foundation to create new flavours that best suit your palate. I have used Meyer lemon in this recipe but a number of other citrus including sudachi lime, lemonade fruit or Cara Cara orange can be used in the same way, too.

SERVES 4

120 g (4½ oz) ghee
1 × 600 g (1 lb 5 oz) boneless ocean
 trout fillet, skin on

Meyer lemon, sago and chive sauce
2 Meyer lemons (or best available citrus)
100 g (3½ oz) sago (tapioca) pearls
100 ml (3½ fl oz) cold water
2 French shallots, diced
100 ml (3½ fl oz) white wine
2½ tablespoons white-wine vinegar
250 ml (8½ fl oz/1 cup) vegetable stock
75 ml (2½ fl oz) pouring (single/light)
 cream
125 g (4½ oz) butter, chilled and diced
sea salt flakes
juice of 1 lemon
pearls of 2 finger limes
1 bunch chives, finely chopped

Preheat the oven to 150°C (300°F).

To make the sauce, put the Meyer lemons in a saucepan of cold water and cover the surface with a square of baking paper and a small plate to keep them fully submerged. Bring the water to the boil, then strain. Repeat this process twice more, then transfer the lemons to a blender and blitz to a fine puree. Pass through a fine sieve into a lidded container, adding a little water to smooth it out if necessary. Cover with a lid and set aside until needed. This makes more puree than you'll need for the recipe, so place the leftovers in an airtight container and freeze for another time. It will keep for several months.

Bring 200 ml (7 fl oz) of water to a boil, add the sago and cook for 12 minutes, or until the pearls have a small white spot in the centre. Drain through a fine sieve and rinse under cold running water until the sago has cooled, then transfer to a lidded container. Stir through the cold water and set aside.

Combine the shallot, wine and vinegar in a medium saucepan over a medium heat, bring to a simmer and cook for 8 minutes, or until reduced and thickened to a light syrup. Stir in the stock and cream and bring to the boil, then reduce the heat and add the butter, stirring to emulsify. Add 2 tablespoons of the Meyer lemon puree and season to taste with salt, then stir through the finger lime pearls, chives and drained sago pearls. Keep warm until you are ready to serve.

Heat half the ghee in a cast-iron skillet or ovenproof frying pan over a medium heat to a light haze. Place the ocean trout fillet, skin side down, in the centre of the pan, put a fish weight or small saucepan on top and cook for 2 minutes, or until you see colour around the edges of the fillet. Lift up the fillet using an offset palette knife and move it to another part of the pan, moving the weight to cover a different part of the fillet as you go. Cook for 2 more minutes, then remove the weight and discard the ghee. Add the remaining fresh ghee, then transfer the pan to the oven and cook for a further 6 minutes, or until the flesh is set and measures 40°C (104°F) when tested with a probe thermometer.

Discard the ghee, then return the pan to the stove and heat over a medium heat for 30 seconds to ensure the skin is thoroughly crisp and puffed from edge to edge. Transfer the fillet to a wire rack, skin side up, and rest for 5 minutes.

Take the fillet to the table whole. Carve and divide among plates, making sure everyone gets some of the crispy skin. Pour over the warm lemon sauce and serve.

12

Yellowtail Kingfish

I can still remember the taste of my very first piece of wild kingfish. It was at Fish Face restaurant in Darlinghurst, Sydney, and was cooked by one of my mentors, Stephen Hodges. I don't know whether it was his exuberant enthusiasm about just receiving this line-caught wonder that morning, or the surgical precision with which he cooked it, but it still lives long in my memory as being an extraordinarily tasty fish.

Since then, I have had a great affection for line-caught wild kingfish, as I feel its clean, oyster-like flavour profile cannot be beaten. However, many prefer the firm, buttery texture of the farmed variety and it is *certainly* easier to procure and less susceptible to spoiling by parasites than the wild alternative.

Personally, I believe the two are completely different and their unique characteristics should be treated in very different ways. In this chapter, for example, I suggest using wild kingfish belly to make a raw dish with finger lime ponzu, which accentuates the fish's natural texture and minerality. Elsewhere, farmed fish is used to make a roast saddle of kingfish that benefits from the additional fat, firmness and thickness of skin to create a crisp, glassy exterior. (The mortadella recipe on page 194 has the versatility to use either fish as a way of using offcuts and trim.) Whichever route you go, be sure to have conversations with your local fish shop or marketplace to ensure you buy a fish that is the best it can possibly be.

Alternatives
SPANISH MACKEREL · MAHI MAHI · TUNA

Points to look for
**COOK A SECTION OF THE FISH TO DETERMINE ITS FLAVOUR
AND TEXTURE SO YOU CAN APPLY THE BEST POSSIBLE
METHOD, WHETHER RAW OR COOKED**

Best cooking
RAW · PAN-FRIED · CURED · ROASTED · POACHED

Accompanying flavours
**BUTTER · SORREL · CITRUS · SEAWEED · ONIONS · GRAPES
ROSEMARY · THYME · SOY · MISO**

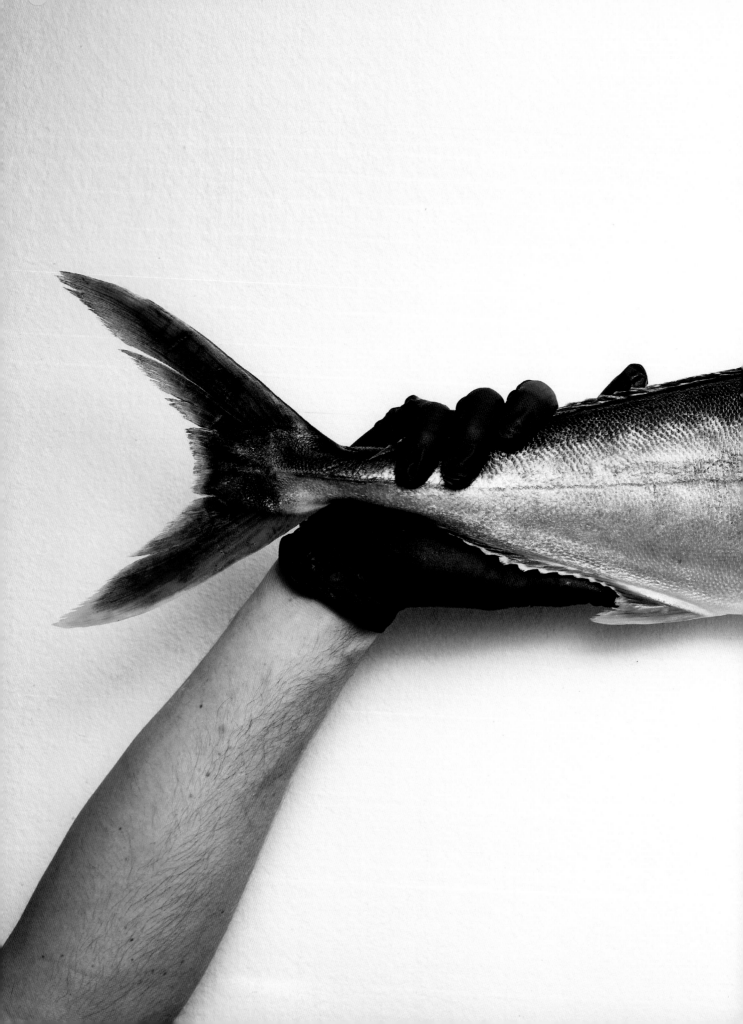

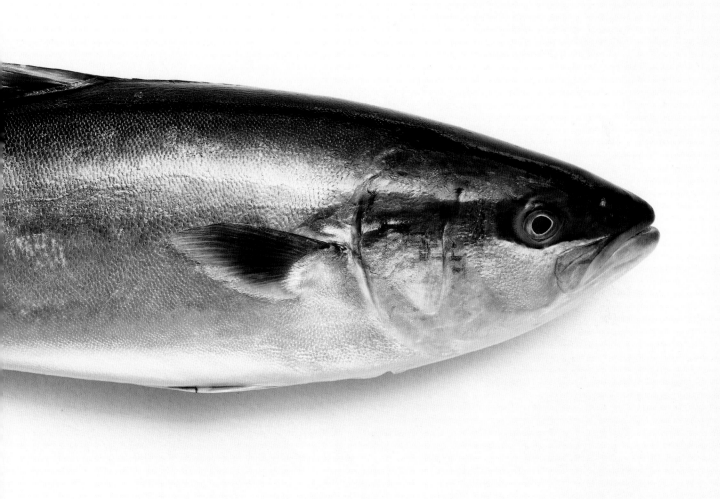

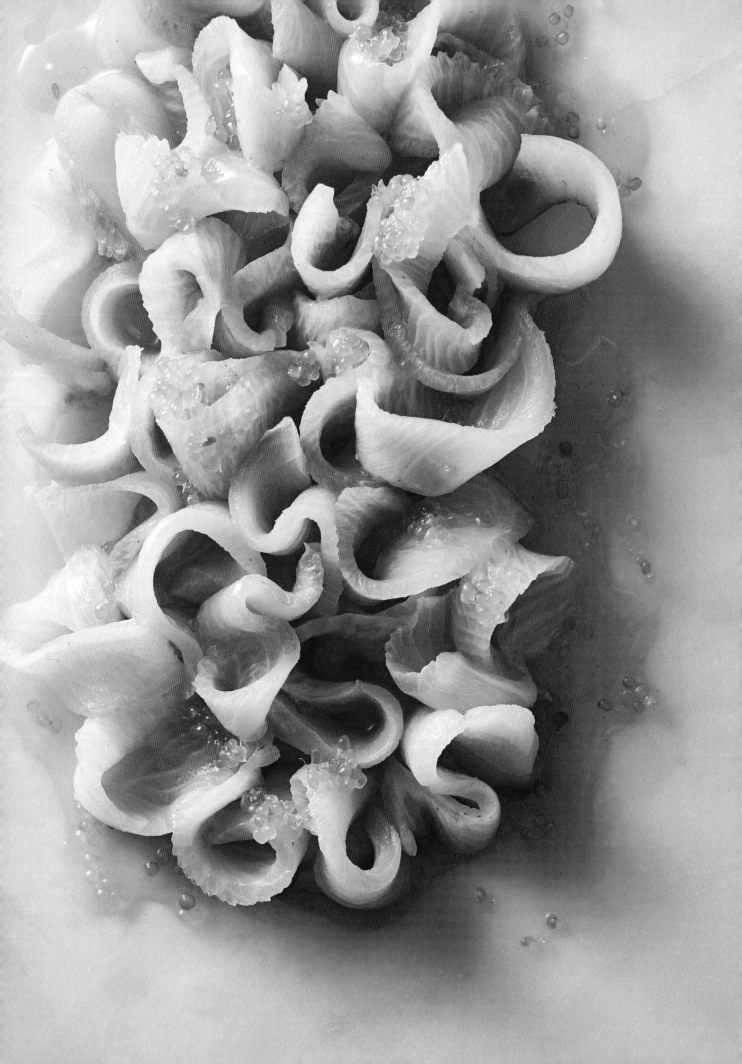

RAW KINGFISH BELLY AND FINGER LIME PONZU

Chefs are often reluctant to target dishes considered to be low-hanging fruit, for example beef and beetroot, fish and fennel, pork and apple. However, in the case of this dish, which is literally raw fish and ponzu, I'm happy to make an exception. The kingfish belly carries so much of the fish's oyster-like flavour profile, and pairing it with the unrivalled pop and acidity of finger limes is a wonderful way to fall in love with this combination all over again, or indeed for the very first time. Use quality ingredients in the ponzu (as the fish is very much nude on the plate and shouldn't be overwhelmed by an imbalance of flavours) and serve at room temperature, so that you can best experience the perfection of wild kingfish at the height of its season.

SERVES 4-6

400 g (14 oz) skinless, boneless
 kingfish belly
fine salt

Finger lime ponzu
2 tablespoons rice vinegar
125 ml (4 fl oz/½ cup) mirin
7.5 cm (3 in) square piece of kombu
15 g (½ oz) shaved bonito flakes
zest of 1 lemon, fruit segmented
 and finely diced
zest of 1 lime, fruit segmented
 and finely diced
zest of 1 orange, fruit segmented
 and finely diced
zest of 1 yuzu and 1½ tablespoons juice
 (otherwise use a pomelo or
 store-bought juice)
zest and pearls of 3 finger limes
1½ tablespoons lemon juice
1½ tablespoons lime juice
1½ tablespoons orange juice
125 ml (4 fl oz/½ cup) white soy sauce
 (or light soy)

To make the ponzu, combine the vinegar and mirin in a small saucepan and bring to approximately 80°C (176°F). Remove from the heat and add the kombu. Stir in the bonito flakes and citrus zest, then cover and allow to cool completely; ideally refrigerate overnight to allow the flavours to develop. The next day, strain the chilled liquid to remove all the solids. Combine the strained liquid with the citrus juice, soy and finger lime pearls. Store in an airtight container in the fridge for up to 1 week. The sooner you use it the more floral and fragrant it will be.

To prepare the kingfish belly, start by removing the skin with a sharp knife. Place the fillet skin-side down with the tail facing you. Put the blade of the knife between the skin and flesh then, keeping the angle of the knife positioned down towards the skin, force the blade along the length of the skin working towards the head of the fillet. The objective here is to leave behind as much of the silver skin as possible, retaining the flavour and natural oils that lie within. Once the skin is removed, turn the fish so that it is silver skin-side up and cut it into thin slices. (Alternatively, ask your fishmonger to do this for you.)

Stir the diced citrus segments into the ponzu dressing.

Arrange the fish slices neatly around a warm bowl that can support a generous spoonful of the ponzu dressing. When you spoon it over the kingfish you want there to be a good balance of citrus segments and pearls.

SADDLE OF KINGFISH

Who says a Sunday roast can't be fish? Here are the bare bones for creating a kingfish roast with its own gravy. In order to achieve a nice crispy exterior and a just-set, rosy interior not dissimilar to a good old-fashioned lamb roast, it is important to start with a very dry skin. The vegetables pictured overleaf are what were available to me at the beginning of spring, but work with whatever vegetables are at their seasonal best. It might be beautiful glazed carrots, onions and peas, perhaps some roast celeriac, parsnips or artichokes, or everyone's favourite: crunchy roast potatoes. Quality mustard or chutney would also be a welcome addition.

Saddle is a butchery term that refers to the meat at the animal's back and hips – in more or less the same place as a saddle on a horse. I use the term for this and other fish as I feel aesthetically it carries a similar bone structure, and also gives you the opportunity to broaden your horizons when it comes to fish, and think beyond the fillet. And because it's cooked on the bone, it has so much more flavour.

SERVES 6–8

1 × 3 kg (6 lb 10 oz) whole kingfish, gutted and scaled
100 ml (3½ fl oz) grapeseed oil
sea salt flakes

Kingfish bone sauce
2 kg (4 lb 6 oz) kingfish bones and trimmings (from the butchery of a whole fish)
10 French shallots, finely sliced
4 garlic cloves, finely sliced
300 ml (10 fl oz) white wine
200 ml (7 fl oz) white-wine vinegar
12 thyme sprigs
80 ml (2½ fl oz/1/3 cup) dark soy sauce
600 ml (20½ fl oz) Brown Fish Stock (page 256)

To prepare the kingfish saddle, start by removing the head and collars by cutting down either side of the collar with a sharp knife. When your two cuts meet at the top, using your hands, break the spine at the cut and pull the head off. Set it aside for the sauce.

Next remove the first portion of the fillet from the kingfish on both sides, leaving behind the main central spine. You can use these fillets in another recipe. Using sharp scissors, clean away the surrounding bones and framework from the central spine and leave behind the one single bone.

For the tail, using your knife, take about 10 cm (4 in) of fillet off the bone from both sides. This will expose the framework of the kingfish spine. Using scissors, trim off the skirting on either side of the spine, leaving the single central spine bone. This is not only for flavour but also for its presentation quality.

Place the kingfish on a cutting board and, assuming you are right-handed, start with the head to the left. The aim here is to cut the belly and rib bones off the fish. Draw the blade down the lower half of the fillet, where the fish tapers into the belly, all the way down to the tail. Repeat on the other side. These cuts will give you the two top loins sitting on one central spine that you can see at the head end right through to the tail end. Now that the cavity of the fish is fully exposed, using scissors and starting at the head end, snip away the remaining rib bones from the central spine. Repeat on both sides of spine. You will now be able to pin-bone the fish from within the cavity.

The end result is a barrel of kingfish with an exposed spine bone at both ends, free of both rib and pin-bones (see picture overleaf).

To make the bone sauce, place the fish bones and trimmings in a wide shallow frying pan that will fit them in one layer and brown over a medium–high heat for at least 15 minutes. The aim is to scrape up the sediment that settles on the base as it forms, allow all the fat to render, and the trimmings to crisp up. When very brown, tip everything into a colander over a bowl and allow any fat to drain, reserving it for later.

Return the solids to the same pan, add the shallot and garlic and cook for 10 minutes, or until lightly coloured and starting to smell sweet. Add the wine, vinegar and thyme and cook, stirring often, for 10 minutes, or until reduced to an almost glaze-like consistency. Add the soy sauce and stock and return to the boil, then reduce the heat and simmer very gently, turning the fish occasionally, for 20 minutes or until thickened and reduced. Strain through a sieve, pressing hard on the solids, then strain again through a second clean sieve and leave to rest in a warm spot so the fat separates from the sauce. Allow to cool to room temperature. Pass the warm reserved fat through a very fine sieve, then pour over the sauce. Warm the sauce through over a low heat just to heat it through without boiling.

Preheat the oven to 100°C (210°F).

To cook the kingfish saddle, heat a wide-based cast-iron frying pan over a medium heat. Brush the kingfish with a little oil and season liberally with salt flakes, then carefully place in the hot pan, skin side down. Cook for 3 minutes, moving it around the pan to ensure the skin browns evenly. Flip it over and cook the other side for 3 minutes.

Position a wire rack inside a baking tray. Place the browned kingfish saddle, bone side down, on the rack and roast for 45 minutes, or until the thickest part of the fish reaches 40°C (104°F) on a probe thermometer.

Remove from the oven and leave to rest for 8–10 minutes.

Place the kingfish in the centre of a serving plate and glaze the saddle with the bone sauce. Serve with seasonal vegetables and your favourite mustard or chutney.

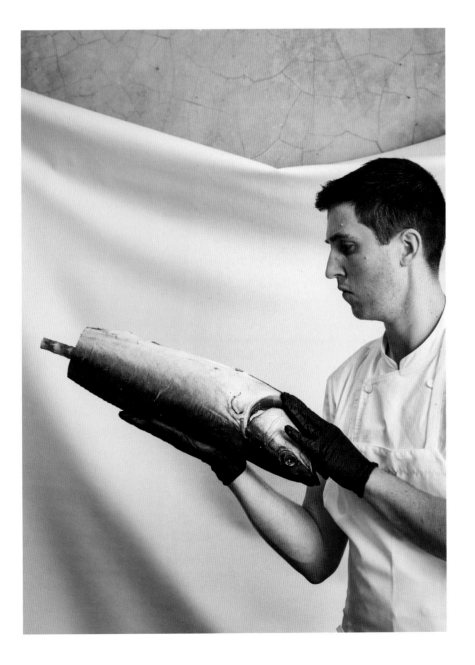

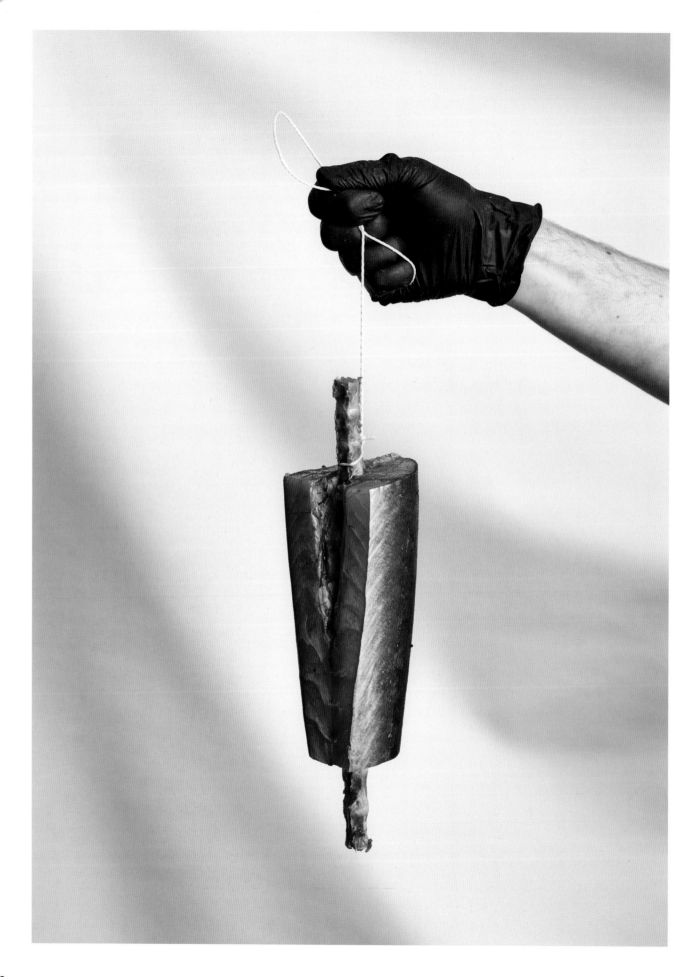

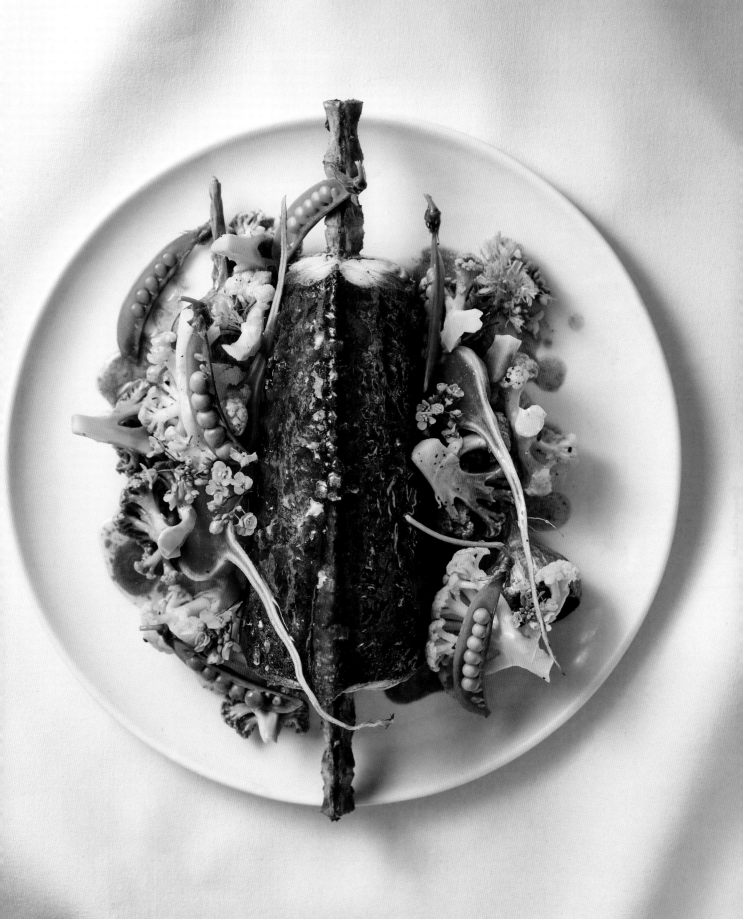

KINGFISH BANH MI

We added this banh mi sandwich to the Fish Butchery takeaway menu right after we wrote *The Whole Fish Cookbook*, which included a recipe for kingfish milt mortadella. Chef Rebecca Lara helped develop and fine-tune this delicious recipe. Please don't be daunted by the number of elements. If you don't have time to make them all to create the sandwich, try making just one and adapting it to suit whatever ingredients you have to hand.

SERVES 4

4 baguettes, halved horizontally
90 g (3 oz/1/3 cup) quality mayonnaise
2 Lebanese (short) cucumbers, sliced
 lengthways into long batons
1 bunch coriander (cilantro), roots
 removed, sprigs separated
large handful mint leaves, torn
8 spring onions (scallions), green part
 only, sliced into long batons
Quick Pickled Vegetables
 (page 260), to serve
1 red chilli, finely sliced
2 teaspoons Maggi seasoning
 or light soy sauce

Kingfish brawn
3 litres (101 fl oz/12 cups) Brown Fish
 Stock (page 256)
3 kingfish heads (about 500 g/1 lb 2 oz)
3 titanium-grade gelatine leaves
chilled water, for soaking
2 French shallots, finely diced
½ bunch chives, finely sliced
½ bunch chervil, leaves picked and
 finely sliced
¼ bunch flat-leaf (Italian) parsley,
 leaves picked and finely sliced
1 teaspoon dijon mustard
40 g (1½ oz/1/3 cup) tiny salted capers,
 rinsed and drained
40 g (1½ oz) finely diced gherkin
 or cornichon
salt flakes and freshly cracked
 black pepper

Kingfish liver pâté
2 tablespoons white-wine vinegar
2 tablespoons white wine
1½ French shallots, finely sliced
½ teaspoon thyme leaves
2 tablespoons ghee
300 g (10½ oz) kingfish livers, trimmed
iced water, for chilling
120 g (4½ oz) butter, softened
sea salt flakes and freshly cracked
 black pepper

Kingfish mortadella
1 kg (2 lb 3 oz) skinless, boneless
 kingfish fillet, cut into 2.5 cm (1 in)
 cubes
80 g (23/4 oz) tapioca starch
1 teaspoon fine salt
1 teaspoon caster (superfine) sugar
2½ tablespoons Garum (page 257)
 or fish sauce
1 teaspoon baking powder
210 ml (7 fl oz) water
1 tablespoon freshly cracked
 black pepper

For the brawn, bring the fish stock to the boil in a large saucepan. Remove from the heat, submerge one of the fish heads in the hot stock and cover with a fitted lid. Cook over a low heat for 12–15 minutes, until the flesh from the head starts to slip off. Repeat with the remaining heads, cooking them one by one. Remove the stock from the heat. While the heads are still hot, put on a pair of disposable gloves and carefully pick off the flesh, taking care to avoid any scale, bone or cartilage. Once you've finished, check the picked flesh again to make sure, then let it cool to room temperature.

Boil the stock over a high heat until reduced to 200 ml (7 fl oz).

Soak the gelatine in chilled water for 5 minutes until softened. Squeeze the water from the gelatine leaves, then add them to the reduced stock and stir to combine.

Place the picked fish flesh in a large bowl and stir in the shallot, herbs, mustard, capers, gherkin or cornichon and reduced stock and gelatine mixture. Season to taste with salt and pepper. Now you can either roll the brawn into a log or, more traditionally, set it in a terrine mould lined with plastic wrap. If doing the latter, pack the mix in tightly with no gaps or air pockets. If you are rolling it, chill the mix in the fridge for 10 minutes or so first to make it easier to handle. The tighter you pack the mix the better the cut profile will look. Place on a plate in the fridge and chill for at least 6 hours but preferably overnight. This brawn will keep in the fridge for up to 4 days and is wonderful simply served with a green salad, some chutney and toast.

For the pâté, place the vinegar, wine, shallot and thyme in a small saucepan over a medium heat and reduce to a syrup, about 5 minutes. Heat the ghee in a medium frying pan over a high heat and bring to a light haze. Briefly sauté the livers on both sides until well caramelised, about 1 minute all up. Place the liver and reduction in a blender and blitz for 2 minutes or until smooth and combined. Remove from the blender and, using a pastry card, force the mixture through a drum sieve to remove any graininess or imperfections. Set the smooth pâté over a bowl of iced water to cool slightly.

Place the butter in a stand mixer fitted with the whisk attachment and whip until very pale and doubled in volume. Add the cool but not fully set pâté and whisk for 2 minutes until smooth. Season well with salt and pepper. Store in the fridge for no more than 3 days, otherwise it will start to discolour. This is another great recipe to serve as a canapé or snack with crisps and bitter leaves.

To make the mortadella, coarsely mince the kingfish fillet using a mincer or food processor. Transfer the mince to a baking tray or bowl and cool in the freezer until almost frozen. Combine the chilled mince with the remaining ingredients in a chilled blender and blitz until smooth, making sure it stays very cold. (To ensure your blender remains cool during this time remember to chill your jug before adding the mince.) It is important at this stage that the kingfish is blended to the point of being really whipped, with the consistency of a sticky mousse. Roll the mortadella into three small sausages, using a square of plastic wrap for each one to create the sausage-like casing. Steam at approximately 85°C (185°F) for about 40 minutes, until firm and evenly set. Use a probe thermometer to check the temperature of the water and adjust the heat accordingly. Refrigerate the mortadella sausages overnight for at least 12 hours until completely chilled. Store in their plastic wrap in the fridge for up to 6 days.

To assemble, take a baguette and spread mayonnaise on one of the cut sides and pâté on the other. Layer with four slices of mortadella, four thin slices of brawn, four slices of cucumber, a few coriander sprigs, a few mint leaves, spring onion and pickled vegetables. Finish with sliced red chilli and a few drops of Maggi seasoning or soy. Close the sandwich and repeat with the remaining baguettes and filling ingredients.

KINGFISH FAT CARAMEL MACARONS

Fish fat seems to be cropping up in a multitude of recipes throughout this book. I became drawn to the idea of using it once I learned that, for some farmed species, fat accounts for upwards of 5 per cent of their total body weight. The first recipe we tried was a salted caramel, where we replaced a significant amount of butter with fish fat. The result was delicious, with only a very mild hint of fish flavour. It is extraordinary to work with and I believe these macarons are another great way of showcasing this underutilised ingredient.

Once completely cooled, the caramel can be stored in a container in the fridge or added directly to the buttercream. The best way to melt chilled caramel straight from the fridge is to warm it in a small saucepan until it liquifies. Just make sure you let it cool before using so it doesn't melt the buttercream.

MAKES 40

Kingfish fat salted caramel
65 g (2½ oz) thick (double/heavy) cream
½ vanilla bean, split and seeds scraped
130 g (4½ oz) caster (superfine) sugar
20 g (3/4 oz) liquid glucose
50 g (13/4 oz) butter
30 g (1 oz) Rendered Fish Fat
 (page 258)
pinch of sea salt flakes

Macarons
250 g (9 oz/2 cups) icing (confectioners')
 sugar, sifted
250 g (9 oz) almond meal, sifted
90 g (3 oz) egg whites
250 g (9 oz) caster (superfine) sugar
80 ml (2½ fl oz/1/3 cup) water

Vanilla powder
1 vanilla bean

Caramel buttercream
60 g (2 oz) butter, softened
¼ teaspoon fine salt
90 g (3 oz/3/4 cup) icing
 (confectioners') sugar, sifted
1 tablespoon thick (double/heavy)
 cream
10 g (¼ oz) kingfish fat salted caramel,
 melted and cooled (see recipe intro)

For the fish fat caramel, combine the cream, vanilla bean and seeds and half the sugar in a medium saucepan and warm over a low heat for about 5 minutes to dissolve the sugar and infuse the vanilla flavour. Set aside and allow to cool.

Combine the liquid glucose and remaining sugar in a clean large heavy-based saucepan and cook, without stirring, over a medium–high heat for 10 minutes until the sugar has fully dissolved into the glucose. Continue cooking for another 4–5 minutes until it is a nice dark colour, then pour in the vanilla cream, being very careful as it will spit and boil rapidly. The cream will stop any further colouration of the caramel. While stirring the caramel cream, bring the temperature up to 128°C (262°F). Remove from the heat and whisk in the butter, fish fat and salt until smooth and combined.

Pour the caramel into a large mixing bowl and allow to cool completely on the bench. Set aside or refrigerate until needed.

To make the macarons, place the icing sugar, almond meal and half the egg whites in a bowl and beat in with a pastry card or spatula. Set aside.

Place the remaining egg whites in the bowl of a clean stand mixer fitted with the whisk attachment. Start mixing on medium speed until lightly foamy, then slowly rain in 25 g (1 oz) of the caster sugar and whisk to stiff peaks.

Meanwhile, place the water and remaining caster sugar in a saucepan over a medium heat until the sugar has dissolved, then heat over a high heat until it reaches 112°C (233°F). Remove from the heat, then, with the motor running, carefully and slowly pour into the beaten egg whites to make an Italian meringue. Set aside to cool at room temperature to 40°C (104°F).

With a pastry card or spatula, gently fold the almond meal mixture into the meringue until well incorporated

Line four large baking trays with baking paper (or work in batches) and use a marker to trace around a 4 cm (1½ in) ring cutter as a guide, leaving a gap of about 3 cm (1¼ in) between each mark. Turn the paper over so it is ink side down. Scoop the macaron mixture into a piping bag fitted with a 1 cm (½ in) flat nozzle, then pipe onto the marks on the lined trays. Tap the trays lightly on the bench and leave to rest for about 1½ hours until the mix forms a light skin.

Preheat the oven to 140°C (275°F).

To make the vanilla powder, microwave the vanilla bean for 20-30 seconds on full power, or until it puffs up and become crisp. Remove from the microwave and leave to cool, then grind to a coarse powder in a mortar and pestle.

Using a fine-mesh sieve, dust the vanilla powder over the macarons, then bake for 12–15 minutes until the macarons loosen easily from the paper and the shell is dry. To achieve the best chewy/crunchy texture, fill the shells as soon as they have cooled. If you are making them ahead of time, store the cooled shells in the freezer.

For the buttercream, place the butter and salt in a stand mixer fitted with the paddle attachment and beat for about 1 minute. (You can use a hand mixer instead if preferred.) Sift in the icing sugar in several batches, beating on low and scraping the side of the bowl after each addition. Add the cream, followed by the fish fat caramel and continue to beat on low until you have an even, fluffy consistency.

Transfer the whipped caramel buttercream to a piping bag fitted with a 1 cm (½ in) flat nozzle. Arrange half the macarons with the base side up and pipe a small coin's worth of buttercream in the centre. Sandwich with the remaining shells, pressing down very gently to spread out the buttercream, and serve immediately.

Once assembled, the macarons should be served within a couple of hours. However, if you want to make the components ahead of time the unfilled shells and caramel will keep for months in separate airtight containers in the freezer. For best results, the caramel buttercream should be stored in the fridge and used within 7 days.

13

Spanish Mackerel

Spanish mackerel is one of my favourite eating fish. It is also an excellent game fish, though that is somewhat lost on me, as I have very little skill in catching fish. (I like to think I make up for this in cooking!) This high-speed fish certainly delivers at the table – anatomically its bones, ribs and structure lend themselves to a plethora of unique cuts that offer up different ways of cooking and seasoning. The flesh has the ability to stand up to the richness and strength of a fiery curry, the clarity and definition of Mediterranean flavours as well as robust herbs such as rosemary, thyme and marjoram.

As with all fish species, starting with a quality specimen puts you in the best place to realise a fantastic end result. Working with line-caught iki jime spiked fish, which arrive whole to the Fish Butchery, has been very exciting, as we have discovered that dry-ageing allows it to develop a wide range of flavour. Between days two and five the fish carries a sweetness and briny-like characteristic that is perfect for pan-frying, roasting or poaching, while from days 12–16 the fish develops a savoury, almost mushroom-like complexity that lends itself to being roasted on the bone and paired with heartier accompaniments. When buying Spanish mackerel (and in particular the fillet), pay attention to the colouring of the flesh – look for a fine red lateral muscle, silvery/bluish skin with no bruising or markings and no discernible odour beyond a light brininess from the ocean.

Alternatives
MAHI MAHI · BAR COD · MULLET

Points to look for
VIBRANT RED MUSCLE AND TRANSLUCENT (NOT DULL) FLESH

Best cooking
PAN-FRIED · ROASTED · POACHED · CURED

Accompanying flavours
CHILLI · CUMIN · TOMATOES · BASIL · OLIVES · MUSHROOMS
SEAWEED · CELERIAC · APPLES · PARSLEY

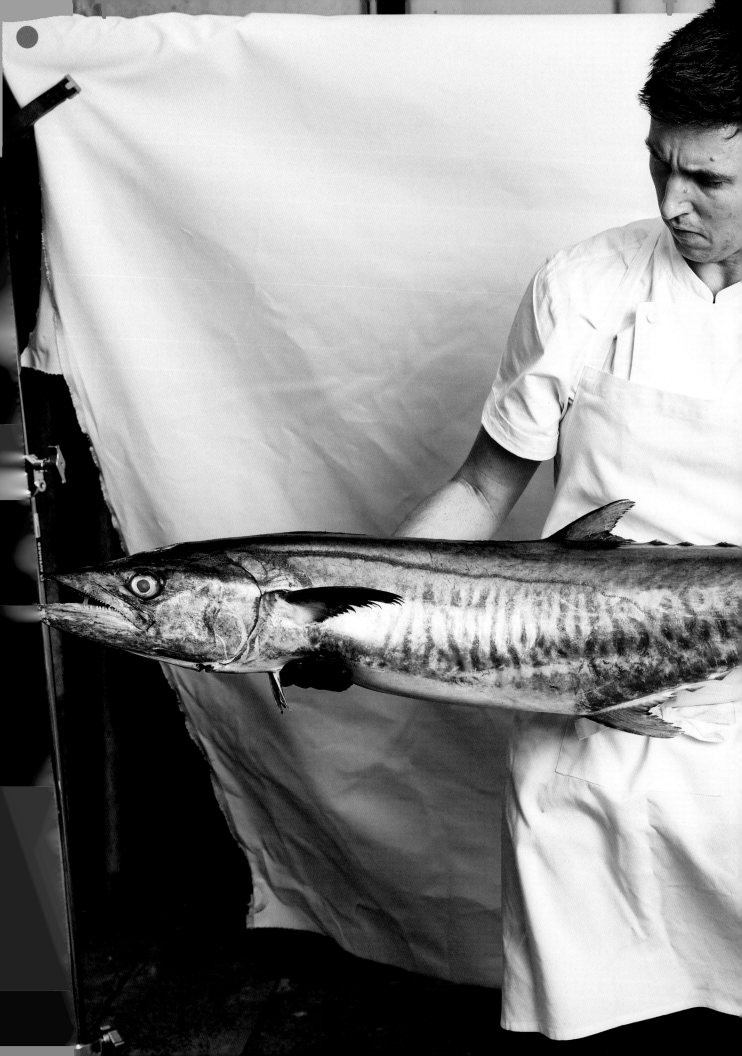

SPANISH MACKEREL CURRY WITH FRIED BREAD

While our restaurant was closed in 2020 we worked with the legendary David Thompson of Long Chim and Nahm restaurants to produce a fish green curry using his incredible paste made from native Thai ingredients. Given the lengths David goes to to procure his ingredients, replicating it is extremely difficult, but here is my best attempt using one of my all-time favourite fish, Spanish mackerel, which brings with it a wonderful briny, oceanic flavour.

The flavours in the curry are nicely balanced. The addition of white pepper and nutmeg shouldn't be overlooked, and take care not to overwhelm the fish with too much seasoning and chilli. That said, when you are serving, consider adding some extra pounded lime leaves, coriander roots and fresh lime juice to really lift the aromatics.

SERVES 4

1 large green chilli, finely chopped (seeds in or out, up to you), plus extra to serve
¼ teaspoon sea salt flakes
12 coriander (cilantro) roots, washed, scraped and finely chopped
2 thick lemongrass stems, white part only, finely sliced
1 tablespoon finely chopped fresh galangal
1 teaspoon finely chopped fresh turmeric
8 kaffir lime leaves, plus extra sliced leaves to serve
4 large banana shallots, finely sliced
6 garlic cloves, finely sliced
1 teaspoon roasted shrimp paste
12 whole white peppercorns, toasted
1 teaspoon coriander seeds, toasted and ground
¼ teaspoon cumin seeds, toasted and ground
pinch of freshly grated nutmeg
600 ml (20½ fl oz) coconut cream
2½ tablespoons peanut oil
2 teaspoons finely shaved dark palm sugar (jaggery), or to taste
60 ml (2 fl oz/¼ cup) Garum (page 257) or fish sauce, or to taste
250 ml (8½ fl oz/1 cup) coconut milk
250 ml (8½ fl oz/1 cup) Brown Fish Stock (page 256)
2 × 300 g (10½ oz) bone-in Spanish mackerel chops or darnes
handful Thai basil leaves
lime wedges, to serve (optional)

Fried bread
320 g (11½ oz) plain (all-purpose) flour, plus extra for dusting
1 large egg
1 teaspoon fine salt, plus extra to serve
2 teaspoons baking powder
1 tablespoon full-cream (whole) milk
40 g (1½ oz) butter, softened
100 ml (3½ fl oz) water
cottonseed oil, for deep-frying

To make the fried bread, place the flour, egg, salt, baking powder, milk and butter in a stand mixer fitted with the dough hook attachment and mix together on the lowest setting. Keeping the speed on low, gradually add the water in a few batches, then continue to mix the dough for 15 minutes until very soft and coming away from the bowl. Cover and allow to rest for 10 minutes.

Turn out the dough onto a clean, lightly floured surface and roll into a long flat loaf shape, about 5 mm (¼ in) thick and 10 cm (4 in) wide. Do your best to make it perfectly uniform. Place the dough in the centre of a large piece of baking paper and wrap it, tucking the ends underneath. Refrigerate overnight.

The following day, take out the dough and let it sit on the counter (still wrapped) for 1–2 hours until it has come back to room temperature and is soft to touch.

While the dough is resting, make the curry paste. Using a mortar and pestle, grind the green chilli and salt to a fine paste. Adding one ingredient at a time, add the coriander root, lemongrass, galangal, turmeric, lime leaf, shallot and garlic, grinding each to a fine paste before adding the next. Add the shrimp paste and grind to combine, then add the peppercorns and pound until finely ground. Finally, add the ground coriander and cumin seeds and nutmeg, pound to combine and set aside.

Pour the coconut cream and peanut oil into a large saucepan and simmer over a medium heat, stirring frequently, for 10 minutes or until thickened and the oil rises to the surface. Add half the curry paste and cook, stirring, for 5 minutes until fragrant. (The remaining paste can be frozen for the next time.)

Add the sugar to the pan and cook for 2–3 minutes, then stir in the garum or fish sauce. Add the coconut milk and stock, stir to combine and simmer for 4–5 minutes. Remove from the heat and add the mackerel chops and Thai basil. Cover with a fitted lid and leave off the heat for 8–10 minutes, or until the mackerel flesh is just set and measures 44°C (111°F) when checked with a probe thermometer.

Meanwhile, make the fried bread. Heat the oil for deep-frying in a deep-fryer or large saucepan over a medium–high heat until it reaches a temperature of 200°C (400°F).

Unwrap the dough and lightly flour it on all sides, then cut it crossways into even 2.5 cm (1 in) wide strips. Stack the strips two by two, then press the centre with a chopstick or a bamboo skewer. Hold the two ends of each stack and gently stretch the dough until about 23 cm (9 in) long. Working in batches so you don't overcrowd the pan, carefully lower the stretched dough into the oil – it should puff and come to the surface right away. Using tongs or chopsticks, quickly roll the dough around in the hot oil to ensure even colour and cook for 1½ minutes, or until golden brown. Remove from the oil and drain on paper towel. Season well with fine salt.

To serve, spoon the curry into bowls and top with extra finely sliced lime leaves and chilli. Serve with the fried bread and lime wedges, if using.

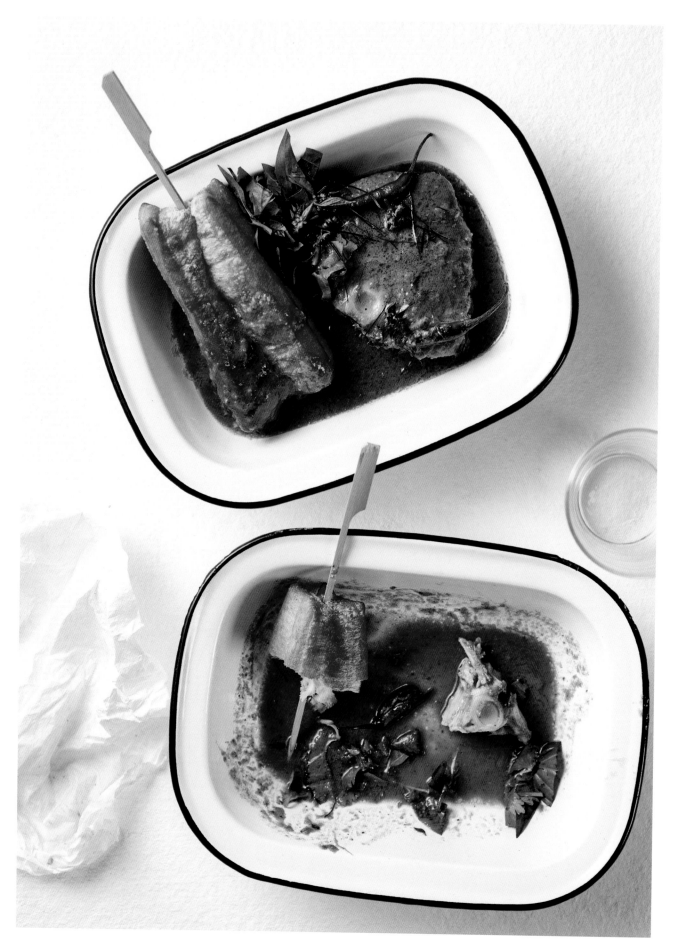

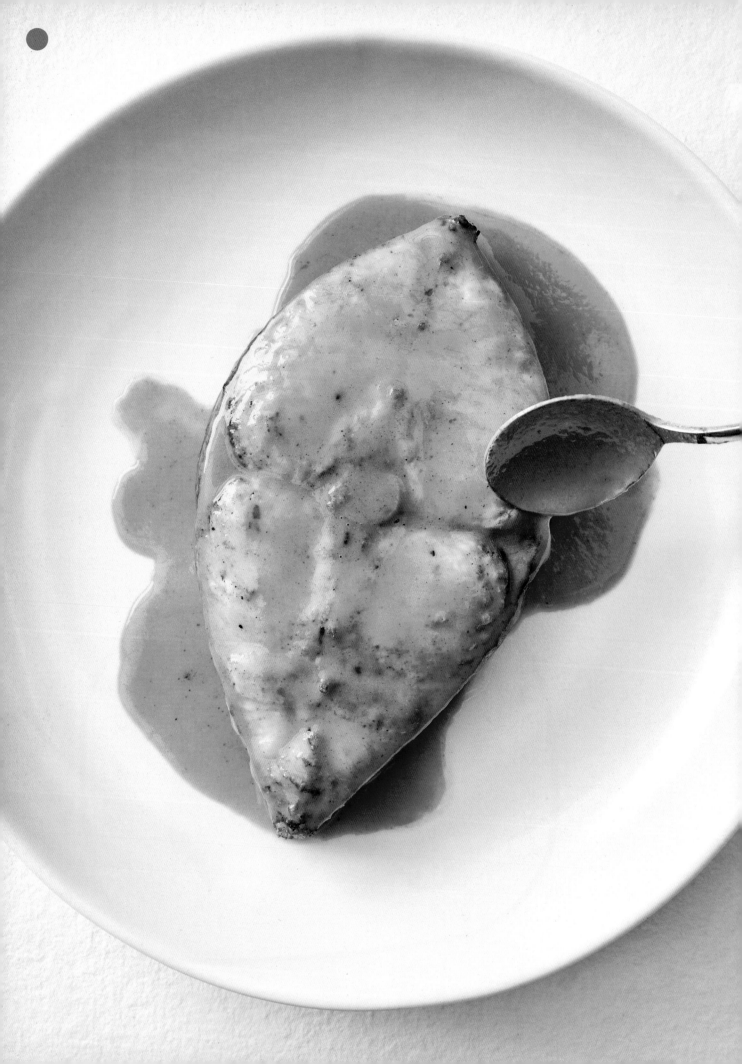

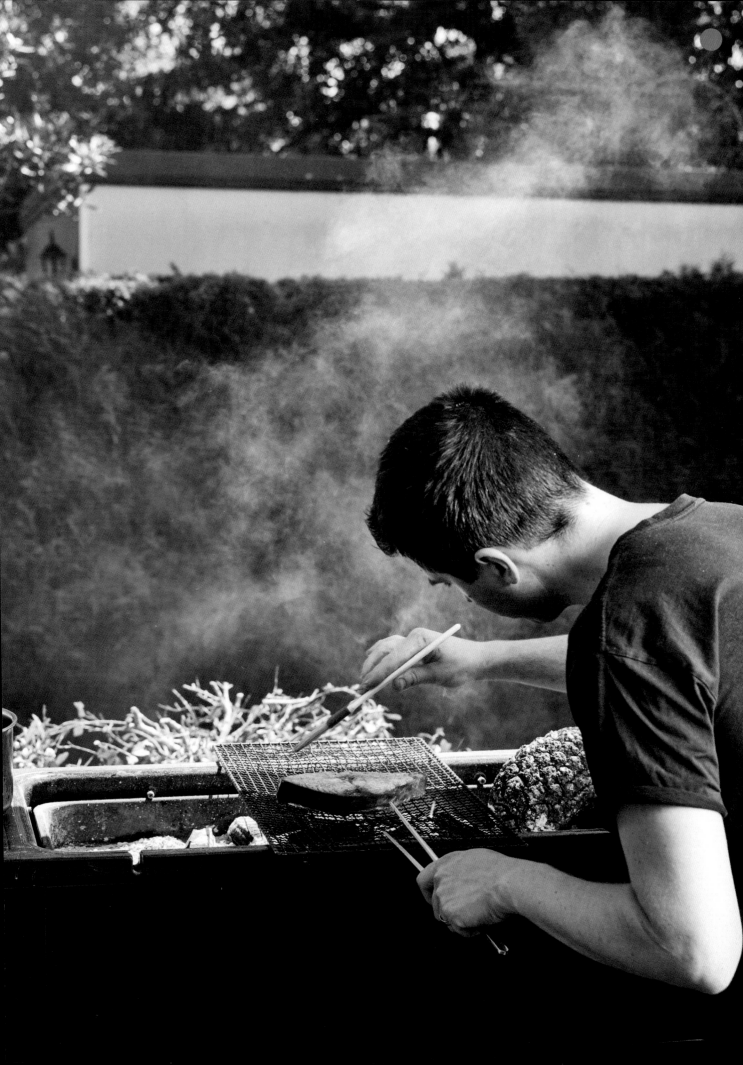

SPANISH MACKEREL CHOPS COOKED IN VADOUVAN

This French colonial-influenced Indian curry blend has a complex yet mild flavour profile that appeals to a very broad audience. Vadouvan is made from a blend of onions, garlic, cumin seeds, mustard seeds and fenugreek. Although true vadouvan is dried and ground into a powdered spice, for this recipe I make a puree that can be simply added to a sauce to eliminate the drying stage. If you would like to dry out the puree, just spread it onto a lined baking sheet and dry in a 90°C (195°F) oven for three to four hours until crisp. Once dried and ground, store it in a sealed container until required. It is a fantastic pantry item that you will find yourself using not only for Spanish mackerel chops but lamb chops, too.

SERVES 2

500 g (1 lb 2 oz) French shallots, peeled
250 g (9 oz) butter
sea salt flakes and freshly cracked
 black pepper
30 curry leaves
1 teaspoon fenugreek seeds
60 g (2 oz) ghee
1 kg (2 lb 3 oz) brown onions,
 finely sliced
12 garlic cloves, finely grated
1 tablespoon ground cumin
1 teaspoon ground green cardamom
1 teaspoon brown mustard seeds
3/4 teaspoon ground turmeric
½ teaspoon freshly grated nutmeg
½ teaspoon chilli flakes
¼ teaspoon ground cloves
2 × 300 g (10½ oz) Spanish mackerel
 chops
100 g (3½ oz) fresh Spanish mackerel
 roe (optional)
250 ml (8½ fl oz/1 cup) Brown Fish
 Stock (page 256)
juice of ½ lemon, or to taste

Preheat the oven to 200°C (400°F).

Place the shallots in the centre of a square of aluminium foil, add 100 g (3½ oz) of the butter, a sprinkle of salt flakes and 10 curry leaves. Secure the foil around the shallots and place on a wire rack set on a baking tray. Roast for 35 minutes or until the shallots are very tender and have begun to take on colour. Remove from the oven and leave to rest for 10 minutes.

Grind the fenugreek seeds to a powder using a mortar and pestle.

Heat the ghee in a large deep saucepan over a medium heat to a light haze, then add the onion and garlic and cook, stirring often, for 25–30 minutes, until a deep golden colour but not burnt. Add the roasted shallots and all the juices from the foil parcel, along with the ground fenugreek seeds, ground spices and remaining curry leaves, and season well with salt and pepper. Cook for a further 5 minutes, then remove from the heat and chill in the fridge until needed.

Preheat the oven to 200°C (400°F).

In a large cast-iron frying pan, melt the remaining butter over a medium heat until just beginning to foam without colour, add the Spanish mackerel chops and, without colouring the flesh, coat the fish in the butter. Add 2 heaped tablespoons of the vadouvan puree and the Spanish mackerel roe, if using. Turn the fish over, pour in the fish stock and bring to the boil. Cover with a square of aluminium foil, then transfer to the oven and roast for 4 minutes. Remove the foil and turn the fish over, then replace the foil and roast for a further 4 minutes. The fish is ready when the internal temperature at its thickest point registers 44°C (111°F) on a probe thermometer.

Remove from the oven and turn the fish over so the presentation side is on top. Place on a warm plate. Return the pan to a medium heat and reduce the cooking juices until very thick and shiny. Season with lemon juice and a little salt if needed.

Spoon the thick vadouvan sauce over the Spanish mackerel chop to glaze and serve immediately.

DRY-AGED SPANISH MACKEREL DIANE

When I first started testing species to see which were suitable for prolonged ageing, a significant stand out was Spanish mackerel. What began as a clean, lightly salty, mineral-driven flavour profile on day two and three, morphed into a highly savoury, 'mushroom meets baked bread' characteristic come days 12 to 16.

Without the efficiency of a commercial cool room or a designated static fridge, this is very challenging to replicate, but I wanted to add a version of this recipe to the book. To achieve a similar result and introduce the idea that a fish can be in your fridge for longer than a couple of hours, start with the freshest possible bone-in cut of Spanish mackerel and keep it on a perforated tray in the crisper of your fridge for a minimum of three days. Then let it sit uncovered in the main chamber of the fridge for a further 24 hours to dry the skin.

The rich Diane sauce makes the perfect partner for this beautiful fish, and you can take your pick of suitable accompaniments – mashed potato, sautéed mushrooms, glazed artichokes, even pan-fried Spanish mackerel liver. Treat this recipe as a springboard for making something elaborate for a special dinner.

SERVES 4–6

1 x 1 kg (2 lb 3 oz) Spanish mackerel fillet, bone in
grapeseed oil, for cooking
sea salt flakes

Diane sauce
1 kg (2 lb 3 oz) Spanish mackerel bones
100 ml (3½ fl oz) grapeseed oil
250 g (9 oz) ghee
750 g (1 lb 11 oz) onions, finely sliced
10 garlic cloves, finely sliced
sea salt flakes and freshly cracked black pepper
1 kg (2 lb 3 oz) portobello mushrooms, finely sliced
15 thyme sprigs
2 fresh bay leaves
3 rosemary sprigs
250 ml (8½ fl oz/1 cup) brandy
2 teaspoons dijon mustard
50–60 ml (1¾–2 fl oz) worcestershire sauce
2 litres (68 fl oz/8 cups) Brown Fish Stock (page 256)
150 ml (5 fl oz) pouring (single/light) cream
100 g (3½ oz) butter
4 French shallots, finely diced
1 bunch flat-leaf (Italian) parsley, leaves picked and finely chopped
Garum (page 257) or fish sauce, to taste
juice of 1 lemon

On the day you intend to cook them, remove the mackerel chops from the fridge and bring to room temperature for at least 1 hour before cooking.

To make the Diane sauce, preheat the oven to 190°C (375°F) and line a baking tray with baking paper.

Spread the Spanish mackerel bones over the prepared tray, oil lightly with the grapeseed oil and roast until completely coloured and dried, about 30 minutes.

Meanwhile, heat the ghee in a large saucepan over a medium heat to a light haze, add the onion and garlic and cook for 20 minutes, or until very lightly coloured. Season well with salt, add the mushroom and herbs and cook for 30 minutes, or until all the mushroom juices have evaporated. Add the brandy and cook until reduced by half, then stir in the mustard and cook for a further 2 minutes. Add the worcestershire sauce and stock, bring to a simmer and cook for 15 minutes or until reduced by about one-third. Remove from the heat and stand for 30 minutes to allow the flavours to infuse. Strain, discarding the solids, and season to taste with salt and pepper. (At this point, the stock can be frozen and thawed when required.)

Prepare a charcoal grill, making sure the grill is hot and the charcoal has cooked down to hot embers. Divide the coals across the floor to create a cooler side and a more intense side of the grill.

Brush the skin of the mackerel with a little oil and season with salt flakes. Start with the skin side down over high heat and grill for about 4 minutes to develop good colour. Turn onto the bone side and transfer to the cooler side of the grill, then cook for a further 8–10 minutes to allow a more gentle heat to set the protein. The fish is ready when the internal temperature registers 50°C (122°F) on a probe thermometer.

Remove from the grill and allow to rest. This is critical so the residual warmth continues to set the protein without creating a dry, overdone texture.

While the mackerel is resting, finish the sauce. Bring the stock to the boil in a saucepan over a medium heat. Add the cream and whisk to combine, then reduce the heat to low and whisk in the butter to thicken the sauce. Add the shallot and parsley and season to taste with salt, pepper, a little garum or fish sauce and a squeeze of lemon to freshen it up. Transfer to a serving jug.

Before serving, brush the mackerel with a little more oil and season with a touch of salt. Cut the mackerel into chops, divide between plates and serve with the Diane sauce and your choice of accompaniments.

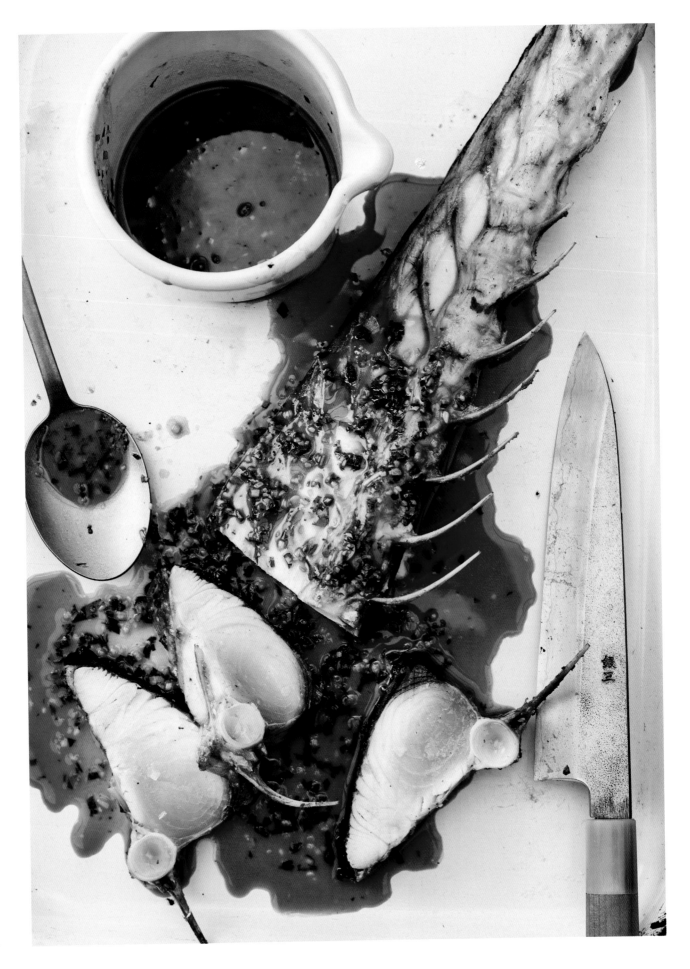

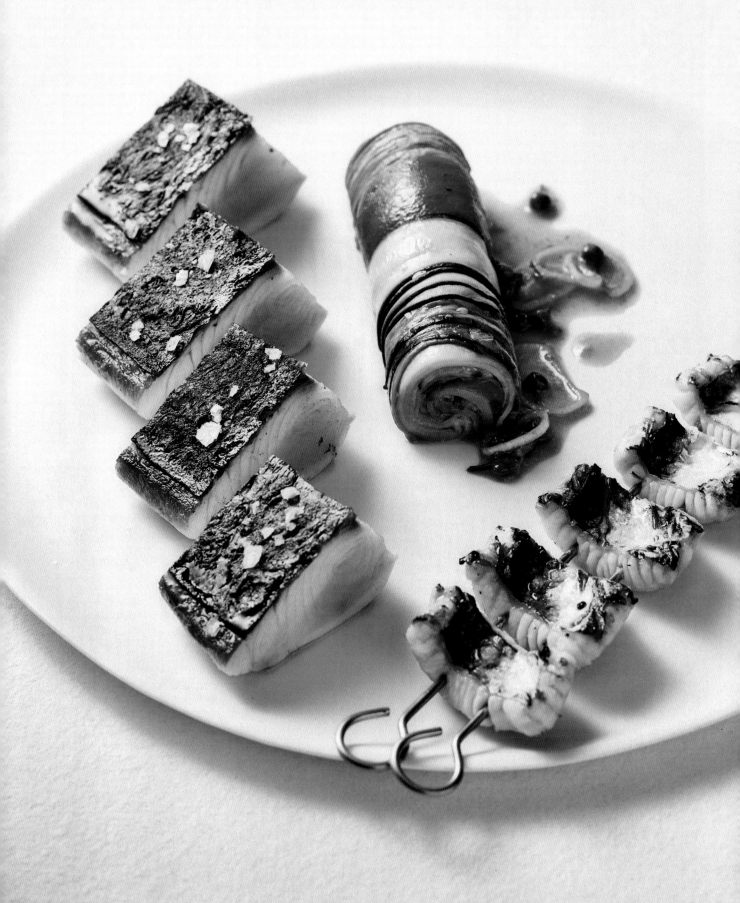

SPANISH MACKEREL AND ROLLED RATATOUILLE

When I worked in a Nicoise-style restaurant years ago I developed a great affection for Provençale dishes, from chickpea socca and pissaladière (see page 28) to the world-famous ratatouille. The critical thing about these dishes is that the ingredients are of the highest quality so, while this recipe uses ingredients that are readily available year round, take a leaf out of Roger Vergé's book *Cuisine of the Sun* and make it only when they are at their seasonal best. Whether ratatouille is served as a stew or rolled up into a neat log (as we do here), its flavours work so beautifully with the natural salinity of Spanish mackerel. If it's unavailable, don't despair; mahi-mahi, wild kingfish and spotted mackerel all make very good alternatives.

SERVES 4

100 g (3½ oz) ghee
1 × 600 g (10½ oz) boneless Spanish
 mackerel fillet, skin on
sea salt flakes

Ratatouille
2 green zucchini (courgettes)
1 eggplant (aubergine), peeled
sea salt flakes and freshly cracked
 black pepper
2 red capsicums (bell peppers), charred,
 peeled and seeds removed
200 ml (7 fl oz) extra-virgin olive oil
8 male zucchini (courgette) flowers
4 anchovy fillets, finely diced
zest of 1 orange
1 teaspoon thyme leaves
1 tablespoon Garum (page 257)
 or fish sauce
8 large basil leaves

Ratatouille dressing
500 g (1 lb 2 oz) ripe ox heart tomatoes
2 tablespoons tiny salted capers,
 rinsed and drained
2 French shallots, finely sliced
½ teaspoon finely grated garlic
2 tablespoons chardonnay vinegar
80 ml (2½ fl oz/1/3 cup) extra-virgin
 olive oil
1 tablespoon caster (superfine) sugar
1 tablespoon Garum (page 257)
 or fish sauce

For the ratatouille, the aim here is to create four even cylinder-shaped parcels. Start by preheating a charcoal grill, barbecue plate or heavy chargrill pan over a medium heat to grill the vegetables.

Using a very sharp mandoline, cut 2–3 mm (1/8 in) thick ribbons of zucchini and eggplant. You want them to be a similar thickness to the capsicum. Lightly season the zucchini and eggplant ribbons with salt flakes and allow to stand for at least 15 minutes.

Pat dry the peeled capsicums and brush lightly with extra-virgin olive oil. Grill for about 2 minutes each side to intensify the flavour and add colour. Repeat this step with the eggplant and zucchini. Cut each capsicum into four strips.

Cut the stem and core from each zucchini flower and open the flower into one flat sheet using a small knife to split one of the petals. Briefly grill the flowers to wilt, literally for just 10 seconds.

Once the capsicum, eggplant, zucchini and flowers have been grilled, place on a large baking tray and liberally dress with the remaining olive oil, diced anchovy, orange zest, thyme leaves and garum or fish sauce. Leave to marinate for at least 1 hour to allow the flavours to develop.

To assemble the ratatouille, place a large square of plastic wrap on a clean bench. For each of the four rolls, start by laying out two of the zucchini flower sheets from the top of the bench to the bottom, creating lines that interlock. Place two strips of capsicum on top of each, followed by one-quarter of the zucchini, then one-quarter of the eggplant.

Paint a little of the anchovy marinade over the eggplant. Pull up the plastic wrap at the bottom and, keeping out as much air as possible, roll the vegetables into a firm log. Tighten the wrap, neaten the roll and tie off at both ends. What you should see is the zucchini flowers encompassing all the vegetables. Set aside until needed.

For the dressing, cut the tomatoes in half through the circumference so you have maximum surface area to grill. In a heavy cast-iron pan over a high heat, burn the face of the tomato for 2 minutes, then repeat on the other side. Transfer to a coarse sieve and push on the tomato solids with a ladle to produce a smooth tomato pulp. To this liquid add the capers, shallot, garlic, vinegar, olive oil, sugar and garum or fish sauce. Combine well and hold somewhere warm for serving.

Heat 60 g (2 oz) of the ghee in a cast-iron skillet or ovenproof frying pan over a medium heat to a light haze. Place the mackerel fillets, skin side down, in the centre of the pan, making sure they are not touching. Put a fish weight or small saucepan on top and cook for 1 minute, or until you see colour around the edges of the fillets. Lift the fillets up using an offset palette knife and move to the another part of the pan, moving the weight to cover a different part of the fillet as you go. Cook for another 3 minutes, then remove the weight and discard the ghee from the pan, replenishing it with the remaining fresh ghee.

If the fillets still seem cool to the touch on the flesh, position the weight on top and cook for another 2 minutes, or until the fish is 75 per cent of the way set, the top of the fillet is warm and the skin is crisp from edge to edge. Remove the pan from the heat and turn the fillets over for just 10 seconds to set any rawness on the flesh, then transfer to a warm plate to rest briefly.

Bring a saucepan of water to the boil, reduce the heat to low and gently lower in the ratatouille parcels. Cover with a lid and leave for 4 minutes to warm through, then remove with a slotted spoon and carefully take off the plastic.

To serve, place the fillets, skin side down, on a cutting board and use a very sharp knife to cut each one in half. (If cooked correctly the interior will be warm to the touch but still show signs of rareness.) Divide among four serving plates, adding a ratatouille roll to each. Season with salt flakes, spoon over the dressing and serve immediately.

X·LA

RGE

14

Tuna

To me, tuna has always been beef. Always. At least I suppose this is what goes through my head when I look at this incredible fish. I firmly believe that, when tuna is presented in this way, the other half of your brain awakens and all of a sudden the challenge is set. From meatballs, to meat pies to chilli con tuna ... nothing is off limits.

From a culinary perspective, tuna holds a great deal of potential that goes well beyond the 50–77 per cent yield that tends to be realised. The eyes can be transformed into prawn cracker-like chips, its blood turned into black pudding, and its head roasted to a dark amber colour and cooked gently to create a pork-like stock suitable as the base for ramen or the beginnings of a rich gravy. The bones can be smoked and powdered for seasonings or even transformed outside of a recipe into bone china!

The liver, heart, spleen and stomach can be handled in the same vein as meat offal too, understanding that there is little fat in these organs and that they need to be worked with considerately, of course.

Understandably there are huge concerns around the sustainability of tuna. Here in Australia I am extremely lucky to be able to work with some of the best fisheries in the world. Walkers Seafood, based in Mooloolaba, Queensland, is the first tuna fishery in the country to earn the international gold standard for seafood sustainability: the coveted Marine Stewardship Council (MSC) certification. Working directly with both Heidi and Pavo Walker for the past five years has been an absolute privilege – I very much admire their dedication to quality and their commitment to sustainably and ethically caught fish.

Alternatives
SWORDFISH · BONITO · MACKEREL

Points to look for
**FIRM, UNDAMAGED FLESH AND RED MUSCLE WITH VIBRANT COLOUR
LITTLE TO NO AROMA · BE SURE TO REQUEST THE GRADE OF TUNA
SPECIFIC TO THE METHOD OF COOKERY YOU ARE CHOOSING**

Best cooking
RAW · CURED · PAN-FRIED · GRILLED · SMOKED · CONFITED

Accompanying flavours
**ONIONS · JUNIPER · PEPPER · THYME · SOY · MUSTARD · HORSERADISH
STONE FRUIT · OYSTERS · CUCUMBER · TARRAGON · CHIVES**

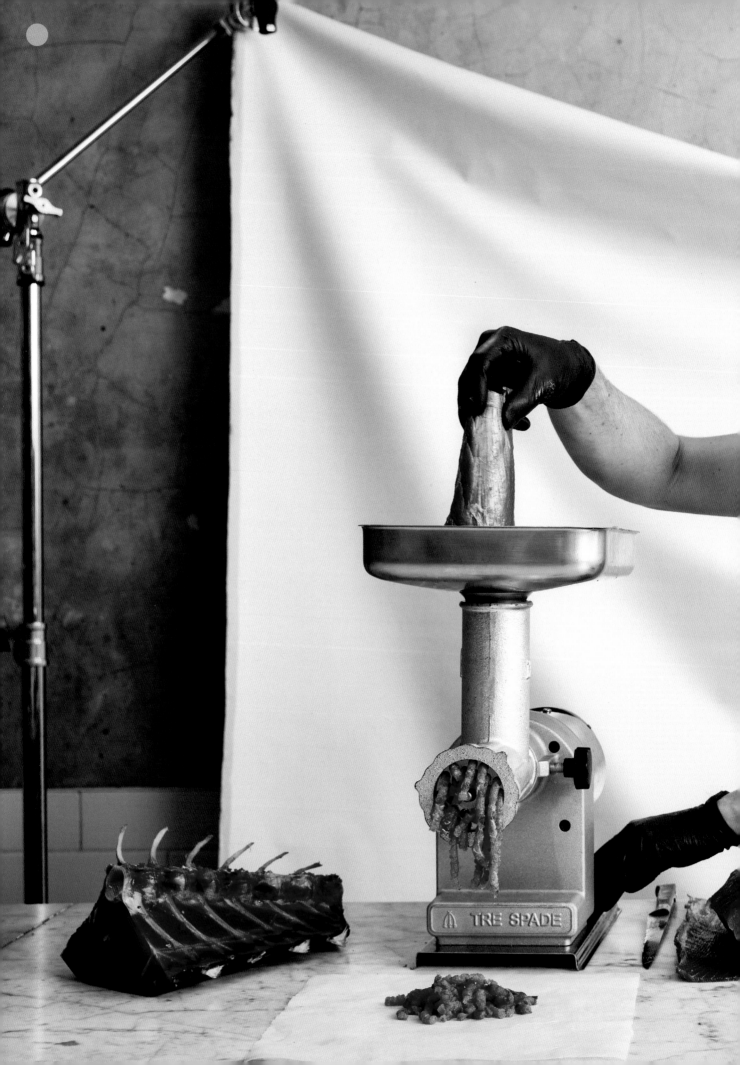

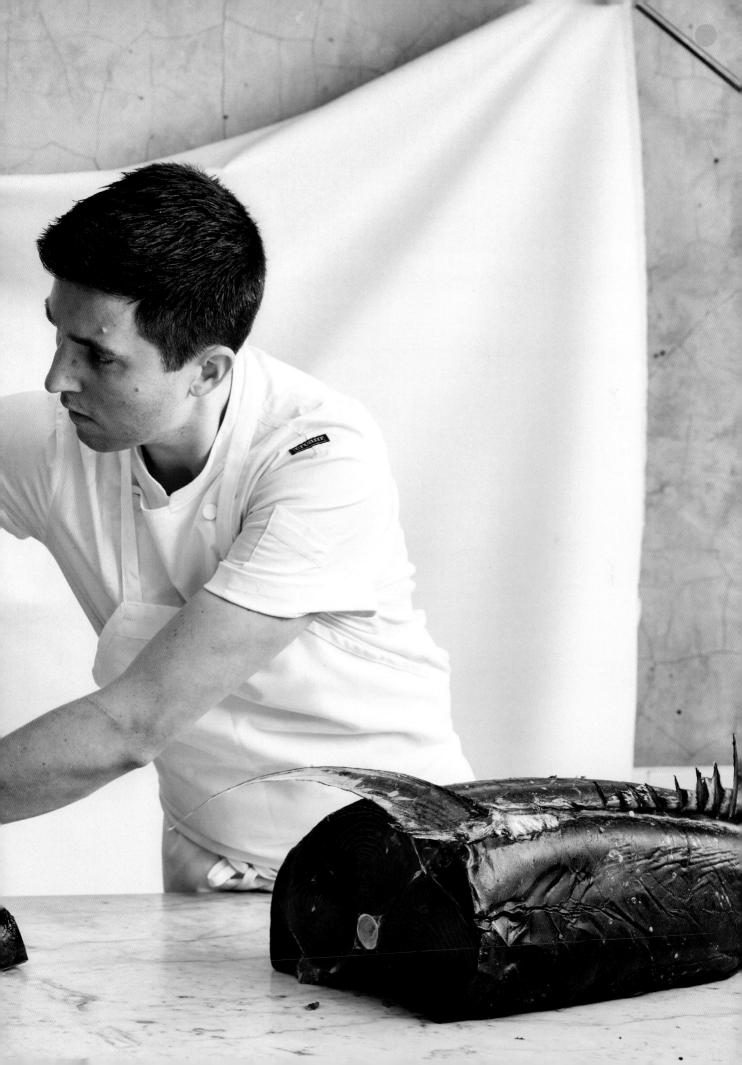

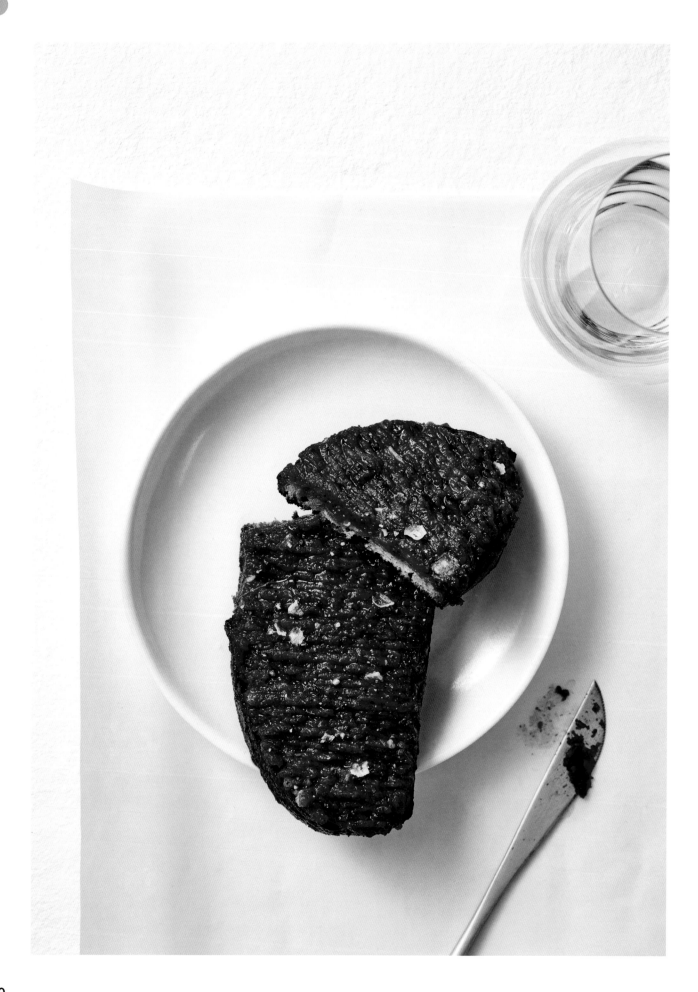

TUNA 'NDUJA ON TOAST

A great way to use up the trimmings after breaking down a tuna is this 'nduja recipe. Unlike the traditional meat-based version, this doesn't require any form of fermentation. Instead, it's very quick to make and the results are absolutely delicious served up on toast like this or as an addition to pasta or vegetable-based dishes. The easiest way to cook the 'nduja is by frying it in a little oil – separating out the fat (which you can use for grilled veg, or even octopus or calamari) and transforming the texture into a fine mince.

SERVES 4

500 g (1 lb 2 oz) yellowfin tuna
 loin, trimmed
3 garlic cloves, 2 finely grated,
 1 peeled and halved
110 g (4 oz) Rendered Fish Fat
 (page 258), melted and cooled
 slightly (or olive oil)
sea salt flakes and freshly cracked
 black pepper
4 slices of quality
 sourdough bread
extra-virgin olive oil, for brushing
 and finishing

'Nduja spice mix
1½ tablespoons smoked paprika
½ teaspoon freshly cracked
 black pepper
½ teaspoon ground fennel seeds
pinch of finely grated nutmeg
½ teaspoon chilli flakes
1 teaspoon sea salt flakes

To make the 'nduja spice mix, combine all the ingredients in a small bowl.

Pass the trimmed tuna through a meat grinder on a coarse setting (or chop into a coarse mince consistency with a sharp knife). Transfer to a large bowl, add the spice mix, grated garlic, rendered fish fat and a pinch of salt, and stir gently to combine, being careful not to overwork it. Set aside.

Brush both sides of the bread slices with extra-virgin olive oil, taking it right to the edges.

Heat a chargrill pan over a medium heat, add the sourdough slices (in batches if necessary) and grill for 2–3 minutes each side, or until very well toasted with nice char lines. Remove from the pan and rub with the halved garlic clove, then transfer to individual serving plates.

Pile a heaped tablespoon of the 'nduja onto each slice of hot toast and drizzle with 2 teaspoons olive oil. Using a fork, drag the tips through the 'nduja, working from left to right to create even ridges for the oil and seasoning to settle into. Season liberally with salt flakes and black pepper and serve immediately. Store any leftover 'nduja in an airtight container in the fridge for up to 4 days.

TUNA MAPO TOFU

Mapo tofu is one of my favourite dishes. The spicy sichuan ingredients mixed with the minerality and richness of the tuna and the creaminess of the tofu is such a good match. I promise you won't miss the traditional recipe once you've tried this version. Any leftovers make an unbelievable jaffle! The paste can be made in advance and stored in an airtight container in the fridge until needed.

SERVES 6

1 tablespoon sichuan peppercorns
190 g (6½ oz) fresh ginger, peeled
190 g (6½ oz) garlic cloves, peeled
10 French shallots, peeled
375 g (13 oz) doubanjiang (fermented broad bean paste)
300 ml (10 fl oz) grapeseed oil
80 ml (2½ fl oz/1/3 cup) shaoxing rice wine
50 g (13/4 oz) caster (superfine) sugar
125 ml (4 fl oz/½ cup) tamari
1 tablespoon sesame oil
1.8 kg (4 lb) minced (ground) yellowfin tuna (see page 232 for cuts to use here)
200 g (7 oz) silken tofu, cut into small cubes
1 bunch spring onions (scallions), finely sliced
40 g (1½ oz/¼ cup) toasted sesame seeds
1 dried red chilli, finely sliced (optional)
steamed short-grain rice, to serve

Toast the sichuan peppercorns in a dry frying pan until fragrant, then use a mortar and pestle to grind to a rough powder. Set aside.

Place the ginger, garlic, shallots, doubanjiang and 150 ml (5 fl oz) of the grapeseed oil in a food processor and blitz to a smooth paste.

Heat 100 ml (3½ fl oz) of the remaining grapeseed oil in a large heavy-based saucepan over a high heat. Add the paste and fry, stirring occasionally, for 8–10 minutes until dried and fragrant, then reduce the heat and simmer for a further 15 minutes, until the rawness from the vegetables has been completely cooked out. Stir in the shaoxing wine, sugar, tamari and one-third of the ground sichuan peppercorns, then spoon the mixture into a large bowl.

Wipe out the pan, add the sesame oil and remaining 2½ tablespoons of grapeseed oil and heat over a high heat. Working in two batches, add the tuna mince to the pan and fry for 2 minutes, or until the mince is coloured and has separated into individual strands, then stir through the fried paste mixture to combine.

To assemble the mapo tofu, return the tuna mixture to the saucepan and warm through over a low heat. Add the tofu, cover with a lid and heat for 3 minutes, then spoon into serving bowls. Top with the spring onion, sesame seeds, chilli, if using, and the remaining ground sichuan peppercorns. Serve with steamed rice, if you like.

CHILLI CON YELLOWFIN TUNA AND CORNBREAD

Make sure you plan ahead and have a conversation with your local fish shop or market so they can organise some tuna trim for mincing and also some fatty belly that will help enrichen the chilli. When browning off the tuna the pan needs to be smoking hot, as you want to caramelise it but not destroy its texture through overcooking. You may be surprised by the butter in the chilli but it helps round out some of the acidity in the tomatoes and also balance the heat from the spices. The cornbread makes the perfect simple accompaniment, though you can always have the chilli with sour cream, steamed rice and lime wedges, if you prefer.

SERVES 6

450 g (1 lb) yellowfin tuna loin (20% tuna belly), trimmed
125 ml (4 fl oz/½ cup) extra-virgin olive oil
2 large onions, finely diced
1 star anise
6 garlic cloves, finely grated
1 long red chilli, seeds removed and finely diced
1½ teaspoons ground cumin
1 teaspoon chilli powder
1½ teaspoons smoked paprika
2 tablespoons tomato paste (concentrated puree)
140 ml (4½ fl oz) red wine
1 × 400 g (14 oz) tin chopped tomatoes
400 ml (13½ fl oz) Brown Fish Stock (page 256)
240 g (8½ oz) drained and rinsed tinned red kidney beans
250 g (9 oz) grilled red capsicums (bell peppers) (homemade or store-bought), peeled and finely diced
1 teaspoon tomato sauce (ketchup)
½ teaspoon worcestershire sauce
80 g (23/4 oz) butter, chilled
sea salt flakes and freshly cracked black pepper

Cornbread

120 g (4½ oz) plain (all-purpose) flour
120 g (4½ oz) polenta, plus extra for dusting
20 g (3/4 oz) baking powder
1 teaspoon fine salt
40 g (1½ oz) caster (superfine) sugar
280 ml (9½ fl oz) buttermilk
100 ml (3½ fl oz) full-cream (whole) milk
2 large eggs, lightly beaten
zest of 1 lime
50 g (13/4 oz) butter, melted and cooled, plus extra for greasing
smoked paprika, for dusting

Preheat the oven to 180°C (350°F).

Pass the trimmed tuna through a meat grinder on a coarse setting (or chop into a coarse mince consistency with a sharp knife).

Heat 3 tablespoons of the olive oil in a large saucepan over a high heat until smoking hot. Working in small batches, add the tuna and cook, stirring, for 1 minute, until nicely caramelised but not overcooked. Remove and drain on paper towel.

Reduce the heat to medium and add the remaining olive oil to the pan, along with the onion and star anise, and cook until the onion begins to colour. Add the garlic and chilli and cook for another 5 minutes. Add the ground spices and cook for 2 minutes until fragrant and toasted, then stir in the tomato paste and cook for another 5 minutes. Pour in the red wine, bring to a simmer and cook until reduced by two-thirds, then add the tomatoes and stock. Return to a simmer and cook over a low heat for 1 hour, or until reduced down to a thick, sauce-like consistency.

While the chilli sauce is reducing, make the cornbread. Sift the flour, polenta, baking powder, salt and sugar into a bowl and make a well in the centre. Whisk together the buttermilk, milk, eggs, lime zest and melted butter and pour into the well. Stir with a rubber spatula until the mixture comes together.

Butter a 12-hole muffin tray and dust it with a little extra polenta, then spoon the mixture evenly into the holes. Bake for 18–20 minutes, then take the tray out of the oven, ease out the muffins and leave to cool on a wire rack.

Once the chilli has reduced, return the browned tuna mince to the pan, along with the kidney beans and capsicum, and simmer until heated through. Stir in the tomato sauce, worcestershire sauce and butter until well combined and the butter has melted. Season to taste and serve immediately with the cornbread.

TUNA RIB EYE WITH BORDELAISE AND FISH FAT YORKSHIRE PUDDINGS

We all put thought into buying a regular beef steak, considering whether the animal followed a grain- or grass-fed diet, or if the cut came from the rib or fillet, and I believe we should do the same with tuna. And as this is an elaborate cut (ask your fishmonger to do this for you) you'll want to be very particular about both its quality and provenance, so be sure to ask whether it has been ethically caught and handled, too. While you're there, ask for any trimmings, bones or scraps of tuna to go into the bordelaise sauce.

As with any bone-in cut of tuna, it is imperative that it rests after coming off the heat. The warmth and heat transfer generated post-cooking give it the desired delicate texture. Cooking it over too high a heat for too long on each side will deliver a dry, even slightly powdery finish, with a raw band of cold tuna in the centre where the heat hasn't had the opportunity to penetrate. Be confident, and think of it as the beef you know and love to cook. This is a show-stopping piece of fish and will win over even the most hard-nosed carnivorous critics.

SERVES 2-3

550 g (1 lb 3 oz) yellowfin tuna steak, bone in
2 teaspoons freshly cracked black pepper
2 teaspoons ground fennel seeds
50 g (13/4 oz) ghee, melted
sea salt flakes

Fish fat Yorkshire puddings
250 g (9 oz) eggs
250 g (9 oz/12/3 cups) plain (all-purpose) flour
½ teaspoon fine salt
250 ml (8½ fl oz/1 cup) full-cream (whole) milk
240 ml (8 fl oz) Rendered Fish Fat (page 258) or ghee

Bordelaise sauce
150 g (5½ oz) ghee
2 kg (4 lb 6 oz) tuna bones and trimmings
10 French shallots, finely sliced
4 garlic cloves, finely sliced
300 ml (10 fl oz) red wine
200 ml (7 fl oz) red-wine vinegar
12 thyme sprigs
80 ml (2½ fl oz/1/3 cup) dark soy sauce
600 ml (20½ fl oz) Brown Fish Stock (page 256)
1 small tomato, peeled, seeds removed and diced
1 tablespoon finely chopped tarragon
50 g (13/4 oz) yellowfin tuna bone marrow (optional)

For the Yorkshire puddings, place the eggs, flour and salt in a bowl and whisk to combine, pouring in the milk as you go to form a smooth batter. Finish with a hand-held blender and pass through a fine sieve, then transfer to the fridge and leave to rest for at least 24 hours (up to 72 hours).

To make the bordelaise, heat the ghee in a frying pan over a medium–high heat to a light haze. Add the fish bones and trimmings and cook for 20 minutes, scraping up any sediment that settles at the base of the pan as it forms, until very well browned all over. Transfer to a colander set over a bowl and allow any fat to drain, reserving it for later. Return the solids to the pan, along with the shallot and garlic, and cook for a further 10 minutes, or until lightly coloured. Add the wine, vinegar and thyme and bring to a simmer, then cook, stirring, for 20 minutes, or until reduced and thickened to a glaze-like consistency. Add the soy sauce and stock and bring to the boil, then reduce the heat to low and cook very gently, turning the fish pieces occasionally, for another 20 minutes, or until reduced and thickened. Strain into a bowl, pass the warm reserved fat through a fine sieve, then pour over the sauce. Set aside.

When you are ready to cook, preheat the oven to 210°C (410°F). Remove the tuna from the fridge and stand at room temperature for at least 30 minutes.

To cook the Yorkshire puddings, add a tablespoon of rendered fish fat or ghee to each hole of a 12-hole muffin tray and place in the hot oven for 10–12 minutes to heat the oil to a haze. Carefully remove the tray from the oven and pour the batter evenly into the holes to fill them halfway. Cook for 25 minutes, until puffed and golden.

Meanwhile, either preheat a chargrill pan over a high heat or a charcoal grill with evenly burnt-down embers.

Mix together the black pepper and ground fennel seeds in a bowl. Lightly brush the ghee over both sides of the steak (this will aid with heat conduction and minimise the risk of scorching the dry spices), then season liberally with salt flakes and sprinkle the fennel and pepper mix over to cover evenly.

Carefully place the tuna on the grill and cook for a total of 4 minutes, turning every minute. Remove and leave to rest for 2–3 minutes, or until the internal temperature measures between 44°C (111°F) and 46°C (115°F), depending on how rare you like it.

When you are ready to serve, warm the bordelaise sauce over a low heat (taking care not to let it boil) and add the tomato, tarragon and tuna bone marrow, if using. Spoon over the tuna steak and serve immediately with the Yorkshire puddings.

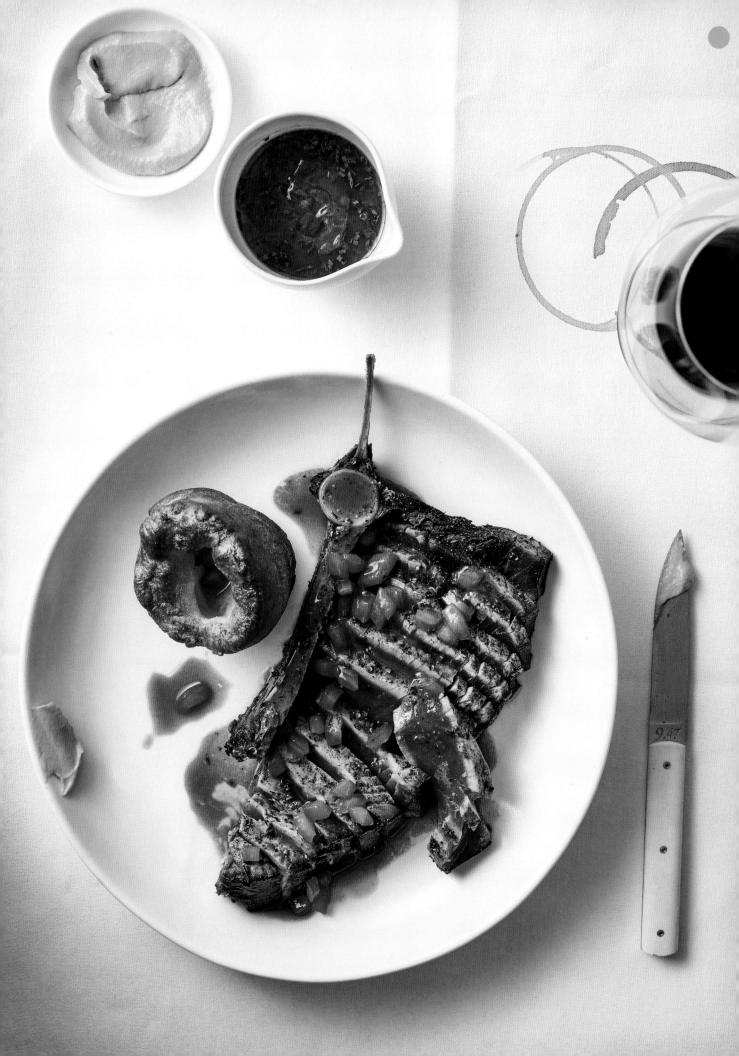

TUNA LASAGNE

Now, the thought of this might make you cringe but, trust me, this is one recipe you'll want to cook again and again. The texture and appearance of the tuna mince will have you second guessing whether it is actually fish and will certainly break you out of the chicken/veal/pork loop. It should also be noted that I don't expect anyone to be mincing down sashimi-grade yellowfin tuna belly or the centre cut of a potential tuna steak here – instead, you're looking to use the sinew-heavy area or scrappy chunks that come away from behind the tuna head at the top of the loin, along with any tail cuts and scrapings from the frame of the fish. These are the bits that often get tossed away at the markets because of a perceived lack of customer interest, so it's great to find a good use for them. Ask your fishmonger or market vendor for them next time you're shopping.

SERVES 4

8 dried lasagne sheets
100 g (3½ oz/1 cup) finely
 grated parmesan
50 g (13/4 oz/1/3 cup) finely
 grated mozzarella

Ragù
½ bunch of thyme
1 fresh bay leaf
1 teaspoon black peppercorns, toasted
1 star anise
300 ml (10 fl oz) grapeseed oil
3 garlic cloves, finely grated
sea salt flakes and freshly cracked
 black pepper
1 large onion, finely diced
1 large carrot, finely diced
1 small fennel bulb, finely diced
1 teaspoon tomato paste
 (concentrated puree)
150 ml (5 fl oz) red wine
200 g (7 oz) tinned peeled
 tomatoes, crushed
250 ml (8½ fl oz/1 cup) water
250 g (9 oz) minced (ground)
 yellowfin tuna

Béchamel
500 ml (17 fl oz/2 cups) full-cream
 (whole) milk
1 parmesan rind
50 g (13/4 oz) butter
50 g (13/4 oz/1/3 cup) plain
 (all-purpose) flour
freshly grated nutmeg, to taste
sea salt flakes and freshly cracked
 black pepper

To make the ragù, tie the thyme, bay leaf, peppercorns and star anise in a piece of muslin (cheesecloth) to make a bouquet garni. Heat 150 ml (5 fl oz) of the grapeseed oil in a large heavy-based frying pan over a medium heat, add the garlic and a pinch of salt and sauté for 30 seconds. Add the onion and another pinch of salt and cook for 10 minutes, or until the onion is translucent and just beginning to colour. Add the carrot, fennel and another good pinch of salt and cook for a further 10 minutes until softened, stirring every few minutes to ensure nothing sticks to the base and burns. Stir in the tomato paste and fry for 2 minutes, then add the bouquet garni and red wine. Bring to a simmer and cook until reduced and thickened to a glaze consistency, about 10 minutes. Add the crushed tomato and water and bring to the boil, then reduce the heat to very low and simmer gently for 45 minutes, or until the sauce is thickened, reduced and fragrant. Season to taste with salt and pepper and set aside.

Heat 75 ml (2½ fl oz) of the remaining oil in a cast-iron skillet or frying pan over a medium heat to a light haze. Add half the tuna and fry, stirring to separate the strands, until coloured. Season lightly with salt and pepper, then add to the tomato sauce. Repeat with the remaining oil and tuna, and stir everything well to combine. Leave to cool completely, then transfer to the fridge until you are ready to assemble the lasagne.

For the béchamel, place the milk and parmesan rind in a medium saucepan over a medium heat. Bring to a gentle simmer, then reduce the heat to low and keep warm for 20 minutes, to allow the flavour of the parmesan to infuse the milk.

Melt the butter in a separate saucepan over a medium heat. Add the flour and cook for 2 minutes, stirring with a wooden spoon to form a roux. Remove the parmesan rind from the milk, then gradually add to the roux, one-third at a time, whisking after each addition to create a smooth sauce. When you have incorporated all the milk, bring the sauce to the boil, then remove from the heat, stir in a little grated nutmeg and season to taste with salt and pepper. Closely cover the sauce with plastic wrap or baking paper to stop a skin forming, then refrigerate until completely cold.

Preheat the oven to 200°C (400°F).

To assemble the lasagne, spoon a layer of the tuna ragù over the base of a 1.5 litre (51 fl oz/6 cup) baking dish. Cover with a layer of béchamel, then a layer of lasagne sheets. Repeat the process with the remaining ingredients, finishing with a layer of béchamel. Sprinkle over the grated cheeses in a generous blanket and cover with aluminium foil. Bake for 30 minutes, then remove the foil and cook for another 10 minutes until golden brown and bubbling on top, and the pasta is tender when tested with a skewer in the centre. Remove from the oven and rest for 10 minutes before serving, perhaps with a fresh salad of green leaves and herbs.

TUNA KOFTA WITH BBQ GRAPES AND SOUR GARLIC SAUCE

Kofta are traditionally made with ground meat, onion and spices but I urge you to try them with minced tuna. They are so good! I suggest a few dips and a tabbouleh that I like to serve them with, and they are phenomenal hot or cold rolled up in freshly made flatbread, but these accompaniments are by no means essential – the kofta are very much the stars here. Another tick in the margin is that they freeze exceptionally well, so you can make them up ahead of time.

This is a fantastic spread for a long weekend lunch with friends so feel free to double the quantities. You could also try replacing the tuna with swordfish, marlin, albacore or Spanish mackerel – whatever looks best at the fish market.

SERVES 4

grapeseed oil, for brushing
sea salt flakes
150 g (5½ oz) large red grapes

Kofta
60 ml (2 fl oz/¼ cup) buttermilk
40 g (1½ oz/½ cup) fresh white
 breadcrumbs
500 g (1 lb 2 oz) yellowfin tuna
 belly, trimmed
3 teaspoons finely grated garlic
3 teaspoons finely diced French shallot
3 teaspoons freshly ground
 coriander seeds
2 teaspoons freshly ground cumin seeds
2 teaspoons sumac
1 teaspoon ground cinnamon
1 teaspoon smoked paprika
¼ teaspoon cayenne pepper
1 teaspoon sea salt flakes
½ teaspoon freshly cracked
 black pepper
80 ml (2½ fl oz/1/3 cup) grapeseed oil

Sour garlic sauce
125 g (4½ oz) natural yoghurt
80 ml (2½ fl oz/1/3 cup) buttermilk
1 tablespoon minced garlic
2 teaspoons lemon juice
sea salt flakes
½ bunch chives, finely sliced

To serve (optional)
Eggplant and Macadamia Puree
 (page 261)
Brown Butter Hummus (page 262)
Lovage Tabbouleh (page 262)
flatbreads, such as Naan Bread
 (page 261)
salad leaves

For the kofta, pour the buttermilk over the breadcrumbs in a large mixing bowl. Leave to soak for 10 minutes until the bread swells and there is no residual liquid left in the bowl. Pass the trimmed tuna through a meat grinder on a coarse setting (or chop into a coarse mince consistency with a sharp knife). Add to the breadcrumb mixture, along with all the remaining ingredients. Using your hands, mix everything together for about 1 minute, to strengthen the mix slightly (be careful not to work it too far or the kofta will end up being too firm). Divide the mix into 12 even pieces and roll into long sausage shapes. Shape the kofta onto stainless steel skewers and store on a plate, covered, in the fridge until needed.

To make the sour garlic sauce, whisk together all the ingredients in a mixing bowl. Set aside in the fridge.

Either preheat a chargrill pan over a medium–high heat or a charcoal grill with evenly burnt-down embers. Level out the embers so the heat is even.

Brush the kofta with a little grapeseed oil and season with salt flakes, then grill for 2–2½ minutes, turning carefully at 40-second intervals, until cooked through and nicely coloured all over. Transfer the kofta to a large serving platter and set aside to rest.

While the kofta are resting, brush the grapes with a little oil, then grill for 2 minutes or until the skins are charred and blistered and the juices start running from the fruit. Serve with the kofta, sour garlic sauce and your choice of accompaniments.

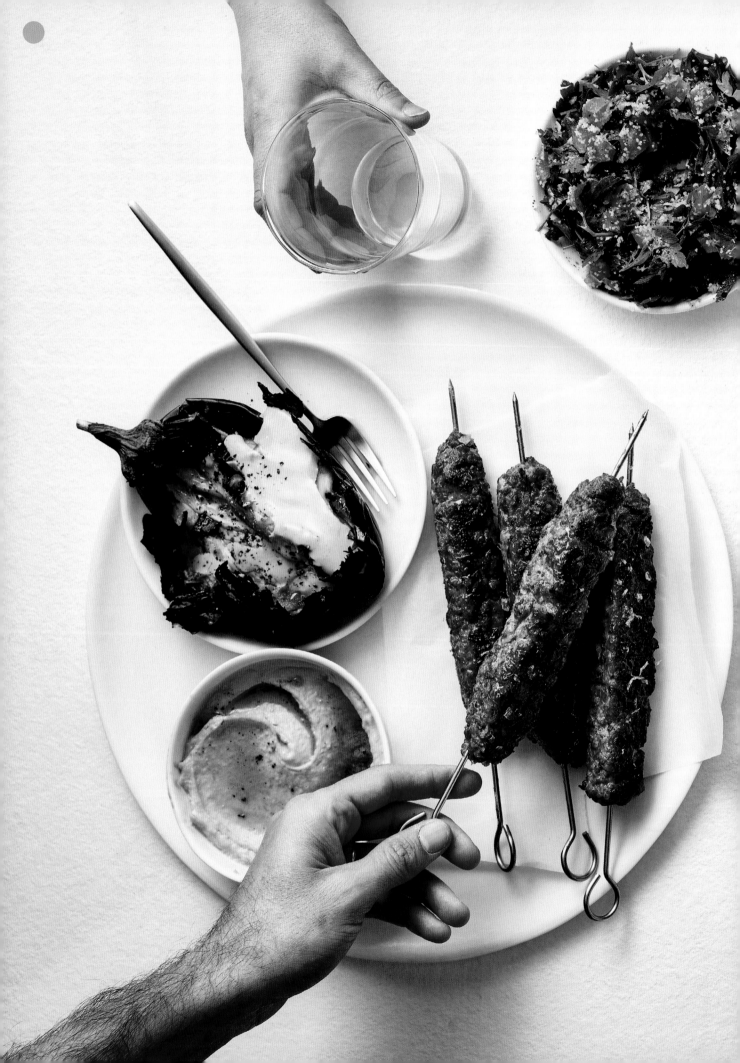

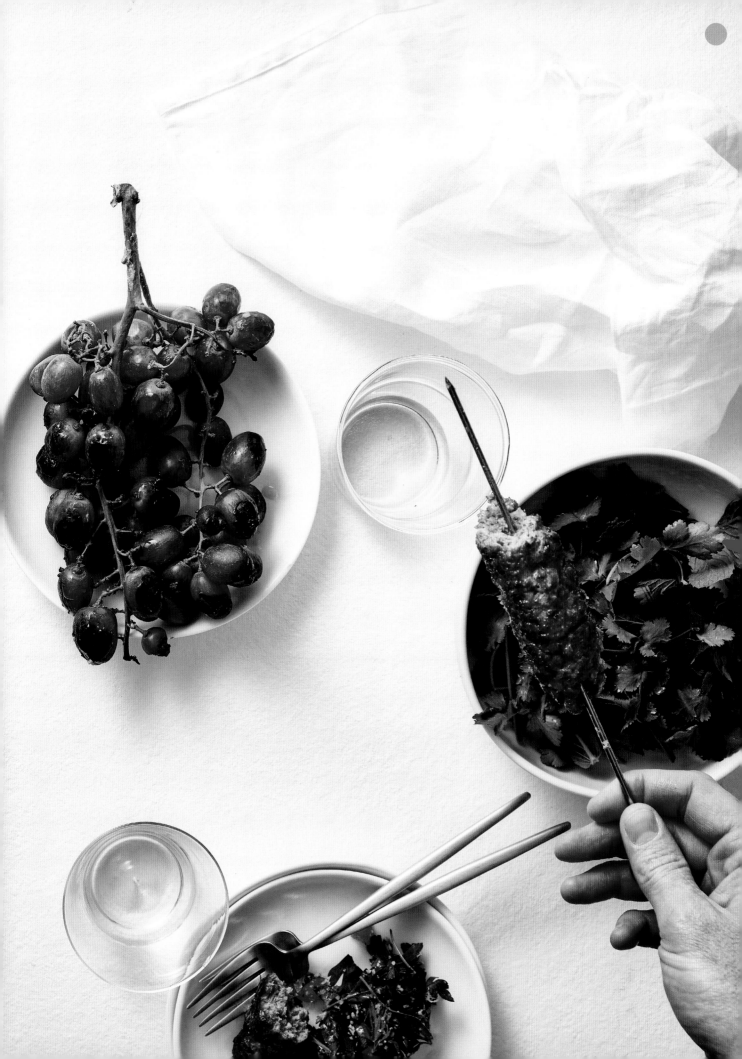

15

Swordfish

Easily distinguished from their marlin and sailfish cousins by their relatively long and wide flattened swords, adult swordfish live in deep oceanic waters and feed on pelagic fish and squid. From very early on in my culinary career I have been fascinated by the intramuscular fat in these magnificent fish – a characteristic that lends itself to meat-based preparations, and the reason that my mind always considers this particular fish to be like pork. Texturally they share similarities, and this way of thinking opens up the opportunity to introduce a wide array of flavours in their cooking and preparation.

When selecting swordfish, pay close attention to its visual appearance. Look for a glassiness and clarity in the loin when grilling as a steak or serving raw. For cuts that aren't quite so premium, there are plenty of methods you can use to achieve a desirable outcome. Be sure to ask your local fish shop or marketplace for trim or more muscular tail cuts for recipes such as the swordfish and bone marrow pie here (see page 245), or even substitute these pieces for the tuna in recipes such as my lasagne and kofta on pages 232 and 233. Remember, this book is about arming you with more creative methods and applications with fish; it's not only about discussing the full potential of a fish beyond the fillet but also what to do with this overlooked catch, which is often seen as 'inferior' or of lesser value.

Alternatives
TUNA · SPANISH MACKEREL · MAHI MAHI · GROPER

Points to look for
**FIRM, VIBRANT (NOT MILKY OR DULL) FLESH AND RED MUSCLE
LITTLE TO NO AROMA**

Best cooking
RAW · CURED · PAN-FRIED · GRILLED · CRUMBED · SMOKED

Accompanying flavours
**CAPERS · GARLIC · TOMATOES · SEAWEED · BREAD · ANCHOVIES · PEAS
BLACK PEPPER · GROUND FENNEL · CHILLI · NUTS · PEPPERS · OLIVES**

SORREL WRAPPED RAW SWORDFISH, AVOCADO AND APPLE

Sorrel turns a rather unappealing shade of khaki green when it comes into contact with heat, so cooked sorrel has generally been avoided in the restaurant kitchens I have worked in. But here I'm playing up its almost seaweed-like appearance and the welcome acidity it adds to the dish. Be sure to use the best-quality swordfish you can for this recipe – you want a piece from the very centre of the loin to minimise sinew.

The dressing is a free-form one that you can adjust with more garum, vinegar or oil to suit your palate. The toasted rice vinegar makes quite a lot, and will become an asset in your pantry for a number of fish, poultry and meat dishes. It will keep for months. If you'd like to make this elegant starter into more of a lunchtime salad, try adding cucumbers, radishes and other crisp green leaves to round it out.

SERVES 4 AS A STARTER

2 bunches sorrel leaves
4 × 100 g (3½ oz) sashimi-grade
 centre-cut swordfish loins
extra-virgin olive oil, for brushing and
 to serve
sea salt flakes
30 g (1 oz) ground wakame or kelp
2 ripe avocados
1 granny smith apple
white soy sauce or Garum
 (page 257), to serve

Toasted rice vinegar
150 g (5½ oz/3/4 cup) brown rice
10 g (¼ oz) bonito flakes
1 litre (34 fl oz/4 cups) apple-cider
 vinegar

To make the toasted rice vinegar, toast the rice in a dry frying pan over a medium heat for 4 minutes or until fragrant but not coloured. Tip the hot rice into the apple-cider vinegar, add the bonito flakes and store in a sterile mason (kilner) jar for at least 24 hours. The longer you can leave it to infuse the better.

Cut the stems out of the sorrel leaves with a sharp knife and lay the stemless leaves on a wire rack that is resting over the sink or in a deep tray to catch the water.

Bring a medium saucepan of water to the boil and carefully tip this hot water over the sorrel, then immediately place the rack of leaves in the fridge to cool. Once cool, gently place the leaves between two clean tea towels (dish towels) to dry.

Place a square of plastic wrap on a clean surface and lay out the dried sorrel leaves, interlocking each other.

Lightly brush the swordfish loins with extra-virgin olive oil, season with salt and a dusting of the ground wakame or kelp. Cover each piece of swordfish with the blanched sorrel, stretching the leaves over and around so that no part of the swordfish is left exposed. Tightly wrap each loin individually in the plastic wrap and transfer to the fridge to set. Leave for a minimum of 1 hour to ensure the sorrel has a chance to grip onto the fish.

When you are ready to serve, peel the avocados and cut them in half, then cut into 4 mm (3/16 in) thick half-moon slices. Season with salt. Cut the apple in half and slice finely.

Remove the swordfish from the fridge and cut into 2–3 mm (1/8 in) thick slices (approximately six from each loin). Lay the slices down on a serving plate and position the avocado and apple slices behind and in front.

Strain the rice from the vinegar as required and discard (it is inedible). Spoon a small amount of garum or white soy over the ingredients on the plate, followed by a spoonful of the roasted rice vinegar and a liberal spoonful of the olive oil. Serve at room temperature.

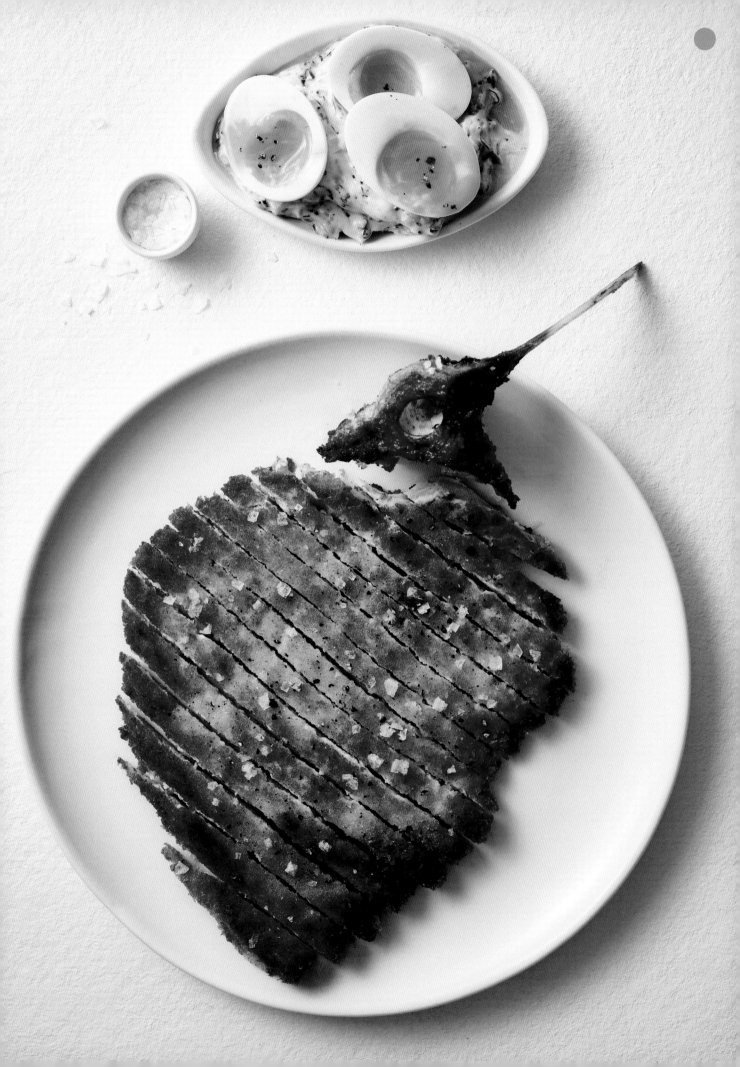

SWORDFISH SCHNITZEL AND EGG SALAD

Who doesn't love a good schnitty! This bone-in, Flintstone-like chop relies heavily on being fried in ghee. The flavour and stability of temperature that ghee provides is unrivalled by other cooking fats.

SERVES 2

2 × 250 g (9 oz) swordfish cutlets, bone in
250 ml (8½ fl oz/1 cup) full-cream (whole) milk
1 large egg
sea salt flakes and freshly cracked black pepper
250 g (9 oz/12/3 cups) plain (all-purpose) flour
180 g (6½ oz/3 cups) white panko breadcrumbs
160 g (5½ oz) ghee

Egg salad

4 soft-boiled eggs, cooled and peeled
100 g (3½ oz) freshly made or best-quality mayonnaise
1 tablespoon dijon mustard
1½ tablespoons finely diced red onion
1½ tablespoons finely diced celery heart
1 tablespoon tiny salted capers, rinsed and drained
1 bunch chives, finely chopped
pinch of cayenne pepper
sea salt flakes and freshly cracked black pepper

Place each swordfish cutlet between two sheets of baking paper and beat with a meat mallet to an even thickness of approximately 2–3 mm (1/8 in).

Place the milk and egg in a shallow bowl, season with salt and whisk to combine. Tip the flour and breadcrumbs onto separate flat baking trays or dinner plates.

Dip the swordfish first into the flour and tap away any excess, then dip it into the egg mixture, allowing the excess to drip away. Lastly, coat with the breadcrumbs, pushing down firmly so the breadcrumbs stick evenly from edge to edge.

Melt half the ghee in a large cast-iron frying pan over a medium heat. Add one cutlet and cook for 4 minutes, keeping the pan moving to swirl the fish around in the hot fat and turning it over halfway through cooking, until golden and evenly coloured on both sides. Season liberally with salt and pepper, then transfer to a plate lined with paper towel to rest. Repeat with the remaining ghee and the second cutlet.

For the egg salad, halve the soft-boiled eggs lengthways. Stir all the remaining ingredients together in a serving bowl until combined, then position the halved eggs on top. Season with a little more salt and pepper. Serve with the swordfish cutlets.

SWORDFISH AND ITS BONE MARROW PIE

This rich and very savoury pie is inspired by the wonderful Fergus Henderson and team at St. John restaurant in London. I make it as one large pie here, but you can easily divide it between two smaller dishes if you prefer. Order the swordfish vertebra from your fishmonger ahead of time as this will nearly always be discarded during processing, and be sure to request muscular, less popular cuts of swordfish for your mince as it doesn't need to be premium centre-cut swordfish on this occasion. Be sure that the marrow is extremely fresh and proudly positioned in the centre of the pie.

SERVES 6–8

1 quantity Sour Cream Pastry
 (page 259)
1 swordfish vertebra
sea salt flakes

Filling
140 g (5 oz) ghee
1 kg (2 lb 3 oz) onions, finely diced
5 garlic cloves, finely grated
sea salt flakes
2 tablespoons tomato paste
 (concentrated puree)
60 g (2 oz) plain (all-purpose) flour
750 ml (25½ fl oz/3 cups) red wine
315 ml (10½ fl oz) Brown Fish Stock
 (page 256)
2 tablespoons dark soy sauce
1 teaspoon worcestershire sauce
2 teaspoons freshly cracked
 black pepper
2 fresh bay leaves
6 thyme sprigs
2 rosemary sprigs
1.25 kg (3 lb 12 oz) minced (ground)
 swordfish loin and trimmings

Egg wash
4 egg yolks
1 tablespoon pouring
 (single/light) cream

Make the pastry according to the instructions on page 259, then roll it out between two sheets of baking paper to a rectangle about 2–3 mm (1/8 in) thick. Chill the pastry in the fridge for at least 1 hour before baking.

To make the filling, heat 80 g (2¾ oz) of the ghee in a large saucepan over a medium–high heat to a light haze. Cook the onion and garlic, stirring, 10 minutes or until translucent. Season with salt, add the tomato paste and cook for another 1 minute, then stir in the flour to combine. Cook for 1 minute, then pour in the red wine, bring to a simmer and cook for about 12 minutes until reduced by half. Add the stock, soy, worcestershire, pepper and herbs and cook, covered, over a medium–low heat for 30 minutes or until thick and fragrant. Reduce the heat to very low and keep warm while you prepare the swordfish.

For the swordfish, heat 1 tablespoon of the ghee in a frying pan over a high heat, add one-third of the swordfish mince and cook briefly until coloured, using a whisk to stir and separate the mince into small even strands. Season lightly with salt, then transfer the mince to the red wine sauce. Repeat in two more batches with the remaining ghee and swordfish mince. Stir to combine, then remove the filling from the heat and leave to cool, then transfer to the fridge to cool completely.

Spoon the cold filling into a large pie dish, filling it to about two-thirds full. Set the swordfish vertebra in the very middle of the dish. Using a small ring cutter, cut the same size hole as the vertebra in the centre of the pastry, then drape it over the top so that the hole matches up.

Using your thumb and index finger, lightly press the edges of the pastry so they adhere to the edge of the pie dish. Whisk together the egg wash ingredients and brush liberally over the pastry, reserving the leftovers. Refrigerate until the egg wash has dried completely.

Preheat the oven to 200°C (400°F).

Before baking, brush with the egg wash again and lightly season the surface with salt flakes. Bake the pie for 20 minutes, or until the pastry is a deep golden brown. Remove and rest for 10 minutes. Serve with a simple salad, such as parsley and pickled onion.

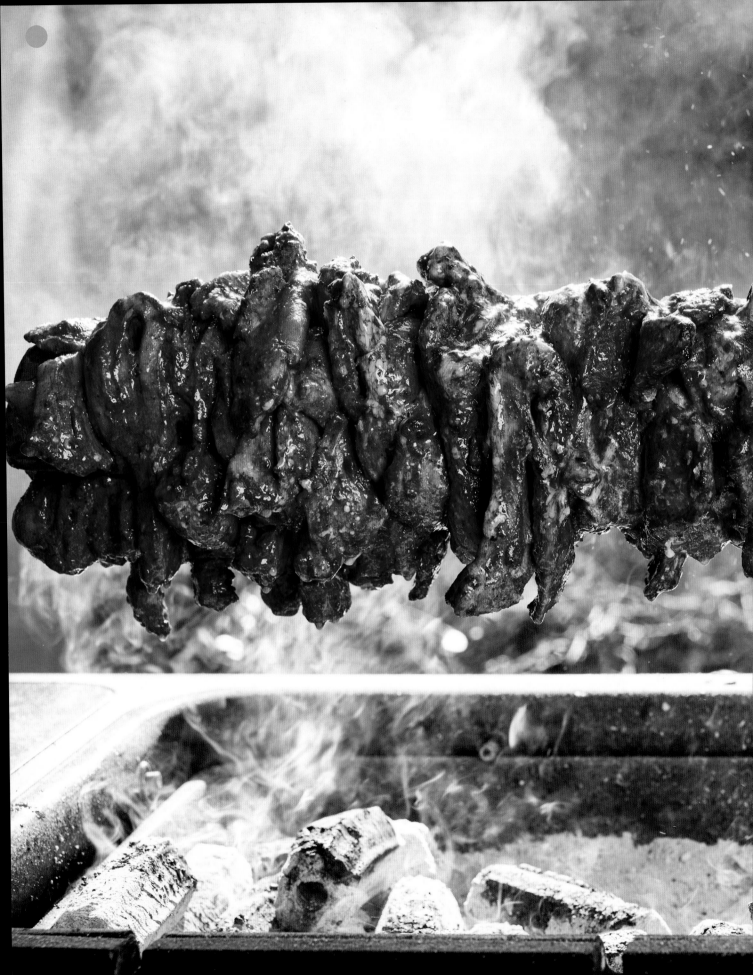

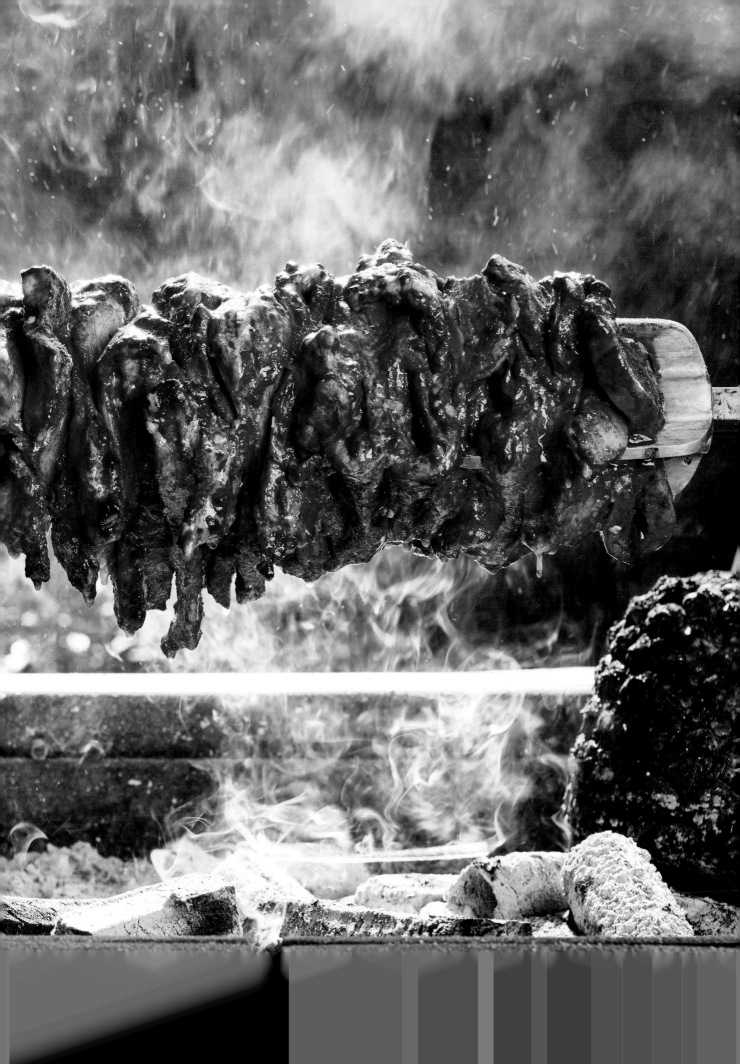

SWORDFISH TACOS AL PASTOR

I first tasted tacos al pastor only a few years ago in LA, where they have some unbelievably good taco vendors. Besides the beauty of the spinning pork adorned with a glorious golden pineapple, I was completely mesmerised by the vendor's muscle memory; it was incredible to see the speed at which he sliced the pork and presented it in perfectly formed corn tortillas.

While I know that swordfish doesn't carry the same rich fattiness as pork, I just had to try replicating this absolutely delicious dish using fish and the horizontal rotisserie grill on my barbecue (though a regular grill or griddle pan also works well). I'm really happy with the result.

SERVES 8–12

2 1/2 tablespoons grapeseed oil, plus extra for brushing
8 garlic cloves, coarsely chopped
2 teaspoons dried oregano
1 teaspoon freshly ground cumin seeds
1 teaspoon freshly cracked black pepper
1/2 teaspoon freshly ground cloves
7 dried Guajillo or Ancho chillies, stems and seeds removed, cut into 2.5 cm (1 in) pieces
180 ml (6 fl oz) pineapple juice
80 ml (2 1/2 fl oz/1/3 cup) apple-cider vinegar
100 g (3 1/2 oz/1/3 cup) achiote paste
sea salt flakes
2 kg (4 lb 6 oz) trimmed swordfish loin, sliced into 3 mm (1/8 in) thick rounds
1/2 medium pineapple, peeled

To serve
20 warm corn tortillas
1 large onion, finely diced
sea salt flakes
2 bunches coriander (cilantro), stems and leaves coarsely chopped
3 limes, cut into wedges

Heat the oil in a medium saucepan over a medium–high heat to a light haze. Add the garlic and cook, stirring occasionally, for about 1 minute until lightly coloured. Reduce the heat to medium, add the oregano, cumin, pepper and clove and cook until fragrant, about 1 minute. Add the chilli and cook, stirring, for 30 seconds or until it begins to blister and bubble. Add the pineapple juice, vinegar and achiote paste and bring to the boil. Remove from the heat and stand for 5 minutes.

Pour the chilli mixture into a blender and blitz to a smooth puree. Season well with salt. Decant the marinade into a very clean stainless steel baking tray or clean airtight container. Add the swordfish loin and turn to coat liberally and evenly. Leave uncovered in the fridge to marinate overnight.

The next day, thread the marinated fish onto a vertical/horizontal spit (or onto large metal skewers), folding the rounds over to create half moons. Alternate the direction of the slices so the finished result is even and the slices are interlocked.

If you are using a charcoal grill, make sure the grill is very hot with evenly burnt-down embers. If you are working with a rotisserie, make sure the coals are spread evenly through the centre of the grill, so the fiercest heat is in the middle.

The key to cooking this dish well is to work over a very high heat – the more caramelisation you can achieve on the marinade the better. If the temperature is too low the fish will cook before it has any real colour.

Before grilling the fish, brush the peeled pineapple with a little grapeseed oil. Grill over a medium heat, turning every 3–4 minutes, until it is evenly charred on the outside with tender flesh on the inside. (Alternatively, set the pineapple in the embers and leave for 1 hour until blackened all over.) Set aside.

Brush the skewered swordfish with grapeseed oil and grill over a high heat, turning regularly to allow the fish and marinade to toast and caramelise. The cooking time will vary, depending on the fattiness of the swordfish and the heat of your grill, but it could take between 12–15 minutes.

The best way to check is to insert a probe thermometer close against the skewer: the temperature should not exceed 46–48°C (115–118°F). Too much heat will result in very dry, chalky swordfish. Remove from the grill and rest for 4–5 minutes.

To serve, using a very sharp knife, slice the swordfish off the skewer straight onto warm corn tortillas. Cut the pineapple into thick slices. Top the tortillas with diced onion, salt flakes, a slice of grilled pineapple and chopped coriander, and finish with a big squeeze of lime.

Serve hot with cold beers.

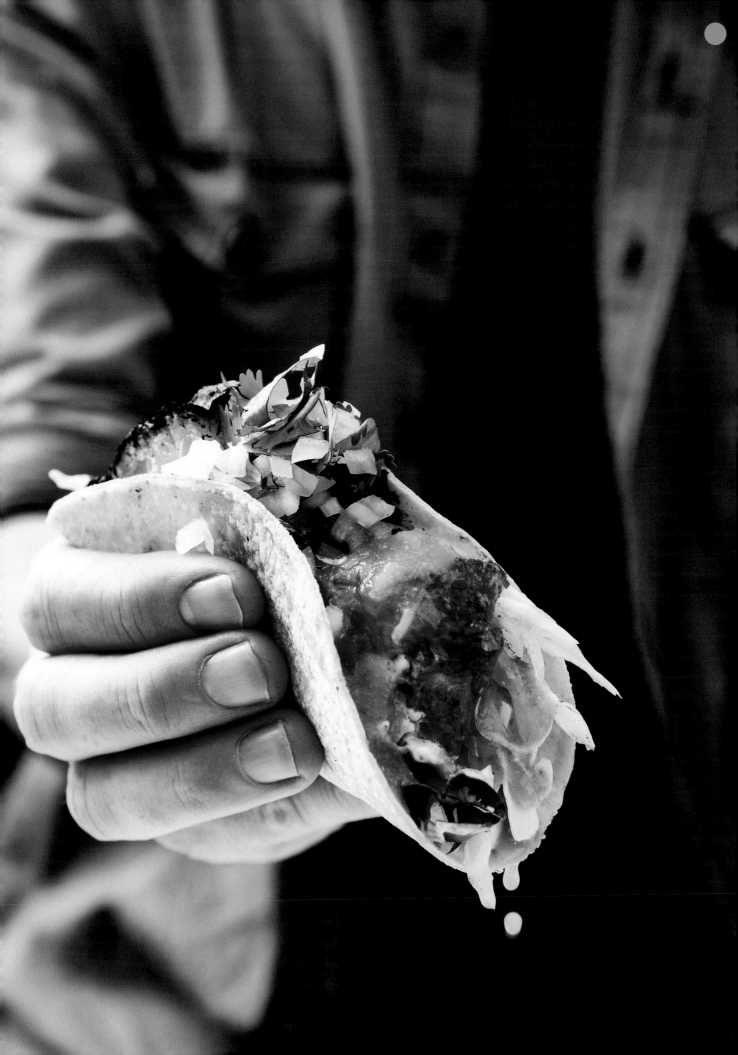

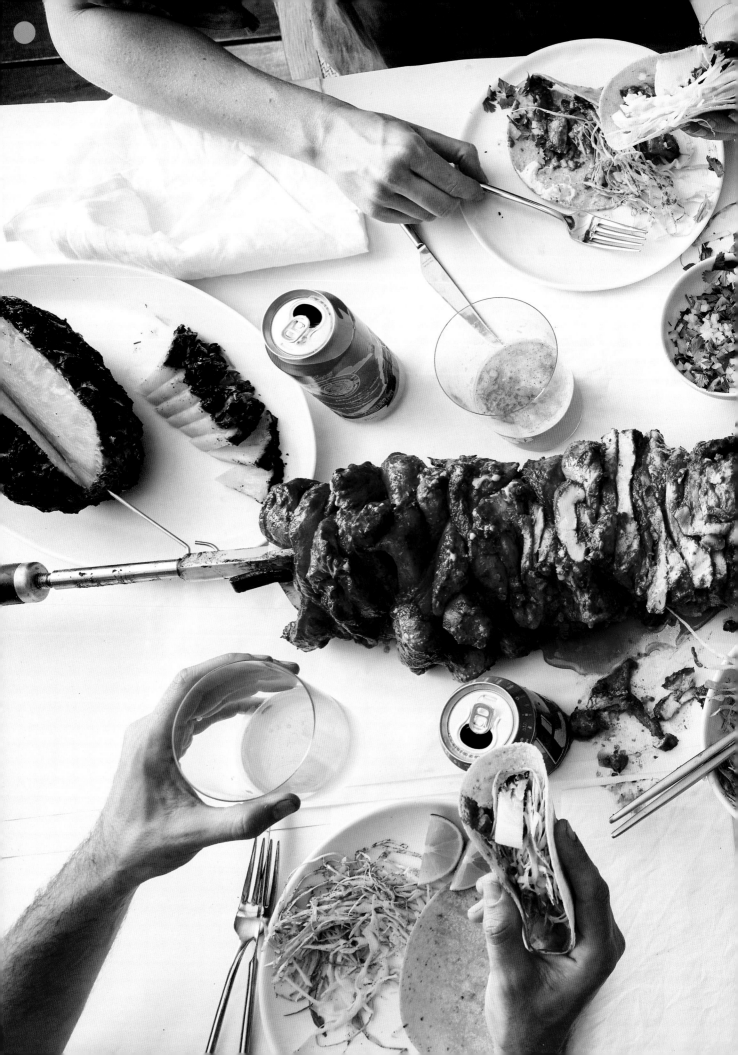

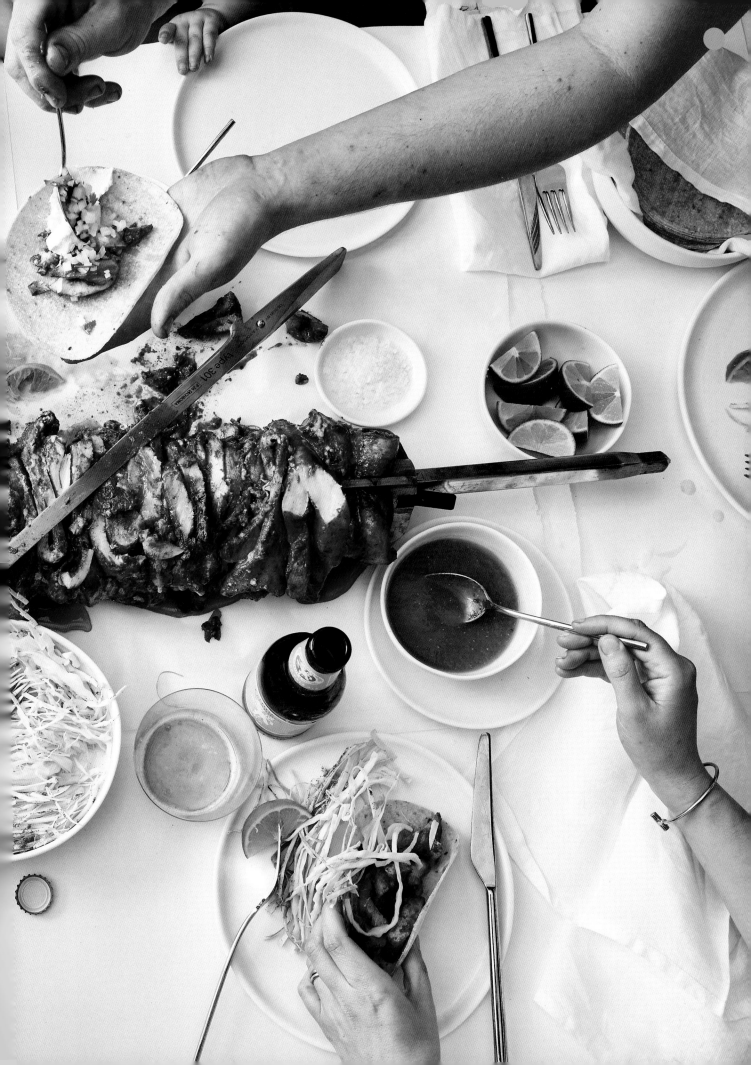

ICS

BROWN FISH STOCK

To produce a great brown fish stock, try to work with the same species of fish rather than a mixture. It's important not to wash your fish bones; soaking a fish frame in water to 'purge off the blood' or wash away impurities is backward logic as it only dilutes the qualities of the fish frame. Frames that have been allowed to dry slightly in the fridge overnight will take on colour better and give you greater flavour, as well as being less likely to stick to the pan, so try to take this step where possible.

The ingredients list should only be viewed as a rough guide; the main thing is to follow the proportions indicated by the percentage points. The stocks I make are derived from whatever ingredients I have to hand, so feel free to scale it up or down and substitute flavours as you like. That said, it is important to note that a stock should not be seen as a compost bin that you can throw any scrap into. Be considerate with the quality of ingredients you use as this will be the difference between a good stock and an amazing one.

ghee or neutral-flavoured oil, for pan-frying
fish frame pieces (85%)
evenly chopped vegetables, such as onion, garlic, leek, fennel and celery (10%)
hard herbs (thyme, rosemary) and toasted savoury aromatics (star anise, fennel seeds, coriander seeds) (up to 5%, depending on the requirements of the stock)

Heat enough ghee or oil in a wide, heavy-based saucepan or stockpot over a high heat to a light haze. Carefully distribute the fish frame pieces around the base, taking care not to overlap them or overcrowd the pan. (Work in batches if necessary.) Cook for about 5 minutes until browned, then remove and set aside.

Keeping the heat high, add the vegetables and coat well with the fish fat and caramelised scratchings from the base of the pan. Cook for 5–6 minutes, then remove the vegetables and reserve, and discard any oil from the pan. Return the fish frames to the pan, then pour in enough cold water to just cover the ingredients.

Cook over a medium–high heat, without skimming the surface, for 15–20 minutes. Return the par-cooked vegetables to the pan, along with any aromatics you are using, and cook for a further 10 minutes or until the liquid has reduced by half and developed a beautiful tan colour.

This lack of skimming may go against the grain, but the impurities that rise to the surface have a lot of flavour and I prefer a richer, more viscous stock to one with less intensity. Adding the vegetables and aromatics to the stock in the later stages of cooking results in a cleaner profile, allowing the individual ingredients to be articulated rather than tasting one-dimensional.

Pass through a fine mesh sieve, discarding the solids. This stock is now ready to be used as a base for making sauces. Store the strained stock in airtight containers in the fridge for up to 4 days or freeze in portions for up to 2 months.

GARUM

This recipe produces a stable fish sauce that can be made from just about any fish waste. Because the amount of trimmings or discarded bones varies from fish to fish, this recipe is based on percentages rather than set quantities, enabling you to work with what you have. It's so versatile it can also be adapted to produce scallop, prawn (shrimp) or cuttlefish garums. At the restaurant we have stored strained garums for up to 12 months as they develop flavours over time. We leave the finished product in a dark cool place until required.

To produce the garum, calculate the total weight of heads, bones and scraps you have from small fish such as sardines, mackerel, anchovies or gurnard (make sure that the gall bladder is removed as it will make the finished sauce extremely bitter). Measure 50 per cent of that weight in water and add to the trimmings. Calculate 20 per cent of the combined weight and add this quantity of fine salt.

Mix together, then transfer to a mason (kilner) jar, seal and place in a circulator bath set to 40°C (104°F). Leave for 7 days, stirring once a day.

Once it's ready, store the garum in a sterilised mason jar or airtight container in the fridge for up to a month.

XO SAUCE

Variations of XO sauce are forever coming in and out of fashion as they carry a great deal of umami and fantastic texture if cooked correctly. Serve this sauce with fish, roast meats, vegetables and rice dishes. It stores well and only gets better with time.

MAKES ABOUT 350 ML (12 FL OZ)

250 ml (8½ fl oz/1 cup) grapeseed oil
75 g (23/4 oz) finely diced spring onion (scallion)
75 g (23/4 oz) finely diced fresh ginger
50 g (13/4 oz) finely diced garlic
100 g (3½ oz) finely diced chilli, seeds removed
50 g (13/4 oz) dried scallops, coarsely chopped
50 g (13/4 oz) dried shrimp
60 ml (2 fl oz/¼ cup) dark soy sauce
75 g (23/4 oz) bass groper roe, scraped from membrane
 (optional)

Heat the oil in a wide-based frying pan or large saucepan over a medium heat to a light haze. Add the spring onion, ginger and garlic and cook for 10 minutes until lightly browned, stirring to stop the ingredients catching on the base or taking on too much colour. Add the chilli, dried scallops, dried shrimp and soy sauce and stir well to coat in oil.

Reduce the heat to low and cook for 30 minutes for a fresher, less intense flavour; if you take it up to 45 minutes the ingredients become quite dark and chewy. If you are using the roe, stir it in during the last 10 minutes of cooking to allow the individual eggs to separate and disperse through the sauce. Remove from the heat and leave to cool until needed.

Store the sauce in an airtight container or sealed vacuum-pack bag in the pantry for up to 2 months. This has a very good shelf life and really does get better with time.

RENDERED FISH FAT

When I refer to the fat, I am talking about the visceral fat that surrounds the fish organs. It resembles chicken or duck fat and can be simply removed by peeling it away from the cavity of the fish. Fish that I have personally worked with that carry this type of fat are Murray cod, kingfish, groper and fattier snappers. Try to use fish that are white fleshed, and when the fat is rendered, strained and cooled, be sure to taste it to check that it has no acidity or imperfections.

Place the fish fat in a saucepan and gently render over a low heat; it should take about 10 minutes for it to liquefy. Strain through a fine mesh sieve to remove any impurities. Pour into airtight containers and cool, then store in the fridge for up to 2 weeks, or in the freezer for up to 2 months.

SMOKED HERRING FILLET

The subtle use of honey and celery here transforms the humble smoked herring into something very moreish, but don't stop there. This is a technique you can also try with a plethora of other species, such as amberjack, sardines, mackerel, skipjack tuna and anchovies.

MAKES ABOUT 200 G (7 OZ)

200 g (7 oz) boneless herring fillet, skin on
2 teaspoons fine salt
60 g (2 oz) honey
1 teaspoon toasted celery seeds
80 ml (2½ fl oz/1/3 cup) water
1 × 14 g (½ oz) brick of apple wood chips,
 soaked in water for at least 1 hour

To cure the herring, place the fillet in a sterile container or tray. Whisk together the salt, honey, celery seeds and water in a separate bowl, then pour over the fish and cover. Cure in the fridge for a minimum of 12 hours, and up 24 hours.

After curing, remove the herring from the brine and place on a trivet, ready to smoke.

You need a smoker that is capable of hot-smoking, or the most suitable alternative – a cheap double steamer lined with aluminium foil and soaked wood chips in the base is always good. Add the wood chips to the steamer base and ignite. Place over a low heat to maintain a steady temperature. Once the chips are smouldering, place the fish in the steamer basket, set it on the base and cover with the lid. Make sure the temperature does not exceed 120°C (248°F), as this will alter the texture of the fish too much – ideally it should be around 90°C (195°F). Smoke for 20–25 minutes.

If you are using a commercial smoker, place the cured herring on a wire rack suited to your smoker and smoke for 20–25 minutes, depending on your desired degree of smokiness and doneness.

Remove from the smoker and rest until it reaches room temperature, then store uncovered in the fridge, skin side up, to dry any surface moisture until you are ready to serve.

SOUR CREAM PASTRY

This pastry can be made in advance and stored in the freezer. Depending on the recipe, you can either thaw it before use or bake it straight from the freezer.

MAKES 450 G (1 LB)

200 g (7 oz/11/3 cups) plain (all-purpose) flour, frozen
140 g (5 oz) butter, frozen and diced
1 teaspoon fine salt
2 teaspoons chilled water
100 g (3½ oz) sour cream, chilled

Pulse the flour and butter in a food processor to create very fine crumbs. Tip onto a cold surface and make a well in the middle. Dissolve the salt in the water and add to the crumb, along with the sour cream, and gently push the dough together until the liquids are fully incorporated and the dough is smooth but has visible ripples of sour cream. It's very important that you don't overwork the dough at this stage.

Divide and roll out the dough following the instructions in your chosen recipe, then chill in the fridge for at least 1 hour before baking.

PARATHA

Paratha is such a delicious vehicle for so many things and shouldn't be limited only to Indian cookery. Once tried and tested, you'll find this is a wonderful accompaniment to a host of different dishes, including curries, for rolling up grilled meats and vegetables, and trust me, for something more decadent, it's a beautiful way to serve caviar or sea urchin.

MAKES 12

2½ tablespoons full-cream (whole) milk
190 ml (6½ fl oz) water
2 tablespoons melted ghee, plus extra for brushing and pan-frying
500 g (1 lb 2 oz/31/3 cups) plain (all-purpose) flour, plus extra for dusting
1 teaspoon fine salt
2 teaspoons caster (superfine) sugar
sea salt flakes

To make the paratha, combine the milk, water and ghee in a bowl. Place the flour, salt and sugar in the bowl of a stand mixer fitted with the dough hook attachment and combine on a low speed. Increase the speed to medium and gradually add the milk mixture. Work the dough for about 20 minutes, or until the dough is firm and glutinous. Cover the bowl with a tea towel (dish towel) and leave to rest for 20–30 minutes.

Once rested, tip the dough onto a lightly floured surface and divide into 12 even balls. Using a rolling pin, roll out each ball as thinly as possible, then, using a little more of the melted ghee, brush generously from edge to edge. Lightly dust the surface with flour and sprinkle over a few salt flakes, then pick up the dough at the top two corners and gradually fold it onto the bench in a concertina fashion. Once the dough is folded in front of you, roll it into a snail shape and brush the top with more melted ghee. Leave to rest for 15 minutes or so, then dust the tops very lightly with flour and roll out each one to a 3 mm (1/8 in) thick disc. Cover with a clean tea towel (dish towel) so they don't dry out.

When you're ready to cook, heat 60 ml (2 fl oz/¼ cup) ghee in a large frying pan over a medium-high heat to a light haze. Carefully place one paratha in the pan and fry for 1 minute or until the base is golden. Flip and repeat on the other side. The paratha should be buttery (but not greasy) and crisp around the edges. Repeat with the remaining paratha, replenishing the ghee each time.

Serve hot, seasoned lightly with salt flakes.

GRILLED PICKLES

You can store these pickled onions and chillies in an airtight container for months, as long as you ensure they are completely submerged in the pickling liquid. If you are in a hurry by all means use them straight after making, but they improve with time so a little planning will definitely pay off .

MAKES 1 LARGE JAR

3 large red onions
3 large green chillies

Pickling liquid
375 ml (12½ fl oz/1½ cups) apple-cider vinegar
125 g (4½ oz) raw (demerara) sugar
1 teaspoon fine salt
1 star anise
3 whole allspice
1 cinnamon stick
10 black peppercorns

To make the pickling liquid, place all the ingredients in a saucepan and bring to the boil over a high heat. Remove from the heat and set aside to cool slightly.

Meanwhile, peel the onions, then use a very sharp knife to cut them into concentric rings about 5 mm (¼ in) thick. Heat a heavy cast-iron frying pan over a high heat, add the onion rings and cook until heavily charred, about 2 minutes each side. Remove from the pan and add straight to the hot pickling liquid.

Prick the green chillies with a fork or sharp skewer, then grill quickly in the pan over a high heat (or over charcoal) until blistered and toasted. Add to the hot pickling liquid. Leave to cool completely, then transfer to a mason (kilner) jar or airtight container and store in the pantry until needed.

QUICK PICKLED VEGETABLES

These quick pickled vegetables are easy to make and very versatile. Carrots and daikon give a great result, though you can also try other vegetables such as cucumbers, radishes and kohlrabi. These pickles are best eaten on the day you make them, but you can store them in the fridge for a couple of days if you like – they just start to lose their crunch over time.

MAKES 1 JAR

60 ml (2 fl oz/¼ cup) distilled white vinegar
2 tablespoons warm water
1 large carrot, cut into 7.5 cm (3 in) matchsticks, about 5 cm (¼ in) thick
60 g (2 oz) daikon (white radish), cut into 7.5 cm (3 in) matchsticks, about 5 cm (¼ in) thick
1 teaspoon fine salt
1 teaspoon caster (superfine) sugar

Combine the vinegar and water in a jug.

Toss together the carrot, daikon, salt and sugar in a bowl and rub until the sugar and salt have dissolved. Set aside for 15 minutes to allow the vegetables to soften slightly.

Add the vinegar mixture, then leave to pickle and soften further for another 30 minutes. Serve just as they are or add aromatics, such as dill, fennel or caraway seeds to deliver another level of flavour.

NAAN BREAD

The semolina here gives the bread its lovely texture on the outside and a slight nuttiness that plain flour just can't deliver. For incomparable flavour and texture, do try and cook the naan breads on a wood or charcoal burning grill.

MAKES 8

5 g (¼ oz) dried yeast
125 ml (4 fl oz/½ cup) lukewarm water
 (or, ideally, yoghurt whey)
1 teaspoon honey
1 tablespoon ghee
140 g (5 oz) natural yoghurt
250 g (9 oz/1⅔ cups) plain (all-purpose) flour,
 plus extra for dusting
1 tablespoon fine salt
100 g (3½ oz) semolina

Combine the yeast, lukewarm water and honey in a large mixing bowl. Cover and set aside in a warm place for 10–15 minutes or until foamy. Add the ghee and yoghurt and whisk until smooth, then add the flour and salt and bring together with a spoon to form a very wet dough.

Working with damp, clean hands, gently knead the dough for 2 minutes to bring it together, then place in a clean mixing bowl and cover with a cloth. Leave to prove somewhere warm in your kitchen for about 1½ hours or until doubled in volume.

Tip the dough onto a clean surface dusted with semolina to make it easier to handle. Continue to work with lightly floured hands until the dough is looking slightly smoother, then divide it into eight even balls.

Dust your surface once more with semolina. Using a rolling pin, roll out each ball of dough to a thickness of about 3–4 mm (1/8 in). If you find this challenging due to the wetness of the dough, place the semolina-dusted dough between sheets of baking paper before rolling it out.

Cover the rolled dough with a cloth and rest for 4–5 minutes.

The naan breads need to be grilled on a clean, hot, dry surface. A hot barbecue or charcoal grill would be ideal, otherwise use a heavy cast-iron frying pan set over a high heat. Be sure to grill the breads dry, without any fat or oil. Cook on the first side for 2 minutes, or until toasted evenly, then turn and cook the second side for 30–60 seconds until toasted, bubbly and soft with a slightly chewy texture. Serve warm.

EGGPLANT AND MACADAMIA PUREE

This luscious puree makes an excellent addition to the tuna koftas on page 233, but it's also delicious on toast, served alongside grilled meats and poultry, or simply used as a dip for raw vegetables and leaves. The macadamias add a wonderful richness here but can be replaced with almonds, walnuts or pine nuts if you prefer.

MAKES 800 G (1 LB 12 OZ)

50 g (1¾ oz/1/3 cup) macadamia nuts
1 kg (2 lb 3 oz) eggplants (aubergines)
½ teaspoon freshly ground cumin seeds
1 garlic clove, finely grated
65 ml (2¼ fl oz) extra-virgin olive oil
65 g (2¼ oz) natural yoghurt
Garum (page 257) or fish sauce, to taste

Preheat the oven to 160°C (320°F).

Spread out the macadamias on a baking tray and toast in the oven for 15 minutes or until lightly golden.

Tip the hot nuts into a Thermomix if you have one. Set it to 70°C (158°F) and blend for 10 minutes until completely smooth and the consistency of peanut butter. Alternatively, blend the nuts in small batches in a high-powered blender, adding up to 60 ml (2 fl oz/¼ cup) water to help achieve the smooth texture.

Preheat a charcoal grill or set a wire rack over an open gas flame. This might be messy work but it will give you a smoky result that you just can't achieve in a frying pan or in the oven.

Place the whole eggplants on the grill, turning regularly with tongs, until blackened all over. Transfer to a large baking tray, cover with a fitted lid or aluminium foil and leave to sweat for 30 minutes. Peel off the burnt skin and place the soft flesh in a large mixing bowl. Discard the skins but keep the smoky resting juices in case you'd like to increase the smokiness of the finished dip.

Add the macadamia butter and remaining ingredients to the eggplant and mix together well. Use a fork if you like a coarser texture, or a hand-held blender if you prefer it more refined. Taste and add more smoky resting juices, garum or fish sauce if needed. Store in an airtight container in the fridge until needed (it will keep for up to 1 week). Serve at room temperature.

BROWN BUTTER HUMMUS

It's so easy to grab a tub of hummus off the shelf and crack the lid, but it tastes infinitely better when you make it yourself. Here, I've added brown butter, roast garlic and toasted cumin seeds, giving the hummus a profound complexity and luxurious mouthfeel. Serve it with any protein or grilled cauliflower, celeriac or parsnip as the quiet star of the show.

MAKES ABOUT 300 G (10½ OZ)

1 garlic bulb
extra-virgin olive oil, for drizzling and to store
2 teaspoons sea salt flakes, plus extra if needed
30 g (1 oz) butter, diced
250 g (9 oz) drained, rinsed tinned chickpeas
2–3 tablespoons tahini paste, to taste
1 tablespoon water
1 teaspoon freshly ground cumin seeds
juice of 1 lemon, plus extra if needed

Preheat the oven to 180°C (350°F). Line a small baking tin with baking paper.

Using a serrated knife, cut the base off the garlic bulb, being careful to only cut off the roots, leaving the bulb intact and exposing the individual cloves. Place the garlic bulb in the prepared tin, cut side down, drizzle liberally with olive oil and season with the salt flakes. Roast for 35–40 minutes, until the husk of the garlic is dry and golden brown and the cloves have caramelised to a jammy consistency. Leave to cool in the oil, then shake the bulb over the tin, allowing the soft garlic cloves to fall out of the husks into the aromatic oil. Store these cloves under olive oil in an airtight container until needed (they will keep for about a month and are good used in a variety of ways).

Melt the butter in a high-sided saucepan over a medium heat. Continue to stir over the heat for 5–6 minutes until the butter foams and sizzles around the edges, has begun to turn golden brown and smells intensely nutty. Working quickly, pour the brown butter into a cold bowl and leave to cool completely.

Place the butter, drained garlic cloves and all the remaining ingredients in a food processor or blender and blitz until completely smooth. Taste and add more salt or lemon juice if needed. Store in an airtight container in the fridge until needed (it will keep for up to 1 week). Serve at room temperature.

LOVAGE TABBOULEH

Tabbouleh is so much more than a one-dimensional condiment that only appears alongside kofta or similar Middle Eastern dishes. Far from it – this acidic, bright and colourful salad has a place at every family barbecue. The lovage adds an earthy celery flavour that I absolutely love, and if you find yourself with leftovers in the fridge, it's truly wonderful with poached eggs and avocado for breakfast the next day.

SERVES 6

30 g (1 oz) fine burghul (bulgur wheat)
400 g (14 oz) ripe truss tomatoes
6 white salad onions
juice of 2 lemons
½ teaspoon freshly cracked black pepper
½ teaspoon freshly ground allspice
½ teaspoon freshly ground coriander seeds
½ teaspoon sumac
¼ teaspoon freshly grated nutmeg
175 g (6 oz) lovage leaves
generously handful mint leaves
100 g (3½ oz/5 cups) flat-leaf (Italian) parsley leaves
iced water, for refreshing
100 ml (3½ fl oz) extra-virgin olive oil
sea salt flakes

Rinse the burghul in cold water until the water runs clear, then drain well in a sieve and place in a large mixing bowl. Fluff up with a fork.

Using a sharp knife, halve the tomatoes and scoop the seeds and pulp into the bowl with the burghul. Finely dice the tomato flesh and the salad onions and add to the bowl. Stir in the juice of 1½ lemons.

Mix together all the ground spices in a small bowl. Treat this as a seasoning for the salad to use at your discretion.

Rinse and refresh the herbs in iced water. Take the lovage, mint and parsley leaves and pile them up together. Using a sharp knife, finely slice them once, then add to the salad bowl. Add the olive oil, season with the mixed spices and salt flakes and toss well.
Taste and add more salt, lemon juice or spices if needed.

FLOUNDER GRAVY

Like most of the brown fish stock-based sauces in this book, this one takes the bones of a single species of fish (in this case, the flounder) and roasts them until they are very well caramelised. This step is critical as it lays strong foundations for the sauce. Too much colour will result in a bitter outcome, and not enough will see an insipid, watery gravy. The dark soy and Vegemite round out the sauce, adding deep umami characteristics that can be challenging to extract from fish (as opposed to meat) bones.

To check the viscosity of the reduced sauce, spoon it onto a cool dinner plate to see exactly how thick it is when it cools. This is also a good opportunity to taste it. I realise the abundance of ingredients doesn't give a significant yield, but look at it as the icing on a cake in terms of making a meal complete. And anyway, who doesn't love gravy?

MAKES ABOUT 250 ML (8½ FL OZ/1 CUP)

100 g (3½ oz) ghee
2 kg (4 lb 6 oz) flounder frames, gills and guts removed
6 large brown onions, finely sliced
6 garlic cloves, sliced
1 fresh bay leaf
15 thyme sprigs
300 ml (10½ fl oz) white wine
2½ tablespoons sherry vinegar
1 teaspoon Vegemite
1 teaspoon dark soy sauce
750 ml (25½ fl oz/3 cups) Brown Fish Stock (page 256)
sea salt flakes and freshly cracked black pepper

Heat the ghee in a large heavy-based saucepan over a medium heat to a light haze, add the flounder bones and caramelise for 10 minutes until well browned. Add the onion, garlic, bay leaf and thyme and stir to combine. Cook, covered, for 10 minutes, or until the onion is soft and translucent. Remove the lid and cook for a further 10 minutes until the onion is caramelised, then deglaze the pan with the wine and vinegar and simmer until reduced to a syrup. Stir in the Vegemite and dark soy, followed by the fish stock, then bring to a simmer and cook for 20 minutes, or until reduced by half. Season well with salt and pepper.

Transfer everything to a food processor and blitz to a thickish, coarse sauce (do this in batches if necessary). Pass this liquid through a fine sieve, discarding the solids, then taste and adjust the seasoning. At this point the sauce may need further reducing (see recipe intro); if so, return to a medium heat and simmer for further 5 minutes or until the gravy is thick enough to lightly coat the back of a spoon. It is now ready to serve.

Store the stock in an airtight container in the fridge for up to a week, or in the freezer for up to a month.

FRIES

Fries or chips? Chips or fries? I love a thick-cut chip, but here I want to talk about its longer, thinner cousin and achieve the same scoffable standards set by takeaway food giants.

When cutting fries, seek out very large, elongated potatoes that will give a generous yield and not have you hunched over the sink for too long. And leave the skins on! So much of a potato's flavour is in its skin. Be sure to start this extensive task a couple of days ahead, as truly excellent fries do require a little patience and TLC.

As a final note, fries don't always have to be seasoned with plain old salt – mix it up, grind up some seaweed or develop your own concoction.

SERVES 8–10

2 kg (4 lb 6 oz) sebago potatoes
fine salt
5 litres (170 fl oz/20 cups) cottonseed oil

Scrub the potatoes thoroughly, leaving the skin on, and cut into batons about the width and length of your index finger. Soak in cold water overnight to remove some of the starches that can sometimes colour inconsistently when deep-frying.

Drain the soaked fries and place in a large heavy-based saucepan or stockpot. Cover with cold water and season the water well with salt as this will make your fries tastier in the end.

Heat the cottonseed oil in a deep-fryer or large saucepan over a medium–high heat until it reaches a temperature of 140°C (275°F).

When the oil is at temperature, place the fries in the deep-fryer basket (or a slotted spoon if using a saucepan) in batches and submerge in the oil. Cook for 2–3 minutes, until a blistered skin has formed on the fries. It's important to be patient here and wait for the skin to blister, as this stage determines how crispy the finished fries will be.

Remove the fries from the oil and drain, then set aside to cool. Spread them over a wire rack and place in the freezer to dry overnight.

Reheat the oil to 180°C (350°F). Add the par-cooked fries and cook for another 3 minutes or until very crisp and golden. Drain well, season with salt and serve hot.

FISH FAT BRIOCHE

Yes, another recipe with fish fat! This heavenly French loaf gets an update by switching out some of the butter for fish fat. Now, hear me out. The fish fat gives the bread a wonderful shortness, along with an intriguing deep savouriness. I encourage you to try it, but if you can't get your hands on any fish fat just replace it with an equivalent amount of butter.

This recipe makes two loaves and they freeze well, so you can always have homemade brioche squirreled away for a rainy day.

MAKES 2 LOAVES

200 g (7 oz) butter
100 g (3½ oz) Rendered Fish Fat (page 258)
15 g (½ oz) dried yeast
2 tablespoons warm milk
6 eggs
2 teaspoons fine salt
30 g (1 oz) caster (superfine) sugar
1¼ tablespoons water, plus an extra 1–2 teaspoons if needed
500 g (1 lb 2 oz/3 1/3 cups) baker's flour
1 egg, extra, and 1 egg yolk, lightly beaten
 to make an egg wash

Take the butter out of the fridge 15 minutes before beginning the dough. Keep the fat chilled.

Dissolve the yeast in the warm milk in the large bowl of a stand mixer fitted with the hook attachment.

Whisk together the eggs, salt, sugar and water in a smaller bowl.

Add the egg mixture and flour to the mixer bowl and beat on a medium speed until the dough is smooth and has formed a ball. It should look very wet to begin with but it will come together. Add a little extra water if needed.

Meanwhile, place the butter between two sheets of baking paper and beat with a rolling pin to soften to a workable consistency (you want it to be as similar as possible to the consistency of the dough).

With the mixer on a medium speed, slowly add small pieces of the butter to the dough and mix well, then add the chilled fish fat and beat for 10 minutes, or until the dough is smooth and homogeneous.

Remove the dough from the bowl and repeatedly throw it onto a clean surface until the dough is smooth and peels cleanly from the bench in a nice tight ball. Transfer to a large bowl with plenty of room for the dough to rise. Dust the dough very lightly with flour and cover with a slightly damp cloth to prevent a crust forming.

Put the bowl in a warm part of your kitchen and let it rise for about 2 hours until doubled in volume.

Knock down the dough with lightly floured hands. Stretch it twice by pulling a big handful of dough up out of the bowl and returning it over itself. Remove the dough from the bowl and gather it into a ball, then return it to the bowl. Cover the bowl with plastic wrap and place in the fridge to rest overnight.

Butter and line the base and sides of two large loaf (bar) tins.

The next day, place the dough on a very lightly floured bench and flatten it quickly by hand. The side of the dough that was on top in the fridge will have a slight crust, and the dough will be easier to shape if you first enclose the crust in the centre of the dough. The dough must be cold when it is shaped so it's important to work quickly.

Divide the dough in half and roll each half into a cylinder. Cut each cylinder into five even pieces. Roll each piece into a tight ball and place five balls in a row in the bottom of each prepared tin, pressing them together to flatten slightly so they all fit in a straight line. Gently press each ball with the end of a rolling pin to flatten.

Brush the tops with egg wash, then leave to rise in a warm place (not too warm, otherwise the brioche will have no structure and less flavour) until it almost reaches the top of the tins, about 2 hours.

Preheat the oven to 190°C (375°F) and place a heavy baking sheet on the middle shelf.

Place the tins on the hot baking sheet and bake for 5 minutes until the tops of the loaves just begin to brown. Reduce the heat to 160°C (320°F) and bake for a further 30 minutes. The brioche is ready when it has taken on even brown colouring and a probe thermometer inserted into the centre registers 85–90°C (185–195°F).

Remove from the oven and immediately turn out the loaves onto a wire rack, then leave cool to room temperature. Slice and toast lightly before serving.

To store, slice the cooled brioche into portions and wrap in plastic wrap or baking paper. They'll keep in the freezer for up to 3 months.

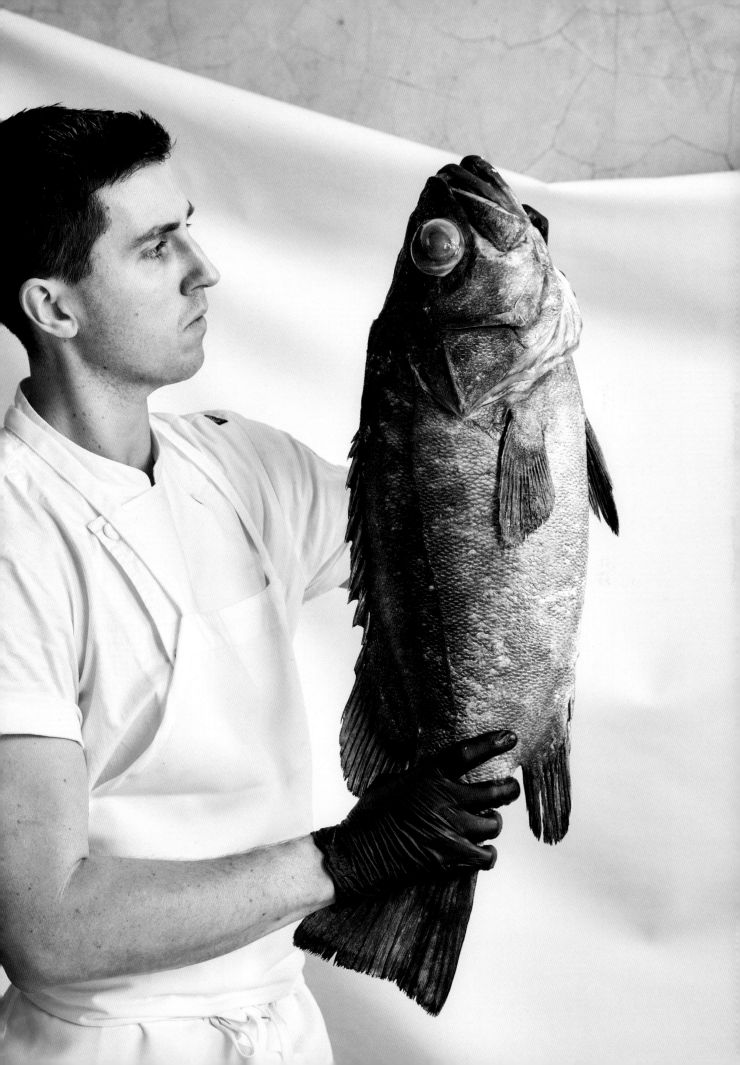

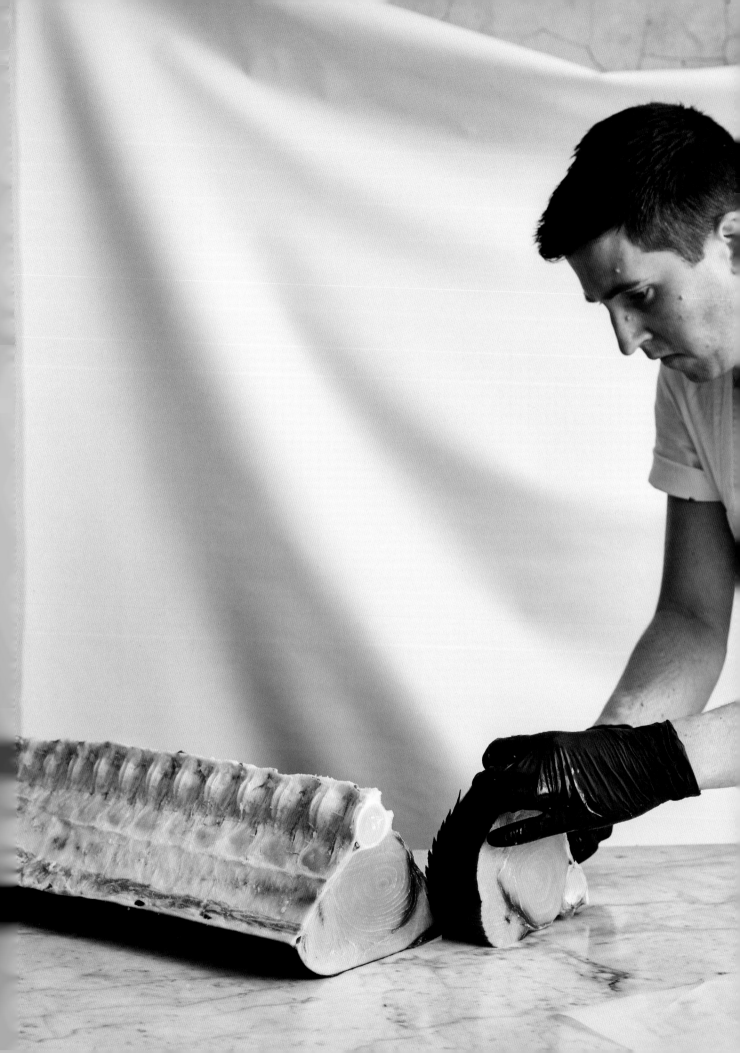

Index

Acknowledgements

To Julie Niland, my wife, thank you for your friendship, kindness and support. For the past 12 years we have been inseparable ... and 10 years of marriage later we find ourselves with so much to be thankful for.

To my Mum and Dad, Stephen and Marea Niland. I know since leaving home at 17 I haven't ever really looked back, but thank you for your unconditional love. The resilience, grit and determination you gave me from a young age is a gift that I only hope I can pass on to my children.

To Hayley and Ian Edmunds, your support, love and kindness means the world to me, thank you.

Monica Brown, your loyalty and friendship over these years has proved essential in the continued growth of both me personally but also our business as well

To my good friends Marty, Dean, George, Brendan and Tony. Your mentorship and wisdom always brings me great joy and I value your friendship more and more as the years go by. Thank you, gents.

To Jane Willson and the Hardie Grant team, without your tenacity and enthusiasm as a publishing company neither *The Whole Fish Cookbook* nor *Take One Fish* would have been written. To Simon Davis, Daniel New, Rob Palmer, and Steve Pearce and Jessica Brook of Sage Creative, thank you for your patience and eye for detail. And to the teams at Fish Butchery and Saint Peter, thank you from the bottom of my heart for continuing to show up and exceed expectations.

It is truly remarkable to be a part of your lives and I value all of you a great deal. Thank you.

Published in 2021 by Hardie Grant Books, an imprint of Hardie Grant Publishing

Hardie Grant Books (Melbourne)
Building 1, 658 Church Street
Richmond, Victoria 3121

Hardie Grant Books (London)
5th & 6th Floors
52–54 Southwark Street
London SE1 1UN

hardiegrantbooks.com

 A catalogue record for this book is available from the National Library of Australia

Take One Fish
ISBN 978 1 74379 663 4

10 9 8 7 6 5 4 3 2 1

Publishing Director: Jane Willson
Project Editor/Editor: Simon Davis
Copy Editor: Rachel Carter
Design Manager: Mietta Yans
Designer and Cover Illustrator: Daniel New
Photographer: Rob Palmer
Stylist: Steve Pearce
Home Economist/Styling Assistant: Jessica Brook
Props: Sage Creative Co
Production Manager: Todd Rechner

Colour reproduction by Splitting Image Colour Studio
Printed in China by Leo Paper Products LTD.

 The paper this book is printed on is from FSC®-certified forests and other sources. FSC® promotes environmentally responsible, socially beneficial and economically viable management of the world's forests.

Hardie Grant acknowledges the Traditional Owners of the country on which we work, the Wurundjeri people of the Kulin nation and the Gadigal people of the Eora nation, and recognises their continuing connection to the land, waters and culture. We pay our respects to their Elders past, present and emerging.

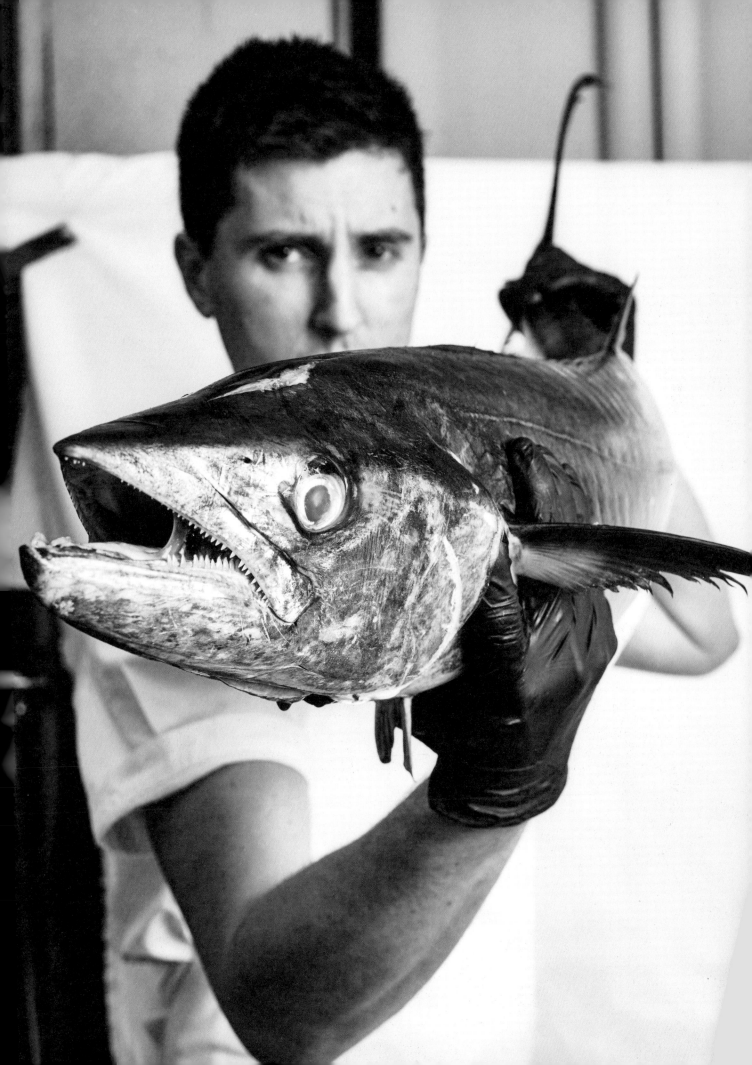